A History and Dictionary
of
BRITISH FLOWER PAINTERS
1650–1950

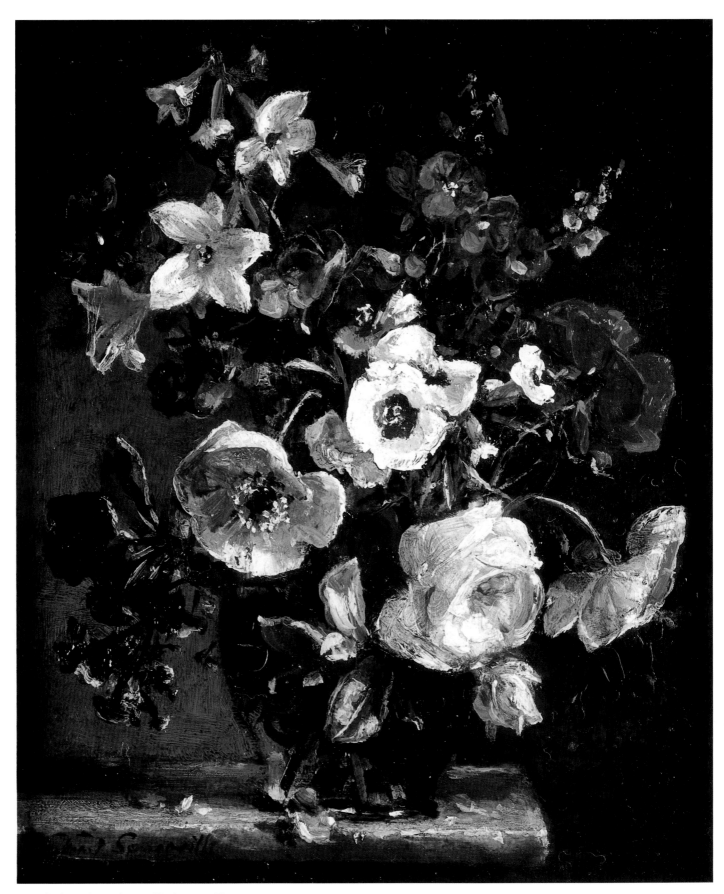

Frontispiece. Stuart Somerville. Summer Flowers.

A History and Dictionary
of
BRITISH FLOWER PAINTERS
1650–1950

Josephine Walpole

Antique Collectors' Club

ISBN 10: 1-85149-504-5
ISBN 13: 978-1-85149-504-7

British Library Cataloguing-in-Publication Data
A catalogue record for this book is available from the British Library

Printed in China
for the Antique Collectors' Club Ltd., Woodbridge, Suffolk

Antique Collectors' Club

Formed in 1966, the Antique Collectors' Club is now a world-renowned publisher of top quality books for the collector. It also publishes the only independently-run monthly antiques magazine, *Antique Collecting*, which rose quickly from humble beginnings to a network of worldwide subscribers.

The magazine, whose motto is *For Collectors-By Collectors-About Collecting*, is aimed at collectors interested in widening their knowledge of antiques both by increasing their awareness of quality and by discussion of the factors influencing prices.

Subscription to *Antique Collecting* is open to anyone interested in antiques and subscribers receive ten issues a year. Well-illustrated articles deal with practical aspects of collecting and provide numerous tips on prices, features of value, investment potential, fakes and forgeries. Offers of related books at special reduced prices are also available only to subscribers.

In response to the enormous demand for information on 'what to pay', ACC introduced in 1968 the famous price guide series. The first title, *The Price Guide to Antique Furniture* (since renamed *British Antique Furniture: Price Guide and Reasons for Values*), is still in constant demand. Since those pioneering days, ACC has gone from strength to strength, publishing many of today's standard works of reference on all things antique and collectable, from *Tiaras* to *20th Century Ceramic Designers in Britain*.

Not only has ACC continued to cater strongly for its original audience, it has also branched out to produce excellent titles on many subjects including art reference, architecture, garden design, gardens, and textiles. All ACC's publications are available through bookshops worldwide and a catalogue is available free of charge from the addresses below.

For further information please contact:

ANTIQUE COLLECTORS' CLUB

www.antiquecollectorsclub.com

Sandy Lane, Old Martlesham
Woodbridge, Suffolk IP12 4SD, UK
Tel: 01394 389950 Fax: 01394 389999
Email: info@antique-acc.com
———————— or ————————
Eastworks, 116 Pleasant Street – Suite 18
Easthampton, MA01027, USA
Tel: (413) 529-0861 Fax: (413) 529-0862
Email: info@antiquecc.com

To Mary Elliott Lacey
1923-2004

CONTENTS

FOREWORD – FLORAL ART by Julian Royle FRSA 9

ACKNOWLEDGEMENTS 10

INTRODUCTION 11

CHAPTER I 13
 A Brief Introduction to Floral Art

CHAPTER II 22
 British Flower Painting in the Seventeenth Century

CHAPTER III 27
 British Flower Painting in the Eighteenth Century

CHAPTER IV 43
 British Flower Painting in the Nineteenth Century

CHAPTER V 65
 British Flower Painting in the Twentieth Century

DICTIONARY 141

ABBREVIATIONS 231

BIBLIOGRAPHY 233

INDEX to Chapters I to V 235

Art is the flower – life is the green leaf. Let every artist strive to make his flower a beautiful living thing – something that will convince the world that there may be – there are – things more precious – more beautiful – more lasting than life.

<div align="right">Charles Rennie Mackintosh - 'Seemliness' 1902</div>

FOREWORD

FLORAL ART

I little thought, when I met Josephine Walpole on my first visit to the Deben Gallery on Market Hill over thirty years ago, that Woodbridge would become my eventual home. Attending exhibitions at the gallery of work by Janet and Anne Grahame-Johnstone, twin daughters of the distinguished equestrian artist Doris Zinkeisen, in turn led to my publishing *Anna,* a biographical tribute by Josephine Walpole to the equally distinguished artist Anna Zinkeisen, sister of Doris.

In 1988 Josephine's beautifully illustrated account of the life of the artist *Vernon Ward* was published by the Antique Collectors' Club. Many of the subjects included were familiar to me not only as prints and cards but as paintings that we enjoyed in our home. The universal appeal of flower painting ensured that it formed the largest category of reproduced subjects in the *Royle Collection of Cards by Famous Artists.* We often referred to our cards as a form of non-verbal communication, international in acceptance. We shared with florists the injunction to 'Say it with Flowers', but in an incorruptible form. I wish that I had acquired a copy of Josephine Walpole's lovely researched book during my active years as a fine art publisher. No less than fourteen of the contemporary artists included were regularly represented in our collection of publications. It was a great privilege to work with and befriend such masters of flower painting, in addition to Vernon Ward, as John Lancaster, Leslie Greenwood, James Noble, Edith Hilder, Marjorie Blamey, Eleanor Ludgate, Nicole Hornby, John Strevens and Gillian Whitaker, to name but a few.

My mother Dorothy, who had studied at the St Martin's School of Art in London, was a gifted amateur flower painter whose work we also included in our collection. I was in turn encouraged to paint at my preparatory school by Maurice Feild, who later taught at the Slade, but I found my visits to the studios of so many outstanding artists inhibited my own artistic efforts while making me appreciate the skill of so many truly gifted artists. We are most fortunate to own a representative number of their paintings. We also reproduced the work of many of the great names from the past whose paintings now hang in public galleries and private collections throughout the world.

I commend this excellent book to all those who lover flower paintings and whose curiosity encourages them to know more of the fascinating lives which have been led by so many distinguished British artists. Their work encompasses both botanical illustration and poetry in paint.

Julian Royle, FRSA
Woodbridge
June 2004

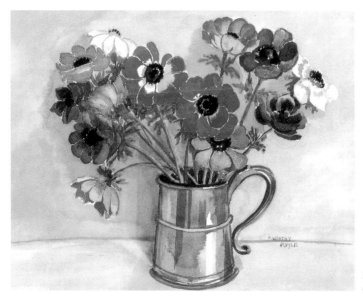

Dorothy Royle (late mother of Julian, an enthusiastic amateur painter). Anemones.

ACKNOWLEDGEMENTS

So many people have been involved with this book that it would be too space consuming to mention them all individually, especially those living artists who have so kindly helped with details of themselves and their work and to whom I am deeply grateful; I have endeavoured to use as many as practical of the illustrations they have so generously provided. More poignantly, I feel I must thank individually Rösli Lancaster, Catherine Somerville, James Harrigan, Lilian Greenwood, David Nunn, Anthea Sieveking and Angela Skailes for whom talking and writing about the work of their late husbands or wives, parents or siblings, must have been more painful.

Thanks are due to many others, starting with Dick Henrywood with whom the project was instigated back in 1989, although the whole concept has changed considerably since our early discussions. I am eternally grateful also to Dr Richard Brinsley-Burbidge, Professor William T. Stearn, Ray Desmond, Dr Shirley Sherwood, Claire O'Mahoney and Rachel Boyd (Richard Green Gallery), John Allen (Mandell's Gallery, Norwich), John Day (Eastbourne Fine Art), Elaine Wintle (Stacy-Marks, Eastbourne), Peyton Skipwith (Fine Art Society), Gillian Raffles (Mercury Gallery), Richard Parks (Westcliffe Gallery, Sheringham), Jane Buchanan-Dunlop (Broughton Gallery, Biggar), Aitken Dott, Edinburgh, Thompson Gallery, London and Aldeburgh, and Bury St. Edmunds Art Gallery.

Other help I acknowledge with thanks has come from Julian Royle, Anne Paterson-Wallace, Tony Morrison, the Paperhouse Group, the Royal Pharmaceutical Society, Royal Botanic Gardens, Kew, Royal Botanic Garden Edinburgh, and the Fitzwilliam Museum, Cambridge. The list grows longer but I must include Jack Kramer, Pamela Henderson (Society of Botanic Artists), Ann Middleton (Society of Flower Painters), Anne-Marie Evans, George Greenshield, Richard Mabey, Grant Waters, Lys de Bray, Winifred Walker, Val Hurlston-Gardiner, Don Edwards, Colin Slee, Joe Lubbock. To anyone I have inadvertently omitted, I apologise sincerely.

Lastly I must thank those kind people who have provided illustrations from their private collections but who, for obvious reasons, prefer to remain anonymous.

J.W.

INTRODUCTION

I have to confess at the outset that this book, styled *A History and Dictionary of British Flower Painters,* hardly conforms to the conventions of either. At the same time I should like to think that in years to come it will add something to the heritage of British flower painting which, compared with its Dutch and French counterparts, is short – in fact some of the most acclaimed British flower painters were born in the early to mid-twentieth century. Obviously there is history dating much further back in which many excellent exponents, notably in the botanical field, have represented us but, numerically, our history is comparatively recent.

Perhaps not everyone will agree with my selection of representatives of British flower painting through the ages; such choices are inevitably personal, although attention must be paid to the reputation and life history of the individuals concerned. Comparable flower artists appear in the Dictionary but to mention all these in a general resumé would not only become tediously repetitive as one ran out of adjectives but suggest discrimination against the rest. Absolutely no slight is intended; some highly professional and dedicated painters paint to live and live to paint without, perhaps, any background story to tell.

To compile a purely academic dictionary I have found impossible. Hard as one may try, one cannot be coldly objective about painters who are alive and frequently known personally in the same way as the average dictionary definition describes those who have long since departed this life. Another paradox (which a distant future history may sort out) lies in the fact that so often the best painters, particularly of the older generation, are reluctant to talk about themselves and invariably keep no record of their achievements; they are content to let the work speak for itself, their obvious success adding another voice. Younger painters by contrast will provide detailed and comprehensive CVs to promote themselves; competition is intense and there is greater pressure to succeed, to make money and a reputation.

Fortunate indeed is the painter today, whether of flowers, landscape or anything else, who is sufficiently secure to paint for the love of what he or she is doing, letting the rest of the world go by. Perhaps equally happy is the artist who cares nothing for money, ambition or material possessions as long as he can enjoy doing what he wants to do without distraction. For the rest of us, let us just appreciate the fruits of their labours, as far as good flower paintings are concerned being grateful for a very lovely but less ephemeral substitute for the real thing which inspires our interest in the first place.

J.W.

Colour Plate 1. Alexander Marshal. Flowers in a Delft Jar (oil on panel)

CHAPTER I
A Brief Introduction to Floral Art

From ancient times flowers have been loved for their extraordinary sensual beauty and appreciated for their decorative quality, their colour and fragrance and, not least, their ephemeral existence. The transitory life of such wondrous creations has for ever inspired an overriding ambition among artists, gardeners, scientists and flower lovers somehow to preserve them or their images for ever.

Floral art has had its own place throughout history, well before the late sixteenth and seventeenth centuries when flower paintings in the sense that we know them today started to come into their own. The tombs of the early Minoans, over 2000 years before Christ, were found to have contained gold jewellery in the form of lilies, roses and other flowers and flowers were used in decoration in Crete and the Cyclades. Both the early Egyptians and the Romans were keen gardeners. The Egyptians, while growing many crops for food, clothes and other utilitarian purposes on their wonderfully fertile soil, were also great flower lovers and used their flowers for ceremonial occasions, both civic and religious, as public decoration or homage to their gods, and in bouquets, head-dresses and garlands for individuals. They became the subject of wall and even pavement decoration, inspired decoration for jewellery and ornaments and for the tombs; the dead seem always to have been honoured with floral tributes.

The ancient Romans were equally great gardeners, but favoured the more formal garden rather than the riotous display. They made use of columns and sculpture as foils to the plants and often painted the garden walls with suitable background subjects. They chose to decorate their homes with wall paintings of gardens[1] and flowers as well as the tombs of family and friends, while household ornaments, the inevitable jewellery and garments frequently incorporated floral design.

The ancient Greeks, who came later to the idea of floral decoration, used such designs in their famous mosaics and pottery, inspired more by wild flowers than cultivated varieties. They were regarded as something that grew naturally rather than under the auspices of man and so became part of their mythology, the stuff of legends and tradition.

Throughout the Old Testament which, after all, starts with the Garden of Eden, there are numerous references to plants and flowers, one of the most frequently quoted being from Solomon's Song of Songs, 'I am the Rose of Sharon and the Lily of the Valley'. The Rose of Sharon was actually *Tulipa sharoneosis,* the Sharon tulip, just as in 'the desert shall rejoice and blossom as the rose' (Isaiah) – the Hebrew translates as narcissus. The actual rose, the ancient Phoenician rose much loved by addicts of heritage roses, myself included, appears in Exodus 11: 'And as many fountains flowing with milk and honey, and seven mighty mountains whereupon there grow roses and lilies, whereby I will fill thy children with joy'. In ancient Mesopotamia flowers and plants from the Bible were again used as inspiration for jewellery and other adornment and the Assyrian Mesopotamians (ninth and tenth centuries BC) were extremely conscious of the sacred nature of trees of the Old Testament. Even earlier, the Sumerians were using flowers in their jewellery and women's head-dresses and in carved ivories. The depictions were very stylised by today's standards, but the interest in and feeling for flowers and plants was, nevertheless, plainly evident.

In 1957 the talented botanical painter, Winifred Walker, united the Biblical with our own time by producing a book called *All the Plants of the Bible* in which she illustrates with her customary professionalism 114 of these plants. Not all are floral in the accepted sense – plants include trees, shrubs, fruit and vegetables – but there is a tremendous floral variety and most of the drawings of trees, especially fruit trees, include an illustration of the blossom, as in the one captioned 'comfort me with apples'. Some of the lesser known references, too, provide beautiful illustrations that clearly indicate her feeling for the flowers themselves. In Ecclesiasticus, for instance, 'I gave a sweet smell like cinnamon and aspalathus' shows a charming and delicate flowering shrub; likewise the drawing of the pomegranate, '...and Saul tarried under a pomegranate tree'. The author's fascination with the scriptures as well as the flowers and her scholarly translation from the Hebrew text gives us a valuable insight into the ancients' love for their

flowers and how their names translate into those of our own, equally cherished, plants of today.

As well as the early Romans and Egyptians, the Japanese and Chinese, also the Indians, have a long tradition of floral decoration. The Han Dynasty, 200 years before Christ, used floral motifs in tomb decoration and only a few hundred years later the Buddhists were using the theme extensively. In India, well before the time of Christ, floral patterns were being used on earthenware pots, jars and figurines; interestingly one finds present-day potters emulating these designs, often to considerable effect. In every country in the world, flowers have come to be used more and more in all forms of decoration – china, pottery, church architecture and hangings, textiles, tapestries, illuminated books and manuscripts… the list is endless.

In view of all this early floromania it seems quite surprising that flower painting in today's accepted sense, pictures to be framed and hung on the wall or illustrations for books, was only considered around the fifteenth century. Coming to the early years of the Christian era, the Chinese Sung Dynasty, AD 960-279, which has been described as 'a splendid age of flower painting', was encouraged by the Emperor Hui Tsang, an enthusiastic collector of bird and flower paintings as well as being a painter himself. His collection is said to have run into several thousand works, mainly in the form of hanging scrolls of various sizes or hand scrolls. This was the start of a noble tradition and Oriental art with its own distinctive hallmark has been recognised and appreciated in Western countries ever since. Although some of the delicate natural quality of the earlier years was temporarily lost when the Ming Dynasty adopted a more stylised approach, the basic character continues until this day.

Coming closer to home, mosaics, tapestries and frescoes constitute the earliest examples of floral art in Europe. One very early mosaic depicting a basket of flowers and now in the Vatican is said to date from the second century AD, but, if so, it has been somewhat over restored. In the two centuries before paintings as such were introduced, floral tapestries were favoured wall decorations for better off families and some have been carefully preserved in Paris, New York and probably elsewhere. Again, modern designers of tapestries are more and more frequently drawing on these old but very beautiful tapestries for inspiration. As far as the frescoes are concerned, flowers were combined with religious subjects, particularly those depicting the Blessed Virgin Mary. Flowers

were an important feature both symbolically and as part of the act of worship, although in the early years of Christianity there was some doubt about the use of flowers at funerals, for church decoration or for celebrations of a sacred nature. To some it seemed like a return to pagan practice and was condemned by many elders of the Church including St Jerome and St Ambrose. St Augustine, however, quoting Christ's words on the lilies of the field, appreciated the beauty of the wild flowers and it became an act of love to use them in adornment of the churches. About the same time the use of incense, which tended to be associated with flowers, became accepted, although the introduction of flowers into religious paintings came much later. As time went on altarpieces provided scope for painted or embroidered flowers around religious themes and some very lovely early examples can be seen in the Uffizi, Florence. Many legendary floral symbols date from the thirteenth and fourteenth centuries and are remembered and quoted today – the white lily as a symbol of the Immaculate Conception, for example, and the various spiritual connotations applied to the rose.

The ancient herbals represented yet another form of art from nature, coming nearer and nearer to conventional flower painting along with some of the beautifully illustrated and illuminated books and manuscripts. The production of beautiful flower books has continued and, thanks to modern sophisticated printing processes, they have become more generally accessible. Referring back to the herbals, although that of Gerard (c.1597) is undoubtedly the most famous, his was only one of many inspired by a spate of discoveries by early botanists of 'new' plants from all over the world which set in train the enthusiasm for botanical drawing and painting which came into being in the late fifteenth century. The Ghent-Bruges school of illuminators, for instance, became passionate about close botanical study before faithfully drawing and/or painting single flowers, butterflies and insects, exact in every detail; an excellent example is the illuminated border from the *Grimani Breviary* (c.1510) in St Mark's Library, Venice. The *Book of Hours* of Master Mary of Burgundy in the Berlin Printroom is another wonderful manuscript, also those of Jean Bourdichon (1457-1521) which have borders depicting between three and four hundred plants, all meticulously detailed miniature portraits. The drawings and watercolour florals of the unique Albrecht Dürer (1471-1528) belong to this era and were executed with a sensitivity that Dürer made all his own. His study of the columbine is universally familiar,

likewise the remarkable *Das grosse Rasenstück* (1503) which never fails to inspire awe and wonder.

The study of botany developed with extraordinary speed during the sixteenth century. Botanists, naturalists and artists travelled all over the world collecting and bringing to their own country the aforementioned 'new' plants to study and paint. From the Botanical Gardens of Padua, founded in 1548, many others grew up to help satisfy the voracious appetites of these dedicated students of nature. Even before Gerard's, the very early Italian herbals and others served as an encouragement to artists to emulate and improve on their example.

The most important sixteenth century botanical painters include Georg Flegel (1563-1638), a German painter whose main work was a beautiful album of watercolour flower studies unfortunately damaged during the war, and Jacques Le Moyne de Morgues (1533-1588). The latter led an adventurous life for a painter but his botanical work is outstanding; there is a good collection in the British Museum. After fleeing his native France to escape the Massacre of the Huguenots, he spent the rest of his life in England where he soon acquired some influential patrons. Georg Hoefnagel (1542-1600) produced some splendid manuscripts illustrated with flowers from all over the world. Pietro Michiel (1510-1566) was a Venetian botanist who spent some time in charge of the Botanical Gardens at Padua where he made full use of the material available in his herbal, *I Cinque Libri di Plante,* now in St Mark's, Venice. Many of the illustrations were painted by one Domenico dalle Greche whose only life record seems to rest on his paintings. The Veronese Giacomo Ligozzi (1547-1626), although best known for his oil paintings, produced some very superior watercolour botanical work now in the Uffizi, Florence.

As we move into the seventeenth century the French Nicolas Robert (1614-1685) represented both the old tradition of the manuscript painters and the more scientific modern botanical artists. Robert was appointed Peintre Ordinaire de sa Majesté in 1664, Louis XIV having inherited the vélins (paintings on vellum) of his predecessor's brother of which Robert eventually painted seven hundred. Claude Aubriet (1665-1742) was another significant French botanical artist who contributed a further 394 subjects to the aforementioned *Vélins du Roi* and became official painter at the Jardin du Roi after travelling extensively in search of plants including that which bears his name – aubretia. A close follower of Robert was the German, Maria Sybilla Merian (1647-1717) who was another perfectionist in her rendering of flowers and foliage in their setting. Her style, like Robert's, undoubtedly characterised this important period of transition. The most significant British botanical painter of this time was Alexander Marshal who died in 1682 (Colour Plate 1); his work will be considered in greater detail later in this volume.

The eighteenth century saw a magnificent age of botanical painting which has provided inspiration and influence for many of today's leading botanical artists; such auspicious names as the German, Georg Dionysius Ehret (1708-1770), the Austrian, Francis Bauer (1758-1840), said by Wilfrid Blunt to be the greatest botanical artist of all time, and his brother Ferdinand (1760-1826), the famous French Pierre-Joseph Redouté (1759-1841) and his contemporary Pancrace Bessa (1772-1835), another Austrian, Moritz Michael Daffinger (1790-1849) and, not least, the distinguished Briton, Philip Reinagle (1749-1833) will probably dominate their field for ever. Redouté was followed by a number of talented pupils who, although in their time tended to be overshadowed by the Master, are well represented in the Fitzwilliam Museum, Cambridge. The famous Lyon School, too, produced some excellent botanical painters.

Throughout the nineteenth century botanical painting was dominated by French and British artists. Along with these we must include the wonderful artists of Kew who continue to produce work of superlative quality and certainly raise the standard of British botanical painting to the very top of this exacting but rewarding profession.

Retracing our steps to those early botanical discoveries, we find that the 'new' plants were also a source of inspiration for the early traditional flower painters who skilfully combined them with the symbolic flowers often in exquisite garlands round a religious theme. It was an illustrator, Jacob de Gheyn, who produced at the turn of the sixteenth/seventeenth centuries a wonderful album of flower paintings and who, along with Ambrosius Bosschaert the Elder (1573-1621) and Jan Brueghel the Elder (c.1568-1625), has been termed the father of flower painting as we know it. History tells us of two even earlier (mid-sixteenth century) flower painters, Lodewyck Jansz van der Bosch and Pauwels Coecke van Aelst, but existing examples of their work have yet to be discovered. If Willem van Aelst (1625-c.1685) is a successor, as seems likely, he is a more than worthy follower. Born in Delft, he was taught by his uncle, Evert van Aelst, before moving on to Paris, Florence and Rome and becoming court

painter to Ferdinand II, the Medicis and the Grand Duke of Tuscany. During the late sixteenth and throughout the seventeenth century flower painting was dominated by the masters of the Flemish and Dutch schools. This period was aptly designated 'the Golden Age of Flower Painting' and the incredible beauty of most of this work defied description. Some artists produced literally hundreds of flower paintings and the tremendous upsurge of interest in newly discovered plants as well as the 'tulipomania' in the Low Countries ensured a warm reception for all things floral.

Many of the early works, notably by the Catholic element in the South, were, in a way, descendants of the breviaries in that the increasingly elaborate floral border was replaced by lavish garlands of flowers bordering paintings, often by a different artist, of the Madonna and Child, the Holy Family or other religious grouping. One of the earliest was that of Jan Brueghel the Elder (c.1568-1625), 'Garland of Flowers with the Virgin', in which the figures were by Rubens. Another noted exponent of the garland was Brueghel's talented pupil and fellow Catholic, Daniel Seghers (1590-1661), whose imaginative compositions in this sphere and exquisitely painted flowers combining the 'modern' with the symbolic are a feast for both eyes and soul. One of the most remarkable in its complex profusion of almost living blooms and cherubs is 'Garland of Flowers with St Ignatius Loyala', now in the Vatican, although the sensitivity of 'Wreath of Flowers around a Cartouche of the Virgin and Child' in Gemaldegalerie alte Meisters, Dresden, and 'Garland of Flowers around the Flagellation of Christ' adds a deeper spiritual dimension.

The prevailing enthusiasm for flowers and flower painting in its most natural form soon extended from the religious connection to floral arrangements and elaborate still-life studies with flowers, insects, butterflies and often fruit or shells, which became extremely popular, often being specially commissioned by the rich Protestant merchants. The Elder Jan Brueghel ('Brueghel of the Flowers'), having been appointed Court Painter in 1606, painted for European royalty, the aristocracy and leading Church dignitaries. Dr. Marie-Louise Hairs, a leading authority on Flemish flower painting, lists over 150 surviving works from tiny studies with a few meticulously crafted flowers in a glass to massive arrangements of flowers in wooden tubs or vases and, of course, garlands. Always each bloom is a miniature portrait, a likeness portrayed by an artist who is only satisfied by

perfection. Unlike many of his contemporaries, his own pupils being the obvious exceptions, Brueghel always painted from living flowers which invariably shows in any flower study, whether of the Middle Ages or the twentieth century.

Many of Brueghel's small paintings, like those of some other early flower painters, were on copper grounds which has helped to preserve the brilliance of the colours. While these were often not more than 10in. x 8in., the tub arrangements were generally 4ft. or 5ft. wood panels. How many hours it must have taken to complete one of these mammoth creations is hard to imagine — every conceivable flower through every season of the year must have appeared in Brueghel's tubs. Peter Mitchell claims to have recognised in one nearly two hundred flowers of forty species.

Jan Brueghel's sons, Jan the Younger (1601-1678) and Ambrosius (1617-1675), also painted flowers. Jan the Younger was plainly influenced by his father while Ambrosius, his half-brother, was more individual. He painted wonderfully detailed flowers although his compositions were more con-trived and his indulgence in the fashionable passion for tulips at times rather overdone. Notwithstanding this, his painting was of an extremely high standard, as was that of the three flower painting sons of Jan the Younger, particularly Abraham (1631-1697) who faithfully followed his grandfather's conviction that an artist should paint only from living flowers. Two of Jan the Elder's daughters married painters and one gave birth to another flower painter of distinction, Jan van Kessel (1626-1679). Van Kessel, who was plainly influenced by Daniel Seghers, reverted at times to the tradition of elaborate floral garlands as well as some splendid flower bouquets and arrangements.

Of equal importance to the Brueghels was the famous Bosschaert Dynasty. The most significant members were Ambrosius Bosschaert the Elder (1573-1621), his brother-in-law Balthasar van der Ast (1593-1657), his three sons Ambrosius the Younger (1609-1645), Johannes (c.1610-c.1648) and Abraham (c.1613-1643) and his daughter Maria's husband, Jeronimus Sweerts (1603-1636). The Elder Bosschaert, like Brueghel, painted flowers as portraits but working from his comprehensive reference studies rather than from nature. Out of season flowers appear together and are not always relative to each other. Comparing the blooms of the two Elders one is tempted to conclude that they 'borrowed' from each other. Bosschaert showed less versatility than Brueghel; most of his flowers were rather stiffly arranged

in beautifully painted vases, in some instances using just a few large heads, in others more abundance. Often these vases were set in alcoves or ovals but there were few excursions into anything more adventurous.

Many works of the Younger Ambrosius are reminiscent of his father – rather lighter arrangements in vases. As he grew older his work broadened considerably, probably under the influence of his uncle, Balthasar van der Ast, who was a more imaginative worker. He started producing larger works, more unusual compositions into which he introduced fruit, insects and other small accoutrements. The second son, Johannes, has been described as a child prodigy who started painting and exhibiting at a very early age. In his case the influence of his uncle was even more apparent; a perfectionist painter, he obviously liked to use baskets as containers, spilling over with flowers, some fruit and, here and there, shells, butterflies and other incidentals. Even his more conventional compositions were freer than his father's and more natural, but without any loss of botanical accuracy. The third son, Abraham, produced fewer flower paintings than his father, brothers and uncle, possibly discouraged by the knowledge that he lacked much of their exceptional ability.

Other flower painters in the Bosschaert tradition include Osias Beert the Elder (1580-1624), Jacob Wouterez (1584-1641), Hans Bollongier (1600-1655), Jan Philips van Thielen (1618-1667), Jan van der Hecke (1620-1685), Pieter van der Venne (d.1657) and, later, Philip de Marlier (fl.1640-1677). Bartholomeus Assteyn (1607-1667) was much influenced by van der Ast and so, to a degree, was his brilliant pupil Jan Davidsz de Heem (1606-1684), one of the most significant of all flower painters internationally. Although both the Brueghel and Bosschaert influences, also those of Seghers and his teacher, show in de Heem's work, gone are the rather staid arrangements. Although opulent and full, de Heem's flowerpieces have a style, grace and delicacy hitherto unseen. While each flower is technically perfect, the whole has a natural quality, a new realism that excites more than simply visual delight. The waxen lilies actually smell, the snail can be seen toiling along a leaf, the characteristic stem of corn heels over as the butterfly lands.

Cornelis de Heem (1631-1695), son of Davidsz, although not the only flower painting member of the family, is the only one worthy of his father; were it not for the comparison, Cornelis would have become a much more prominent figure in his own right. The feeling for more natural, fuller and richer flowerpieces communicated itself among (many) others to Nicholas van Verendael (1640-1690) and his pupil Jan Baptiste Morel (1662-1729), Jacob Walscapelle (1644-1727), Jean François Eliaerts (1761-1848), Jan Franz van Dael (1764-1840) and to perhaps the best loved family of all, the van Huysums.

The father of the family, Justus van Huysum the Elder (1659-1716), extended the freer, more natural and more opulent style introduced by de Heem but made it all his own. Considering how few of his works have survived we are fortunate to have two examples in the Fitzwilliam (Cambridge) collection where there is an even rarer example of the work of his son Michiel (c.1704–c.1760). It was the eldest of his four sons, Jan (1682-1749), who became the outstanding artist and who painted for most European Royalty. Sir Robert Walpole also accumulated a fine collection. There is something gloriously sensuous about the flowers of Jan van Huysum – splendid highly complex bouquets spilling out of their containers in magnificent riot.

Wild flowers and corn tangle with more conventional blooms, insects and butterflies abound, and the addition of a bird's nest was a favourite ploy. Despite the fulsome compositions, no detail was omitted or misplaced; form, texture and botanical accuracy were supremely important, indicating that he worked from real flowers. The joy that he obviously found in his painting communicates itself to the viewer and probably accounts for the unusually high level of popularity, both in his lifetime and ever since.

His brother, Jacobus (c.1687-1740), was similarly talented and had it not been for the demon drink might well have achieved something of his brother's eminence. Some surviving works still hold their own and I suspect a squandered talent. Other important followers of the van Huysums were Jacobus Linthorst (1745-1815), the van Spaendoncks, Gérard (1746-1822) and Cornelis (1756-1840), Christien van Pol (1752-1813), Gerrit Jan van Leeuween (1756-1825), the great Jan van Os (1744-1808), his closest 'rival' and his son, Georgius Jacobus Johannes van Os (1782-1861). The combined influence of the van Huysums and their followers is plainly apparent in a number of Austrian, German and, most of all, French flower painters of the eighteenth and early nineteenth centuries.

Often today flower painting is associated with women painters but, although fewer by far than their male counterparts, the early Flemish and Dutch female flower painters were the

extremely talented pioneers. The earliest, Clara Peeters (1594-1657), generally combined beautifully painted flowers with still life such as silver, fruit or food, a source of inspiration for the British Eloise Harriet Stannard. Maria van Oosterwyck (1630-1693) gained much experience from de Heem's teaching and became a respected painter in royal circles. Best known of all, of course, is the famous Rachel Ruysch (1664-1750), a pupil of van Aelst, who could hold her own with any of her male contemporaries, even van Huysum himself. Unusually for the period, she continued painting into her eighties and left a remarkable legacy. While Ruysch may have been partially influenced by van Huysum, his only pupil as such was Margareta Haverman (fl.1716-1750). A mark of her excellence, if the story is true, is that van Huysum became jealous of her. Presumably unaffected, she left him and moved to Paris.

Although seventeenth and early eighteenth century flower painting belongs essentially to the Flemish and Dutch, there were contemporaries in other European countries although they were largely under the influence of the artists of the Low Countries. Juan de Arellano (1614-1676) remains to this day Spain's most outstanding flower painter although his pupil, Bartolomo Perez (1634-1693) is well represented in the Prado and Pedro de Camprobin (1605-1675) is somewhat underrated. These painters were undoubtedly inspired by the Flemish/Dutch Schools and so, to a degree, were their Italian contemporaries, Mario Nuzzi (1603-1673) who was much influenced by Seghers, and Paolo Papera (1617-1673). A more individual Italian style was created by Andrea Scacciati (1642-1710) and Giuseppi Recco (1634-1695) who introduced a certain lightness and delicacy which I feel may later have inspired the glorious flower paintings with which Francesco Guardi (1712-1793) continually surprises and delights. A personal favourite from this period is the German, Abraham Mignon (1640-1679), who was the pupil of another German flower painter, Jacob Marrel (1613-1681). Both artists studied under Jan Davidsz de Heem bringing us back yet again to the influence of the Netherlands, although Mignon certainly added a note of realism he made all his own.

Leaving out their exceptional botanical painters, flower painting in France, while triggered initially by the Dutch influence, became strongest in the late eighteenth and nineteenth centuries. The earliest French flower painters, however, were frequently pupils of or had some connection with the painters of the Netherlands. Jean-Baptiste Monnoyer (1636-1699), that doyen of French flower painting in the Flemish tradition, made his reputation as principal flower painter to Louis XIV at Versailles but also contributed to the permanent flower decoration of many famous royal homes and palaces. He lived and worked in England for a number of years, painting flowers for Queen Mary and for important figures of the nobility and aristocracy. He employed several talented assistants including his son Antoine (1672-1747) who, although he inherited much of his father's talent, was somewhat overshadowed. Another pupil/assistant, who married his daughter Marie, was the almost comparable Jean-Baptiste Belin de Fontenay (1653-1715). In some ways the latter's work has even more in common with the Flemish painters while in others it is quite difficult to distinguish his work from that of his illustrious father-in-law. His work, although one hopes not all of his personal characteristics, was carried on by his son, also Jean-Baptiste (1688-1730), and pupil Jean Marc Ladey.

Also in the tradition of the Netherlands were, among others, Jacques Linard (c.1600-1645), Alexandre-François Desportes (1661-1743), Michel Nicholas Micheux (1678-1753), Nicolas de Largillière (1656-1746) who trained in Antwerp and also painted portraits, Jacques Bailly (1700-1768), François Nicolas Laurent (1775-1828), Elise Bruyère (c.1776-1842), a pupil of van Dael, Jacob Ber (1786-1863), a pupil of van Spaendonck who also influenced Jean Benner-Fries (1796-1849), his son Jean Benner (1846-1906) and Nicolas Baudesson (1611-1680) whose work, although early and occasionally confused with Monnoyer, has elements of Italian and Spanish gained on his travels.

Of these early French flower painters perhaps the most obviously her own woman was Anne Vallayer-Coster (1744-1818). Although suggestions of Dutch influence can be recognised, particularly in her treatment of old-fashioned roses, this artist, against all the odds (for in those days scales were weighted heavily against women painters), worked in her own delightfully French style and gained the esteem of her contemporaries as well as posterity. Undoubtedly she is one of the most significant female flower painters of all time, perhaps the French equivalent of the esteemed Rachel Ruysch.

Moving on from the Dutch influence and the early botanical painters, Professor Hardouin-Fugier and Etienne Grafe have produced a wonderful and extraordinarily comprehensive book on nineteenth century French flower painting,[2] essential reading for all serious students of flower painting. The over 3,000 artists listed in the dictionary include not only the most

famous, such as the inimitable Henri Fantin-Latour (1836-1904), who is known to have painted nearly six hundred flower studies and with whose work everyone is familiar, but artists who paint many other subjects but have, for instance, exhibited even one outstanding flower painting in the Paris Salon or other important venue. It also includes the painters of the Lyon School, whether they were painters of textile designs, porcelain painters, botanical painters or more conventional flowerpieces. Of the more traditional Lyon painters the best known is Antoine Berjon (1754-1843) who, for whatever reason, seems for too long to have been underrated outside France. To me his work is so beautiful and lively and the scope of his talent so broad that he is one of France's truly exceptional painters.

A very strong neo-Dutch element runs through the eighteenth and nineteenth centuries exemplified by such painters as Jean-François Eliaerts (1761-1848), a naturalised Frenchman born in Holland, Antoine Chazal (1793-1853), a pupil of Gérard van Spaendonck, Simon Saint-Jean (1808-1860), Jean Alexandre Couder (1808-1879), Michel-Bruno Bellenge (1726-1793), Melanie de Comolera (fl.1816-1854), and even the great teacher himself, Augustin Thierriat (1789-1870), sometimes betrayed an affinity with the Dutch. Gradually even the full blown, opulent bouquets took on a lighter, more delicate and characteristically French touch. Some of the most famous examples include Pierre-Adrien Chabal-Dussurgey (1819-1902), Jean-Pierre Lays (1825-1887), André-Benoit Perrachon (b.1828), Adolphe Louis Castex-Degrange (1840-1918), Eugène Claude (1841-1922), Georges Jeannin (1841-1925), Eugène-Henri Cauchois (1850-1911) and Eugène Bideau (fl.1867-1900), these two being possible forerunners of the Impressionists with their sparkling colour and gay abandon.

The watercolour tradition has always been exceptionally strong in France and here, in flower painting, we find overlapping by some of the botanical artists. Pierre-Joseph Redouté himself could be very decorative as well as botanically accurate and the same could be said of Nicolas Robert (1614-1685), the Prévosts, Olympe-Marie Arson (1814-c.1870), Caroline Adrien and Claude Aubriet.

Other outstanding French watercolourists who specialised in flowers include the extremely decorative Lucy de Beaurepaire who flourished mid-nineteenth century, Anne-Ernestine Panckoucke (1784-1860), Pauline Géradin (b.1818), Louise d'Orléans (1777-1847) and Antoine Pascal (1803-1859), who were all star pupils of Redouté. Worthy of special mention, too, are Dominique Dumillier (fl.1857-1892), the brothers Paul-Henri and Raoul-Henri Maucherat de Longpré (b.1855 and 1859), Elisa Honorine Champin (d.1871), who used watercolour in the Flemish tradition, Louis-Pierre Schilt (1790-1859), and the inspired teacher and painter Eugénie-Juliette Faux-Froidure. Works by these artists and other French watercolourists can be seen in the Fitzwilliam Museum, Cambridge.

Almost all the French Impressionists painted flowers occasionally. Pierre-Auguste Renoir (1841-1919) was undoubtedly the most prolific in the floral field. Hardouin-Fugier and Grafe list about fifty works and this number probably discounts certain paintings in private collections. Renoir painted all sorts of flowerpieces from a few blooms in a glass to his large sumptuous bouquets. As a teenager he was apprenticed to a firm of porcelain painters and the interest in flowers developed there continued when he joined the artists of the Impressionist movement. The sheer joy of combining brilliant jewel-like colours, the play of sunlight and the revelry in nature that characterises the Impressionists, made flowers a perfect subject to which Renoir did full justice. Flowers were often added to his figure studies, giving colour and life to an already lively style. The Scottish artist, James Paterson (1854-1932), one of the so-called 'British Impressionists' and who trained in France, exemplifies in his flower paintings the inheritance from other cultures and ages which has made British flower painting of the twentieth century such a rich and exciting development.

While Berthe Morisot (1841-1895) only occasionally painted flowers her brother-in-law, Edouard Manet (1832-1883), enjoyed painting them and, like Renoir, often added flowers to his more general subjects. Flowers were an ideal subject for Manet who suffered from a motor neurone disease which prevented him from moving around to the same extent as his fellow Impressionists, particularly in his later years. Those luscious paeonies seem to have been favourite subjects, although roses and other flowers appear again and again. Oscar-Claude Monet (1840-1926) is always thought of as a painter of waterlilies but, beautiful as these flowers are, he produced many other, more orthodox (if such a word can be applied to the Impressionists!), flower studies and also some delightful garden paintings with wonderful flowering trees and lush banks of blossom.

On the edge of the Impressionists, Camille Pissarro (1830-1903), who married a lady florist, produced a number of flower paintings, generally in a rather lower key than the

Impressionists and with a warm appeal all of their own. Paul Cézanne (1839-1906), on the other hand, painted more floral subjects, but with less attraction as far as I am concerned. Compared with his contemporary flower painters, the work seems stiff and laboured.

In all painting genres and in every country there will always be the individualists and France, as might be expected, had plenty of those. In flower painting a plethora of names spring to mind. One thinks first of Odilon Redon (1840-1916). While some of his brightly hued flower paintings show a certain appreciation of natural beauty, others are totally imaginary and rather stylised. Gustave Courbet (1819-1877) started painting flowers in prison, mainly because there was no way of getting out to paint landscapes or portraits and visitors could bring him subjects. Perhaps this opportunity for close refle~ ~ study gave his flower studies their strange intensity and, ~ ~ ~ome of his compositions may seem a little odd, this ~~~ well have been of necessity for his few later flower paintings became extremely sophisticated. Henri Matisse (1869-1954) loved flowers and painted them in a unique style I wish I liked better, considering the importance of their creator. Henri-Julien Rousseau (1844-1910), of course, painted his stylised, rather primitive, but beautifully coloured flowers always looking as if they were grown in his famous jungles and, although few people directly associate Ferdinand-Victor-Eugène Delacroix (1798-1863) with flower painting, his output in this sphere was considerable

with gorgeous combinations and striking colour. Antoine Grivolas (1843-1902), Edouard Vuillard (1868-1940) and Adolphe Monticelli (1824-1886) all painted highly individual flower studies while Jean-Marie Reignier (1815-1886) had a romantic approach wherein beautifully crafted flowers appear in imaginative settings. Jean-François Raffaëlli (1850-1924) managed to get away with the busiest of floral creations without them looking a mess.

One could go on and on in this vein, but this book is about flower painting in Britain. If my introduction has appeared to be a digression, I make no apology. British flower painting has its own unique if relatively recent history, but it can only be judged in the light of the wider history of the subject and by comparison with other, particularly European, countries. In every aspect of visual art there is inevitably a combination of influences from other cultures, other countries and other ages which interact to form 'new' ideas, 'new' presentations, sometimes completely 'new' movements, all in due time becoming integral threads in the immense tapestry of world flower painting and floral art. Just as no man is an island, no painter can claim to be unique or to be inspired totally by his own ideology.

We are fortunate in this country in having opportunities for looking at great flower paintings from many countries and cultures. Easily the most important public collections are those of the Ashmolean Museum, Oxford, and the Fitzwilliam, Cambridge.

1. In the Museo delle Terme, Rome, there is a well-preserved wall painting from the villa of the Empress Livia, first century B.C. It shows an incredibly beautiful, gloriously luxuriant, garden in characteristic Roman style.

2. *French Flower Painters of the 19th Century,* Elisabeth Hardouin-Fugier and Etienne Grafe.

Colour Plate 2. Anna Zinkeisen. Madonna of the Tree of Flowers. Reading this book it will frequently become clearly apparent that a contemporary artist has, wittingly or unwittingly, been influenced by one or more flower painters from the past in botanical work or traditional floral arrangements. Early in this introduction I mentioned the beautiful floral garlands, usually encircling a religious theme, by the late 16th century Flemish masters most notably the innovative Catholic artist, Daniel Seghers. Perhaps uniquely linking ancient and modern in this genre, over 350 years later, are the Madonnas of Anna Zinkeisen exemplified by the illustration opposite.

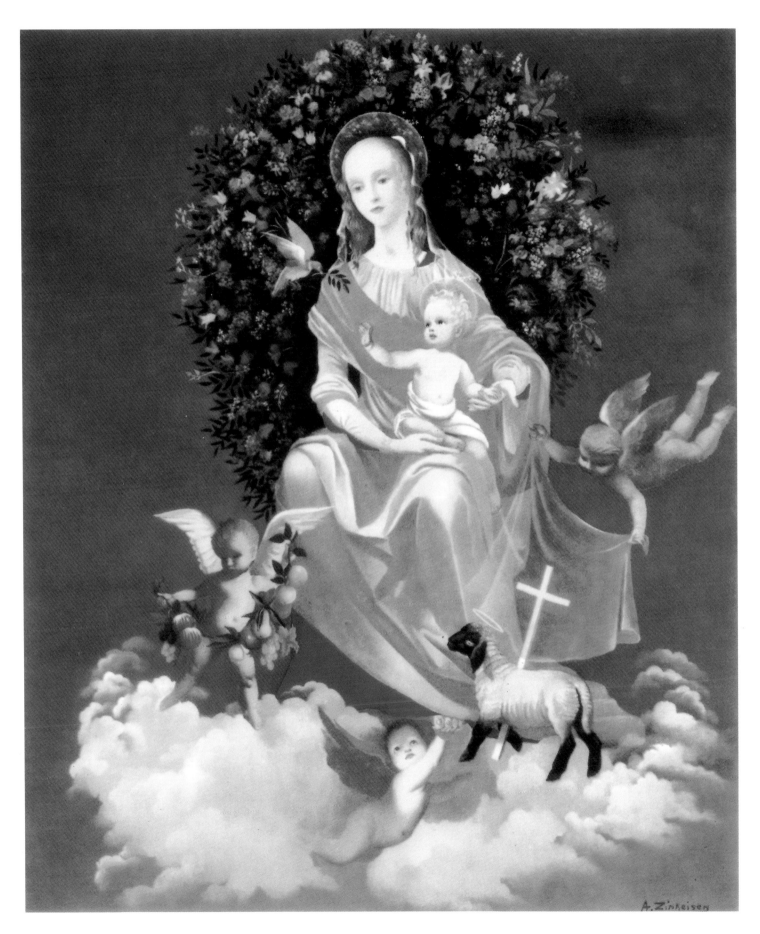

CHAPTER II

British Flower Painting in the Seventeenth Century

Britain came late to flower painting and to a large extent its exponents have been and still are individualists rather than part of a school or movement. I propose to divide this study into four periods – pre-1700 and the eighteenth, nineteenth and twentieth centuries. As far as the seventeenth century is concerned, a recent survey of 257 acclaimed and well-documented flower painters of the period found that 216, over 80%, were Flemish or Dutch and of the rest many had studied or worked in the Netherlands. It is easy, then, to understand how thinly the rest are spread.

Before 1700 the few British flower artists of any significance were in the botanical field with the possible exception of the Scottish William Gowe[1] Ferguson (1632-1695). Ferguson, having decided to visit the Continent, notably France and Italy, en route visited Utrecht where, captivated by the Dutch painters, he decided to stay and lived in The Hague from 1661 to 1668. We are told, rightly or wrongly, that he paid his rent in paintings. He was basically a painter of still life, often introducing dead game birds, but his flower paintings were very much cast in the Dutch mould and, judging by the (only) one I have seen illustrated, rather after the early Bosschaerts.

Of the botanical artists, the earliest was probably John White (fl.1540-1594). White, under orders from Raleigh, joined a company of some one hundred men who landed on the island of Roanoke off North Carolina as official artist and cartographer. After about a year they were returned to England by Drake. Then, in 1587, White was put in charge of a second expedition. However, after returning home to replenish supplies, the expedition was interrupted by the Spanish Wars and not resumed until 1590. On arrival the voyagers found the whole colony had perished, including White's own daughter and grandchild, and Raleigh's plans to colonise Virginia had been brought to nothing. White rejoined Raleigh on his estate where he was last heard of in 1593. In spite of all the tribulations, White had managed to produce a number of meticulous drawings of species plants of Virginia, most of the survivors now being in the British Museum.

John Parkinson (1567-1650), a botanist and doctor, was appointed as apothecary to James I and, later, herbalist to Charles I. He produced one of the earliest florilegiums entitled *Paradisi in Sole Paradisus Terrestris* (1629), which took him ten years and was dedicated to Queen Henrietta Maria. Later he produced another herbal but, although some illustrations were probably original, most of them were copies (by Parkinson) of the Plantin woodblocks.[2]

John Ray (1627-1705) has been described as 'one of the finest systemic botanists of his age' and no doubt he did some important botanical work in the fields of classification and science. He illustrated some of his own books but there seems no record of him as an artist per se; rather is he known as a botanical scientist. The same could be said of Robert Morison (1620-1683), a Scottish botanist again noted for his work in this field and for his *Plantarum Historia Universalis,* a mammoth work using some of his own drawings, although it is largely illustrated by a Dutchman.

Better known artistically is Richard Waller (c.1650-1715), by profession a City merchant, and a competent linguist. In 1687 he became Secretary to the Royal Society, having shown a very real interest in zoology, botany and anatomy. He seems to have had the idea at some time of producing a book or folio dealing with British wild flowers; he plainly had a strong feeling for the intrinsic beauty of such 'insignificant' plants as groundsel, knapweed, grasses and even the so-called weeds of meadow and hedgerow. His watercolours, presumed to have been intended as illustrations for his book and of which about forty remain, are extremely sensitive and really quite beautiful. Although of amateur standing, much of his work has the delicacy and care of Dürer's watercolours. Those which survive are in the library of the Royal Society.

The most famous and most prolific of the few early botanical artists was Alexander Marshal who died in 1682.

Colour Plate 3. Mark Catesby. *Magnolia grandiflora* from *The Natural History of Carolina. Georgia, Florida and the Bahama Islands.*

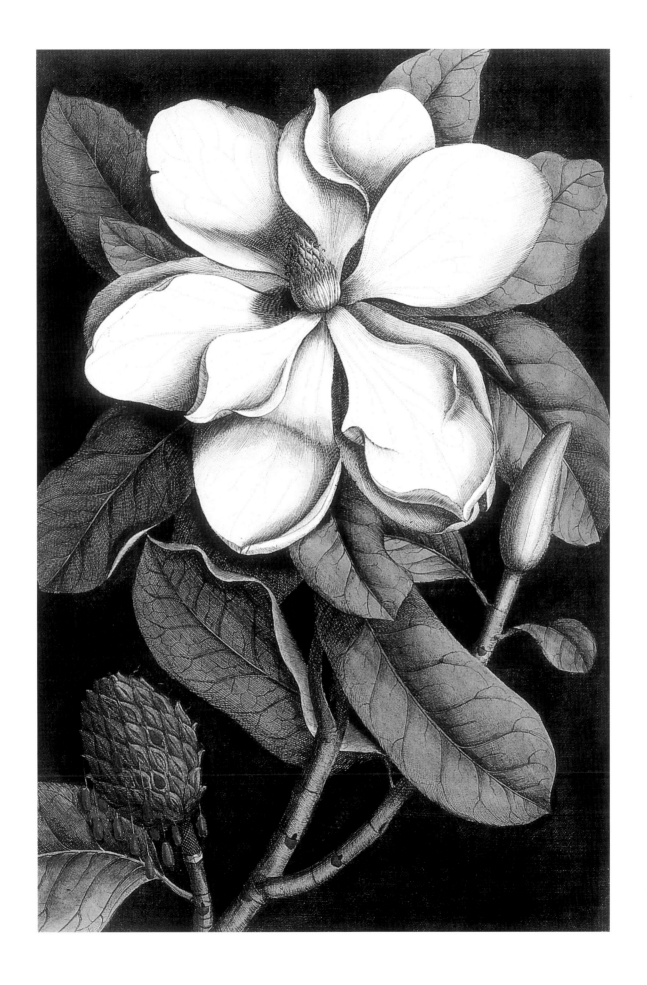

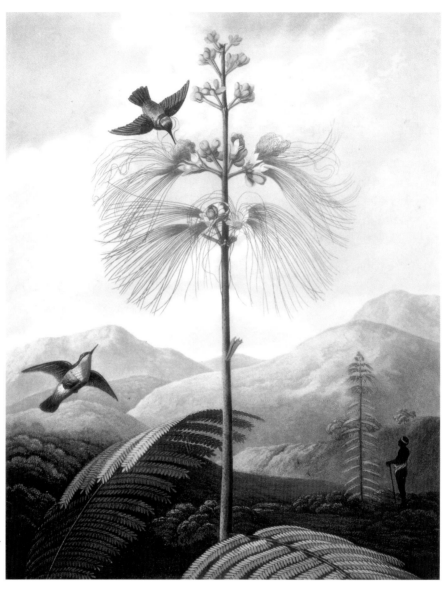

Colour Plate 4. Philip Reinagle. 'Large Flowering Sensitive Plant' (*Calliandra grandiflora*). Colour print from oil painting for R. Thornton, *The Temple of Flora* (1799-1807).

Marshal was fascinated by the continuing discoveries of new plants that were so inspiring to the Continental painters. A keen collector himself, he spent some time in France and may well have been influenced to some extent by Nicolas Robert and his French contemporaries.

As well as collecting plants and being an enthusiastic gardener, Marshal collected birds and insects indicating, as borne out by his drawings, a student of the natural world with a great love for his subject. As an educated man of independent means, painting was something he could indulge at will for the sheer joy of it, without the need to think financially. There are some indications that he ventured into other subjects, including portraiture at which he did not excel, but his reputation rests on his flower painting, particularly the beautiful volumes in the Royal Library at

Windsor (Colour Plate 1). John Tradescant is said to have owned another book in which Marshal had painted on vellum most of his 'choicest flowers and plants' (Walpole). Mention is made in various records of a book of paintings of insects and other works for certain persons of note, but it is the Windsor florilegium, his most important work, that survives and remains, in spite of the various hands through which it has passed since his death, in wonderful condition. Marshal was fanatical about accurate colouring and invariably made his own pigments from plants, berries, roots and other natural sources. He must have made an intensive study of the science of colour; it is perhaps no accident that his colour, to this day, is fresh and vibrant and remains botanically correct.

The Windsor volumes of 159 sheets illustrate approximately 1,000 different flowers all painted with loving care, botanical

Colour Plate 5. Peter Henderson. Blue Egyptian Waterlily (*Nymphaea caerulea*). Colour print from watercolour drawing by Peter Henderson for R. Thornton, *The Temple of Flora* (1799-1807).

accuracy and a sincerity which shines through. In 1985 Gollancz published *Mr Marshal's Flower Album from the Royal Library at Windsor Castle* which illustrates a number of these flowers to which a commentary has been added by John Fisher, author of many books on flowers and plants, another collector, dedicated flower lover and gardener. The little that is known of Marshal's life is summarised in the introduction but the illustrations and commentaries make this book a valuable collectors' item for addicts like myself. It is the wild, wayside flowers which are the most fascinating, little specimens usually considered insignificant turned into the incredibly lovely little creatures they really are. Marshal cared nothing for design – each flower was just put on the paper where there was space, no one being dependent on any other as in an 'arrangement', but each with its own personality and character, standing alone

and holding its own, sometimes with a tiny insect for company. The delicacy of these little wild 'weeds' belongs to him alone, but his roses are, dare I say it, more sensitive than Redouté's and his elegant tulips would hold their own with those of any tulipomanic Dutch artist.

The few formal drawings surviving are less significant than the two Windsor volumes. There are some specimens in the British Museum, mainly undated but reckoned to have been made about 1680 in Haarlem for William of Orange. One only is definitely English and dated 1659.

There is little more to say about British flower painting in the seventeenth century. The great Mark Catesby (Colour Plate 3) was, of course, born c.1680, but any work of consequence was done in the following century and will be considered in the next chapter.

1. English sources spell this Gow or, more usually, Gowe, and the new *Scottish Dictionary of Painters* spells it Gouw.
2. The Antwerp based house of Plantin (or Plantin Press) produced during the latter half of the sixteenth century a number of botanical works illustrated by woodcuts.

The woodblocks used were based on drawings supplied by a number of botanical artists of the time including the famous Pierre van der Borcht (1545-1608). Some of the original blocks are preserved in the Plantin Museum, Antwerp.

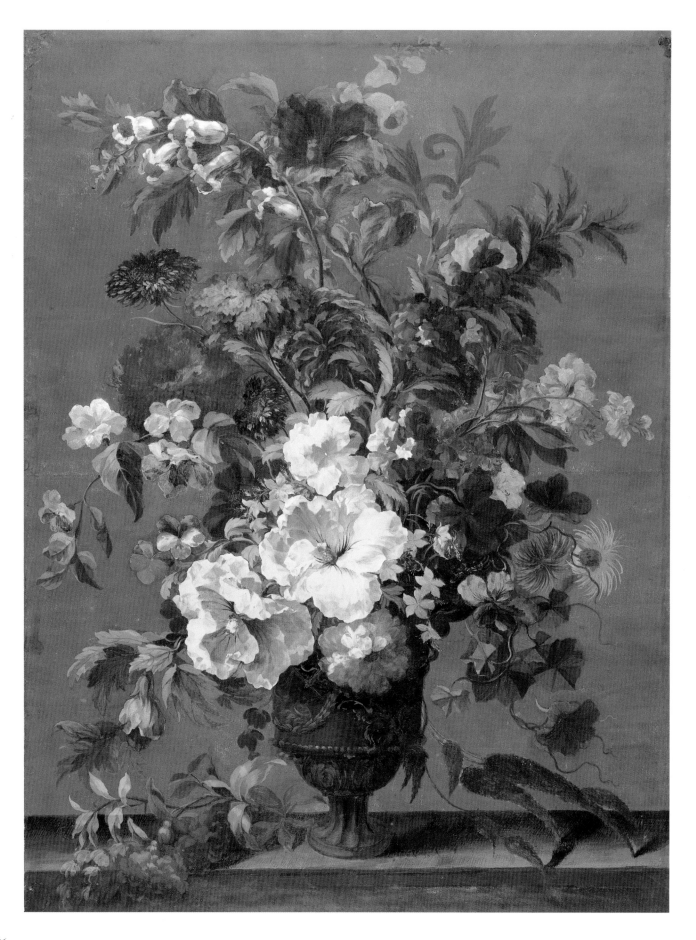

CHAPTER III

British Flower Painting in the Eighteenth Century

As we move into the eighteenth century the picture becomes brighter. A number of minor artists are recorded as having painted and exhibited flowers, usually along with other subjects, but also some very fine specialist painters begin to emerge. The more conventional flower painters remain thin on the ground, but botanical painters prove that real talent in this field was very much alive and well in eighteenth century Britain.

On the traditional side we have John Baker (1736-1771) who sadly died at the early age of thirty-five. He was a founder member of the Royal Academy where he exhibited flower paintings in the first four exhibitions. By profession he was a decorator of coachwork, but had a strong interest in flower painting after the Dutch manner. He would appear to have taken more than a passing interest in the Dutch and Flemish masters, although few examples of his work remain.

Mary Moser (1744-1819) was the daughter of another founder member of the Academy, G.M. Moser, who was also its first Keeper. As a drawing master (who taught drawing to George III), he obviously started work early on his daughter who was exhibiting at the age of eleven and receiving significant accolades by the time she was fourteen. In spite of her youth she was herself elected in 1768 as a founder member of the R.A. where she regularly exhibited flowers and some portraits (Colour Plate 6).

Mary Moser's flower paintings, sometimes shown under the name Mary Lloyd after her marriage to Captain Hugh Lloyd, are very beautiful indeed, executed generally in watercolour with added body colour and dignified by a very mellow colour sense. The detail and finesse are exemplary and, amazingly for her time, owe very little to the Dutch influence except, perhaps, for her rich backgrounds and distinctive arrangements. Queen Charlotte employed her to decorate a room at Frogmore, a significant tribute to her elegant taste.

Her work can be seen in the Fitzwilliam Museum, Cambridge (Broughton Collection), the Victoria and Albert Museum, the Courtauld Institute and the Royal Collection. Sadly she had to give up painting in 1802 on account of failing eyesight, but she remains the most prominent British woman flower painter of her time.

James Hewlett (1768-1836) was born in Bath, the son of a gardener from whom he inherited his interest in flowers. Little is known about his life and few works survive, but he appears to have been both prolific and successful and he exhibited regularly in London. Although he worked largely in the tradition of van Huysum, he also produced some delicate watercolour studies showing a good sense of detail and botanical accuracy.

Thomas Keyse (1721-1800) was a London artist who started the Bermondsey Spa Gardens. Again few examples of his work survive, some in the collection of Colonel Grant (Fitzwilliam Museum) who admired his work and wrote of him in the *Burlington Magazine* as 'A Forgotten English Flower Painter'. His work was also praised by Sir Joshua Reynolds. Obviously influenced by the Dutch, his well structured paintings also have a style of their own and the individual flowers, simply arranged, are perfect flower portraits.

The Norwich School painter, James Sillett (1764-1840), who was apprenticed to a sign painter, changed direction and went to study at the Royal Academy Schools, returning to East Anglia on marriage. Sillett was an exceptionally versatile painter, able to turn his hand to almost anything. He painted some floral oils on panels reminiscent of the early Dutch with heavy heads in a smallish vase but, as far as I am concerned, his watercolours of flowers constitute the cream of his work. Not generally classed as a botanical painter, his flowers are finely detailed and botanically accurate, but rather more decorative in style than most botanical studies. This work was often used in book illustration and there is a particularly fine example of a single spray of mallow (Colour Plate 7) in the British Museum. The delicate transparency of the petals is skilfully reproduced and the effect enhanced by a subtle

Colour Plate 6. Mary Moser. Flowers in an Ornamental Urn with Sign of Libra. COURTESY FITZWILLIAM MUSEUM, CAMBRIDGE

suggestion of shadow. Other work in Norwich Castle Museum holds further evidence of his consummate skill (Colour Plate 33).

Another East Anglian, Isaac Johnson of Woodbridge (1754-1835), is recognised as a highly skilled map maker and architectural draughtsman. What is less well known is that he was also a particularly distinctive flower painter (Colour Plate 8). The beautiful Dutch style composition of flowers with grapes, butterflies and insects on a marble slab, painted in watercolour, could hold its own alongside Walscapelle or van Huysum. Johnson's work has been described as 'so fine that his drawings have been mistaken for engravings, his titling for print and his coloured drawings for aquatints…'.

Trajan Hughes (fl.1709-1716) was another artist who painted in the Dutch manner, but very few examples are known. His flowers appear less formally 'arranged' than most of the Dutch, but frequently incorporate butterflies, other insects and sundry decorative incidentals.

Robert J. Thornton (1768-1837) is noted for his famous florilegia, *The Temple of Flora*, part of a much bigger scheme illustrating the sexual system of Carolus von Linnaeus, the production of which became so extravagant that Thornton was rendered penniless. He was trained as a dentist and, although he did some botanical drawing and painting, his artistic claim to fame was the wonderfully flowery and descriptive prose that accompanied the illustrations in *The Temple of Flora*, the work of several commissioned artists with one, 'Roses', of Thornton's own. This does no credit to the work as a whole, the roses being stiff and lifeless around a similarly pathetic bird posing as a nightingale.

Best known of the other illustrating artists was Philip Reinagle (1749-1833); others included Peter Henderson (fl.1799-1829) and Abraham Pether (1756-1812). Thornton had decreed that the artists' flamboyant but lifelike renderings of the chosen flowers and plants, while being botanically accurate, should be set against a landscape or allegoric background appropriate to the subject. Reinagle, who painted the originals for eleven of the plates, worked in oil with an extraordinary finesse considering the heavy medium. He had been the pupil and hack of the portrait painter Allan Ramsay but, frustrated by the slavery to which he was subjected, he gave up the idea of portrait painting, turning to animals, landscape and, finally, flower painting. Perhaps his best known contribution to the *Temple* is the Group of Tulips, illustrations of different species in a spray dominated by Louis VI, its pinky

white petals stained with black. Also frequently reproduced is his Superb Lily *(Lilium superbum),* brown speckled orange, magnificent against a dramatic sky and rich mountain scenery. These backgrounds were there for romantic appeal rather than relating to the flowers themselves; for instance, Reinagle's painting of the Jamaican night-blowing Cereus is set against an English church tower by moonlight! Alice Coats has succinctly commented on *The Temple of Flora* that 'an unprejudiced eye might find it over theatrical and pretentious'. She also makes the interesting point that scarcely two copies are identical as the copper plates used were extremely delicate and needed frequent retouching.

On the botanical side, flower painting had become a much more serious business. The turn of the century introduced Mark Catesby (1679?-1749), author and illustrator of *A Natural History of Carolina, Georgia, Florida and the Bahama Islands,* 1730-47 (Colour Plate 3), to which the great Ehret also contributed three illustrations. Catesby took lessons in etching from Joseph Goupy and printed his own drawings for this *History.* In the first two editions he personally hand coloured many of the 220 illustrations; the original drawings are now in the Royal Library at Windsor.

Catesby was born in Sudbury, Suffolk, of an American father. When his father died leaving him a small legacy, he decided to visit America where he had a married sister who had settled in Virginia with her husband. He sent back to Britain seeds and specimens to the extent that, on his return, he found himself regarded as a serious collector and a group of people sponsored a second trip to the United States so that he could continue with this valuable work. He stayed there from 1722 to 1726, visiting Virginia, Georgia, the Bahamas and, briefly, the Appalachians.

Although considered an amateur, Catesby's work is by no means amateurish. He always drew from living plants, 'fresh and just gather'd', which enhances the work of any worthwhile floral artist. Further examples of his work include twenty-four illustrations for Robert Furber's noted seed catalogue, *Twelve Months of Flowers,* including the Virginian Aster *(Aster grandiflorus),* and for his own second book, Hortus Britanno-Americanus; or A Curious Collection of Trees and Shrubs, subtitled – *the produce of the British Colonies in N. America, adapted to the soil and climate of England.*

Colour Plate 7. James Sillett. Study of Mallow.

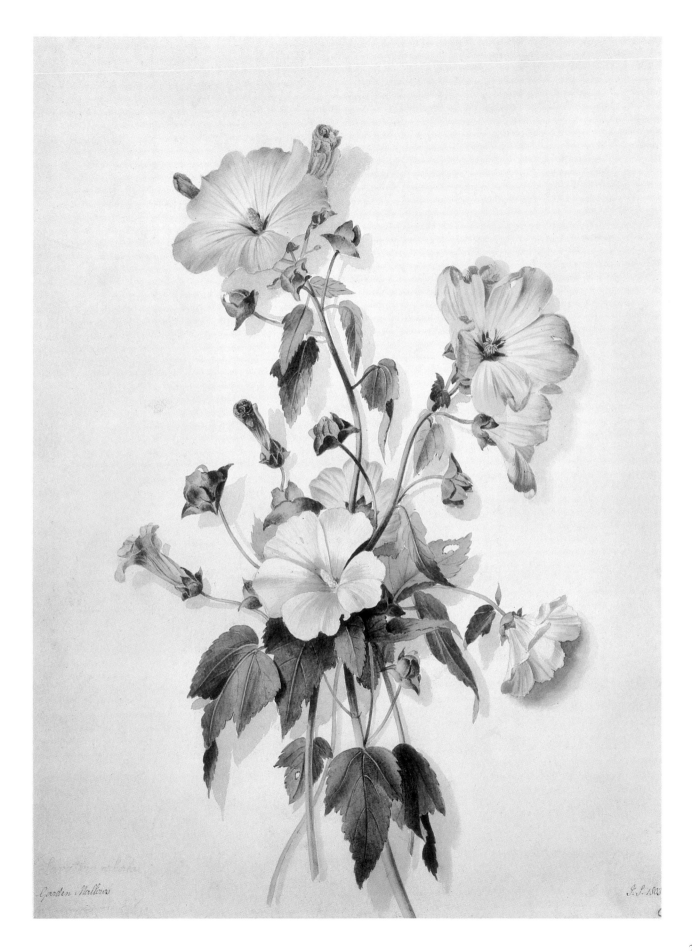

Garden Mallows

J.S. 1803

Later in the eighteenth century a cluster of names emerged that remain household words in floral and botanical circles to this day. Who has not heard of James Sowerby, William Kilburn, Sydenham Teast Edwards, Sydney Parkinson, Frederick Nodder and the famous Hookers? Although two of the Hookers were born just in the eighteenth century, most of their work was done in the early 1800s and will be dealt with in the next chapter.

Sydney Parkinson (1745-1771) was born in Selkirk, the son of a Quaker brewer; this may seem something of a contradiction in terms but it remains a fact. Sydney was initially apprenticed to a wool draper and received some art training at De la Cour's drawing school in Edinburgh, an establishment set up principally to improve the quality of design in textile manufacture and thereby allied to Sydney's work as a textile manufacturer's apprentice.

In 1765 his father died and Sydney moved with his mother to London. He had long painted flowers in watercolour purely for enjoyment and recreation and had developed into quite a highly skilled draughtsman. Following the move to London, he met the nurseryman, James Lee, who provided many subjects for him and he exhibited some of these paintings at a Friendly Society Exhibition. He also gave lessons to Lee's daughter, Ann, and through the contacts he was making met the eminent botanist, Sir Joseph Banks. Banks introduced him to Kew, having recognised the young man's talent, and for some time Sydney Parkinson worked at Kew Gardens assiduously drawing plants, the thing he most wanted to do. His excellent botanical accuracy prompted Banks in 1768, when Parkinson was twenty-three years old, to invite his young artist friend to join him and a Swedish naturalist, a former pupil of Linnaeus, on Captain Cook's epic voyage on H.M.S. *Endeavour.* Parkinson drew and painted plants in Madeira, Brazil and Tierra del Fuego from specimens collected by the Swede, Solander; some 30,000 were collected and dried for preservation. Parkinson is said to have produced twenty-one volumes of natural history drawings, of which eighteen were botanical,[1] and comprised over all 955 drawings, 675 sketches and 280 fine botanical paintings. His work was eventually finished by Nodder and the Miller brothers.

During the *Endeavour's* ill fated voyage, Parkinson worked like a slave, often drawing all night. The artist, Alexander Buchan, whose duty was to record the topographical features of the places visited, died of a fit in Tahiti and Parkinson took

care of as much as he could of the dead man's mission as well as his own. He was not daunted by hard work – it kept him out of the way of certain members of the crew whose drunken and disorderly behaviour in the ports disgusted his Quaker sensibilities – but no doubt his resistance was being lowered for he contracted dysentery and died on the voyage home at the age of twenty-six, abruptly ending a more than promising career. By the end of the voyage thirty artists, botanists and sailors had died.

Frederick Polydore Nodder (fl.1770s-1800), was predominant in the completion of Parkinson's watercolour sketches and was appointed Botanical Painter to the King and Queen Charlotte in 1781. Not a great deal is known of him personally but he contributed to Margaret Meen's *Exotic Plants* and is best known for his detailed study of the complex flowers of the *Haemanthus multiflora,* a tropical African bulb which had been reintroduced to Europe after seeming to be lost to us. He also provided illustrations for Erasmus Darwin's *Botanic Garden* and some delicate plant drawings for Martyn's *Flora Rustica.* Some of his original work is in the Kew collection and the British Museum (Natural History). He is also known to have exhibited at the Royal Academy and the Society of British Artists.

Also involved in the completion of Parkinson's work was John Miller (c.1715-c.1790), who was born Johann Sebastian Müller and changed his name to Miller. As well as working on Parkinson's sketches he started several ambitious projects of his own and also worked for the botanist Philip Miller (no relation), making 108 plates for the *Illustration of the Sexual System of Linnaeus,* 1777, which Linnaeus himself considered to be 'more beautiful and more accurate than any that had been since the world began' (Colour Plate 9). There is a copy of this volume at Kew and more than 1,000 of Miller's original drawings are in the Natural History Museum, London, and the Oxford Department of Botany. He exhibited at the Royal Academy, the Society of Artists and the Free Society and, in 1766, was awarded the Society of Arts premium.

Although perhaps less well known than his father, John Frederick Miller (fl.1768-1794) was a competent botanical artist. Like his father and with his brother, James, he completed some of Parkinson's sketches and, again with his

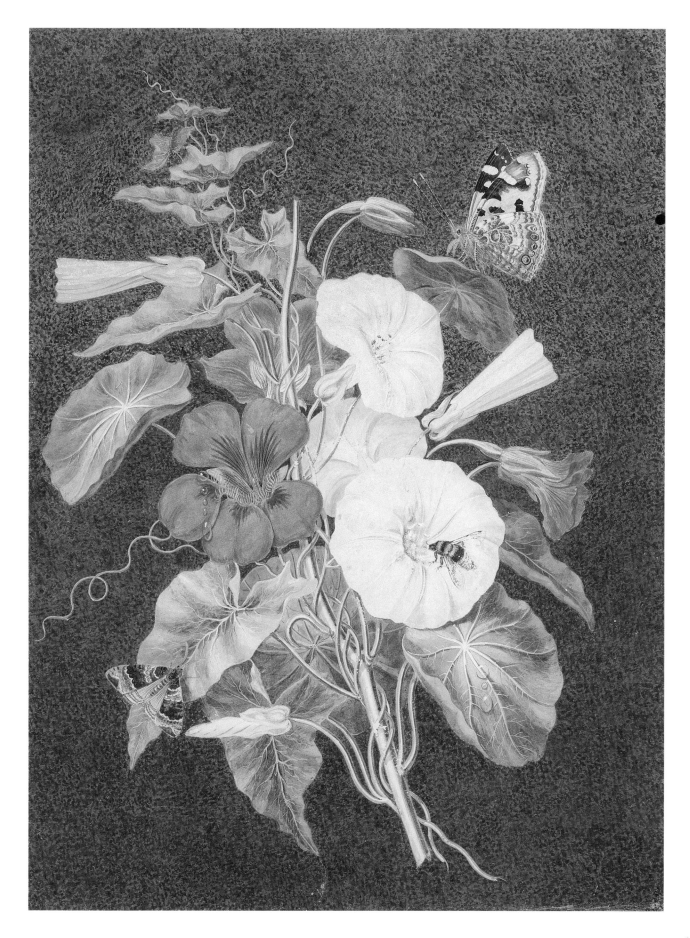

brother, collaborated in the production of the botanical *Illustratio Linneai,* 1770-1777. J.F. Miller accompanied Sir Joseph Banks and Solander, along with another botanist, John Clevely, on an expedition to Iceland to record the plant life of that inhospitable area. He exhibited with the Society of Friends and some of his work is in the British Museum.

William Kilburn (1745-1818), the son of a Dublin architect, learnt drawing and engraving, for which he showed considerable talent at a very early age. His father, however, did not agree with his son embarking on an artistic career and apprenticed him to a calico printer; at least this work needed a certain artistic bent and would carry a more secure income than drawing and painting.

Kilburn continued with this work until the death of his father, then moved to London and took lodgings (with ulterior motives) close to William Curtis' garden at Bermondsey. He showed Curtis some of his drawings and Curtis promptly invited him to work on the plates for his *Flora Londinensis* as artist and engraver (Colour Plates 10 and 11) and to provide illustrations for the now legendary *Botanical Magazine* introduced in 1787 with Curtis as editor.

Kilburn produced a great many drawings of extremely high quality for Curtis, but eventually, gave up in frustration at the small fees which were all Curtis could afford to pay. He returned to calico printing at which he became so professional that he started his own business, initially with great financial success. His experience and skill in the sphere of botanical painting gave him a considerable edge on his competitors in the field of textile design. He combined flowers and leaves of immense variety in intricate designs, often on dark striking backgrounds. The flowers really were flowers as opposed to the more usual, rather stylised, designs. The very fact that his unique designs were so exciting inevitably led to cheap and inferior imitations and exploitation by competing firms. Kilburn's annoyance at this iniquitous practice led him to petition Parliament c.1787 to pass a Bill granting a two month 'exclusive' on original designs, but this proved inadequate and Kilburn was impoverished by plagiarism, a sad reflection on the public lack of artistic discrimination.

The Victoria and Albert Museum holds a wonderful album containing 223 of Kilburn's exquisite watercolour designs for textiles, some of which have been reproduced as elegant gift wrap by an American firm.

James Sowerby (1757-1822) was another contributor to *Curtis's Botanical Magazine.* He originally studied at the Royal Academy Schools and for a time painted portraits and marine subjects in which he had been instructed by Richard Wright. In what connection is uncertain, but he met the famous botanist, Héritier de Brutelle, who asked him to do some botanical paintings, presumably being sufficiently impressed by Sowerby's talent to assume that he could turn his hand to any subject.

Certainly this proved to be true as far as botanical painting was concerned; Sowerby became totally involved with drawing and painting plants and began assisting Curtis and other botanists. He produced two works of his own – *An Easy Introduction to Drawing Flowers according to Nature,* 1789, and *Flora Luxurians,* 1789-91; then, between 1795 and 1803, he published *Coloured Figures of British Fungi* with 400 illustrations.

The Sowerbys were a large family of distinguished naturalists which no doubt explained James' enthusiasm for botanical subjects once he became aware of their attractions and partly, probably, his additional talent in this field. His record and huge output is certainly impressive. As well as the achievements already mentioned, his output included making drawings for Sir James Edward Smith's *English Botany* which was eventually published in thirty-six volumes with 2,500 drawings. This mammoth undertaking meant giving up working for Curtis, but later Sowerby worked on some of the plates for Thornton's *Temple of Flora* and engraved many more for Arton's *Hortus Kewensis,* 1780, in the illustrious company of Georg Dionysius Ehret and Francis Bauer.

Should all this not be considered enough for one artist, Sowerby produced 100 original paintings entitled *Hortus Sylva Montis* in 1787 from plants growing in the Lettsom's garden at Camberwell; these works are now in the Broughton Collection, Fitzwilliam Museum, Cambridge. He contributed to a folio called *Petrius* with Ehret, Frederick Bauer and Sydney Parkinson and, in 1806, with his son, James de Carle Sowerby, started working on Sibthorp's *Flora Graeca.*

Wilfrid Blunt describes Sowerby as 'a scientist of wide interest, an artist of distinction and a talented engraver'. In spite of all his commitments he found time to exhibit at the Royal Academy between 1774 and 1790, also the Society of Artists. In later life he settled in Paris.

Colour Plate 9. John Sebastian Miller. Passion Flower.

33

James de Carle Sowerby (1787-1871), eldest son of James, became a naturalist and artist and contributed many plates to later editions of *English Botany,* although nothing compared to the vast amount supplied by his prolific father. He also illustrated a later supplement by W.J. Hooker and engraved some plates for Sibthorp's *Flora Graeca* although, again, far fewer than his father. His crowning achievement was the production of nearly 10,000 tiny drawings to illustrate *Loudon's Encyclopedia of Plants,* 1829.

Yet another contributor to *Curtis's Botanical Magazine* was Sydenham Teast Edwards, (c.1769-1819). Born in Abergavenny, the son of a Welsh school teacher, the young Edwards loved drawing and painting flowers; one of his chosen aids to learning was making copies of plates from *Flora Londinensis.* His drawings were shown to Curtis quite early in his career and Curtis at once offered him a position and specialist training. Edwards accompanied Curtis on many of his botanical expeditions and, over twenty-eight years, contributed 1,646 drawings to the *Botanical Magazine* starting in 1788 with the second volume. Concurrently he was working on many other famous botanical books of the time, including the study of Hyacinths for *The Temple of Flora.*

After the death of Curtis, Edwards soon fell out with the new management of the *Botanical Magazine.* He severed his connection in 1815 and started the *Botanical Register* as a rival publication with text by Benjamin Maund and plates engraved by E.D. Smith.

Edwards contributed twenty-one plates to the sixth facsimile of the *Flora Londinensis* and all the illustrations for McDonald's *A Complete Dictionary of British Gardening,* 1807. Both artistically and botanically Edwards' work continued to become more and more professional and his later work is quite exceptional.

He found time amidst all his other work to exhibit in the Royal Academy exhibitions and is represented now in the Victoria and Albert Museum, the British Museum and, of course, Kew.

Francis Masson (1741-1805) was born in Aberdeen but moved to England in search of work. He became Kew's first official plant collector and also an excellent self-taught artist. He was another of the young botanists/artists who attracted the attention of Sir Joseph Banks; Banks sent him to study the natural flora of the Cape and bring home seeds and plants. Masson travelled extensively in South Africa after leaving the U.K. in 1772. He returned in 1785 bringing with him a most

interesting journal in which he had written graphically of the topography and plant life of the countries he had visited and his concern, above all, for the animals. He produced also what has been described as a 'hauntingly beautiful collection of illustrations of one of the least known of South Africa's succulent families', returning to complete the work in 1786 and staying for ten years.

In 1796/7 he published *Stapelia Novae,* illustrating forty-one species, only two of which had previously been known in this country. During his time in South Africa he sent a constant stream of new plants to Kew and to James Lee for his nursery, thereby making an inestimably valuable contribution to this country's plant collections. Interestingly, one of his introductions was the now ubiquitous misembry-anthemum.

Masson died in 1805 in Montreal but his work can be seen in the British Museum and at Kew.

Not infrequently one sees reproduced the work of Thomas Robins the Elder of Bath (1716-1770) and his son, Thomas Robins the Younger (1743-1806), but all too little is known of these artists and sometimes there is confusion as to which Robins is the artist of a particular study.

The elder Robins is known to have been a topographical draughtsman as well as a flower painter. He worked in watercolour with a botanist's eye for detail in the flowers themselves, although some of his work is rather more in the Dutch 'arranged' style. There is an unusual delicacy about all his painting which, although botanically faithful, is in no way scientifically approached. His is a very personal style and, for its day, very individual and quite beautiful. Many of his flower drawings are in the Fitzwilliam Museum (Colour Plate 12), Cambridge (Broughton Collection).

The younger Robins is known almost solely for his flower paintings which are, in many respects, similar to those of his father. There is an album of his paintings in the Broughton Collection, having 109 leaves of exceptional quality, and two larger, Dutch style, flowerpieces in watercolour. Father and son shared a lightness of touch which made their work seem relatively modern, yet no detail is spared and a judicious use of body colour adds to the dimensional interest. It would be good to know more of them as people, as the sort of individualists their painting suggests, but so far biographical details are sparse to say the least.

'Sir' John Hill (c.1716-1775) has been described by Richard Mabey as the court jester of eighteenth century botany, but he was unquestionably an interesting botanical

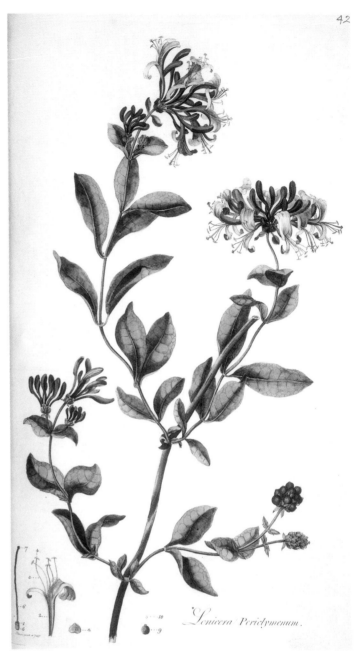

Colour Plate 10. William Kilburn. *Anthriscus.*

Colour Plate 11. William Kilburn. *Lonicera.*

artist and illustrator of several books, mainly concerning the Royal Gardens.

He originally trained at Chelsea Physic Garden as an apothecary, but decided he was never going to make a living in herbal medicine. He tried selling dried and mounted plants, writing articles and books on almost every subject under the sun, including two novels, he flirted for a while with the stage and filled in with a variety of jobs and projects. His real love through it all remained with botany, especially medical plants, both to study and to draw. In 1754 he published *A Useful Family Herbal* which, although of no great scientific merit, became very popular and, through 1756/7 he introduced his *British Herbal,* a serial publication in fifty-two numbers. Whatever the medical quality of the text, the illustrations had considerable merit.

In 1759 he published *Exotic Botany* illustrated with large plates from his own drawings, some of which were exotic in the extreme and somewhat flamboyantly portrayed. They

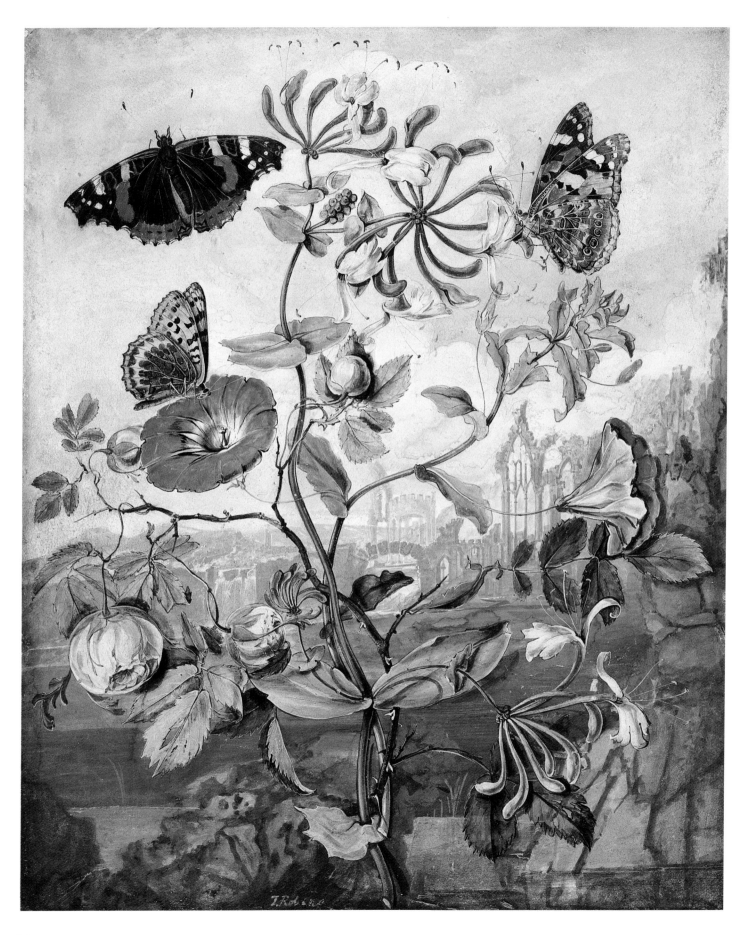

included twenty-five new plants raised at the Physic Garden along with other ornamental varieties. Give Hill his due, he quite openly and happily referred to his illustrations as 'designs' which, in some cases, is just what they were and, as such, presented a different approach to botanical and flower painting. The original drawings for *Exotic Botany* are in Alnwick Castle; others can be found at Kew.

Other published works with additional illustrations contributed by other artists as well as Hill himself included *The Vegetable System*, started in 1759 and issued in twenty-six folio volumes over sixteen years and featuring 1,600 engravings of 26,000 plants (see page 179). Unfortunately it proved a financial failure but Hill seems to have been fairly philosophical about such things. In 1760 he published *Flora Britanica*, again with his own decorative if undistinguished drawings.

Hill was described by Dr Johnson as 'an ingenuous man with no veracity'.

By the eighteenth century some interesting female botanical artists were making a name for themselves in what had previously been a male dominated sphere. The best known today is probably Clara Maria Pope (c.1750-1838). For many years she painted miniatures which she exhibited at the Royal Academy along with some flower paintings in the Dutch tradition. Later she turned to botanical work for which she became renowned.

These works tended to be large and opulent, a strange digression for a miniaturist, and she favoured such flowers as camellias, paeonies and roses which lent themselves to this new style. They have been unkindly described as 'spectacular, dazzling but [they] show no true sympathy or understanding; they lack soul'. Clara Pope illustrated Curtis' *Monograph of the Genus Camellia,* 1819, and provided some of the plates for his *Beauties of Flora,* 1806-20, plainly inspired by *The Temple of Flora* and ostracised for that reason, although the camellias were more successful. While for some Clara Pope may appear too dramatic for a botanical painter, the fact that her work was accepted by the Royal Academy for forty years gives it credibility. Several of her paintings are in the Natural History Museum.

Unlike Clara Pope, Ann Lee (1753-1790) has had an unwarranted lack of publicity. Daughter of the nurseryman, James Lee, she painted many specimens from her father's

nursery and did great credit to Parkinson's teaching. Working in watercolour, often on vellum, she displayed real talent and her painting is lively and natural as well as accurate and meticulously observed. Her work can be seen in the Kew collection and should not have been so neglected in the annals of botanical painting.

Queen Charlotte (1744-1818), who is well known for her passionate love of gardens, flowers and plants, was no mean painter herself, while still collecting the work of others. Both she and George III were enthusiastic patrons of the great Francis Bauer and it was Bauer himself who taught the Queen flower painting in watercolour. Later she also worked in gouache which lent itself well to her style and, in spite of her royal status and her large brood of fifteen children, she was a diligent and committed painter making full use of her talent and the excellent teaching she had received.

One of the new plants brought from South Africa by Francis Masson in 1775 was named by Sir Joseph Banks in Queen Charlotte's honour – *Strelitzia Reginae,* the 'Bird of Paradise flower' – an honour which was greatly appreciated.

Margaret Meen (fl.1770-1824) was born in Bungay, Suffolk, and it may have been that the magical East Anglian light to some extent accounted for the feeling of light and movement in her rendering of plants. In 1770 she moved to London to teach the painting of flowers and insects and she also exhibited regularly at the Royal Academy between 1775 and 1785. She painted many of the exotic plants then coming into Kew where there is a comprehensive collection of her work in the Herbarium.

In 1790 she began a serial publication entitled *Exotic Plants from the Royal Gardens at Kew* with the intention of producing two issues a year although in actual fact only two issues were ever published with ten beautifully painted plates. Richard Mabey maintains that these 'show her to have been an artist of outstanding talent and vision' and certainly she deserves a much higher profile than she has so far enjoyed.

Elizabeth Blackwell (fl.1737-1774) is perhaps better known as the saviour by her paintings of an errant husband than for anything really outstanding about the paintings themselves although they are, at least, competent and painstakingly executed.

Elizabeth Blackwell's husband was a doctor whose rivals, for reasons of their own, conspired to close him down and he was subsequently imprisoned for debt. Elizabeth, seeking a way out of this sorry situation, published *A Curious Herbal,*

Colour Plate 12. Thomas Robins the Elder. Flower drawing with Gothic ruin in background. Courtesy Fitzwilliam Museum, Cambridge

Plate 245.

Colour Plate 14. Mary Lawrance. *Passiflora alata.*

1737-1739, for which she travelled daily to the Chelsea Physic Garden to draw and paint specimens for illustrations (Colour Plate 13) while her husband worked on the text in his prison cell. She learnt engraving so that she could make plates from her drawings relatively cheaply and two years

after its publication the book had made enough money to discharge her husband's debts and so release him from prison. Her dedication was not rewarded as it should have been for the wayward doctor was subsequently executed for treason.

The *Herbal* was, however, reissued in 1757-73, having been enlarged and with the plates more professionally engraved by Dr. Trew of Nuremberg. Wilfrid Blunt, damning with faint praise, described Elizabeth Blackwell's five hundred hand

Colour Plate 13. Elizabeth Blackwell. Male Piony.

coloured etchings as 'the work of an industrious amateur that shows no touch of genius', although in fairness it has to be admitted that, to engender the sales that it did, the *Herbal* must have had some merit.

It is always a toss up when writing about flower 'painters' whether to include Mary Delany (1700-1788), but does painting necessarily have to involve tubes of pigment and a brush? At any rate nearly 1,000 of her flower portraits are in the Prints and Drawings Department of the British Museum.

Mary Delany was a society lady, unofficial aunt to Queen Charlotte's children, close friend of the Duchess of Portland and, according to Burke, was 'the highest bred woman in the land and the woman of fashion of all ages'. Widowed in 1774, she began collecting plants and flowers which led indirectly to her flower 'mosaics' made by cutting up scraps of coloured paper and pasting them on to a black background. So described this sounds like rather plebeian craftwork and gives no idea of their remarkable realism and the lifelike results of her intricate work.

It all started when a piece of scarlet Chinese paper on a table caught her eye simultaneously with a geranium of exactly the same shade and she idly started to cut out 'petals' from the paper, laying them on a nearby black ground. She was so fascinated by the result that she looked for some green paper appropriate to the leaves and some suitable black paper for the base and continued with her collage.

She became more and more involved with this particular handiwork; endless patience, a passionate love of flowers and a strong artistic colour sense combined to make it the ideal hobby for her. But this was no ordinary hobby craftwork. Using flowers from her own garden, that of the Duchess of Portland at Bulstrode and specimens from the Chelsea Physic Garden, she minutely and carefully dissected them and cut out tiny, intricate pieces – petals, sepals, calyx, leaves and stems, sometimes literally hundreds of paper shapes going into one plant or cluster. She collected scraps of paper from everywhere, often meeting the ships that came in from China and Japan and chatting up the captains. She bought up scraps and odds and ends from all manner of sources, faded papers, papers whose colours had run, anything likely to help provide her with the multiplicity of shades she might need. Sometimes she used layers of paper to bring out the tone she needed or to give additional depth; sometimes she gave the

papers a light wash. Sometimes she even treated and used real leaves where suitable. During the fifteen years following her initial experiment she completed over 1,000 mosaics of almost every species obtainable. 'Crafty' as the whole enterprise sounds when described, the end results were unbelievably lifelike, vivid and true colours occasionally touched up here and there by brush, delicate and fragile, waxy or satin-like, their authenticity was quite remarkable and no detail was omitted or misplaced. As well as in the British Museum collection, some of her work is in the Royal Collection at Windsor Castle.

It is worth mentioning that Mrs Delany was also a highly skilled embroideress, always using floral themes on cushions and covers, quilts and handkerchiefs, all in her own designs, also the seats in a chapel. She designed and worked her own court dress with embroidered flowers on petticoat, bodice, overskirt and sleeves. Her embroidered work is also represented in the British Museum.

At the turn of the century we have Mary Lawrance (fl.1790-1831), a teacher of botanical drawing. In 1799 she published a folio monograph, *A Collection of Roses from Nature,* which was more highly acclaimed than it actually deserved in spite of, or perhaps because of, its high price. The ninety hand-coloured etchings were very decorative but rather flat and not always strictly botanically accurate. To be fair, its popularity may well have been justified as a decorative book from a layman's angle even if rather looked down on by the botanists because of her profession as a teacher (an excellent teacher from all accounts) of botanical drawing who commanded high fees from her pupils.

As well as the better known *Roses,* she drew and engraved illustrations for *A Collection of Passion Flowers,* c.1797 (Colour Plate 14), and in 1801 published *Sketches of Flowers from Nature,* a students' manual taking pupils through the stages of producing a drawing and providing an outline to be coloured. It was quite an attractive book but maybe deliberately kept too simplified for the approval of the hard line botanists. Between 1794 and 1804, then from 1814 to 1827 under her married name of Mary Kease, she exhibited over fifty paintings at the Royal Academy, which suggests an acceptable standard, and her work is in the collection at Kew and in the Natural History Museum.

1. Parkinson also worked on insects, birds and other native wild life.

Colour Plate 15. Elizabeth Twining. The Turpentine Tree.

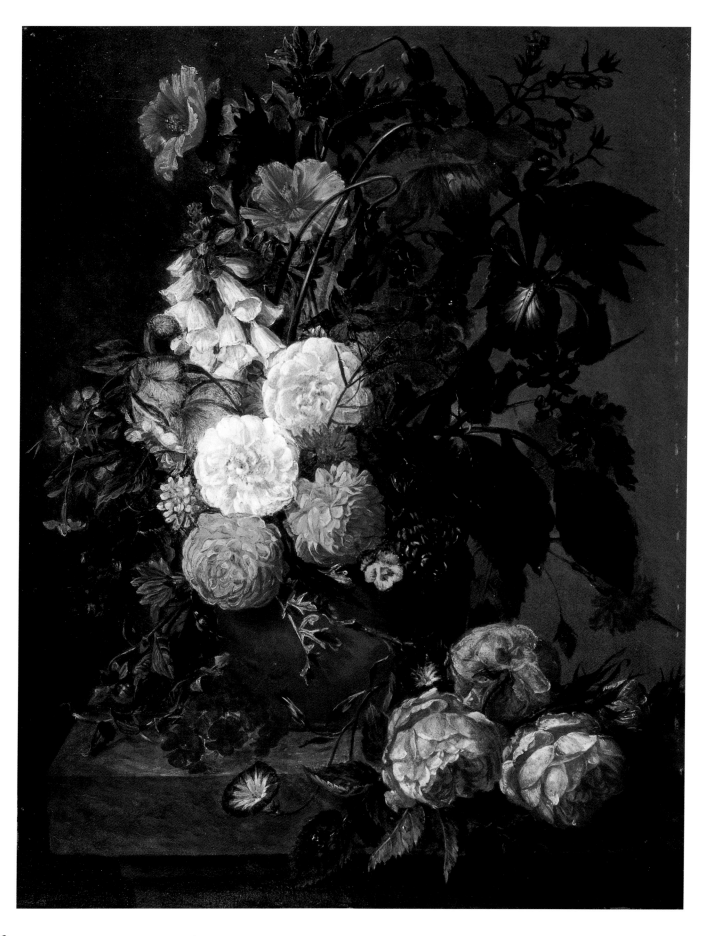

CHAPTER IV

British Flower Painting in the Nineteenth Century

The nineteenth was a strange century as far as flower painting was concerned. It was the century that produced the cream of the country's landscape painters – Gainsborough and Constable, Crome, Cotman and other Norwich painters, Nasmyth, Leader, F.W. Watts, Arnesby-Brown, T.S. Cooper and many, many more, yet traditional flower painters lagged behind.

Quantity overtook quality; during the later years of the century, in particular, every well-bred young lady was taught to play the piano, to embroider and to paint in watercolour. Although many, perhaps most, were mediocre, some of these lady watercolourists, amongst whom flowers were a favourite subject, were very good indeed in a decorative sort of way. In his excellent volumes *Dictionary of British Flower, Fruit and Still Life Painters,* Richard Brinsley Burbidge lists the names of many amateur painters who have exhibited just one or two flower painters at the Royal Academy or Suffolk Street which, while suggesting a certain standard, in no way makes them flower painters per se. The more seasoned exhibitors are listed in the dictionary appended to this volume, but the distinction must necessarily be made.

That said, the few really well-known traditional flower painters were very good indeed. One immediately thinks of Emily (Mrs Joseph) Stannard (1803-1885), a dedicated flower painter in the Dutch tradition. Even before she met Joseph Stannard, himself an exceptional landscape and seascape painter, she had visited Holland with her father, Daniel Coppin, and spent time studying and copying the Dutch flower paintings in the Rijksmuseum. She returned home with an enthusiasm for the subject that never left her and continued to paint magnificent flower and still life pieces for the rest of her long life. Joseph Stannard died tragically at the absurdly early age of thirty-three, despite the efforts of his loving wife who gave him every possible care and spared no expense when it came to calling on the best doctors available. Emily Stannard, on the contrary, lived on into her eighties, an exceptional age for her time, and must have derived some consolation from her painting. The Dutch influence remained the dominant note in her work; she had learnt a great deal during her stay in Holland so that, when she came to transfer the technique into her own compositions, the results were extremely rewarding. Her favourite subjects remained flowers accompanied in the Dutch fashion by insects and other small features (Colour Plate 16), but she seemed also to have a feeling for dead game birds – equally professionally painted but much less appealing to the eye.

The Joseph Stannards had one daughter, another Emily (1827-1894) who also painted flowers and assisted her mother in their teaching practice. Her work, while obviously more than competent, was not in the same class as that of her mother.

The same could not be said of Joseph Stannard's niece, daughter of his brother Alfred, who was a most worthy successor to her aunt Emily. Eloise Harriet Stannard (1829-1915) was a brilliant flower painter, if anything outshining her aunt (Colour Plate 17 and 34). She was a master, also, of painting fruit and most of her paintings involved both subjects. Her feeling for texture was quite remarkable, the delicate satinised feel of some flower petals, the bloom on the grapes or peaches, the sheen or suede-like matt of the leaves – everything she painted was so realistic that one feels able to lift it from the picture.

Accurate colour was crucially important to her and for that reason she insisted on painting outside or near a window in order to reproduce the colour as seen in clear natural light. An interviewer once asked her how she achieved this in winter. E.H. (as she was usually called) replied, 'In the winter I put the gold in my paintings'. She then explained to the bemused interviewer that the gold, silver and pewter containers for her flowers or the items of plate alongside, often borrowed from Norwich City Corporation, could be painted at any time irrespective of the pure light so necessary to the accuracy of the flowers.

Colour Plate 16. Emily Stannard. Mixed Summer Flowers in an Urn on a Marble Ledge. COURTESY MANDELL'S GALLERY, NORWICH

E.H., although considered to be the delicate member of the family, lived to a great age and was always fully employed carrying out commissions or working for exhibitions. She had no need of pupils but the one exception she made was for Maria Margitson (1832-1896), the niece of John Berney Ladbrooke. Maria's work deserves more attention than it has received, partly because she was not particularly prolific but also because, under the shadow of the lady Stannards, she was inevitably undervalued.

Perhaps more than during any other period it is in the nineteenth century that the distinction between flower painting and still life becomes distinctly blurred. A very famous artist who worked in a similar style to Eloise Stannard was Edward Ladell (1821-1886), whose flower painting was so incredibly beautiful that he could not be excluded from any literature on the subject but who always combined flowers with fruit, dead birds, a glass of wine or water, prawns, a bird's nest or a piece of porcelain – all painted with nothing less than perfection (Colour Plate 18). His feeling for glass is particularly impressive; in fact the realism in everything he painted seems little short of miraculous. These were not over-arranged still-life poses either, everything looked quite comfortable as it was, the colour true, the general aura soft and gentle – a master craftsman.

Little is known of the lives of Edward Ladell and his second wife Ellen, a former pupil whose work was similar to that of her husband and a credit to his teaching. Although Ellen Ladell appeared to sign most of her paintings while Edward used a back-to-back monogram, there have been times when the identities of their paintings have been confused.

Ladell was a native of Colchester, Essex, where he lived until 1878 when he and his wife moved to Torquay. Whether the reason was climate, health or simply a desire for change we do not know. Their obvious dedication suggests that perhaps both of them, and Edward in particular, painted to live and lived to paint. He died in Exeter in 1886 and is said to have been working on commissions up to this time. His death was mercifully sudden occurring only a week after a severe cold led to congestion of the lung.

Edward Ladell was a natural painter; as a self-taught artist he can only be described as a genius. Although he was brought up in his father's coach building business, this had no great appeal for him and he took up engraving, later turning to painting in his chosen genre. From 1856 he exhibited regularly at the Royal Academy, also the British Institute and

Suffolk Street. His work is in Bristol City Art Gallery, Exeter Memorial Museum and in Harrogate, Reading, Sheffield and many private collections.

Flowers and still life combine in the work of another family of painters, the brothers Clare – George (1835-1890), Oliver (1853-1927) and Vincent (1855-1925). The brothers lived in Birmingham but, beyond that, little is known of their personal lives. They were so extraordinarily prolific that one is tempted to wonder if they, like the Ladells, had much life outside their work which was extremely popular, even in their lifetime. The work of George and Oliver is very similar; it would frequently be difficult to distinguish between unsigned paintings. Both were patently influenced by William Hunt, particularly in their obvious affection for birds' nests with eggs, the most frequent accompaniment to their flowers, although fruit was also introduced at times. Spring flowers obviously had a special appeal; primroses appear regularly, always in a natural setting, perhaps on a mossy bank, also apple blossom, pansies, primulas, lilac and polyanthus. They worked on a small scale, rarely over 10in. x 8in., and painted with great precision, the flowers being particularly well observed (Colour Plate 19). The fact that they were cosy, comfortable paintings no doubt added to their popularity but without detracting from their artistic excellence.

Vincent's work is similar in subject matter and execution but it is coarser and less disciplined than that of his brothers; that is not to say that it is unattractive, simply a little less professional.

All the Clares exhibited in the main London galleries as well as in the Midlands and there has rarely been a lack of demand for their work.

Two other painting brothers were Albert Dürer Lucas (1828-1918) and Edward George Handel Lucas (1861-1936). The latter, although he painted some decidedly unusual still lifes, is not known for flower painting, but Albert Dürer Lucas specialised in this field producing some delightful mixed bouquets. His paintings were small and immensely detailed, including all sorts of flowers, foliage and ferns. He seemed particularly fond of wild flowers, often adding butterflies and insects for additional effect. One interesting practice of his was to put the names of the plants on the canvas stretchers,

Colour Plate 17. Eloise Harriet Stannard. Chrysanthemums.

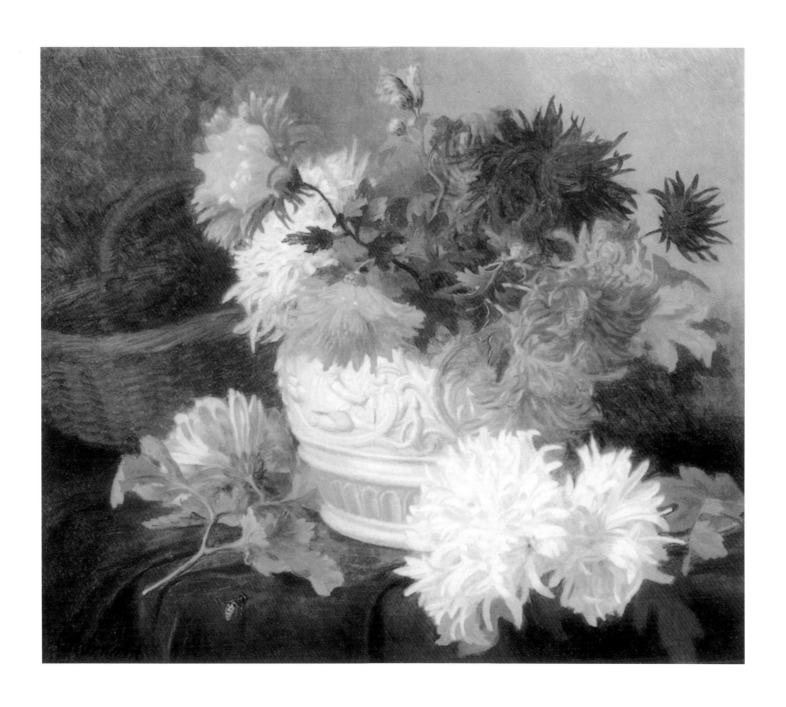

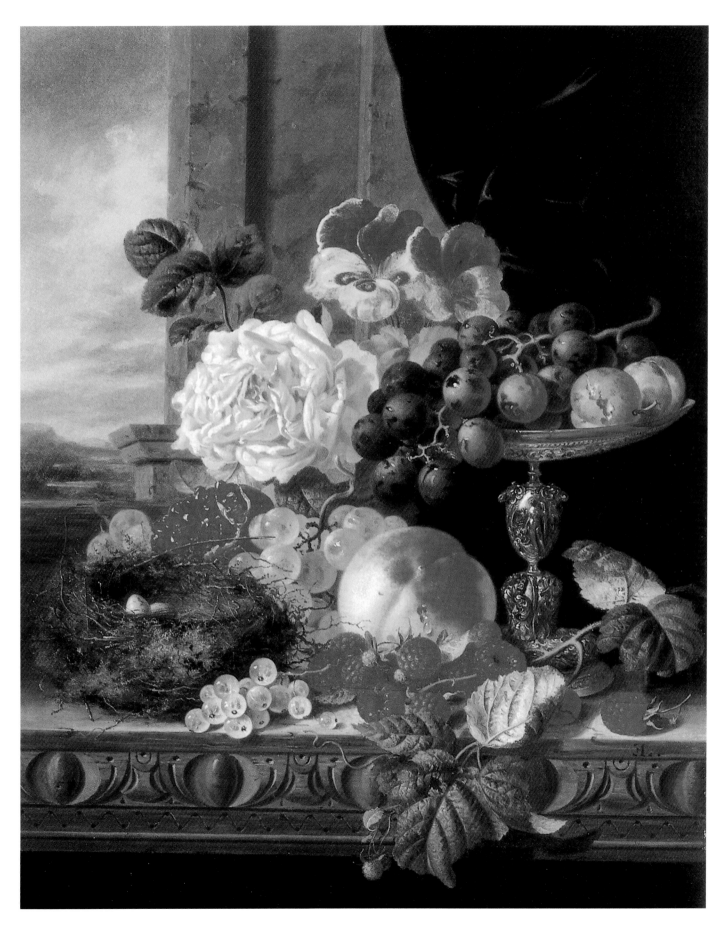

an idea other artists might consider copying. His flower paintings were regularly exhibited in London, at the British Institute and Suffolk Street.

Two other flower painters working in a rather similar vein to the Clares, flowers in natural settings with the inevitable bird's nest or tree stump, were Thomas Worsey, R.B.S.A. (1829-1875) and, a little later, Henry Stanier (fl.1860-1864). Both, oddly enough, were Birmingham painters. Worsey, the better painter of the two, exhibited in Birmingham and in London at the British Institute, Suffolk Street, the Portland Gallery and the Royal Academy. His flowers had a delicate freshness and natural charm painted rather like a tapestry all over the canvas amongst moss, hedgerow and bracken. Stanier may have been influenced by the Clares, strongly favouring the bird's nest and spring flowers but, although quite appealing, his work never quite reached the Clares' standard.

Two Manchester born sisters, Annie Feray Mutrie (1826-1893) and Martha Darley Mutrie (1824-1885), studied at their local School of Design under George Wallis. Early in the 1850s they started to exhibit in London where they attracted the attention of John Ruskin, a champion of those lady artists whose work happened to appeal to him. Christopher Wood quotes Ruskin. '…all these flower paintings are remarkable for very lovely pure yet unobtrusive colour – perfectly tender yet luscious, and a richness of petal texture that seems absolutely scented and the arrangement is always graceful – the background sometimes too faint…'. Ruskin himself was an accomplished painter, even more accomplished in his flowery use of words.

The Mutrie sisters used quite large canvases and a wide variety of flowers, often with other objects. Sometimes the compositions seemed a little too contrived, but they were professional painters and quite individual in style for the Victorian era. Between them they exhibited ninety paintings at the Royal Academy as well as showing at other venues in London, and their work is in several public collections.

Marion Chase, R.I. (1844-1905) was another able lady painter who preferred greenhouse flowers to outdoor or wild specimens and her exotic subjects made for some striking paintings. Both her parents were professional artists and Marion always received help and encouragement from them

and their many artist friends. She worked largely in watercolour. Her very subjects called for bright colours, but it was perhaps the lighter, more fluid, medium that kept them from appearing brash. She painted with great care and attention to detail and was made R.I. in 1875. She exhibited at the Academy, the Royal Institute, the New Watercolour Society, Suffolk Street, the Grosvenor Gallery and the Dudley Gallery. Her work is mainly in private collections but also in Aberdeen Art Gallery.

Little is known of Mary Ensor (fl.1871-1874), but her work is original in style and shows both talent and imagination. She lived in Birkenhead and exhibited mainly in Suffolk Street. She preferred flowers growing in the wild and her arrangements, rather like a vignette of a mass of growing wild flowers, are most unusual. It is a pity that not more of her work is known for it seems to deserve more serious study.

During this century specialist botanical artists were again more plentiful but, by and large and in spite of their quantity, both the eighteenth and twentieth centuries have produced, with certain notable exceptions, better quality work.

I have already mentioned the Hookers, important names in the world of botany and instrumental in giving opportunities to many aspiring botanical painters as illustrators of their many distinguished botanic and scientific books and theses. Sir William Jackson Hooker (1785-1865) was a good botanical artist himself in terms of the accuracy his deep knowledge enabled him to portray, while not being artistically outstanding. He took on the editorship of the *Botanical Magazine* in 1806 and, soon after, took over the illustrating himself simply to keep the magazine going during a rather shaky period. He also produced drawings for a later edition of *Flora Londinensis.* In 1841 he became Director of Kew Gardens.

His son, Joseph Dalton Hooker (1817-1911) took a medical degree at Edinburgh University and inherited his father's interest in and enthusiasm for botany, eventually also inheriting his place at Kew. He was an enthusiastic collector of plants and went on numerous expeditions acting as doctor and naval surgeon as well as pursuing botanical interests. One of his most notable excursions was to the Himalayas to collect rhododendron species of which he made numerous sketches. Martyn Rix describes him as 'the most important botanical traveller to Victorian India' and his book, *Illustrations of Himalayan Plants selected from drawings* (some by Hooker himself) made for the late J.P. Cathcart, Esq., of the Bengal Civil Service as 'one of the most beautiful of all botanical

Colour Plate 18. Edward Ladell. Still Life.

books'. The hand-coloured lithographs were made by Walter Hood Fitch who also drew and lithographed the illustrations for Hooker's *Rhododendrons of Sikkim-Himalaya*, using many of Hooker's sketches.

The many drawings and annotated sketches made *in situ* by Hooker on his broadly based travels have been invaluable to many botanists, botanical writers and artists, largely because of their accuracy of detail and the expert knowledge of exactly what was required to illustrate the most important scientific aspects.

Walter Hood Fitch (1817-1892) was the Hookers' most valuable asset, responsible for hundreds of original drawings and lithographs for their many learned books, articles and theses. He was 'discovered' by Sir William Jackson Hooker in Glasgow when Hooker was Regius Professor of Botany and Fitch was apprenticed to a calico printer. Hooker paid off his apprenticeship fees and, when he was appointed Director of Kew Gardens, took the young Fitch with him to London.

Fitch's first published botanical drawing was in the *Botanical Magazine* in 1834. Subsequently, as one of the earliest and most skilful exponents of the art of lithography, as well as providing many original drawings he produced all the plates for the magazine for almost forty years. Apart from his extensive freelance work, he was official artist at Kew for many years, retiring on health grounds (although he continued to draw and paint) in 1877. In the *Kew Bulletin* of 1915, W.B. Bursley states that 9,960 of Fitch's drawings were published during his working life.

William Hooker was enormously proud of his protégé and of himself for discovering him, while Joseph Hooker maintained that his illustrator could not make a mistake in his perspective and outline 'not even if he tried'. Certainly Fitch helped to an incalculable extent to make Hooker's books the valuable volumes they were, and still are, and well deserved Hooker's description of 'the incomparable botanical artist' with 'unrivalled skill in seizing the natural character of a plant'. Hooker was so conscious of Fitch's inestimably valuable contribution to botanical illustration that he prevailed on the Prime Minister, Benjamin Disraeli, to grant him a Civil List pension.

Fitch's illustrations include, as well as for the *Botanical Magazine* and other journals, those for William Hooker's *Century of Orchidaceous Plants*, 1851, and many of his famous works on ferns, Joseph Hooker's *Rhododendrons Illustrated*, *Flora Antarctica*, 1844-1847, *Florae Novae Zelandiae*, 1853-

1855, and *Flora Tasmaniae*, 1855-1860, Bentham's *Handbook of the British Flora*, 1865, Elwes' *Monograph of the Genus Lilium*, 1880, and many other outstanding books.

Fitch's very distinctive style is admired by most present-day botanical writers. Rix refers to him as 'the most productive artist and lithographer of the period' and describes his drawings for the Magazine as 'stupendous'. Lys de Bray particularly admires his rhododendrons while Blunt mentions his 'incredible ability in dealing with complex botanical structures', adding 'Fitch remains the most outstanding botanical artist of his day in Europe'.

There is no doubt that Fitch had an extraordinary talent and facility and, at the same time, was so prolific that he must have worked with considerable speed as well as accuracy. He is known to have had a remarkably retentive memory, an invaluable asset for a botanical illustrator, and an excellent colour sense. A telling example of his skill was his unique ability when lithographing to draw directly on to the stone from the plant without any preliminary drawing on paper.

In *The Art of Botanical Illustration* Wilfrid Blunt appends eight articles by W.H. Fitch reproduced from *The Gardeners' Chronicle*, 1869, and intended as instruction and advice for aspiring botanical artists. Even today the advice contained is constructive and useful and expressed in a lucid and easily comprehensible manner.

Following in the footsteps of his uncle, John Nugent Fitch (1840-1927) was an excellent and prolific artist and lithographer whose work was at times almost indistinguishable from that of his illustrious forebear. Like his uncle, John Fitch lithographed for the *Botanical Magazine* (nearly 2,500 drawings) for over forty years and his original drawings illustrated *The Orchid Album*, 1882-1897, and A.R. Harwood's *A New British Flora*.

Another good artist who owed much to Fitch's advice and teaching was Robert Morgan (1863-1900) who specialised in drawings of pond weeds. The best of these drawings illustrate *The Potamogetons of the British Isles* (Fryer and Bennett) and he was also an expert lithographer. He produced a number of illustrations for the *Journal of Botany* and for Trimen's *Flora of Ceylon*, 1893-1900.

Two lady botanical artists whose work was and is still outstandingly beautiful were Mrs Augusta Innes Withers (1792-1877) and Miss S.A. Drake (fl.1818-1847). Although Mrs. Withers was married to an accountant and comfortably off, she was also a highly skilled teacher of botanical

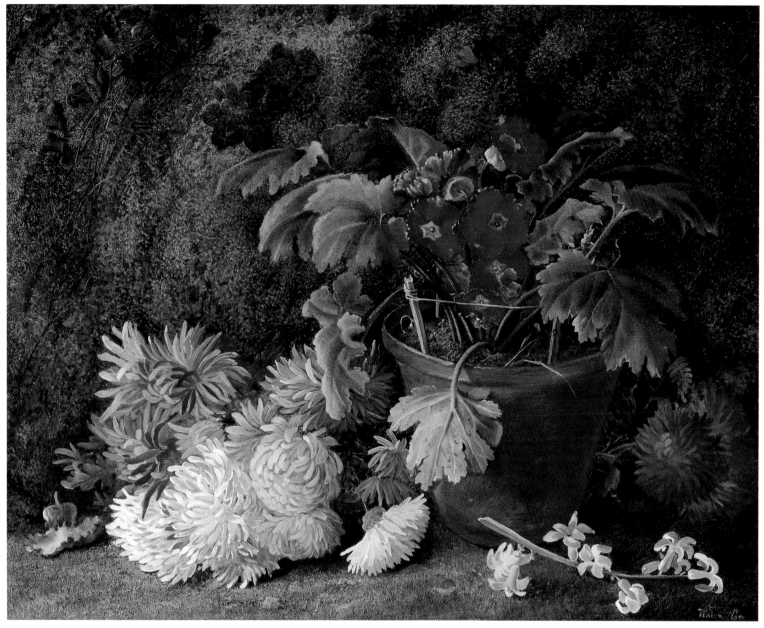

Colour Plate 19. George Clare. Mixed Flowers.

COURTESY MANDELL'S GALLERY, NORWICH

illustration and counted among her pupils the daughters of many of the most prominent nurserymen from both London and the provinces. Most of her life was spent in Fulham and several sources give her address as Grove Terrace, Lisson Grove. Beyond this little is known of her as a person but perhaps her superb botanical painting, her mastery of colour, form and texture as well as unwavering accuracy and a feeling almost of communion with her subjects, tell us all we need to know (Colour Plates 20 and 21). Her work, initially at least, was done for love of it rather than necessity.

Together with Miss Drake she illustrated what Wilfrid Blunt, corroborated by other experts, described as 'possibly the finest and certainly the largest botanical book ever produced', Bateman's *Orchidaceae of Mexico and Guatemala*, 1837-1841. Between them the two ladies produced thirty-seven of the forty illustrations, expertly lithographed by M. Gauci, which show botanical painting as the incredibly skilful and very beautiful art form it is when practised at its best. The publication was in an edition of 125 copies and dedicated to Queen Adelaide; seven of the original illustrations are in the R.H.S. Lindley Library, others in the Kew collection.

Mrs Withers exhibited regularly at the Royal Academy

Tropæolum edule.

Colour Plate 20. Mrs. Withers. *Tropaeolum edule.*

Physalis Schraderiana.

Colour Plate 21. Mrs. Withers. *Physalis schraderiana.*

between 1829 and 1846 and at Suffolk Street and the New Watercolour Society until 1865. Many of her paintings were reproduced in *Transactions of the Horticultural Society* which appeared in ten volumes between 1805 and 1848. She contributed (100 plates) to Maund's *Botanist* and others to *Illustrated Bouquet,* 1857-1863, and *Curtis's Botanical Magazine.* She illustrated the entire *Pomological Magazine* 1828-1830. She was a Member of the Society of Lady Artists and the Society of British Artists and Flower Painter in Ordinary to Queen Adelaide. Sadly her husband lost his sight in later life, about the time of Queen Adelaide's death, and was unable to work. Mrs Withers, of course, gave most of her time to caring for him; as a consequence, in spite of her busy and hard-working life, she died almost penniless at the age of eighty-five.

Even less is known of Miss Drake than Mrs Withers although her work was equally professional and very

beautiful. She is known to have lived at Turnham Green and, as well as sharing Mrs Withers' work with Bateman's *Orchids* and other major works, she provided illustrations for the *Botanical Register* and Lindley's *Sertum Orchidaceum.* Certainly she had a very special talent for reproducing the unique beauty and character of the orchid. Her work can also be seen in the Kew collection.

After these masters of their art, other excellent botanical painters seem almost to come into the also ran category. George Maw (1839-1912), although not the most prolific or celebrated botanical artist, had a talent that deserved putting to greater use. He was head of a firm of decorative pottery and tile manufacturers and, at the same time, a keen geologist, in which capacity he joined Joseph Hooker and John Ball in several of their many excursions. Although not a professional botanist, the subject interested him and he became, in 1886,

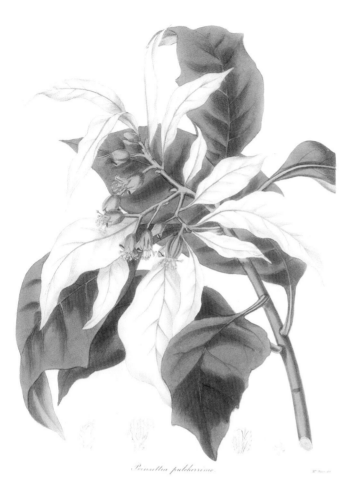

Colour Plate 22. Mrs. Bury. *Poinsettia pulcherrima albida.*

Colour Plate 23. Mrs. Bury. *Mintzela stipitata.*

particularly fascinated by the genus crocus which he started studying in great detail. His decision to make a monograph on the subject resulted in, after ten years of growing, collecting, studying, writing and illustrating, *A Monograph of the Genus Crocus,* 1886, which Blunt describes as 'the most complete work of its kind that has been published on the subject' and Rix calls 'one of the best and most beautiful monographs ever written'.

Maw undertook his own illustrations which can more than hold their own with those of any experienced botanical artist. He used living specimens, grown or collected by himself, and made the most meticulous study of every part of the plant. His sensitive renderings of each plant in the whole were accompanied on the plate by close-up, finely detailed studies of every individual component part, laid out in such a way that the whole represented a fully comprehensive

picture. His drawing itself and the entire presentation could have been the work of a highly trained professional botanical illustrator. Other botanists were generous with their praise and John Ruskin described his drawing as 'most exquisite…and quite beyond criticism'.

John Traherne Moggridge (1842-1874) made some charming studies of flowers of the Riviera, where he spent some time each year for the benefit of his delicate health, including illustrations for his *Flora of Mentone,* 1864-74. The Kew Herbarium holds a large collection of his drawings.

Mrs Edmund Bury (fl.1829-1867) was a Liverpool artist who worked for Maund's *Botanist* and also illustrated her own impressive folio in two volumes, *Selection of Hexandrian Plants,* 1831-1834. This was undoubtedly the most important of the books lady artists self published around that time which included Mrs Cookson's *Flowers Drawn and Painted after*

Colour Plate 24. Miss Maund. *Anemone vitifolia.*

Elizabeth Twining drew and lithographed *Illustrations of the Natural Order of Plants,* two volumes 1849-55, damned with faint praise by Blunt as being botanically sound (the object of the exercise!) but not 'of great artistic interest'. Nevertheless, she twice had work accepted by the Royal Academy which at that time was definitely a mark of accomplishment.

Maund's *Botanist* is well known and many of the illustrations were provided by his daughters known as Miss Maund and Miss S. Maund (Colour Plates 24-26). The latter may also have contributed to Maund's periodical *The Botanic Garden;* in any event the original illustrations eventually came into her hands and she presented them to the Natural History Museum. Of R. Mills (fl. early 19th century) nothing seems to be known except her illustrations for Maund's *Botanist* (Colour Plates 28 and 29) and the fact that the Royal Academy records show that she exhibited one still life painting in 1818. Jane Tayler, too, is a shadowy figure except for her illustrations (Colour Plate 27). It would seem that lady illustrators employed by authors or botanists of the day were simply hacks, however brilliant their work, some of which could certainly be so described.

There appeared in the nineteenth century a few quite remarkable flower painters who fall into no sharply divided category but are still of interest to any student of the genre. One immediately thinks of Marianne North (1830-1890) whose colourful, detailed and extremely decorative paintings are classed by certain writers as botanical but by others, notably Wilfrid Blunt who was probably her sternest critic, as anything but. While admitting that it might seem unkind to speak slightingly of her, he (unkindly) states that, 'Botanists consider her primarily an artist; but artists will hardly agree, for her painting is almost wholly lacking in sensitivity'.

Perhaps this rather substantiates my comment that certain floral artists of the time fall into no cut and dried category but, whatever the arguments, Marianne North was a remarkable woman who produced some extremely useful and informative work, however much the puritans may have disparaged her style.

Marianne North was an intrepid lady traveller who knew nothing of fear or nerves and took the most horrendous adventures in her stride. Hardship and discomfort seemed to mean nothing in her determination to paint what she wanted and in the setting she wanted it. Born in Hastings, her family knew both the Hookers, which no doubt influenced her interest in flowers and plants, and she was taught to paint in

Nature in England, 1830, Mrs Robley's *A Selection of Madeira Flowers,* 1845/6, *Specimens of the Flora of South Africa by a Lady* by Mrs Roupell and those of Jane Webb Loudon. Mrs Bury made no pretension to scientific knowledge or training but was undoubtedly a highly skilled and talented amateur, ten of whose original paintings have the honour of being part of Major Broughton's prestigious collection now in the Fitzwilliam Museum. Her particular skill was the depiction of white flowers which were cleverly arranged in relation to their leaves to give the bloom its full advantage.

Priscilla Susan Bury came from a rich and privileged background; the many exotic and beautiful plants from the family estate provided her with a wonderful choice of subjects (Colour Plates 22 and 23). Of other lady illustrators about whose actual lives we know little or nothing, Elizabeth Twining (1805-1889) ranks quite highly (Colour Plate 15). She was the granddaughter of Richard Twining, the tea merchant whose Twining name is still synonymous with tea.

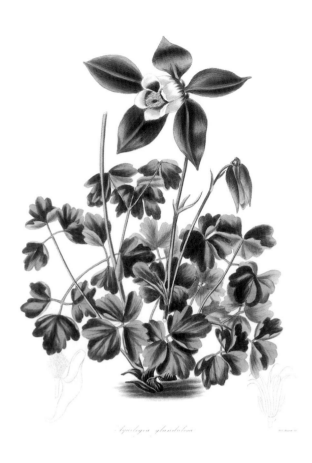

Colour Plate 25. Miss Maund. *Aquilegia glandulosa.*

Colour Plate 26. Miss S. Maund. *Pimelea decusata.*

watercolour by a Miss van Fowinkel and later in oils by an Australian artist. Most of her subsequent work was done in oils which had become her favourite medium, although there is a striking collection in watercolour of Swiss alpines painted from life in their natural environment.

Her love of travel was inherited from her father, no doubt fuelled by accounts of the Hookers' voyages. She and her father travelled extensively, particularly after the death of her mother in 1855. After her father had also died, she embarked on a life of travelling and painting flowers wherever she went. She was particularly keen to paint the exotic flora of the tropical countries in their natural habitat and she was always stimulated by their glorious colour and the striking scenery around them – mountains, forests, lakes and, of course, the abundant foliage.

She went first to Jamaica starting in the excellent botanical gardens there, then on to Brazil followed by Madeira and Japan via Canada and San Francisco, painting, painting and painting wherever she went, regardless of her personal safety

or comfort. Whenever possible she worked outside, often in precarious or even dangerous positions in her determination that the flowers should be in their natural settings with the appropriate backgrounds rather than simply as specimens. Unlike most painters working on the spot and in difficult situations, she continued to work in oils which must have been something of an encumbrance when constantly travelling, although it was certainly a medium that responded to the vibrant colours of the flowers and spectacular scenery. She was particular about accuracy as far as the heavier medium allowed, hence the very personal and attractive combination of botany and artistry.

In Japan Marianne North was taken seriously ill with rheumatic fever but this proved to be no deterrent to her adventurous life. On recovery she moved on to Singapore, then Sarawak, Tegura and Java where an excellent botanic garden gave her many new subjects. On her return to England in 1877 the Natural History Museum mounted an

Acacia pubescens.

Mich Taylor del.

Colour Plate 28. R. Mills. *Strobilantes sabiniana.*

Colour Plate 29. R. Mills. *Acrophyllum venosum.*

exhibition of her work featuring some five hundred canvases. Itchy feet once again prevented her from seeing this through; she left the Museum to look after it and went off to India having been seized with an ambition to paint all the sacred plants of India now displayed at Kew. On her return she started giving some thought as to what ultimately to do with all these paintings for which she had no suitable accommodation. She wrote to Sir Joseph Hooker, suggesting they might be given to the nation, and saying that, if the offer

Colour Plate 27. Jane Tayler. *Acacia pubescens.*

was accepted, she would make herself responsible for providing a building at Kew to house them. The offer was accepted with alacrity and the work put in hand.

In the meantime Marianne North met Charles Darwin who inspired her with an interest in Australian plant life, so off she went again, pausing to paint in Sarawak on the way. From Australia she went on to New Zealand but found the climate did not suit her rheumatism. She decided to return to London and see how work on her gallery was progressing. The result delighted her and she spent a happy time arranging for framing and organising the hanging and display of her paintings. Darwin's pleasure in the Australian paintings

came as further encouragement and she was patently thrilled when the gallery opened in 1882.

Nothing could keep this redoubtable lady at home for long, though, and later that year she left for Africa, finding exciting new material in Port Elizabeth. Illness drove her home once more, but as soon as possible she was off to the Seychelles to paint orchids. Her last voyage was to Chile and Panama where she found some wonderful subjects but, once again, she became ill and was forced to abandon a planned trip to Mexico. Marianne North must have been a woman of means to be able to spend her whole life indulging her ruling passion, then building her own gallery at Kew.

Back home in 1884 she enjoyed herself rearranging and adding to her collection in the gallery which now houses over eight hundred paintings, a massive and brilliantly coloured mural as they hang, cheek by jowl, to provide enough space for them all. Maybe some consider them gaudy but, as a collection of flora from almost every country, they constitute a valuable reference library and it must be remembered that many of the tropical blooms have a strength of colour almost unknown in this country. In his foreword to the *Official Guide to the North Gallery* Sir Joseph Dalton Hooker has written,

Very many of the views here brought together represent vividly and truthfully scenes of astonishing interest and singularity, and objects that are among the wonders of the vegetable kingdom; and that these, though now accessible to travellers and familiar to readers of travel, are already disappearing or are doomed to disappear before the axe and forest fires, the plough and the flock, of the advancing settler or colonist. Such scenes can never be renewed by nature, nor when once effaced can they be pictured in the mind's eye except by such records as this lady has presented to us…

Marianne North must have felt that her herculean efforts in all weathers and in some bizarre conditions, and her insistence on painting the scenic background to her flowers,

were fully justified. She eventually settled in Gloucestershire where she died in 1890.

There could hardly be a greater contrast to the work of Marianne North than that of Alfred Parsons and his sister Beatrice. Alfred Parsons, R.I., R.W.S., R.O.I. (1847-1920) is perhaps better known as a landscape painter, although here his love of flowers is expressed in his propensity for painting orchards with blossom. He was the son of a doctor whose hobby was gardening and who had become an expert on rock plants. He was a spare time painter of flowers, an interest obviously passed on to his son; both he and Alfred were friends of the Editor of *The Garden Magazine.*

The Parsons were a large family and money was not plentiful so Alfred started work at quite an early age. He spent four dismal years with the Post Office Savings Bank but left in sheer frustration to take up painting seriously. The move proved to have been worth the risk, especially when he became the established illustrator of *Harper's Magazine*. As well as a painter, again following in the footsteps of his father, he became something of a landscape gardener.

As far as botanical painting was concerned his chance came when he was commissioned by Ellen Willmott, F.R.H.S., to illustrate her book, *The Genus Rosa*. Miss Willmott was a wealthy gardener who met Alfred Parsons when he became President of the Society of Painters in Watercolour. She loved roses and grew more than 100,000 varieties, more even than the Empress Josephine accumulated at Malmaison. Miss Willmott's enormous garden at Warley Place extended to over sixty acres and she employed 104 gardeners. By this time Parsons had been made a Royal Academician and she obviously considered him a suitable illustrator of her rare and delicate species roses. There were to be 130 individual portraits of these roses by Alfred Parsons with text by herself assisted by J.G. Baker, a professional botanist who worked at Kew.

These rose paintings are the most delicate, totally natural, renderings of the exquisite species roses one can possibly imagine. They combine this perfect naturalism with complete botanical accuracy and are considered by many experts to be superior to those of Redouté. Certainly they are gentler, the colours are softer and there is no suggestion of a 'posed' stiffness. Rix sums up the reaction of most botanists: 'Parsons' paintings are almost the most exquisite of all time – absolutely natural flowing sprays yet botanically accurate, delicate and charming. The colour is soft and beautiful'. On the downside, the book ran into problems, largely because of

Colour Plate 30. Ellen Churchyard. Harebells. Ellen Churchyard was one of the seven daughters of the maverick lawyer/painter Thomas Churchyard. All the girls painted watercolours of indifferent quality except Ellen whose work was greatly superior, although her output was limited. I have always found her few studies of wild hedgerow flowers so charming that I wanted to include her here. PRIVATE COLLECTION

CUCKOO FLOWER
CHIDDINGSTONE
APRIL 1910

CRMMM M

the author's difficult personality and the constant differences she had with Parsons and with her publisher. The quality of the paintings was never in question, but she would argue continually about paper, type style and other details nearly crazing the publisher with her constantly changing ideas. Alfred, who had every sympathy with him, found that his own patience was being tried to the limit.

The originals of these superb illustrations are now in the Lindley Library, Royal Horticultural Society, and other flower paintings are included in some of the public collections holding his work, viz. the Tate Gallery, London, the R.H.S., Bristol, Cardiff and Wolverhampton. He exhibited at the Royal Academy, Suffolk Street, the New Watercolour Society, the Grosvenor Gallery, the New Gallery and other venues including Paris where he earned Gold and Silver Medals. Other botanical work includes eleven plates for *A Garden Flora*. Parsons never married but shared his home with the artist Frank D. Millet and frequently entertained the likes of Lawrence, Alma-Tadema and John Singer Sargent.

Beatrice Parsons (1870-1955), Alfred's sister, is sometimes listed as a flower painter, which indeed she was, although perhaps not in the narrow conventional sense. Her very beautiful paintings of gardens surely entitle her to such a description; they are a genuine delight to the eye and have the essential quality of seeming to draw the viewer into the picture, inviting him or her to walk between those gorgeous banks of rhododendrons and azaleas, to enjoy the shade of trees laden with spring blossom or to inhale the heady perfume of myriad flowers in fulsome mixed borders. Many others have painted gardens with varying degrees of success, but Beatrice Parsons' gardens are not just paintings in terms of a pretty picture. Somehow they manage to convey the quint-essential atmosphere of the traditional English garden most of us like to dream about. English gardens were not her only painting venues. She travelled extensively in Europe and South Africa for patrons who seemed, somehow, to have heard of her talent and wanted their gardens painted for posterity.

Beatrice Parsons, who trained at the R.A. Schools, also exhibited with outstanding success at most major London galleries and her work was purchased by Queen Mary and the Princess Royal.

A much larger family of flower painters is fully documented by Richard Mabey in *The Frampton Flora*. The sisters Clifford, Elizabeth (b.1810), Mary Anne (b.1815), Charlotte (b.1816), Catherine (b.1822), Constance (b.1828) who lived at Frampton Court and their aunts, Charlotte Anne (b.1791 and later Charlotte Anne Purnell), Catherine Elizabeth and Rosamond who lived nearby at Stancombe Park, between the years 1828 and 1851 painted practically all the wild flowers they could find in the area around their Gloucestershire homes. These paintings were 'discovered' in 1892 in an attic at Frampton Court, their colours as lively and unspoiled as the day they were painted. They had been made into scrapbooks and had probably never since seen the light of day.

I respect and admire Richard Mabey far too much to poach on his meticulous research and anyone interested in the history and background of this incredible family should beg, buy or borrow Mabey's book and enjoy a real treat. As far as my book is concerned, I will confine interest to the flower paintings which are fascinating studies. They make no pretence at being botanical illustrations in the accepted sense, but combine botanical accuracy with a more decorative approach. They are exquisite portraits of wild flowers in which the personality and likeness of the subject comes across vividly without skeletal intrusion.

It would appear that these ladies worked as a group to a prearranged plan, a real family enterprise but undertaken as a labour of love, probably with the hope or even intention that their work would provide a historical record of the local flora of the period. It is fully apparent that these flower studies were regarded as serious work; the care and painstaking effort and observation involved contrasts markedly with the somewhat naïve sketches acting as a record of family activities.

With the possible exception of the extremely talented Charlotte Anne Purnell, whose strong sense of design added to the quality of her work, it would be hard to make comparisons between the work of these lady painters. Many studies are unsigned and some appear to incorporate two different hands. Even if this altruistic spirit deemed authenticating unimportant, it is interesting to note that most of the drawings are dated, bearing out the theory that they were painted deliberately as a record for posterity.

One of the most striking attributes of these little gems, and again most pronounced in the work of Charlotte Anne Purnell, is the skilful use of the difficult colour green which frequently

FRITILLARIA
WALBERSWICK
1 9 1 5
CRM SMM

Colour Plate 33. James Sillett. Merry's Pompadour Auricula.

makes the leaves more attractive than the flowers themselves. This is particularly outstanding in the case of an intricate study of fuchsia species, also a rich field maple and a guelder rose, the latter by Charlotte Clifford. Impressive, too, is a spray of hops and a hedge bindweed by Charlotte Anne Purnell. Perhaps the most skilful use of colour as such is evident in an illustration of the yucca flower, an unusual subject beautifully handled.

John Ruskin, L.L.D., D.C.L., H.R.W.S. (1819-1900), art critic and writer, was an able draughtsman and enjoyed painting flowers, although his wonderfully flowery prose and

Colour Plate 32. C.R. Mackintosh. Fritillaria, Walberswick 1915.

his graphic descriptions of individual plants make his flower painting in words more telling than a more visual interpretation. Consider:

I have in my hand a small red poppy which I gathered on Whit Sunday in the place of the Caesars. It is an intensely simple, intensely floral flower. All silk and flame: a scarlet cup, perfectly edged all round, seen among the wild grass far away like a burning coal fallen from Heaven's altars. You cannot have a more complete, a more stainless, type of flower absolute; inside and outside ALL flower. No sparing of colour anywhere – no outside secrecies; open as the sunshine that creates it; fine finished on both sides, down to the extremest point of insertion in its narrow stalk; and robed in the purple of the Caesars…

We usually think of the poppy as a coarse flower; but it is the most transparent and delicate of all the flowers of the field. The rest – nearly all of them – depend on the texture of their surfaces for colour. But the poppy is painted glass; it never glows so brightly as when the sun shines through it. Wherever it is seen – against the light or with the light – always it is a flame and warms the wind like a blown ruby…

Gather a green poppy bud, just when it shows the scarlet line at its side; break it open and unpack the poppy. The whole flower is there complete in size and colour, the stamens full grown but all packed so closely that the fine silk of the petals is crushed into millions of shapeless wrinkles. When the flower opens, it seems a deliverance from torture; the two imprisoning green leaves are shaken to the ground; the aggrieved corolla smooths itself in the sun, and comforts itself as it can but remains visibly crushed and hurt to the end of its days.

Ruskin maintained that fully to understand the structure of a flower and to see its true beauty one had to draw it, which makes good sense and no doubt added to his power of fluent description of an individual bloom. Through this happy combination of visual and verbal description he came to know his flowers and to love them as an artist in the broader sense, rather than as a botanist. These were a species he enjoyed taking a rise out of – their obsession with deviation from the norm, with sexual practice and the like, as well as their elitist nomenclature, simply annoyed him and inspired aggression, mockery and satire in his writing. No doubt the annoyance was reciprocated and probably with less mischievous humour!

Botanists were critical of Ruskin's drawing but then he made no pretence of being a botanical artist. His drawings have a charm all of their own and there is real empathy there, a feeling of love and tenderness towards the flower in question that is often lacking in the more erudite approach of the purely botanical illustrator. His little flower portraits have a very personal appeal and often say as much about their creator as the plants themselves.

Ruskin was Slade Professor of Fine Art at Oxford University from 1869 to 1884 where he founded the drawing school. He exhibited watercolours at the Old Watercolour Society and other venues. Among his many written works perhaps one of the most famous, certainly of those with a floral connection, was *Proserpina* 1874-76, which Rix has described as 'a series of drawing lessons in flowers'.

Art is the flower – life is a green leaf. Let every artist strive to make his flower a beautiful living thing – something that will convince the world that there may be, there are, things more precious – more beautiful – more lasting than life.

So wrote another highly individualistic painter of flowers among many other subjects – Charles Rennie Mackintosh (1868-1928). Mackintosh is perhaps more frequently thought of as an architect or designer of interiors, textiles or furniture, but a closer inspection of all these reveals that flowers and plant forms provided material or decoration for almost every facet of his work. His love for and almost obsession with flowers and plants can be traced throughout his career. His flower paintings themselves are a delight – from the conventional to the abstract, from purely botanical to stylised or imaginary, the Mackintosh hallmark has a fascination all of its own.

Mackintosh worked primarily in watercolour and pencil, using the combination to great effect. His colour has a vibrancy that excites but is never in any way brash or vulgar. His painting of anemones, for instance, is one of the very few I know wherein the colour is true without being blatant. The de Caen anemone is a flower that, by its strength of colour and exquisite petal texture, attracts the flower painter yet, in my own experience and that of others, it just does not 'come off'. Maybe Mackintosh's daring use of yellow mellows the flowers without obtruding, or even the subtle shading of the background paper…

As a native of Suffolk I am compulsively drawn to Mackintosh's Walberswick series along with those from Holy Island and other chosen areas drawn in the same vein (Colour Plates 31 and 32). These are specimen drawings in the sense that they are of single species. They are accurate in depiction and show the full detail of the flower and its structure; partly they are coloured, partly the dark outline is left to say all that is necessary. It is this strong emphasis on the line drawing that distinguishes his work from that of the conventional botanical artists; also the colour is used in a more relaxed manner. Stylistically they have much in common with Japanese botanical illustration with which they share a deceptive simplicity. The use of the cartouche box for signature and details is another link with the Japanese, but whereas the Japanese rely almost solely on the brush, Mackintosh's distinctive outlining with pen and pencil is one of the outstanding characteristics of his work. But Charles Rennie Mackintosh was unique in every way – to try to make comparisons of any sort can seem singularly out of place.

As an acclaimed landscape painter Gertrude Jekyll (1843-

Colour Plate 34. Eloise Harriet Stannard. Pink Roses and a Wicker Basket on a Stone Ledge.

1932), who trained at South Kensington School of Art, would have had no place in this book. However, when her sight deteriorated to the point that she could no longer paint with pigments, she became a flower painter in another medium for which she had an even greater talent.

From a small child Gertrude Jekyll had always been interested in flowers, plants and gardens, an interest fostered by her family's acquaintance with several eminent gardeners. She adored gardening and, above all, garden design and her artistic gifts made her particularly aware of the importance of colour and colour coordination leading her, in defiance of increasing myopia, to paint *with* flowers.

Gertrude Jekyll has probably done more than any of the great gardeners to make others aware of the overriding importance of judicially used colour. For fifty years she gardened at Munstead Wood, her own carefully but imaginatively designed garden, divided into smaller gardens by trees and shrubs, water, walls and hedging, all playing their part in separating, say, the white and blue garden or the grey garden wherein she made subtle and fascinating use of the many grey foliaged plants to be found when one really seeks them out. She would become totally engrossed in the study of colour in relation to plants and gardens, always adding to her store of ideas and inspired combinations. To give her the last word:

Problems of colour arrangement are becoming an engrossing study; every year some new or better combination suggests itself, with its certain reward in the following season. Something of the satisfaction of a good conscience rewards and encourages the designer; for surely one of the objects of a good garden is that it shall be pictorially beautiful – that it shall be a series of enjoyable pictures painted with living flowers.

Lilium regale.

CHAPTER V

British Flower Painting in the Twentieth Century

Coming into the twentieth century we find a much more exciting pattern, or perhaps non pattern, of flower painting evolving. Frequently one hears a flower painting described as 'after the Dutch style' or 'in the French manner', but has anyone ever used such an expression when describing British flower painting of the twentieth century? The truth is that, while earlier painters will undoubtedly have influenced a few successors, twentieth century British flower painting has no sole recognisable inheritance but 'influence' in its broadest sense can be traced to the very earliest roots of the flower painting genre. One can, for instance, affiliate the murals of Graham Rust with those of the Romans bringing their gardens into the house.

Botanical painting alone comes into a much more readily defined category on account of its scientific application. While there is no doubt that, with some honourable exceptions mentioned earlier, the cream of British botanical painting has been produced in the twentieth century, its enormously talented and highly skilled exponents are constrained by the very nature and demands of their craft. Any individuality in layout or presentation must essentially be governed to some extent by the need for complete accuracy of form, shape, colour and growth, although the combined aesthetic approach of such masters as the Bauers, Redouté and our own Margaret Stones, among others, gives some of their work a pictorial as well as botanical dimension.

So much has already been written of the botanical artists of today, particularly those of the Royal Botanic Gardens at Kew, that many of them have become household names. I have no wish to poach on the preserves of such aficionados as Professor Stearn and Richard Mabey, so will confine my present discussion to a very personal selection including certain more individualistic artists working in the botanical field. Many others will be found in the appended dictionary; in no way is any slight or invidious comparison implied, there

are just so many that to discuss them all, even at a highly professional level, would soon become repetitive, especially as the main players are well documented elsewhere. By comparison the traditional decorative flower painters have been neglected for too long and for this neglect I shall try to make some atonement.

Returning to my choice of botanical painters, it is undeniable that Stella Ross-Craig (1906-) is the best known contemporary botanical illustrator. I deliberately use the word illustrator for, excellent artist as she was, she is most highly esteemed for her remarkable scientific and botanical black and white plant drawings showing the main plant accompanied by separate detailed drawings of every individual part of its anatomy, including the root. Ross-Craig supplied 1,286 of these (full page) drawings for *Drawings of British Plants* (published in thirty-one parts 1948-1973), 460 for Hooker's *Icones Plantarum* and 75 for *Flora of West Tropical Africa,* as well as many others for various scientific journals, all of the highest calibre of botanical accuracy.

Stella Ross-Craig was born in Aldershot, Hampshire, and trained at Thanet Art School and Chelsea Polytechnic School of London University. After botanical training she joined the staff at Kew as an R.H.S. artist working in the Royal Botanic Gardens from 1929 to 1960. As well as her regular illustrative work as one of its principal artists during the middle years of the century, from 1932 onwards she produced numerous plates for the *Botanical Magazine*. There are over 3,000 of her drawings, coloured and black and white, in the Kew collection (see page 209).

Perhaps as some sort of antidote to the meticulous scientific drawing, so fine and detailed that on her own admission she sometimes used a microscope, Stella Ross-Craig would paint portraits and landscapes using watercolour quite freely, also some delightful studies in pastel.

This little known aspect of her personal work rather begs the question, how did she find the time? It is an established fact, though, that considering the detailed nature of her professional work, she worked at an incredible speed. This is

Colour Plate 35. Lilian Snelling. *Lilium regale.*

a skill of necessity cultivated by all flower painters, especially those in the botanical field, because of the rapidly changing nature of the subject. The slightest withering or progression of the flowering can change the whole nature of the drawing, emphasising the need to work in cool conditions. Movement can disturb accuracy and plants do move a great deal while, as the flower opens, not only the formation but the colour can and does change. In spite of her propensity and talent for black and white drawings, in her colour work Stella Ross-Craig was obsessive about correct colour and tone and was not afraid to make judicious use of body colour and even occasionally resorted to coloured inks to give where necessary a special brilliance.[1]

Lilian Snelling (1879-1972) became one of this country's most highly acclaimed botanical artists (Colour Plate 35). Most of her life was spent in Kent and London and she began painting flowers for amusement when she was little more than a child. Her talent was 'discovered' by the botanist, H.J. Elwes, who later commissioned her to make twenty-eight plates for his supplement to the *Monograph of the Genus Lilium,* published 1934-1940.

Lilian Snelling worked at the Royal Botanic Gardens, Edinburgh, from 1906, making plant portraits for Sir Isaac Bailey-Balfour, Keeper of the Botanic Gardens and Professor of Botany at Edinburgh University. She became chief artist for the R.H.S. *Botanical Magazine* making most of the plates between 1922 and 1952. She was a worthy successor to the great Walter Hood Fitch, her work having something of the same character; also she was the first artist since Fitch to combine the arts of illustration and lithography. Volume No.169 of the *Botanical Magazine* was dedicated to her and the R.H.S. bestowed on her their supreme accolade, the Victoria Medal of Honour.

As well as her work for the R.H.S., Lilian Snelling is especially noted for her particularly lovely paintings of fifteen species of paeonies for F.C. Stern's *A Study of the Genus Paeonia,* 1946, the originals of which are in the Lindley Library. Lilian Snelling studied lithography under Morley-Fletcher so that she would be able to produce her own plates for the *Botanical Magazine;* she also lithographed for Stella Ross-Craig and other artists. This indefatigable lady hand

coloured her lithographs with absolutely accurate colour, clear but delicate and charming. Most of the plates are now at Kew or in the British Museum collection.

It is said that Lilian Snelling was a delightful person – gentle, shy with strangers, but with an attractive dry wit. Although she produced more colour work than Stella Ross-Craig, her work was similar in many respects and equally faultless. She lived to the great age of ninety-three.

Well known as one of the foremost botanical artists of her time, Margaret Stones was born in Australia in 1920 and studied at Swinburne and National Gallery Schools, Melbourne, before coming to England in 1951. She had been taken ill after nursing in the Second World War and during the enforced period of rest that followed resumed her study of botany.

In England she worked first at the Royal Botanic Gardens, Kew, and the British Museum (Natural History). In 1958 she became principal contributing artist to *Curtis's Botanical Magazine,* producing over 400 coloured and 400 black and white text drawings over the next twenty-five years. Always working independently, she followed in Lilian Snelling's footsteps, making most of the plates for supplements VIII and IX of Elwes' *Monograph of the Genus Lilium,* 1960 and 1962.

She also illustrated Lord Talbot de Malahide's *The Endemic Flora of Tasmania,* published in six parts between 1967 and 1978, the later parts being published after Lord Talbot's death. Margaret Stones produced for the *Flora* 270 coloured drawings and as many working drawings. She visited the country on two occasions but almost all the material, collected in the wild, was flown to her in London. Another particularly interesting commission came from the Louisiana State University for 200 drawings of flora of their State; she has also illustrated many other books and has exhibited widely in this country and abroad. A full list of exhibitions appears in the appended Dictionary.

Again like Lilian Snelling, Margaret Stones, who still lives near Kew, has a wonderfully accurate eye for colour and even the simplest of studies is so skilfully arranged on the page that it becomes a plant personality portrait and is satisfying from a decorative standpoint without losing any of its scientific quality and value.

1. Since the text of this book was completed, Stella Ross-Craig has, at the age of ninety-five, had her first solo exhibition in Spring 2002. 'Stella Ross-Craig: Drawings of British Plants' was mounted at Inverleith House, Royal Botanic Garden Edinburgh, an important venue described by the *Daily Telegraph* as being 'at the international cutting edge'. Miss Ross-Craig herself selected the fifty-five drawings on show from the 1,306 drawings of British plants published in 1979 in an eight volume set. The exhibition again emphasised the skill and artistry of her drawing – as the late, great Wilfred Blunt once commented, 'In the making of scientific black and white line illustrations, Miss Stella Ross-Craig is unrivalled'.

I gather it is a source of amused pride to her that five directors of Kew have been 'brought up' under her magnum opus.

Colour Plate 36. Mary Grierson. *Helleborus argutifolius.*

Mary Grierson was born in Bangor, North Wales, in 1912 of Scottish parents. While serving in World War II she trained as a cartographical draughtsman while, from childhood, she had drawn and painted flowers purely for pleasure. After the War she attended a course run by John Nash, R.A., himself an illustrator of flowers and plants; her intense love of flowers and talent for drawing them along with the accuracy and detail required in her war work combined to encourage her to embark on a career as a botanical illustrator (Colour Plates 36 and 37).

In 1960 she was appointed botanical artist at the Royal Botanic Gardens and illustrated many of Kew's scientific works and Floras. On retirement as Senior Botanical Illustrator in 1972, she decided to spread her wings and focus on her interest in conservation. She spent two seasons in Israel, Sinai and the Negev desert in response to an invitation from the Israeli Nature Reserve Authority. She has also undertaken commissions for the World Wide Fund for Nature and the Pacific Tropical Botanic Garden in Hawaii.

In addition to the many illustrations she produced for the *Kew Bulletin, Curtis's Botanical Magazine* and P. Hunt's folio *Orchidaceae,* 1973, with forty fabulous colour plates of this magnificent species, she has contributed to *An English Florilegium: The Tradescant Legacy* by W.T. Stearn and C. Brickell, *The Genus Cyclamen* by C. Grey-Wilson, Mathew's *The Crocus,* Green's *A Hawaiian Florilegium* and *Trees and Shrubs Hardy in the British Isles* by W.J. Bean. She produced a series of paintings of tulipa species for a Dutch bulb company and, in 1967, a set of four designs for postage stamps of British flora with the Reverend Keble Martin. Her paintings of wild flowers have featured in a number of exhibitions in the U.K. and the Hunt Institute for Botanical Documentation, Carnegie Mellon University, Pittsburgh, PA (hereinafter referred to as the Hunt Institute).

Mary Grierson has been awarded five Royal Horticultural Society Gold Medals for Botanical Illustration and, in 1984, the coveted Gold Veitch Memorial Medal. In February 1998 the Society awarded her their highest token of appreciation, the Victoria Medal of Honour. This special honour is held by only sixty-three recipients at any one time representing the sixty-three years of Queen Victoria's reign.

Although an impeccable botanic painter, Mary Grierson's eye for composition and design sets her in a class apart from many of her contemporaries – excluding, perhaps, some others I have chosen as being rather special. Her courses at

Flatford Field Centre have given her the opportunity to influence younger flower painters including another very talented Kew painter whose work I admire – Joanna Langhorne.

As if all this was not enough, Mary Grierson is an expert embroideress; a very appropriate connection was the derivation of one of her designs from a Marianne North painting. Regrettably I have not (yet) met Mary Grierson, but correspondence, the enthusiasm of mutual friends and looking at her work all help me to understand the intangible quality that the personality of certain artists lends to their work.

Joanna Langhorne, born in 1945, who shared with Mary Grierson an initial grounding from John Nash, R.A., also shares Mary's dedication to her work and deep feeling for her subjects (Colour Plate 38). At school her favourite subjects were biology and art and, in the latter, she naturally received ample encouragement from her father, the eminent painter and designer John Asquith Langhorne. As well as Nash's Field Study Courses in Botanical Illustration at East Bergholt, she attended the Central School of Arts and Crafts, London, from 1963 to 1965, after which she started working for the Freshwater Biological Association under Dr. T.T. Macan, a distinguished entomologist. At that time she was drawing and illustrating fishes, insects and freshwater invertebrates, but her botanical instinct was calling and in 1973 she became Official Artist in Residence at the Royal Botanic Gardens, Kew, where her talent for flower painting and botanical illustration could be suitably indulged.

In 1980 she decided to leave full time work at Kew and turn freelance, working from a rural cottage in the Lake District where, as well as executing numerous commissions, she collected rare and unusual alpines and woodland plants; this gave her a wider range of subject matter as well as the fascination and satisfaction of cultivating and breeding such species. She still retained a connection with Kew, producing work for *Curtis's Botanical Magazine* and such requests as twelve designs for plates to commemorate the 250th Anniversary of the Gardens. She provided illustrations for numerous other botanical and scientific publications and books and found a particular interest in illustrating monographs, the most

Colour Plate 37. Mary Grierson. *Passiflora edulis.*

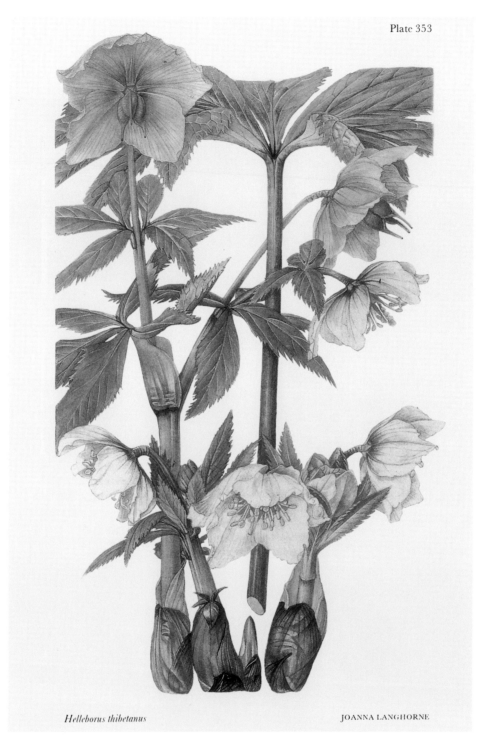

Plate 353

Helleborus thibetanus JOANNA LANGHORNE

Colour Plate 38.
Joanna Langhorne.
Helleborus thibetanus.

recent being Brian Mathew's *Onco and Regeliocyclus.* She has also found time to participate in many mixed exhibitions and has had four solo exhibitions.

Joanna Langhorne has made a serious study of the history of botanical painting considering herself (justifiably) part of the almost dynastic succession through, among others, Georg Ehret, the Bauer brothers and Pierre François Turpin. She

shares the passion of these and all others at the top of the profession for absolute botanical accuracy and realism and, like all good flower painters, insists on working with living

Colour Plate 39. Rodella Purves. *Meconopsis sheldonii,* watercolour, 36in. x 24in. Original owned by Helen and Murray Gray and reproduced by Royal Botanic Garden Edinburgh.

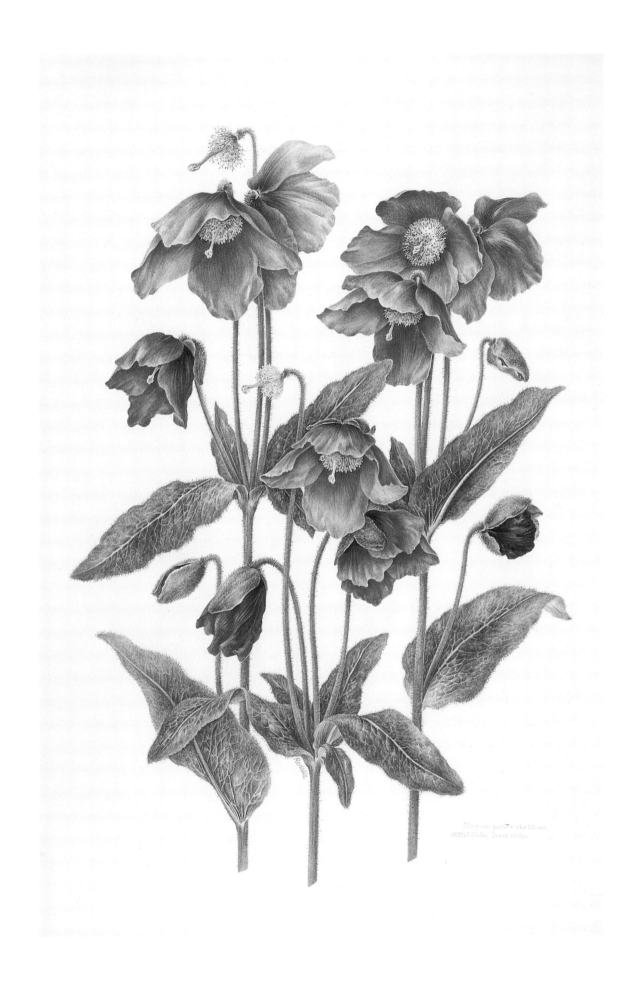

subjects in natural light. Whatever she shares with others, however, and here I detect particularly the influence of Turpin's sensitivity, there is something completely individual about her own work. It is difficult to pinpoint exactly what makes an artist's work special within its own sphere, but one notable feature of Joanna's work is her ability to convey texture and, more unusually, transparency. Somehow she manages to give the impression that there is light and space between, say, a semi-transparent petal and the white paper so that its delicacy is perfectly evident. Sometimes an artist's own vision is elusive but with Joanna Langhorne's flowers one sees them just as she sees them, just as they are. Seeing an exquisitely textured flower or leaf growing or in a green-house, there is an irresistible urge gently to feel, to stroke, to identify with it… that feeling is similarly engendered by Joanna's watercolours. One is constantly being amazed and awed by the inherent skill of many botanical artists and flower painters but, as we go through history, the aforementioned succession are in a class apart.

★ ★ ★ ★ ★

With so much talent and so much good material available in this genre it is hard to be selective but I would like to give special mention to just three more outstanding botanical painters – Rodella Purves, Christabel King, whose outstanding contributions to *Curtis's Botanical Magazine* over many years have assured her of a place in its history, and Ann Farrer whose portraits of Himalayan plants are a classic example of how a single spray of an indigenous plant can subtly convey the atmosphere of its region.

Rodella Purves (b.1945) claims that success in any artistic pursuit requires a lot of luck. This no doubt is true and Rodella Purves has probably had her fair share, but I am of the opinion that with her talent and diligence (she calls it obsession), luck has not been an essential ingredient. One is particularly struck by the freshness and spontaneity of every work (Colour Plates 39 and 40) and she herself admits that, even after thirty years, she feels a renewed excitement every time she is about to start a new project, a determination that this one will be perfect. Most artists would be feeling intense satisfaction at achieving her quality of result, but she maintains that feelings of frustration still drive her to do better next time. Beyond perfection?

From 1969-76 Rodella was working for Dr. Brinsley Burbidge as an exhibition designer at the Royal Botanic

Garden Edinburgh. The success she achieved, despite the limitations of working on a huge scale with industrial materials, encouraged her to embark on plant paintings in watercolour on a more realistic scale. From there everything began, commissions soon started pouring in and even the most exacting horticulturists and researchers were impressed. Her subjects became more and more complex, her striving for perfection more intense and her capacity for long hours of concentrated toil greater and greater. Often she works all night, drawing her subject in great detail from all angles so that precious daylight is reserved for painting to ensure absolutely correct colouring. Her commissions come from an enormous variety of patrons from a train driver, who has seven works, to the Royal Bank of Scotland, and she tells how, only last year, she was painting an iris for her local butcher when she had to break off at the urgent request of Shell and BP International on behalf of the President of Azerbaijan.

Rodella Purves was born in Paisley, went to school in Edinburgh and then to the East of Scotland College of Agriculture, Edinburgh, where she gained a Diploma in Agricultural Botany in 1962 followed by a Diploma in Seed Testing from the National Institute of Agricultural Botany, Cambridge, in 1967. Before joining Dr. Brinsley Burbidge at the Royal Botanic Garden, she worked for the Department of Agriculture in Scotland and the Department of Agriculture, Palmerston, New Zealand. Since transferring to botanical illustration she has not only fulfilled numerous commissions but exhibited widely in London, Scotland and overseas and provided illustrations for many books and other publications including *Curtis's Botanical Magazine*. As an exhibition designer she has been awarded a Chelsea Flower Show Silver Medal and Gold Medals from the Royal Highland Show. She was featured on BBC TV in 1991 in The Beechgrove Garden which led to her major Retrospective Exhibition of sixty-nine works in the City Art Centre, Edinburgh – Botanical Paintings 1976-1996.

As her work bears out, Rodella Purves works only from living specimens and was awarded the Jill Smythies Medal for Botanical Illustration by the Linnean Society in 1998. Her delight at this award, which certain lesser talents might almost

Colour Plate 40. Rodella Purves. *Rhododendron leucogigas,* watercolour, 38in. x 26in. Original owned by Carol Milne and reproduced by Royal Botanic Garden Edinburgh.

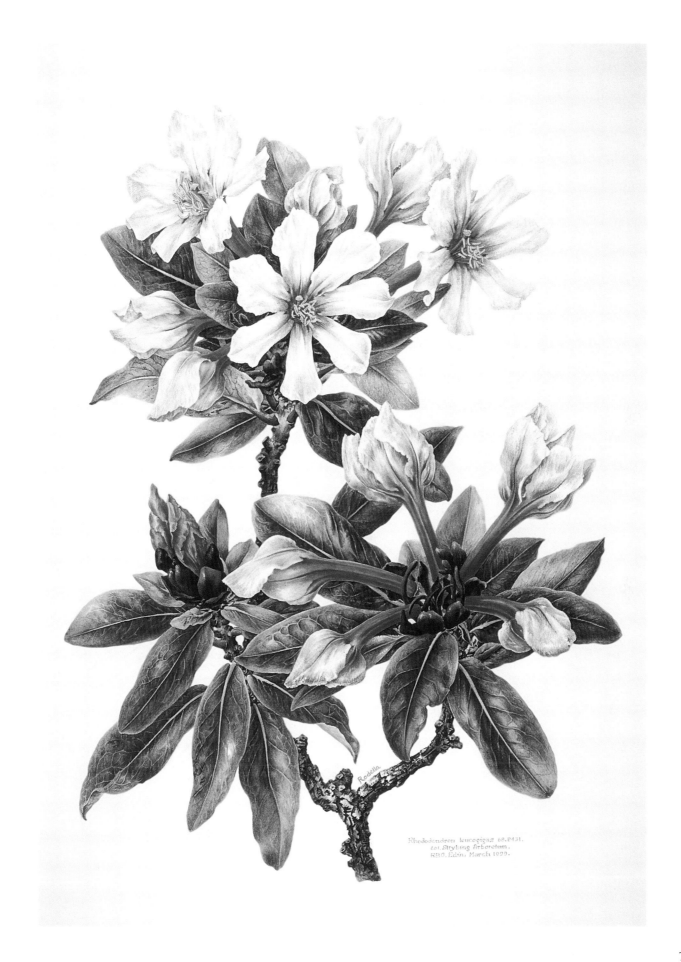

Rhododendron leucogigas 68.P431.
det. Strybing Arboretum.
RBG, Edin. March 1999.

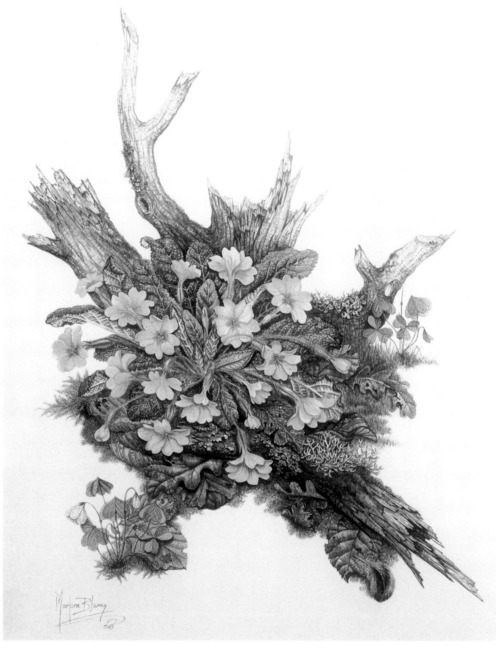

Colour Plate 41. Marjorie Blamey. Primrose.

have taken for granted, bears out the dictum that humility is an essential part of greatness.

Those artists I mentioned as being on the botanical fringe (not by any means a disparaging description) combine a strict albeit attractive botanical approach in their 'official' work with a more decorative rendering of plants in their natural habitat, allowing the artist more freedom of expression and giving the work a clearer stamp of personality.

Here, for me, Marjorie Blamey, Pandora Sellars and Margaret Mee have a special appeal, although I fully realise that they are only three of many high fliers in this category.

Marjorie Blamey was born in Ceylon in 1918, the daughter of a doctor, although she was only a young child when the family moved back to England. No one with the slightest

Colour Plate 42. Marjorie Blamey. Cowslip.

interest in flower painting could fail to be attracted by her work (Colour Plates 41 and 42), partly, I rather think, because she is such an amazing character. As a school girl she enjoyed painting birds and flowers in spite of having been told, by one of the art teachers (so called) with whom we are all familiar, that her kind of painting was a waste of time. Life took over as it is inclined to do, alternative career prospects were more inviting, and then, when war came, she enrolled as a Red Cross nurse leading a very hectic service life. Around this time she met and married a young army officer living near her Surrey home. After the war they became totally involved in a new combined career as farmers in Cornwall. Bringing up their four children and carrying out the multitudinous tasks that fall to the lot of a farmer's wife provided Marjorie

Colour Plate 43. Margaret Mee. *Catasetum.*

with a very full and fulfilled life.

At the age of forty-eight she had a sudden urge to return to painting and, borrowing her daughter's paint box, embarked on a single clematis bloom. Soon, through natural talent, practice and sheer determination, she was producing the sort of flower paintings people actually wanted to buy, although initially she had wanted painting to remain a small hobby. However, a painting hanging in a local exhibition so attracted an author that he asked if she would consider doing some illustrations for him. From then on everything snowballed – more requests for book illustration, commissions from many different quarters, and her own need to go on finding out more and more about flowers in their natural habitat all over this country and overseas. Her husband enthusiastically joined forces with her in this new found career, retired from farming and bought a caravan in

which they travelled around so that Marjorie could work wherever they chose or wherever the commissions were without disrupting anyone else's life.

As well as travelling extensively, Marjorie worked regularly in the Herbarium at Kew although relatively few were actually done for the Botanic Gardens. She worked there mainly on sketches of flowers which were rare and difficult to obtain in the wild but necessary for the books she was illustrating. From the sketches the finished illustrations were done at home and her repertoire now covers most of the flowers of Europe.

The authorities at Kew obviously recognised her exceptional ability and Marjorie Blamey felt it to be a great honour when she was invited to stage an exhibition there in 1989. The theme was wild flowers through the seasons starting with snowdrops and finishing with bare branches and dead leaves. The Queen Mother, who visited the exhibition, fell in love with the cowslips which she claimed not to have seen since she was a girl. Marjorie Blamey does paint single specimens as well as the studies I referred to earlier, occasionally for Kew and also for many of her books, but they have, as well as botanical accuracy, the hallmark of a true individualist, an indefinable quality that separates the born artist from the rest. I rather think its other name is sincerity. It is in the naturally growing plants that this special quality speaks loudest; a cluster of cowslips surrounded by wood anemones amongst last autumn's brown leaves, perhaps, or wild fritillaries growing in meadow grass along with the daisies. If I am coloured by the fact that she obviously shares my passion for Suffolk's indigenous wild flowers, so be it – I make no apology.

Mrs Blamey insists that her painting career could never have taken off without the support, from the very start, of her husband Philip. To quote – 'He is my manager, tea maker, van driver, frame maker, and, above all, the one who organises all the books in the background with the aid of a word processor, fax machine, endless letters and phone calls. That's why you should put "they" instead of "she" here and there, we work as one unit and LOVE it.' She has now illustrated, and in some cases she and her husband have written, about thirty books on plants (five more in the pipeline at the time of writing) including the provision of 2,400 colour plates for Christopher Grey-Wilson's *The Illustrated Flora of Britain and*

Colour Plate 44. Margaret Mee. *Gustavia augusta.*

Gustavia augusta
Amazonas feb 1985

Margaret Mee

Colour Plate 45. Jennifer Andrews. Poppies.

Northern Europe. She has three times been awarded the R.H.S. Gold Medal and a Gold Certificate of the Alpine Garden Society.

Pandora Sellars, a younger artist, was born in 1936 in Herefordshire and attended Hereford College of Art where she trained as a textile designer, later becoming an art teacher and finally a freelance illustrator. With her husband, James Sellars, a teacher of fine art printmaking, she established a wonderful collection of exotic aroids and orchids in their heated greenhouse and the temptation to draw and paint them became irresistible. Since then, although she has painted many, many different flowers, these have become her speciality and the subjects of a number of her published illustrations.

She had the good fortune to meet Margaret Stones at an R.H.S. exhibition and acknowledges the latter's generosity in sharing her extensive knowledge of botanical illustration. Not only was this the start for Pandora Sellars of regular illustrating for the *Botanical Magazine* but Margaret Stones continued to give much appreciated help and support for many years.

Pandora Sellars' orchids and other exotics have a fulsome, quietly glowing quality, giving the feeling that one can reach out and touch them, stroke their polished leaves and satin petals. The particularly individual statement in her work lies in the massed areas of growth providing natural settings for the glamorous blooms, perhaps to some extent a partial inheritance from her training in textile design. Here the flowers nestle within or protrude from their own abundant foliage; although always botanically true, they are shown in their own special context, an integral part of their complex structure, and have an extraordinarily personal attraction far removed from the more stereotyped botanical drawing. It crosses the mind, consciously or otherwise, that something of the inspiration for this approach may have derived from the work of Margaret Mee and

Colour Plate 46. Jennifer Andrews. Morning Glory.

Marianne North, although Sellars' work is infinitely superior to that of North and she denies any conscious influence. She does, however, freely acknowledge that inspiration for her work, although coming firstly from the plants themselves, springs from such artists as Ehret, Ligozzi, le Moyne de Morgues and the Bauer brothers as well as, more surprisingly, such moderns as Matisse, Picasso, Braque and Bonnard.

Pandora Sellars has an R.H.S. Gold Medal and was commissioned to make the prestigious porcelain design celebrating the Princess of Wales glass house at Kew. She has also designed stamps for the Jersey Post Office and illustrated a number of books about which she is characteristically modest.

Margaret Ursula Mee (1909-1988) is alone in her class of botanical artist/flower painter; an individualist in many ways, this characteristic certainly permeates her painting. Margaret Mee was born in Chesham, Buckinghamshire, of sea-faring ancestry; this and the stories of her much travelled grandfather no doubt accounted for her love of travel and strong spirit of adventure. As a young girl she was keen on and studied art, but for a time became involved in political activity. During the Second World War she became a draughtsman in an arms factory which may have encouraged her to take up art once more. After the war she attended Camberwell School of Art, where she was tutored by Victor Pasmore, and later St Martin's where she met Greville Mee, her husband to be.

Margaret Mee is best known for her studies of flowers of the Amazon forest (Colour Plate 44) and her adventures in searching for and painting these wonderful creations are well documented in *In Search of Flowers of the Amazon Forest,* published shortly before her death, and *Margaret Mee's Amazon* published in 2004. The legacy of her work is invaluable to scientists and botanists for many of the rain forests in which she worked have vanished and, sadly, will continue to do so. Not only art and science have benefited, but the entire history of the region.

Margaret Mee's travels began in 1952 from a base in Brazil where she and her husband were living and her work was initially focused on the coastal rain forests around São Paulo which have now almost disappeared. These paintings were exhibited in 1958 in Brazil and later in London when the R.H.S. honoured her with the Grenfell Medal. Her Amazonian travels started in 1956 in the border regions of Pará and Maranháo, later following the Upper Rio Negro bordering Colombia and Venezuela. In 1967 the National Geographical Society sponsored her as the first woman to climb the south face of the Pico da Neblina, the highest mountain in Brazil, following which a folio edition of *Flowers of the Amazon Forest* was produced to coincide with an exhibition of the work at the Tryon Gallery in London.

Later she undertook further Amazon journeys, painting all the time the rare and beautiful species in their natural habitat. Often she travelled under conditions of extreme hardship,

Colour Plate 47. Anna Zinkeisen. Watercolour sketch for later oil painting of a flower border.

Colour Plate 48. Anna Zinkeisen. Spring Flowers.

Colour Plate 49. Vernon Ward. Anemones and Laburnum.

seemingly unperturbed by the dangers of snakes, cannibals and dangerous insects, to say nothing of dangerous human beings like the drunken ruffians who once burst into a hut she was occupying. Slight and womanly as she was, she must have carried the right sort of authority in that they heeded her insistence that it was not proper to enter a lady's domain when she was alone! A later return visit aborted at the sight of her 32 Rossi revolver.

Margaret Mee, perhaps inevitably, suffered several bouts of malaria and hepatitis, but nothing seemed to thwart her determination, against all the odds, to complete her planned collection. Her highest ambition was to record the rare Amazon Moonflower *(Selenicereus wittii),* a type of cactus which flowers just once on one night a year. Although Margaret Mee had seen it, it was never more than a glimpse through the dense jungle but, on her last journey and well

into her seventies, she triumphed. Working by torchlight before the beautiful exotic faded, her crowning ambition was at last realised.

Margaret Mee's paintings, particularly those where the flowers are an integral part of their natural setting, are incredibly beautiful, a tribute to her sympathetic handling as much as the subject themselves. To read her book is a joy and not just for flower lovers and students of botany – it is as good an adventure story as one is likely to find. After all her experiences, all the dangerous situations in which she found herself, it seemed a horrible irony when we heard that she had been killed in a motor accident on a British road. She will always be remembered, not only as one of the most

Colour Plate 50. Kenneth Webb. Summer Flowers.

talented but as the most determined and courageous flower painter of our time.

Margaret Mee's exhibition venues include the Natural History Museum in 1980, the Missouri Botanical Garden where she showed sixty Amazon paintings in 1986, and the Amazon Collection at Kew in 1988. She was made an M.B.E. in 1975, elected a Fellow of the Linnean Society in 1986, awarded the Order of Cruzeiro do Sul (Brazil) and an Honorary Citizenship of Rio de Janeiro and a Guggenheim Fellowship. For ten years she was an Honorary Associate of the Botanical Museum, Harvard University.

Even further towards the botanical fringe is a flower painter whose fascinating work is unusual in the extreme, if not unique. Jennifer Andrews was born in 1933, trained at Oxford School of Art 1954-56 and the Royal College of Art 1956-59. She describes herself as a flower painter/designer rather than as a botanical painter, aiming to create decorative pictures but with accuracy and understanding of the habits of plants, an understanding deepened by her enthusiasm for gardening in her own East Anglian garden and in the garden around Flatford Mill and Willy Lott's House for which she is responsible.

Jennifer Andrews' work includes designs for floral wallpaper (Sandersons), social stationery and china although she now concentrates mainly on her drawing and painting (Colour Plates 45 and 46). Working with waterproof sepia ink and using a flexible nib to give variation of line, she makes her initial drawing without any preliminary pencil, just the flowers in front of her and a mental picture of the finished work. The picture is built up gradually, usually flowers followed by leaves and stems. The ink dries quickly so colour can be added before the drawing is completed; using watercolour and working from light to dark, the washes are kept clear and clean so that the pen work can hold its own without dominating. Further line is never added once colouring is complete.

Both line and wash are skilfully used to indicate the shape and formation of the plants while at the same time creating a satisfying composition. For lightness and contrasting white Jennifer makes the paper work for her in a manner that only a truly accomplished artist could achieve. Such a basic description of an unusual technique may perhaps sound mechanical and bland but the finished pictures are anything but that. From tiny flower portraits to large, sumptuous bouquets, they are not only totally professional but have an intangible magic that is quite arresting, the more so because of its rarity.

Jennifer Andrews still attends the botanical workshops at Flatford Mill started by John Northcote Nash who she maintains has been her greatest influence. Influence manifests itself in many and various ways, though, and in this case is not visually apparent; the only artist to my mind whose work in any way identifies with Jennifer's is Charles Rennie Mackintosh. Perhaps she would contest this but my feeling is that these two have shared a similar vision of flowers, of the delicacy, the tenderness and the transience that gives them their eternal appeal. The low key colouring, too, is another pleasing similarity.

Jennifer Andrews runs her own courses at Flatford Mill on Painting and Drawing Plants and Flowers in Design; she also takes holiday courses at Marlborough College. She has exhibited at the Royal Academy, the Mall Galleries, the Scottish Arts Council and the Hunt Institute. A number of one-woman exhibitions include a bi-annual exhibition in her own home. Her other interests include music and poetry – looking at her work, there is no need to reason why.

As will be observed in the appended Dictionary, it is inevitable that some of 'those who paint flowers' are listed along with the flower painters per se, many of whom are discussed more fully in the general text. Here, too, in all fairness I must include that group of exceptionally well-known painters who can and do paint everything under the sun, but whose flower paintings are so outstanding that not to give them special attention would be a serious sin of omission. In any event, as far as those I have in mind are concerned, their flower paintings are considered by many to constitute the cream of their work.

Anna Zinkeisen, R.I., R.O.I., R.P., F.R.S.A., R.D.I. (1900-1973) is perhaps best known as a society portrait painter on account of the eminence of her subjects from royalty, the aristocracy, the highest echelons of the clergy, the police and the government as well as people famous in other walks of life. Portraits of people can frequently be translated into portraits of animals and flowers, Anna Zinkeisen's flower paintings appearing as beautiful flower portraits, perfect likenesses painted with the same care and attention to detail as she gave to an interesting face, a military uniform or a priest's vestments. No doubt it was the humanity and individuality that she put into her flowers that gave them

Colour Plate 51. Raymond Booth. Harebell.

their unique, almost human, character.

Anna used various approaches to her flower painting although, always, each individual bloom was treated with the same loving care. Loving flowers, as Mary Grierson recently reminded me, is an essential contribution to the success of any flower painting. Some of Anna's earlier flower studies were composed rather in the Dutch manner, glorious lush arrangements, even sometimes in garland form after the style of Daniel Seghers or Christiaan Luyckx. Later she became, to use her own expression, 'allergic to vases' and she turned to wild, growing flowers, often on a dark mysterious background (Colour Plate 48). Sometimes she would take a single bloom, often a rose, and treat it just as a human portrait, sometimes larger than life but, as with her people, expressing its personality as well as its likeness.

Her most famous flower painting is, of course, H.M. the Queen's Coronation Bouquet (which was graciously loaned by Her Majesty for the first Retrospective Exhibition after Anna's death in Woodbridge in Suffolk). Waiting patiently in the shadows until the bouquet was released to her, Anna was whisked away to her studio to make a start on her very special commission. The subject spent its nights in the refrigerator until Anna had every detail, every shade and shape, as near to the original as paint could convey. It surely merited the comment made by the Duke of Edinburgh on seeing Anna's portrait of him – 'Absolutely bang on'.

A contemporary of Anna Zinkeisen and acknowledged admirer of her work was the much maligned Vernon Ward (1905-1985), who was associated by many with flying birds in landscapes adorning trays and chocolate boxes. It is a sad fact of life that many an artist has had to tarnish his or her reputation by the need to earn a living. To those who knew Vernon Ward for his original work, unsullied by inferior reproduction, his flower paintings generally had the strongest appeal and certainly the highest quality. A Retrospective Exhibition after his death amazed many people who had never associated him with such delicate and exquisitely crafted flower paintings (Colour Plate 49).

Vernon Ward painted many subjects solely because he was commissioned to do so, but sometimes without any great enthusiasm. Flowers he loved and, although many of his flower paintings were reproduced as fine art prints and greetings cards,

Colour Plate 52. Raymond Booth. Rhubarb.

his delight in the execution was plainly apparent in the work. He was an incurable romantic and this shines through his flower studies. He described flowers as 'loveliness incarnate' adding 'to love flowers is to love God, it is as simple as that. Why not seek the Kingdom that is not only all round but within us?'

Vernon Ward's actual method of painting flowers was a quite extraordinary feat of manipulating paint with skilful brushwork. The delicacy of some of the floral work suggests a meticulous attention to detail and careful drawing of the plant itself but no… he achieved such a result, yes, but using a large brush (his favourite was a 2½inch varnish brush) and swift dextrous strokes. The flat of the brush was used for the background and larger areas, the chisel edge in some magic fashion produced the detail. Most of Vernon Ward's flower studies are in watercolour but he also used oils from time to time holding an assortment of brushes in one hand like a bouquet, the palette lying on a table beside him. Never one to be afraid of paint, he would lay it on heavily and sensuously then, in some indefinable manner, turn it into a perfect flower, blending in the high and low tones, sometimes adding extra lightness with pieces of pure pigment. The sad point about reproduction of his work is the fact that it gives no idea of the power of texture achieved by this method of painting.

Kenneth Webb, N.D.D., A.T.D. Dist., N.S., F.R.S.A., A.R.U.A., A.R.W.A., an English painter born in Bristol who formed the Irish School of Landscape Painting, is again known for his mastery of any subject from his early passionate studies of African animals to a portrait of the Dalai Lama. For a long time flower paintings were represented by some evocative studies of Irish wild flowers in the natural setting of the bog or in his own charming garden wilderness. Then, in the early seventies, Kenneth visited Lanzarote. The rich volcanic landscape and the wealth of colour all round did nothing to detract from the impact of hundreds of thousands of vibrant, iridescent poppies of every conceivable shade from delicate pink to intense, almost fluorescent, scarlet.

Poppies inspired the next, quite prolonged, phase in Kenneth's painting and have crept into many later works. Poppies grew in the Irish bog, in shadowy woods or by the sea, poppies by moonlight, blood red poppies blooming in virgin snow, poppies in totally unlikely but beautifully painted landscapes and other situations led to an even more surreal approach, a more abstract expressionism. Symbolically they were woven into a series of works based on the myths and

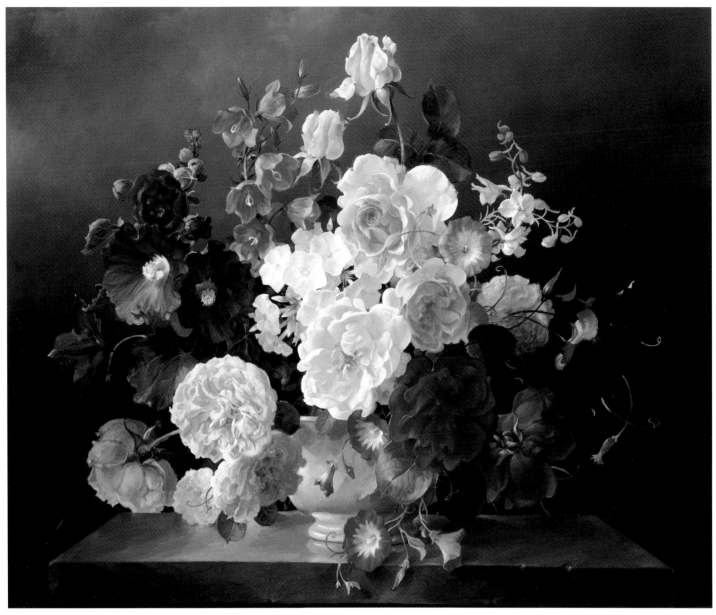

Colour Plate 54. Harold Clayton. Summer Splendour.

legends of ancient Greece where they developed an ambiguity which somehow fitted the allegoric nature of the painted stories; poppies painted in a subtle way became features of the characters sometimes assuming a suggestive, even erotic, significance. Many admirers who associated Kenneth Webb with poppies, poppies and poppies might well be surprised at the diversity of his subjects, certainly prior to Lanzarote.

In a shorter, more traditional, phase inspired by Monet and

Colour Plate 53. Harold Clayton. Mixed Flowers.

Giverny, Kenneth produced some sparkling waterlily studies which, albeit in a different way, gave ample scope for his daring use of colour, especially in the reflections and the mysterious life of the water. The wild flower meadows and bogs of Ireland may have provided a gentler, more orthodox if equally attractive, style, but still the poppies reveal a depth of vision, an intensity of feeling and an emotional, almost spiritual, quality personifying the man himself

Kenneth still paints (among other things) poppies, wild flower meadows, waterlilies in whatever style the mood of the moment dictates (Colour Plate 50). For me, nothing has ever

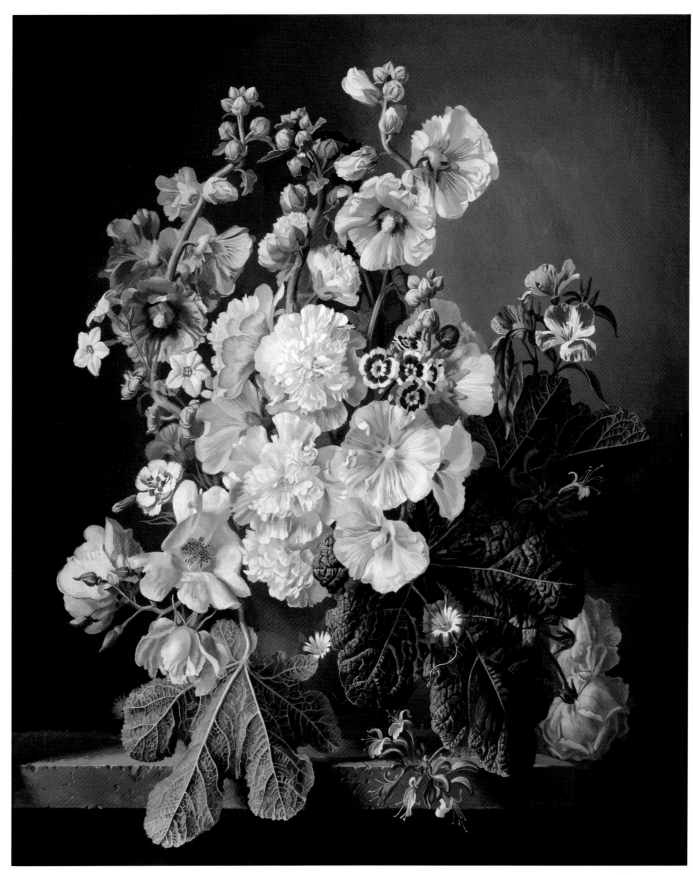

Colour Plate 55. Gerald Cooper. Still Life of Flowers.

PRIVATE COLLECTION, UNITED KINGDOM
PHOTOGRAPH COURTESY OF THE RICHARD GREEN GALLERY, LONDON

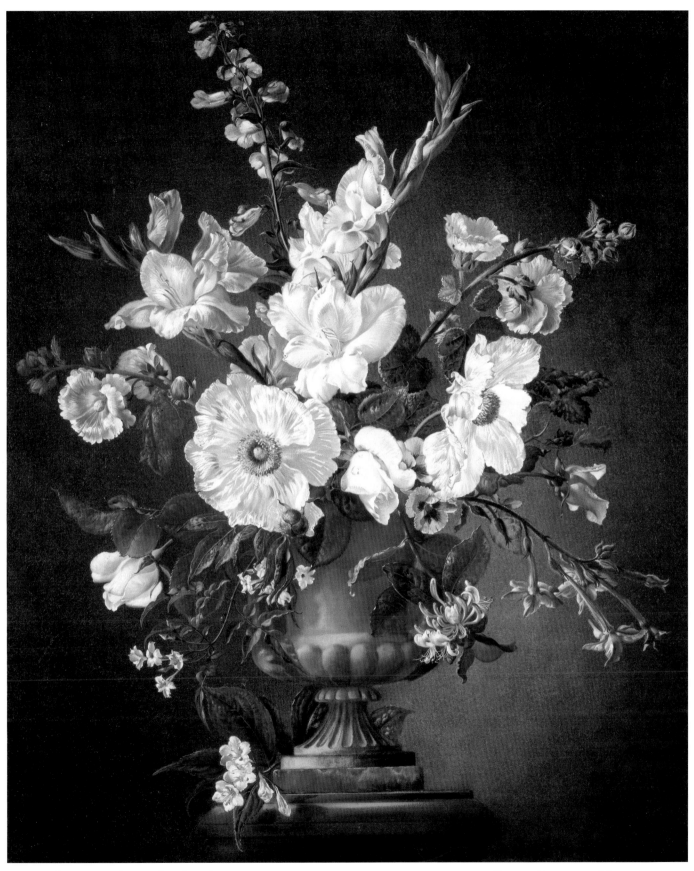

Colour Plate 56. Cecil Kennedy. White Flowers in a Stone Urn.

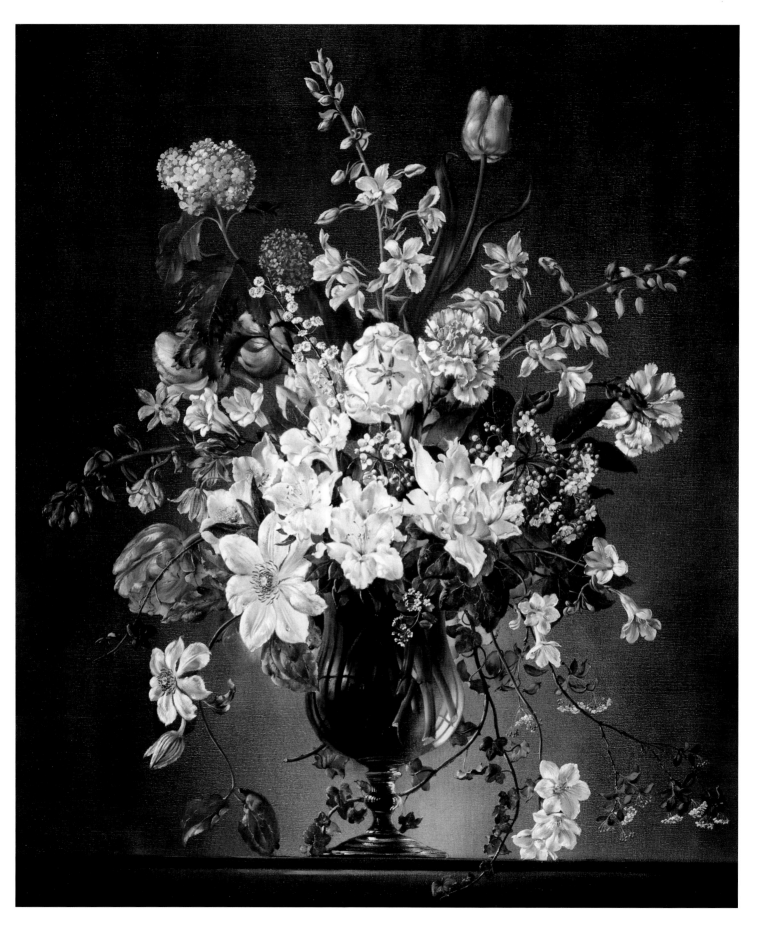

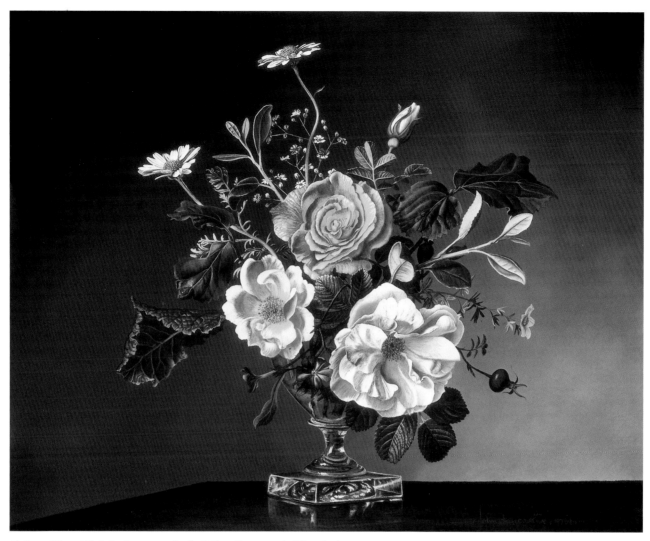

Colour Plate 58. John Lancaster. Speks Yellow Rose etc. in Waterford.

quite equalled the immediate post Lanzarote poppies, painted while the impact, the awe and mystery of that instant vision still cast its extraordinary spell. It was through these poppies that I came really to know Kenneth Webb – if it is not presumptuous to believe that this is even possible!

Another very original artist who has painted many subjects but whose flower paintings, to me, are quite outstanding is Elizabeth Blackadder, R.S.A., R.A., R.S.W., R.G.I., D.B.E.

Elizabeth Blackadder was born in Falkirk in 1931 and attended Edinburgh University and College of Art. She was awarded a Carnegie Scholarship to work in Yugoslavia,

Colour Plate 57. Cecil Kennedy. Late Spring.

Greece and Italy where later she made a study of Quatticocento. In 1956 she married the painter, John Houston, and started teaching at Edinburgh College of Art; she was, at the same time, exhibiting in important exhibitions internationally, usually exhibitions in a modern idiom.

It was when she was well established in her career that she was overtaken by an urge to paint flowers. She had painted them from time to time over the years but paid more attention to landscape, still life, figures and buildings. In 1963 she and her husband acquired a house with a bit of garden and started growing plants they loved, for instance lilies, in pots, which seem to have been the initial inspiration for her study of flowers. She made numerous black and white sketches of these lilies, the very best way of absorbing the detail and habit of any species. Later they moved to a house with a large sheltered

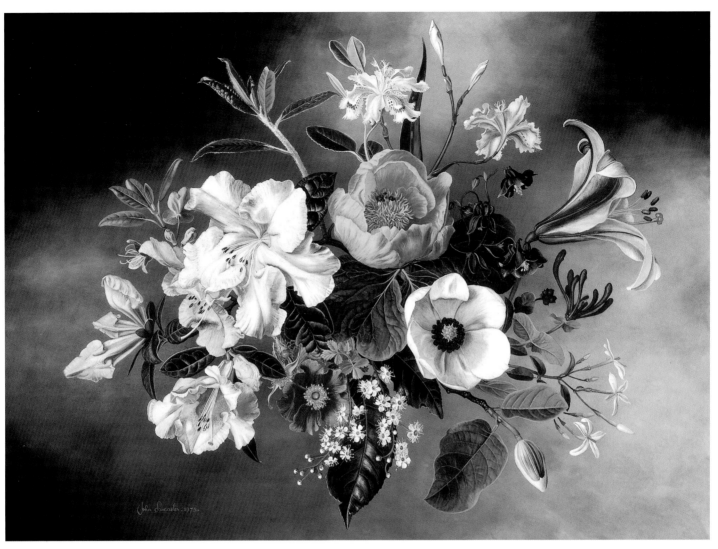

Colour Plate 59. John Lancaster. Yellow Rose off centre, Christmas Roses and Clematis.

garden where they could grow all Elizabeth's favourite flowers – lilies, tulips and, most of all, irises.

Working in watercolour Elizabeth Blackadder developed a very individual, very personal, and wholly delightful style. She studied the work of such masters as Ehret and the Bauer brothers and closely scrutinised individual blooms. She would pick a single flower that appealed to her and watch it in a specimen glass until it seemed to be telling her it was ready to be painted. When the moment arrived, the carefully studied bloom was equally carefully transposed to paper, beautifully 'free' but absolutely accurate. She would repeat this process with other blooms, not necessarily the same species, on separate sheets of paper, then, when a companion

or companions presented themselves, add to the collection on their particular page.

One's first reaction is to see these studies as a random collection on a page reminiscent of Alexander Marshal but, as one goes on looking, the point of the arrangement becomes apparent and it is seen as a well thought-out composition. From then on a complete fascination sets in and one can look, look and look….

The thought and care that goes into these watercolours becomes clearer every time one sees them and the greater is the temptation to stare and stare, marvelling at the extraordinary completeness and careful structure of each flower and the unique relationship of one to the other. Her repertoire is deliberately

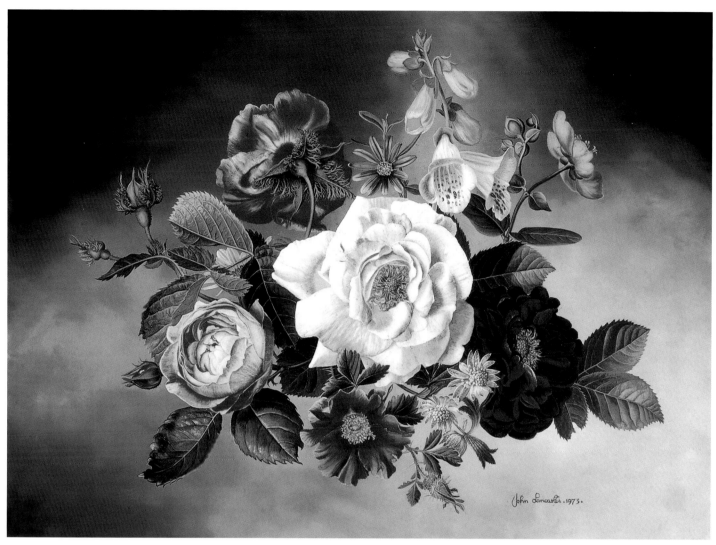

Colour Plate 60. John Lancaster. White Rose centre, three pink roses and one crimson.

limited to her favourite flowers – lilies, tulips, poppies, orchids – all of which have an intangible something in common, sometimes wild flowers but, most of all, irises.

Elizabeth Blackadder seems almost obsessed with the iris. but why not? Is there any other species with such an amazing variety of colour, shape and texture? Although not in her class, I can vouch for the fact that they are an absolute joy to paint; just to look at them, gently feel their magic texture, is an experience in itself. Elizabeth Blackadder must have painted hundreds and hundreds of irises of every possible shade and colour but there is such an infinite variety, being added to all the time, that it will no doubt go on and on.

I understand that over recent years she has recorded in a little

sketch book every type of plant grown in her garden – what a wonderful record for the future. At the same time, flowers have not taken over completely although, for the purposes of this book and in my own humble opinion, they constitute the most important facet of her broadly based work. They creep in indirectly too – in her still life studies of orchids in pots and her *Still life with Objects* series which are frequently Oriental in feeling and sometimes contain a flower head or two.

Elizabeth Blackadder is the first woman ever to become an Academician of both the R.A. and the R.S.A. and no one is more deserving. She was awarded the O.B.E. in 1982. In February 2001 she was appointed 'Painter Laureate' by Her Majesty the Queen, the first woman in the three hundred year old post of H.M.

Painter and Limner in Scotland to hold that office. She was created a Dame of the British Empire in 2003.

I can think of no one more suitable than Raymond Booth to bridge the gap between those artists whose flower painting is an important, even the most important, facet of their work and those whose reputations rest on Flower Painting per se. One of the finest painters of the century, he is one of the most modest and unassuming, but long years spent running an art gallery, even meeting and talking to many artists in the compilation of this book, have convinced me that modesty is frequently an attribute of the most talented painters – and the nicest people. Only a Raymond Booth would answer my leading question – 'Not a lot to tell, of any importance anyway'. Others tell a different story.

Born in 1929, Raymond Booth, who studied at Leeds College of Art 1946-48 and 1950-52 (the break was for National Service), qualified as a teacher, hated it, and decided to make his career as an artist. He is very much a plantsman painter, his small Yorkshire garden being a virtual laboratory for

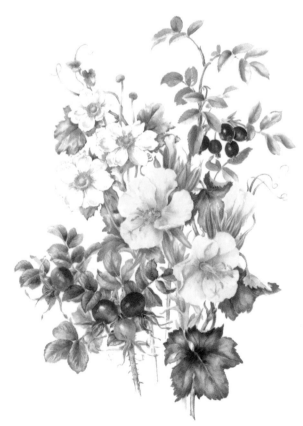

Colour Plate 61. Anne Abraham, Autumn Flowers.

rare and exotic species including orchid seedlings of endangered species from Kew. He knows all his plants as individuals and his array of frames and DIY greenhouses make his garden a working environment rather than a showpiece. In the winter months Booth frequently works in his garden at night thanks to a portable spotlight so that he can reserve precious daylight for his painting. He is a very private person; his agent, Peyton Skipwith of the Fine Art Society, maintains that '…Booth's genius rests in the intimate relationship that exists between himself and his subject, sowing, hoeing, digging, pruning and watering are as important to his understanding of a plant as the evidence of his eyes'.

The reason I put Booth on the edge of my in-between category is that he shares his flower painting with splendid studies of wildlife – hares, owls, badgers and small birds – which are frequently introduced into his flower paintings. Wild flowers, shrubs and foliage in their natural settings invite the inclusion of the little creatures that inhabit such an environment (Colour Plates 51 and 52).

These 'natural' paintings are magical. The absolute perfection of the rendering, which, in some hands, could seem technically polished but contrived and dead, are teaming with life and interest and seem literally to transport the onlooker straight into the subject. One can look at an immaculately and accurately constructed woodland corner with primroses, wood anemones, celandines and bursting bracken overhung by a spring flowering shrub on which an appropriate bird sings happily and actually *be* there – a superb combination of freedom and absolute truth. He paints individual specimens, too, singly or in groups, in which he delights, feeling that he is really getting to know a plant when it has had such detailed and close scrutiny. Maybe that is why they have such a feeling of humanity; there is only a thin dividing line between good portraits of plants and people.

Raymond Booth frequently paints in oils and the strong images produced make excellent illustrations. He provided some beautiful plates for Urquhart's *The Camellia* and, although he has never been to Japan, with Paul Jones grew most of the plants for his *Japonica Magnifica* (text by Don Elick who lives in Japan) published in 1992. He has had two major exhibitions at the Fine Art Gallery and his paintings have been included in mixed and group exhibitions all over the world. His work features in a number of important collections including the Hunt Institute, the Ulster Museum, Belfast, the R.H.S. and the Shirley Sherwood Collection. Publicity appears to mean little

Colour Plate 62. Albert Williams. Spring Flowers.

Colour Plate 64. Anne Cotterill. Sweet Peas in a Jug.

to him, though – he lives very quietly, growing, tending and painting his plants with additional subject matter in the lovely Yorkshire countryside all round him.

★ ★ ★ ★ ★

Colour Plate 63. Anne Cotterill. Lilies of the Valley.

I come now to the 'real' flower painters, the twentieth century artistic descendants of the seventeenth century Flemish and Dutch masters with their riotous bouquets and profusions of glorious flowers. The formidable reputations of these painters, whatever else they may paint and for whatever reason, rest almost solely on their flower paintings for few people think of them in any other connection. Again there

Colour Plate 66. Bennett Oates. Flowerpiece.

are many (see Dictionary) but I shall again select just an important, internationally known few who create an interesting parallel to the famous early flower painters of the Netherlands.

Colour Plate 65. Bennett Oates. Flowerpiece.

Three of the most firmly established names were brought together by the Richard Green Gallery in 1997 in an exhibition which was an absolute feast of delight for lovers of flowers and flower paintings – Harold Clayton, 1896-1979, Gerald Cooper, 1898-1975, and Cecil Kennedy, 1905-1997. These three painters seemed the natural successors of the

Stannard ladies, particularly Eloise Harriet whose work, compositionally at least, was closer to the Dutch. Just as the work of the Elders Brueghel and Bosschaert was taken further if not superseded by their sons, as time has gone on a more modern idiom within the traditional can be perceived and always there has been the continued introduction of new subjects by the plant breeders and through travellers bringing home their spoils.

Admittedly Harold Clayton appeared most to enjoy painting the old-fashioned flowers, particularly summer flowers, roses, honeysuckle, tobacco plants and delphiniums, although going right back to the seventeenth and eighteenth centuries some of his subjects would still have been unknown. His paintings are quite immaculate, sometimes almost too 'arranged' in elegant vases, and his colour is cleverly used. Given some of his chosen combinations, only a talent like his could save them from looking, perhaps, a little too brash (Colour Plates 53 and 54).

Harold Clayton was born in London and studied at Hackney, Harrow, Hornsey and St Martin's Schools of Art, mainly under Norman James. He exhibited at the R.A. in earlier years but, like many of the more traditional painters, gave up in later years.

Most of his painting was done in Hampstead and in Suffolk where he painted some landscapes. He was also a highly skilled etcher which seems not to be generally known, his flower painting having overridden everything else. In 1965 he decided for some reason to move to Cyprus where he stayed until the invasion by the Turks in 1974. He was rescued by a Royal Naval helicopter from the beach at Kyrenia with a rolled-up canvas under his arm, the only possession he was able to preserve. Returning after the armistice he found his old home looted and devastated beyond hope of restoration.

In this country he exhibited primarily in London and in certain prestigious galleries in the provinces such as Stacy-Marks in Eastbourne. Understandably, commissioned work kept him pretty fully occupied. In later life he settled in a three hundred year old farmhouse in Devon, in one of the most beautiful parts of the country ideal for growing the flowers he loved and enjoyed painting. His work has frequently been reproduced as Fine Art prints and greetings cards including some very fine limited editions, and is in important collections all over the world.

His contemporary, Gerald Cooper, an even more talented painter, has been said by many critics to be the finest flower painter of his generation (Colour Plate 55). More than

Clayton, whose actual technique was relatively modern, he empathised with the old master flower painters; his arrangements were more complex, his colour more subtle and his detail, up to anyone's botanical standard, showed penetrating observation without becoming obsessive. There is something intensely satisfying about Cooper's work, one can feel enriched by simply looking.

Gerald Cooper was also born in London and during the First World War served with the Observer Corps flying barrage balloons; later he joined the Royal Flying Corps. It was only after the war ended that he started a career in painting, studying first at the West Bromwich School of Art and later at the R.C.A. In the early days he painted landscapes which most people have forgotten; probably having lived in London for most of his life, he was tempted on country holidays by rustic subjects and rural landscapes. He took up a position at Wimbledon School of Art in 1924 and became Principal from 1930-1964 when Wimbledon had about 2,000 students.

Cooper exhibited at the R.A. for thirty years, at the N.E.A.C., N.S. and most of the major provincial galleries. He was an associate of the R.C.A., a Member of the National Society of Painters and a Member of the National Committee on Art Education as well as being for some time a Ministry of Education Examiner of Drawing and Painting. Yet, in spite of all this. he managed to produce many of this country's most significant flower paintings. I have met several artists who were at Wimbledon in Cooper's time and all speak highly of him and the quality of teaching and general efficiency that marked his time as Principal. I will come later to the one of his pupils who is now probably the greatest living British flower painter.

Cecil Kennedy was another fascinating flower painter who owed a great deal to his wife for her equally fascinating flower arrangements. Like all good flower arrangers, she made use of grasses, wild flowers, foliage and hedgerow plants, hops for instance and sprigs of blackberries, even decorative weeds. This enabled Kennedy to bring modern arrangements into the traditional idiom with striking results creating for him a distinctive style of his own (Colour Plates 56 and 57). I am particularly fond of his studies of all white flowers which are extremely sophisticated and incredibly beautiful. To me they represent the pinnacle of his skill. He also had an extensive botanical knowledge which enabled him to portray his flowers from both a botanical and decorative aspect, coupled with the aforementioned interesting arrangements.

Colour Plate 67. Stuart Somerville. Summer Splendour.

Colour Plate 68. Isobel Bartholomew. Summer Flowers.

Kennedy was born in London into a family of painters – his grandfather, father and four uncles were artists so there were no problems of parental antipathy. He studied in London, Paris, Zürich and Antwerp where he was undoubtedly influenced by the Dutch masters, particularly the flower painters. He was exhibiting from the age of twenty-four at the R.A., R.S.A., R.H.A. and the Paris Salon where he was awarded a Silver Medal in 1956 and a Gold in 1970. He also exhibited with the Fine Art Society for twenty years and his work is in numerous important collections including those of Queen Mary, the Duke of Windsor and the Astors. Sadly he was forced to give up painting in the

1980s because of failing eyesight, perhaps the saddest thing that can happen to a painter.

At the risk of being totally wrong from the artists' point of view, it is interesting to try and identify a parentage between these artists and their Flemish or Dutch predecessors.

Some of the more elaborate arrangements of Kennedy's are reminiscent of the bouquets of Jan Brueghel de Velours albeit less *overcrowded* and more 'natural' in the modern sense. Along with the inevitable Crown Imperials, irises, paeonies

Colour Plate 69. Lynne Broberg. Hellebores.

104

Colour Plate 71. Evangeline Dickson. Spring Flowers.

and, of course, tulips, Brueghel would add little wild flowers, corn, sprigs of berry fruits, even some imaginary flowers or, if not imaginary, now obsolete. Some of the less crammed arrangements, fewer flowers in elegant vases, have greater affinity with Clayton, not least in the daring use of colour, and there is also something of Clayton in the more classic

Colour Plate 70. Claire Dalby. Charity Rose.

work of Jan Philips van Thielen, Jan Brueghel the Younger and Jacob Marrel.

Although of the three Gerald Cooper's style is more in tune with the early painters generally and his actual compositions less 'modern', it is hard to find him a specific parent. Certainly Jan van Huysum is there in good measure; one can also recognise Simon Verelst and, especially in their leaves, Willem van Aelst and Elias van der Broëck.

I have yet to mention John Lancaster but here we have an

Colour Plate 72. Elizabeth Dowle. Auricula 'Walton Heath'.

Colour Plate 73. Elizabeth Dowle. Auricula 'Butterwick'.

obvious descendant of Daniel Seghers especially in the sprays of flowers making up the garlands used by Seghers round his favourite cartouches. Trophy of Flowers in the Musée Royaux des Beaux Arts, Brussels, is almost an earlier version of the lovely sprays of flowers appearing on Lancaster's paintings reproduced by Royle Publications a few years ago as a set of four fine art prints. In both cases the flowers are almost floating in the air without meaningful arrangement as though both artists painted them simply because they were there and had to be recorded immediately to preserve their indescribable beauty for ever.

John Henry Lancaster, 1913-1984, for an artist with a traditional approach, led an unconventional early life with no formal art training. He was born into a military family in India and sent to school in England, to Marlborough, from 1927-31. His talent for drawing won him a school prize but his father was against his son attempting to make a living in the world of art, not an uncommon attitude at that time. Instead John spent eighteen dreary months in a City office then, deciding that such a career was not for him, went out to seek a new life in Kenya. From there he moved on to Hong Kong where he joined the Hong Kong Police. In 1938, as the war clouds began to gather, he joined the R.A.F.

His was an eventful war. Serving in the Middle East, Greece and Europe, he flew a number of important people and accomplished many important missions thereby gaining the Air Force Cross in 1943 and the Greek D.F.C. For two years after the war he piloted Prince Aly Khan, then the Maharaja of Jaipur, until India became independent. He had married an Australian girl during the war and, back in this country, they sent a jointly painted flower painting to the R.A. which not only sold but brought in such a wealth of commissions that there was no going back.

John Lancaster's first real home in England (his parents were still in India) was a derelict cottage in Hertfordshire bought in 1951 and renovated as time went on and where, to quote his widow, he 'grew roses round the door and flowers to paint'. His Australian wife had returned to her native country and, in 1956, he married his second wife, Swiss born Rösli, who still lives in the cottage.

John Lancaster was a very private person who, as an artist, courted no publicity. He rarely exhibited; his pictures sold from home simply by word of mouth as more and more people saw and admired them in the homes of friends. Many more people became familiar with his work through reproduction on greetings cards and prints but, even with the highest quality printing, these cannot convey the unique and very personal quality of the originals. I remember well in the early 1960s being completely captivated by the first one I had seen. The ease of selling from his own home and the artist's naturally unassuming and self-effacing personality meant that all too few people have been accorded the privilege of seeing his work (Colour Plates 58-60).

One of the best known contemporary traditional flower painters is Albert Williams, 1913-c.1990, whose work has featured so prominently on greetings cards, prints and calendars (Colour Plate 62). Even in small scale reproduction his work stands out and the superb quality of some of the limited edition prints brings them closer to the original work than is possible with some styles of painting.

Albert Williams was born and spent most of his life in Hove, Sussex. He trained initially under his father and grandfather, both professional artists, then at Brighton School of Art and later in London and Paris before taking up flower painting and portraiture, so often regarded as complementary. His faultless draughtsmanship provided a firm foundation for all that he did and his perfectionist painting technique is renowned, as is his style and the sophistication of his floral arrangements.

Albert Williams always admired the seventeenth century Dutch artists and their influence shows in his painting. The sumptuous bouquets, the finely balanced arrangements and the perfectionist detail are all shared attributes yet, in a way paradoxically, Williams' work in most cases feels as contemporary as it is – in spite of the inevitable dewdrop. Whether it is the introduction of more modern flowers, new, sometimes synthetic, colours or, simply, the artist's own personality would be hard to say. Whatever it is, the popularity of his work, whether in reproduction or original form, is well established and the only possible criticism would be that, sometimes, it is almost too perfect to be true.

Albert Williams exhibited in all the main London venues – R.A., R.W.S., R.O.I., R.B.A. – the more exclusive provincial galleries and the Paris Salon as well as continuously working to commission. His work was for many years on permanent show at Harrods art gallery and can be found in many private collections as well as public collections in the U.S.A., South Africa and Italy.

Colour Plate 74. Loveday Gabriel. Flowers in Blue.

Anne Cotterill, born 1934 and still working very hard, is, even though it sounds rather a contradiction in terms, a more modern traditionalist. Although she uses her paint in the manner of many of the Dutch painters, her arrangements are those one might see in almost any home where someone has a garden and a love of flowers. There are none of the flamboyant arrangements of flowers of all seasons painted over a long period, none of the carefully crafted efforts that owe much to the Flower Clubs, but although she sometimes mixes two or three varieties in a bunch she concentrates largely on a single species resting informally in one of her

profusion in her own garden provide plenty of subjects and she admits to serious withdrawal symptoms ('I get really ratty!') if she has to go a day without painting. Always she paints from living subjects in natural light, which shows clearly in her work; light and texture are extremely important to her and she uses both to give her work wonderful life and vitality. A detailed understanding of botany enables her to dispense with any underlying drawing or preliminary sketching. Working in oils on board, she goes straight into painting her subject; the flower detail is built up on a plain, unencroaching background using brushwork alone. Her feeling for the flowers themselves comes

Colour Plate 75. Lawrence Greenwood. *Crocus baytopiorum.*

large selection of containers from brassware and silver to simple jam jars. This very informality has its own special attraction and gives her work a spontaneity that suits her lively and enthusiastic personality (Colour Plates 63 and 64).

Born on the Scottish borders and trained at Edinburgh School of Art, Anne Cotterill moved to Somerset on marriage in the early 1960s. The wild flowers of the local countryside and the

over strongly and gives each painting a presence of its own created by her complete involvement with its creation.

As well as selling privately she exhibits regularly in Somerset, Suffolk, Hampshire and London, her exhibitions

Colour Plate 76. Lawrence Greenwood. *Paraquilegia grandiflora.*

112

Colour Plate 77. Julie Harris. Flowers in a Basket.

never failing to attract queues of expectant buyers and always selling out before all have been satisfied. She and her daughter run a highly successful publishing company specialising in faithful reproductions of her work as limited edition prints and fine art greetings cards.

Despite my admiration for all these artists and others, there

Colour Plate 78. Julia Heseltine. Bouquet of Flowers. Julia Heseltine is the daughter of Anna Zinkeisen (see pages 84-87) who inherited her mother's talent as a portrait painter – amongst flowers and other things.

are two who for me represent all that is the very best in contemporary flower painting. Superficially similar, perhaps, yet in many ways very different, they share a pinnacle which, to my mind, raises them way above any other contemporary (British) exponents of the genre.

Bennett Oates was born in London in 1928 and attended Wimbledon School of Art under Gerald Cooper and later the Royal College. of Art. It was Cooper's flower painting that inspired his interest in the subject and made him decide the way in which he wanted to paint. Almost his first real flower painting

Colour Plate 79. Margaret Hems. Study in Blue and Pink.

was accepted for the R.A. when he was only sixteen and quickly sold. He told me how he crossed London in the tube seven times to go and gloat privately over the red 'sold' spot.

I have met other artists who studied at Wimbledon under Cooper and all speak highly of him, his understanding and the inspiration and enthusiasm he engendered in his pupils. Oates

established a strong bond with his tutor and a real affection for him as something of a father figure. His parents, like my own and many others of the period, were not in favour of their son

Colour Plate 80. Bridgette James. Willow Warbler and Flag Irises.

116

Bridgette James

Mary Elliot Lacey

Colour Plate 80. Mary Elliott Lacey. Flower Studies.

Colour Plate 81. Mary Elliott Lacey. Flower Studies.

120

following a career as an artist, perhaps visualising the imaginary painter half starving in his cold garret while he struggled to earn a crust. To Bennett's eternal gratitude Cooper persuaded them to relent. When father and son went to see Cooper and discuss the future, Oates senior started to raise the conventional objections. Cooper brushed them aside. Artists are involved in everything, he maintained; picking up a toothbrush which lay on his desk still on its promotional packing card – 'An artist designed even that', he pointed out, adding that as well as painting pictures artists were designing all sorts of things, many making an excellent income.

While still pursuing his more pictorial flower painting in such spare time as he had, Bennett Oates initially went into textile design. Not only was he able to indulge his passion for portraying flowers – floral textiles are perennially popular – but he gained experience of working in a disciplined but creative activity which could provide him with a solid financial base from which to branch out on his own.

Oates once said that Gerald Cooper was the finest living flower painter which, at the time, may well have been true. Today I know I am not alone in maintaining that the same thing can now be said of Bennett Oates who has built up a world-wide reputation for his magnificent flower studies in which he goes well beyond Cooper (Colour Plates 65 and 66). He shares with Cooper the impeccable drawing, the botanical accuracy, the absolute truth of colour and the well-judged tonal values, but it is his magical use of light and his ability not only to see into the shadowy recesses of his dark backgrounds but to enable others to do the same, that turns his flowers from paintings into living, breathing creatures. Flowers are never still, as anyone knows who has tried to paint them, but to put this quality into a painting is something that defeats so many otherwise excellent flower painters. Looking at Bennett Oates' creations it is easy to forget they are simply judiciously used paint and to see them as real, living flowers. Yes, the influence of Cooper is there as well as that of some of the sixteenth and seventeenth Flemish and Dutch artists, but the essence, the spirit and the magic of the work is pure Bennett Oates.

He paints landscapes too. Flower painting of such quality is exacting and relatively slow and, as he says, a change can be beneficial and the less demanding work keeps the pot

Colour Plate 82. James Lester. Study in Blue.

Colour Plate 83. E. Beryl Moore. *Papaver Somniferum.*

boiling. This does not alter the fact that he is above all a flower painter, a flower painter *par excellence,* and he must know it. As well as painting to commission he exhibits widely, the most regular venues nowadays being London, Stacy-Marks of Eastbourne and the Westcliffe Gallery, Sheringham, with the Guild of Norwich Painters, founded by him in 1978. His own home is also in Norfolk, a former hunting lodge on the old Boleyn estate set in twelve acres of woodland and pasture and and shared with his art historian wife and his Bernese mountain dogs. He exhibited at the R.A. for many years after his initial success until, as he says, and with the agreement of a number of others, "fashions changed and they didn't want to know about flower painting." His faithful international following still do, likewise the general art buying public not affected by the whims of fashion or the gimmickry of modern so-called art. Fashion in

Colour Plate 84. Olga Blandford Lewis. Summer Bouquet.

art as in everything else has a finite existence – tradition goes on and on….

I have equally strong feelings for the work of only one other contemporary painter, sadly no longer with us. Stuart Somerville (1908-1983) was a remarkable man – painter, philosopher, poet – whose flower paintings were to my mind, and have been similarly acclaimed by many critics, unequalled in British (flower) painting. Only Bennett Oates comes anywhere near his quality or shares his incomparable vision but Oates would have been very young in Somerville's heyday. These two alone could bear out the maxim that the twentieth century has spawned the cream of British flower painting even without the many other excellent painters I have already mentioned.

Stuart Somerville was born in Yorkshire, son of the Scottish landscape painter Charles Somerville, who was his tutor and adviser. He first exhibited at the R.A. in 1925 when he was only seventeen, the youngest R.A. exhibitor since Landseer in 1815. Before World War II he had a studio in Chelsea and held his first one-man show at the Claridge Gallery in 1930. He showed a mixture of drawings, paintings and watercolours, all displaying a natural talent and skill, superb draughtsmanship and a poetic imagination. Even then his flower paintings stood out. In his foreword to the exhibition catalogue Hugh Stokes commented that here Somerville proved 'most completely his degree of craftsmanship'. He went on to comment that it is 'as difficult to write about flower paintings as it is about the flowers themselves' and that 'words are at best a clumsy method of expression', a sentiment I wholeheartedly endorse. This book has taught me just how difficult it is!

Stern critic as he was, Stokes goes on to praise the feeling for colour, the intangible use of light, the craftsmanship and the sheer beauty. Remembering that Somerville was only twenty-two at the time, he continued, 'Stuart Somerville is uninfluenced by the fashionable idols of the moment. Quietly and modestly, unattached to school or clique, he is developing on lines more classical than modern. He will go forward, and he will make good'. Over the next forty years his prophesy was certainly fulfilled (Frontispiece and Colour Plate 67).

This exhibition was followed by others in London and Paris until the outbreak of war while in 1934/5 he went with the British Museum Expedition to the mountains of East Africa as expedition artist, many of the subjects having subsequently been reproduced in Patrick Synge's book, *Mountains of the Moon*.

During his time in London, he met his charming wife,

Colour Plate 85. Suzanne Lucas. Dahlia Hybrid.

Catherine, who at that time was studying ballet dancing. In spite of a considerable age difference, they always seemed a couple made for each other and, later, with their six children, made a delightful family. Just after the war their great friend, Cosmo Clark, R.A., drew Stuart's attention to a fascinating but almost derelict medieval hall in Suffolk saying what a wonderful home it could make if sympathetically restored to a habitable condition. Visiting it, the Somervilles were irresistibly tempted – the rats, the leaks, the fungus and moss mattered little; poor but

young and strong, they worked incredibly hard to make it habitable, Stuart painting when he could to help finances. Catherine is a born homemaker and visiting Newbourne Hall as I have done many times is like being welcomed in a friendly warm embrace. The garden, of course, provided Stuart's subjects, mainly established country garden flowers.

Again the difficulty of describing flower paintings rears its head. Somerville's flowers always really lived; one can see them, feel them, smell them but, above all, one can sense and share his love for them. 'To paint flowers well', he once said to me, 'you have to love them and be in love with them – then you can do anything with them'. I remember a lady commenting on a painting he had done for her with her own flowers, 'How beautiful you have made them look'. 'No', he replied, 'God made the flowers beautiful, I have only shown you how to look at them'. It is one thing to have this vision but to be able so to share it is also a wonderful gift of God.

Watching his handling of paint, too, was quite a revelation; a multi-coloured pudding would reach its canvas in perfect shape, its shades and tonal values ready made and with the appropriate texture. Apart from with Frost & Reed in Bond Street, once established in Suffolk Somerville rarely exhibited outside East Anglia where he supported local galleries and principally the festivals at Aldeburgh, Hintlesham and King's Lynn. Like John Lancaster, word of mouth was his best advertising and he also took a few favoured pupils as time allowed. His obituary stated with truth that 'he avoided the limelight and was not attached to any schools, movements or societies'. He abandoned the R.A. when it appeared to be scorning tradition.

Colour Plate 87. Sheila Mannes-Abbott. *Iris trojana.*

Colour Plate 86. Eileen Maddison. *Cyclamen rohlfsianum.*

As a philosopher he could fascinate an empathetic listener by the combination within him of incurable romanticism and sound common sense. If Catherine or any of his family or closest friends went to him with a problem which was causing stress, he would listen attentively, then, taking its points one by one, would ask, 'Well, what can you do about it?' Invariably the answer would be, 'Nothing. That's just it'. 'Then don't worry about it', would be the likely reply, 'No point in worrying about something you can do nothing about'. Dame Margot Fonteyn famously attributed her ability to go on dancing more beautifully than most of her juniors to never allowing her mind to be cluttered with irrelevancies – a philosophy shared by this dedicated painter. Such ability to focus is a talent in itself vouchsafed to only a favoured few.

Colour Plate 88. Audrey Meadowcroft. Morning Dew.

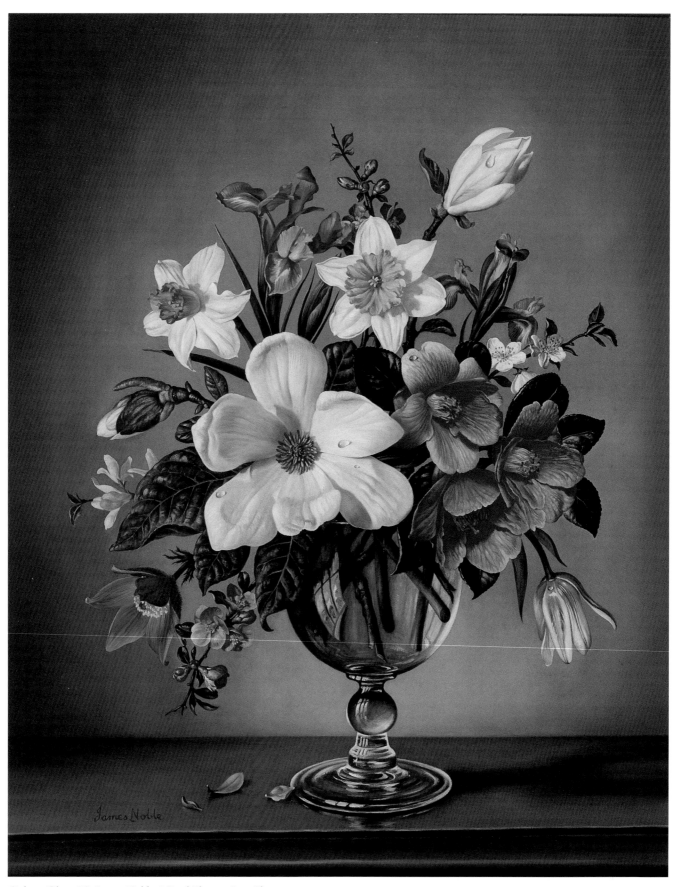

Colour Plate 89. James Noble. Mixed Flowers in a Glass.

Colour Plate 90. Shirley Anne Nunn. Botanical Tablet. Watercolour (34in. x 42in.) Commissioned by the Royal Pharmaceutical Society as a memorial to the eminent pharmacist Harry Burlinson, an international authority on tabletting (see page 200).

CourtESY OF THE ROYAL PHARMACEUTICAL SOCIETY OF GREAT BRITAIN

Colour Plate 91. Linda Patterson. Garden Study.

I make no apology for rhapsodising about the best of British flower painters; after all no one who does not love flowers and flower paintings is ever likely even to glance at this book. At the dawn of a new millennium it is interesting to speculate on the future of the genre, but one thing I would be willing to wager – its popularity is unlikely to wane. It never has; reproductions of the seventeenth century masters are still in favour when most other subjects are changing with the wind and, for my own part, in twenty-five years of running an art gallery, a period covering two major recessions during which picture sales almost died, a good flower study would always sell. In the years ahead love of flowers and flower paintings will still endure long after the piles of bricks, sheep pickled in formaldehyde and unmade beds have been forgotten.

Colour Plate 92. Margaret Ryder. Miniature painting.

Colour Plate 93. Margaret Ryder. Miniature painting.

129

Colour Plate 94. Rosanna Sanders. Burgundy.

Colour Plate 95. Sarah Anne Schofield. *Gentiana sino ornata.*

Colour Plate 96. Una B. Shanks. Purple Iris and Blue Poppies.

Colour Plate 97. Edna D. Stewart. 'Texas Gold' Parrot Tulip.

Edna Stewart

133

Colour Plate 99. Gillian Whitaker. Yellow Roses.

Colour Plate 98. Rosaleen Wain. Marsh Marigold (*Caltha palustris*).

Colour Plate 100. Valerie Wright. Double Paeony.

Colour Plate 101. John Wilkinson. *Meconopsis.*

Colour Plate 102. Anna Zinkeisen.
One of a pair of floral panels.

138

Colour Plate 103. Anna Zinkeisen.
One of a pair of floral panels.

DICTIONARY OF BRITISH FLOWER PAINTERS

(Born between 1650 and 1950)
(where '20th century' appears as an artist's date,
eligibility has been checked confidentially as the artist has not wished to disclose a date of birth)

(★ illustrated)

★ABRAHAM, Anne **20th century**
Cambridge artist and founder member of the Society of Botanical Artists. Shows her work at the Royal Horticultural Society, exhibits annually at Westminster Central Hall and galleries in East Anglia; also has solo exhibitions every two years.

Anne Abraham teaches flower painting at Cambridge University Botanic Garden and botanical illustration at Flatford Mill Field Studies Centre at East Bergholt. She is largely self taught and has attended regular botanical workshops for a number of years.
Colour Plate 61

ABRAHAM, Lilian **fl.1880 - 1886**
London artist, exhibited flower paintings at R.I., R.S.A. Generally worked in watercolour.
lit: Brinsley Burbidge, Desmond

ABRAHAM, Anne. Bearded irises.

ABRAHAM, Mrs R. **fl.1814 - 1832**
British painter of whom little is known but who exhibited some flower paintings at the R.A. and S.S., suggesting a reasonable standard.
lit: Brinsley Burbidge, Grant

ADAM, Robert Moyes **1885 - 1967**
Born Carluke, Scotland. A gardener in the Royal Botanic Gardens, Edinburgh, but when his talent for botanical painting was recognised he was promoted to Official Photographer and Artist. Became artist to the Botanical Society of Edinburgh and contributed to *Curtis's Botanical Magazine*.
lit: Blunt, Brinsley Burbidge, Desmond, Stearn

ADAMS, Elinor Proby, S.G.A. **d.1945**
Born Sudbury, Suffolk, but lived in Kent for many years. Gained both Slade and British Institute Scholarships and exhibited widely in the provinces and abroad as well as the R.A., R.I., and N.E.A.C. in London. Painted flowers as well as a wide range of other subjects.
lit: Brinsley Burbidge

ADAMS, Francis Mathilde **1784 - 1863**
Accomplished flower painter who exhibited flower paintings at the R.A. between 1806 and 1832. Became a court flower painter to Queen Adelaide.
lit: Brinsley Burbidge, Desmond

ADAMSON, Miss **fl.1845 - 1869**
Lived in London. Exhibited flower paintings and still life at the R.A. and R.B.A. between 1845 and 1858.
lit: Brinsley Burbidge, Desmond

ADIE, Edith Helena, R.W.S. fl.1890 - 1930
Studied at South Kensington Art School, Westminster Art School and the Slade and exhibited at the R.A., R.I. and R.B.A. Painted views of gardens. Lived primarily in Kent but spent some time teaching and painting in Italy.
lit: Desmond, Waters

AFFLECK, William
 1869 - early 20th century
Painted flowers as well as landscapes. Exhibited flower paintings at the R.A., R.B.A., N.W.C.S. and S.S. Studied at South Kensington, Heatherley's and Lambeth School of Art. Lived in London.
lit: Brinsley Burbidge, Desmond, Waters

AINSLEE, Miss **fl.1820 - 1835**
Amateur painter but exhibited frequently at the R.A. and became an Honorary Member. Painted mainly flowers but some still life; also murals.
lit: Brinsley Burbidge, Desmond

AIRY, Anna. Reflections.

★AIRY, Anna, R.I., R.O.I., R.E., R.P., P.S.
 1882 - 1962
Born London, granddaughter of the Astronomer Royal, Sir George Biddell Airy. Lived in Playford, Suffolk, for much of her life. Worked in both oil and watercolour and was also a competent pastellist. Trained at the Slade under Tonks, Steer and Russell 1899-1903. Won Slade Scholarship 1902, Melville Nettleship Prize 1900, 1901 and 1902 and other awards and became prominent in many artistic institutions. Painted a variety of subjects, especially portraits, animals and flowers; flowers were particularly important to indicate her exceptional feeling for colour and texture. Many regard her flower paintings as the cream of her work. In 1995 'The Flower Shop' sold at Bonhams for £57,000 and, I understand, has since changed hands for a considerably higher figure. She exhibited at the R.A. for fifty years, also the R.I., Paris Salon and in Montreal, Milan, Ottawa, Pittsburgh, Rome, Toronto and in many U.K. venues. An important retrospective exhibition of her work was held in Christchurch Mansion, Ipswich, in 1985. Her work is represented in the British Museum, the V. and A., the Royal Collection, the Imperial War Museum and in public collections in Liverpool, Ipswich,

ALEXANDER, Edwin. Bee and clover.

Blackpool, Leicester, Newport, Rochdale, Lincoln, Auckland, Sydney, and Vancouver. Author of *Making a Start in Art* and *The Art of Pastel*.
lit: Brinsley Burbidge, Desmond, Ipswich Museums Service, Waters

ALCOCK, Beatrice **fl.1880s**
Known to have exhibited flower paintings in the Manchester Academy of Fine Art.
lit: Brinsley Burbidge

ALDRIDGE, John Arthur, B.A., R.A. 1905 –
Painted a variety of subjects including a number of important floral and still-life works. Assisted at the Slade from 1949. Painted mainly in oils but also worked extensively in book illustration, wallpaper and textile designs. Exhibited widely, member of the R.A., work represented in the V. and A., Contemporary Art Society, Arts Council, British Council and in Leeds, Manchester and Northampton.
lit: Brinsley Burbidge, Waters

★ALEXANDER, Edwin, R.S.A., R.W.S., R.S.W. **1870 – 1926**
Born in Edinburgh and encouraged to paint by his father, Robert Alexander, R.S.A. Trained at Edinburgh Royal Institute and in France under Fremiet. As well as flowers he painted animals and birds, tending towards a Japanese influence. Exhibited R.A., R.W.S., R.S.W., R.S.A. Work represented in public collections in Edinburgh, Glasgow, Preston, and the Tate Gallery, London.
lit: Brinsley Burbidge, Waters

ALEXANDER, Herbert **1857 –**
Born Brighton and studied at the Slade under Miss Herkomers. Painted flowers working mainly in Florence.
lit: Brinsley Burbidge

ALGIE, Jessie **fl.1920s**
Scottish painter of flowers in oils. Lived in Argyllshire, exhibited in Glasgow Institute. Work represented in Glasgow Art Gallery.
lit: Waters

ALLEN, Eliza (née Stevens) **c.1842 –**
Botanical artist who illustrated C.A. Johns' *Flowers of the Field,* 1853.
lit: Desmond

ALLEN, J. Jessie **fl.1881 – 1886**
London artist who exhibited flower paintings R.B.A. and F.P.S.
lit: Brinsley Burbidge, Desmond

ALLEN, Marion **20th century**
Studied life and plant drawing at Ipswich School of Art and trained in London as an illustrator. She turned to painting in oils but became more interested in watercolour under the influence of Cor Visor; her flower studies in the medium were exhibited widely in East Anglia showing a true feeling for the subject.

 She was a founder member of the Orwell Art Club in 1947 and for many years a member of the Ipswich Art Society.
lit: Ipswich Museums Service

ALLEN, Robert **1744 – 1835**
Born and lived in Lowestoft, Suffolk, where he worked in the china factory and later opened his own shop. Decorated china for Wedgwood, Turner and other wares as well as Lowestoft. Also painted flowers in the conventional manner.
lit: Brinsley Burbidge, Desmond, Waters

ALLINGHAM, Helen, R.W.S. 1848 – 1926
Born Derbyshire, later lived in Cheshire. Generally thought of as a rather sentimental

ANDREWS, Carole. Sunflowers.

ANDREWS, Carole. Summer flowers.

painter of cottages and village scenes but the sunny cottage gardens with their riots of flowers warrant her inclusion here, also her painting of Gertrude Jekyll's garden at Munstead Wood. The two were near neighbours.

Helen Allingham trained at Birmingham School of Art and Design and the R.A. Schools. Through her marriage to the Irish poet William Allingham she met Ruskin and became one of his much admired lady artists. She worked primarily in watercolour and exhibited almost exclusively at the O.W.C.S.
lit: Brown, Waters, Wood

ALMA-TADEMA, Anna
fl.1885 - 1903 (d.1943)
Daughter of the great Sir Lawrence Alma-Tadema who painted flowers and exhibited at the R.A. from 1885.
lit: Brinsley Burbidge, Desmond, Waters, Wood

ANDERSON Fay 1931 –
Fay Anderson lives in Cape Town and is well known as an illustrator of indigenous South African plants. She has supplied illustrations for such important works as J.P. Rourke's monograph *Proteas of South Africa,* 1988, and Goldblatt's *The Moraeas of South Africa,* 1986, and his *Genus Watsonia,* 1989.
lit: Blunt and Stearn

ANDERSON, John fl.1827 - 1839
Painter of flowers and landscapes. Exhibited R.A. and S.S.
lit: Brinsley Burbidge

ANDREWS, Arthur Henry, A.R.C.A. 1906 –
Born Birmingham, also lived in London and Dorset. Studied at Hornsey School of Art 1923-26 and the Royal College of Art 1926-30. Head of Batley School of Art 1933-47, then Principal of Poole College. Painted mainly flowers but also landscape and portraits. Exhibited R.A. and had a one-man show at Foyles Art Gallery.
lit: Brinsley Burbidge, Scott-James, Desmond and Wood, Waters

★ANDREWS, Carole, S.B.A., F.P.H.
20th century
Carole Andrews started to study at her local art school at the age of thirteen, later moving to the College of Liberal Arts in Surrey where she studied still life and landscape in oil and pastel. More recently she has been studying her development of watercolour, finding this the most sensitive medium with which to reflect her great love and feeling for flowers. The technique she uses is pure watercolour, glazing one transparent colour over another to create a three-dimensional image of unusual strength.

Many of her flower paintings have been reproduced by Ling Cards, Acorn Cards, Buckingham Fine Art Unlimited Prints and on a W.H. Smith calendar published by A.J. Lockwood. A prestigious commission was from Compton and Woodhouse to depict the story of old roses for the Royal National Rose Society in the Queen Mother's garden at the Garden of the Rose, St Albans. These paintings were initially reproduced on Coalport China as a limited

ANDREWS, F. Jennifer. Hellebores.

ANDREWS, F. Jennifer. Passion flower.

edition collectors' item. Since then Compton and Woodhouse have published six fine art limited edition prints of the Old Roses. Each work was painted from life and Carole's unique talent has enabled her to convey the essence and character of each rose in a manner that is not only botanically correct but aesthetically beautiful.

Carole also teaches flower painting within formal adult education and in small groups in her own home. She was elected to the S.B.A. in 1988 and exhibits regularly with the Society at the Mall Galleries and Central Hall, Westminster. She has also exhibited at many venues including the Turner Art Gallery, Denver, U.S.A., the Guildhall, London, Alexandra Palace and Sofiero Castle, Helsingborg, Sweden.

In 1995 she won the Founder President's Honour of the S.B.A. against 700 entries, the silver gilt personal medal being presented by the Founder President Suzanne Lucas.

ANDREWS, Dorothy Eileen, A.R.C.A. 1897 –
Born West Bridgford, Nottingham, later lived in Essex. Painter of flowers in oil and watercolour. Studied at Nottingham School of Art 1916-21 and at the Royal College of Art under Rothenstein. Exhibited R.A., R.O.I., S.M.A., N.S. and in the provinces.
lit: Waters

ANDREWS, Edith Alice fl.1920 - 1945
Born in London. Painter of gardens and flowers and book illustrator. Studied at Goldsmiths' College and exhibited R.A., R.I., S.W.A. and the Paris Salon.
lit: Waters

★ANDREWS, F. Jennifer, Des. R.C.A. 1933 –
Jennifer Andrews spent her early years in Oxford before moving to East Anglia. Trained at Oxford

School of Art 1954-56 and the Royal College of Art under Arnold Machin, R.A. She was awarded the Pottery Manufacturer's Prize for Flower Drawing; later she attended courses on botanical illustration at Flatford Mill under John Nash, R.A., who became her greatest influence. Each year she joins the Botanical Illustration Workshop at Flatford where she runs her own courses and is responsible for the garden outside the Mill and Willy Lott's House. She also teaches at Belstead House, Ipswich, Snape Maltings and Marlborough Summer School and writes for *Leisure Painter Magazine.*

Jennifer Andrews has exhibited at the R.A., Mall Galleries, Scottish Arts Council and the Hunt Institute. She has had one-woman shows in Sudbury, Colchester, Essex, and Keele University and holds a bi-annual exhibition at her home near Ipswich. She paints in a highly individual style of colour wash with ink drawing which achieves a distinctive and attractive combination of decorative effect and botanical accuracy. She has also painted designs for Sandersons wallpaper, social stationery and china. (See page 84.)
lit: Brinsley Burbidge, Ipswich Museums Service
Colour Plates 45 and 46

★ANDREWS, Henry C. fl.1794 - 1830
Little is known of Andrews' early life; his work consists primarily of hand coloured etchings of floral and plant subjects. Best known for his *Coloured Engravings of Heaths,* 1802-1830, in four volumes containing nearly 300 engravings on which he worked for twenty-eight years, and his *Heathery,* 1804-1812, in six octavo volumes. While these, some of the finest representations of heathers, are, to quote Blunt, 'noble in conception and impressive in execution', his work on other plant species seems comparatively pedestrian. He produced two volumes illustrating

ANDREWS, Henry C. *Erica princeps.*

geraniums and another, *Roses,* in which the flowers are rather over stylised and brash. He started publishing the *Botanist's Repository* in 1797. He lived mainly in Knightsbridge, London.
lit: Blunt and Stearn, Rix, Stearn

ANDREWS, James 1806 – 1876
Illustrator of 'sentimental' flower books, e.g. *Flora's Gems,* c.1839, and *The Parterre,* 1841. Blunt reports that the one surviving work suggests he

ARSCOTT, Jan. Poinsettia and holly.

was very talented. He also published *Lessons in Flower Painting,* 1825.
lit: Blunt and Stearn, Brinsley Burbidge

ANGEL, Marie Felicity, A.R.C.A. 1923 –
Lived in Woking Surrey. Botanical artist working in watercolour, also calligrapher. Watercolours of flowers in many private collections, also the Hunt Institute. Work reproduced in *A Bestiary,* 1964, and *A New Bestiary,* 1968.
lit: Brinsley Burbidge

ANGELL, Ethel Elizabeth fl. from c.1920
Painted in oil, watercolour and pastel, flowers and landscape. Studied at Nuneaton Art School. Exhibited R.A., R.O.I., R.B.A., S.S.A. and the provinces.
lit: Waters

ANGELL, Helen C., A.R.W.S. 1847 – 1884
Born Horsham. Painted flowers and birds mainly in watercolour, also some ceramic decoration at Minton, South Kensington. Flower painting is rather in the style of W.H. Hunt. Exhibited watercolours of flowers at the R.A., O.W.C.S., N.W.C.S., S.S., Dudley Gallery and the Institute of Painters in Watercolour. She became Flower Painter in Ordinary to Queen Adelaide. Work occasionally appears at Sotheby's. Died Kingston.
lit: Brinsley Burbidge, Clayton, Desmond, Roget, Wood

ANGELL, Maude fl.1888 – 1916
Born Hendon, London, and lived mainly in London. Painted flowers and exhibited R.A., R.I., O.W.C.S. and S.S.
lit: Brinsley Burbidge, Desmond, Wood

ANGELL, Mrs Thomas fl.1870s
Drawings of azaleas in the V. and A.
lit: Brinsley Burbidge, Desmond

ANKHORN, J. fl.1860s
London painter of still life and flowers. Exhibited R.A., B.I. and S.B.A.
lit: Brinsley Burbidge, Desmond

ANSON, Minnie Walters, R.M.S. 1875 –
Born London, later lived in Dorset for many years. Studied at Lambeth School of Art. Painted miniature portraits and flowers; won several medals for flower painting. Exhibited at the R.A., R.M.S., in the provinces and abroad.
lit: Desmond, Waters

ANTROBUS, A. Lizzie fl.1880s
Warwickshire flower painter, exhibited S.B.A. 1882.
lit: Brinsley Burbidge, Desmond

APPLEBY, Eileen M., S.F.P. 1932 –
Eileen Appleby discovered her talent for flower painting on retirement but made rapid strides and was made a full member of the S.F.P. in 1996. She works in watercolour.

ARMFIELD, Maxwell Ashby, R.W.S.
** 1882 – 1972**
Studied at Birmingham School of Art and in Paris and Italy. Painted flowers in all media, especially tempera; also landscapes and figures. Many flower paintings have been used as book illustrations. Exhibited R.A., N.E.A.C. and internationally; work is in many public collections.
lit: Brinsley Burbidge, Waters

ARMOUR, Hazel (Mrs John Kennedy)
** fl.1914 – 1940**
Studied at Edinburgh School of Art and in Paris where she trained as a sculptress always, at the same time, painting flowers.
lit: Harris and Halsby

ARMOUR, Mary Nicol Neill, R.S.W., R.S.A. 1902 –
Scottish flower painter in oil and watercolour, some landscapes, also taught at Glasgow School of Art where she herself trained under Forrester Wilson, R.S.A. and Maurice Greiffenhagen, R.A. Exhibited at the R.A., R.S.A., S.S.A. and other venues. Work in permanent collection Glasgow Municipal Gallery and in Greenock, Paisley and Victoria, Australia.
lit: Brinsley Burbidge, Waters

ARMSTEAD, Charlotte (Lottie)
** fl.1880s and 1890s**
Born St John's Wood, London. Both she and her sister exhibited flower paintings at the R.A.
lit: Brinsley Burbidge, Desmond

ARMSTRONG, Thomas c.1832 – 1911
Flower painter of London and Manchester who studied in Paris and lived abroad for many years. Also painted some landscapes and exhibited R.A., B.I. and G.G., London.
lit: Brinsley Burbidge, Desmond, Waters, Wood

***ARSCOTT, Jan, S.F.P.** **20th century**
The Second World War interrupted Jan Arscott's plans to train as an architect and she was drafted into war work. After her marriage and bringing up a family she started painting seriously in 1970, specialising in flower painting and, later, botanical illustration. She works in watercolour and also paints on china. She has exhibited in London, Hong Kong, Sweden and Jersey.

ASHFORD, William **1746 – 1824**
Born Birmingham, painted flowers, fruit and some landscapes. Settled in Dublin and became President of the Irish Society of Artists, Royal Hibernian Academy.
lit: Brinsley Burbidge, Desmond

ASHTON, Miss E. **fl.1830s and 1840s**
London flower painter who exhibited R.A. 1839 and 1840.
lit: Brinsley Burbidge, Desmond

ASTON, Lilias **fl.1860s**
Birmingham artist known to have exhibited flower paintings at several venues.
lit: Brinsley Burbidge, Desmond

ATKINSON, Gerald **1893 – 1971**
Studied at Hull School of Art and became artist and photographer at Kew from 1922-59. Contributed drawings to Hooker's *Icones Plantarum.*
lit: Blunt and Stearn

ATLEE, Della **fl.1886 – 1897**
London flower painter, exhibited flower paintings at the R.A. and other venues.
lit: Brinsley Burbidge

ATWOOD, Clare, N.E.A.C., N.S.
 fl.1886 – 1962
Born Richmond, painted flowers and decorative subjects, usually in oils. Trained at Westminster School of Art and the Slade under Tonks. Also war artist for the Canadian government in World War I. Work is in the Imperial War Museum and the New Zealand National Gallery. Exhibited flower paintings at the N.E.A.C. from 1893, Member from 1912.
lit: Brinsley Burbidge, Waters

ATWOOD, Thomas **fl.1761 – 1764**
Flower painter who exhibited regularly with the Society of Artists. lit: Brinsley Burbidge, Grant

AUSTIN, Emily **fl.1870s and 1880s**
Exhibited flower paintings at the R.A. and other venues.
lit: Brinsley Burbidge, Desmond

AYLING, Albert William **fl.1840 – 1905**
Flower painter who exhibited at the R.A., S.A. and N.G.
lit: Brinsley Burbidge, Desmond

AYRE, Miss Minnie **fl.1880s**
London artist who exhibited flower paintings S.B.A. and N.W.C.S. lit: Brinsley Burbidge, Desmond

AYRTON, William **fl.1880s (d.1920)**
Lived in London but studied in Paris; painted and engraved flowers. Exhibited at the R.A. and Paris Salon.
lit: Brinsley Burbidge

BADCOCK, Miss Leigh fl.1880s and 1890s
Flower painter of Norwood, London. Exhibited R.B.A. and N.W.C.S.
lit: Desmond

BAINES, Anthony **1912 – 1996**
Anthony Baines made his name in music rather than the visual arts and is well known in serious musical circles as a collector, performer and historian of antique instruments. His many musical achievements are outside the province of this book but, during the time spent in Oxford from 1970, when he became curator of the Bate Collection of Historical Wind Instruments at the University, he developed a strong interest in wild flowers. He produced extremely competent notebooks of as many as he could find and, in later life, took up pastel painting which became a dominant interest.

***BAINES, Valerie, F.S.B.A., F.L.S., A.R.M.S.** **20th century**
Valerie Baines cannot remember a time when she was not drawing, painting and pursuing her interest in plants and the natural world. As a child she reared butterflies and kept an assortment of pets which often became her models. She trained at Harrow Art School followed by three years at the Royal School of Music although, on leaving, she worked as a designer for Sandersons making floral designs. After her marriage she continued as a freelance designer and illustrator. Her illustrations appear in the *Natural History of Butterflies,* 1986, *The Naturalist's Garden,* 1987, *The Story of Silk,* 1990, and *Meadows,* 1992, by John Feltwell, F.L.S., also his series of Natural History Books for Schools. She has also illustrated butterflies and plants for the Butterfly Conservation Society and designed a series of bookmarks, The Five Senses, for Yvoire, the theme being the recently restored Medieval Gardens there.

Valerie Baines in a Member of the Linnean Society, a Founder Member of the Society of Botanical Artists and an Associate Member of the R.M.S. She has exhibited at the R.A., R.M.S., R.B.A., the Alpine Gallery, Westminster Gallery, the Linnean Society, the R.H.S. exhibitions (Silver Medal 1986, Silver Gilt 1987), Bromley Library Gallery, London, Medici Gallery, London, Llewellyn Alexander Gallery, London, Museum of Garden History, London, Hampton Court Palace Flower Show, Gillingham Library Gallery, Kent, Francis Iles Gallery, Rochester, Minstrels Gallery, Bexley, the Memorial University, Newfoundland, Carnegie Mellon University Botanical Library, Pittsburgh, and Le Jardin de Cinq Sens, Yvoire. Her work has frequently been reproduced for prints, calendars, etc. and is in private collections in the U.K., U.S.A., India, South Africa, Canada and France.

BAINES, Valerie. Flowers and herbs from a medieval garden.

BAINES, Valerie. Rose 'Pierre de Ronsard'.

BAIRSTOW, Elizabeth. 'Treasure of Spring.'

BAIRSTOW, Elizabeth. 'Scented Romance.'

Museum, Dorchester. The major event of her life, however, has been the acquisition of Barton Meadows in 1989. This is an area of about 100 acres below Black Hill and adjacent to the village of Cerne Abbas; the central portion comprises watermeadows with the River Cerne meandering the entire length with fields on either side. The aim, now well under way, was to farm Barton Meadows in the traditional manner with restoration of hedgerows, planting of trees and returning the land to herb rich meadows with abundance of flowers and wildlife.

In 1992 Elizabeth gave up her gallery and society memberships to concentrate on this project and at the same time contribute to the environment through her painting. An artist can do so much to raise public awareness of the beauty of an environment and the need to preserve the flowers and wildlife of their natural habitat and Elizabeth works every day with this ideal in mind. A major exhibition at Barton Meadows was held in June 2000 not just, as she makes clear, for her work but as a tribute to the work that others have put into the creation of Barton Meadows.

Elizabeth Bairstow obviously feels that all this has dwarfed her many achievements in the world of painting but her work has been widely reproduced, perhaps most notably in an edition of twelve signed prints representing the natural flowers of the hedgerows and fields during each of 'The Twelve Months'. Each month has a very individual charm, is botanically accurate, beautifully composed and totally natural in colour and atmosphere.

BAKER, Annette (Mrs W.D. Gloag)
fl.1890 – 1899
London flower painter. Exhibited R.A., S.B.A. and other venues. lit: Brinsley Burbidge, Desmond

BAKER, Clarissa **fl.1885 – 1886**
Dolgelly flower painter who exhibited flower paintings at S.B.A.
lit: Brinsley Burbidge, Desmond

BAKER, John **1736 – 1771**
Founder Member of the Royal Academy in 1768 where he exhibited flowers painted in the Dutch manner. Formerly a heraldic painter of coachwork. Exhibited R.A. 1769-1771. (See page 27.)
lit: Brinsley Burbidge, Desmond, Grant, Mitchell

BALDWYN, Charles H.C. **fl.1887 – 1893**
Worcester painter of flowers in oil and watercolour, also still life. Exhibited R.A., S.B.A., N.W.C.S.
lit: Brinsley Burbidge, Desmond

BALE, Charles Thomas **fl.1868 – 1875**
London artist who painted mainly still life but flowers were frequently introduced in conjunction with grapes, peaches, dead birds, etc. Exhibited R.A. and S.B.A.
lit: Brinsley Burbidge, Desmond, Wood

BALE, Edwin, R.I., R.O.I. **1838 – 1923**
London painter, mainly of flowers but also genre and landscape. Studied at the Royal College of Art and in Florence. Member of N.W.C.S., also exhibited R.A., N.W.C.S., G.G. and other venues.
lit: Brinsley Burbidge, Grant, Waters

***BAIRSTOW, Elizabeth** **1938 –**
Elizabeth Bairstow is the granddaughter of the late Sir Edward Bairstow, composer, organist and choirmaster at York Minster. An inherited creative talent in her case is expressed in her sensitive watercolours of the indigenous flowers of the Dorset countryside. Her passionate love of this countryside and her staunch environmentalism shine through all her work. A former Member of the S.B.A. and the S.W.A. and owner of her own gallery for many years, Elizabeth Bairstow's work first came to prominence in a Tate Gallery exhibition, 'Summertime', in 1983 which was followed by a definitive exhibition at the County

BARLOW, Gillian. *Helleborus argutifolius*.

BANCROFT, Louisa Mary, A.R.C.A.
 fl.1920 - 1950
Painted flowers and miniatures, studied under J.C. Thompson. Exhibited R.Cam.A., elected Member in 1927, also Member of the Manchester Academy of Fine Art. Married another artist, Elias Bancroft.
lit: Brinsley Burbidge

BARKER, Samuel **d.1727**
Pupil of his cousin, John Vanderbelt. Painted flowers in the style of Monnoyer but with less success.
lit: Brinsley Burbidge, Grant

★BARLOW, Gillian Barbara, B.A., M.A., S.B.A. **1944 -**
From childhood Gillian Barlow's main interests have been nature and plant studies and flower painting has always been a strong interest. She trained in art at the Slade and graduated in History of Art from Sussex University. She turned to specialising in flower painting over all subjects in 1984 when living in New York where an interior decorator commissioned several sets of flower paintings for clients, mainly showy florists' blooms. She soon became more interested in wild flowers and studied botany and ecology to improve her knowledge of the plants. Botanical accuracy is very important to her, hence the need to be fully aware of the structure of the plants, but she also insists that visual beauty is equally important and her work shows that she has successfully achieved this desirable combination.

As well as private commissions Gillian Barlow has had solo exhibitions at the Hudson View Gallery, New York, Blond Fine Art, London, British Council Galleries, Bombay, Contemporary Arts Gallery, Ahmedabad, Vassar College Art Gallery, New York and Spink's, London. She has also exhibited at the R.A., London International Arts Fair, Edinburgh Festival International Art Fair, Tolly Cobbold National Painting Exhibition, Museum of American Illustration, Association of Illustrators, London, the Linnean Society, the Hunt Institute,

Society of Botanical Artists, the R.H.S. (Silver Gilt Medal 1991, Gold Medals 1994 and 1997), Everard Read Gallery Johannesburg, British Iris Society, Tryon and Swann, Reading University Department of Botany and Contemporary Botanical Artists, Shirley Sherwood Collection, Kew.

Her work has been reproduced in many books and periodicals including *The Garden of Flowers Address Book, Dictionary of British Art, 20th Century Painters and Sculptors* (Antique Collectors' Club, 1991), Hunt Institute Catalogue, *The Plantsman and The New Plantsman, Contemporary Botanical Artists,* Kew, *Garden of World Medicine* and *Curtis's Botanical Magazine.* She does work for the College of Arms and her work has been reproduced in *Heraldry,* 1993, and *The Art of Heraldry,* 1998.

Her work is in the collections of the British Council, Boscobel Restoration, New York, Vassar Collection, New York, and the Shirley Sherwood Collection. She is also represented in many private collections.
lit: Lester, Sherwood, Spalding

BARNARD, Catherine fl.1880s - 1922
Flower painter who exhibited R.A. and S.B.A.
lit: Desmond, Wood

BARNARD, Kate fl.1885 - 1888
Lived in Chertsey, Surrey, and painted flowers which she exhibited R.A. and N.W.C.S.
lit: Brinsley Burbidge, Desmond

BARNES, Marion L. fl.1890 - 1895
Lived mainly in London, painted and exhibited flowers R.A., S.S. and N.W.C.S.
lit: Brinsley Burbidge

BARNEY, Joseph 1751 - c.1829
Born Wolverhampton, lived in London from 1767 for twenty-seven years, then in Southampton. Trained under Zuachi and Kauffman and taught drawing at the Military Academy. Personal work mainly flowers and fruit and he was appointed flower painter to the Prince Regent in 1815.

Exhibited flower paintings and fruit at the R.A., S.B.A., O.W.C.S., B.I. Work is in the Broughton Collection, Fitzwilliam Museum, Cambridge.
lit: Brinsley Burbidge, Bryan, Desmond, Grant

BARNEY, W. fl.1815 - 1851
Son of Joseph Barney, who also painted flowers, and became fruit and flower painter to the Queen. Exhibited R.A. and S.S.
lit: Brinsley Burbidge, Grant

BARRAND, Allan F. fl.1873 - 1900
Watford artist who painted flowers and also landscape. Exhibited R.A. (forty-three works), S.B.A. and other venues.
lit: Brinsley Burbidge, Desmond

BARRETT, Jerry fl.1851 - 1883
Brighton artist who painted flowers and landscape. Exhibited flower paintings R.A., B.I., S.S. and other venues.
lit: Brinsley Burbidge

BARROW, Lady Anne Maria (née Trute)
 1777 - 1857
Born Cape but died in England. Her drawings of flowers of the Cape are probably the earliest to have survived. Lived in England from 1803.
lit: Brinsley Burbidge, Desmond

BARROW, Edith Isobel
 fl.1880s and 1890s (d. 1930)
Lived in Dulwich, London, and later in Devon. Studied at Goldsmiths' Institute and South Kensington. Painted flowers and exhibited flower paintings R.A., R.I., R.B.A., S.W.A., S.B.A., N.W.C.S.
lit: Brinsley Burbidge, Waters

★BARTHOLOMEW, Isobel, S.F.P. 1943 -
Although always a spare time painter, Isobel Bartholomew originally trained in the hotel and catering industry becoming a lecturer in catering subjects in technical colleges in England and abroad. It was when running a Hotel Trades School on the Caribbean Island of St Lucia that she was inspired by the lush exotica and brilliant colours of the tropical flora. Working in watercolour, she started to draw and paint indigenous plants.

On her return to England she went on a botanical illustration course with Margaret Merrit and has now, for some time, been painting full time and running a botanical illustration course of her own at Barnfield College, Luton. She has exhibited widely in this country and abroad including with the R.H.S., gaining Silver or Silver Gilt Medals in 1989, 1990, 1991, 1993, 1994, 1997 and 1999. In 1998 she showed thirty daffodil paintings at the Centennial Show of the Daffodil Society and in 1999 Dianthus paintings at the 50th birthday celebrations of the British National Carnation Society who have given her the honour of naming a pink after her.

BARTHOLOMEW, Isobel. Vuylstekeara Cambria 'Plush'.

BARTHOLOMEW, Valentine. China aster.

She has contributed illustrations to the R.H.S. *New Dictionary of Gardening* and her work is in the R.H.S. Lindley Library and the Shirley Sherwood collections.

lit: R.H.S., Sherwood
Colour Plate 68

★BARTHOLOMEW, Valentine, A.R.W.S.
1799 - 1897
Very successful flower painter born in Clerkenwell, London. Appointed flower painter to Queen Victoria and the Duke and Duchess of Kent. He married another flower painter, Anne Charlotte.

He illustrated *Delineations of Exotic Plants* cultivated in the Royal Gardens at Kew, 1796-1803, *Strelitzia depicta*, 1818, Lindley's *Illustrations of Orchidaceous Plants*, 1830-38, also contributed to *Curtis's Botanical Magazine*. He exhibited flower paintings R.A., S.B.A., O.W.C.S. and other venues. His work is in the V. and A. and R.H.S. collections.

lit: Blunt and Stearn, Brinsley Burbidge, Bryan, Desmond, Roget

BATES, Mary **1945 -**
A lifelong interest in botanical painting developed seriously when Mary Bates' children reached school age and she started making drawings of plants for the Royal Botanic Gardens, Edinburgh, where she now works full time as a botanist and illustrator. She also illustrates for many botanical books and journals and takes private commissions.

She has contributed to *Flora of Bhutan*, Grierson and Long, vol.1 parts 2 and 3, *A*

Revision of Dendrobium section Oxyglossum, Reeve and Webb, *The Plantsman*, *The Kew Magazine*, *Curtis's Botanical Magazine*, *The New Plantsman*, Cribb's *The Genus Cypripedium* and papers in *Notes from the Royal Botanic Gardens, Edinburgh*. Her work is in the Hunt Institute, and in 1993 she was awarded the Jill Smythies Prize for botanical illustration by the Linnean Society of London.

lit: Stearn

★BATH, Constance, S.F.P. **1925 -**
Constance Bath, known affectionately as 'Mig' or 'Miggy', is a natural painter, largely self taught. She has painted in oil, acrylic, gouache and watercolour but much prefers watercolour.

She was born in Bedford and educated at Dame Alice Harpur public school for girls. In 1970 she moved from Bedfordshire to Warsash living also for a time in 1971 in upstate New York where she exhibited in local art shows. In 1976 she was a national finalist in the *TV Times* painting competition which inspired her to start painting in earnest; this was helped by a period in Los Gatos, California, when she had ample spare time. She has also spent several years in Venice where she exhibited and sold flower paintings.

She is a Founder Member of the Society of Floral Painters, exhibits with the Society, at Exbury Gardens, the New Forest Show, Romsey Show, Catherington County Show, Central Hall, Westminster, Jermyn's House, Bell Street Gallery, Romsey, and in Sweden. She has had published a set of four limited edition flower studies and floral greeting cards.

BATH, Constance. 'Spring.'

BATH, Constance. 'Autumn golds'.

BATH, Constance. 'Winter.'

BAXTER, Thomas 1782 – 1821
Born Worcester, died London. Painter on porcelain for Worcester and Swansea china. Also painted traditional flower studies, established an Art School in London and exhibited R.A. Contributed to Curtis' *Beauties of Flora,* 1806-1820
lit: Brinsley Burbidge, Desmond

BAYES, Walter 1868 – 1956
Belonged to a well-known family of artists, son of painter and etcher, A.W. Bayes, brother of Gilbert Bayes, sculptor, and sister of Jessie, illuminator and designer. Studied at Westminster School of Art where he himself became Head from 1918-1934; later he became Director of Painting at Lancaster School of Art, 1944-1949.

Exhibited flower paintings in watercolour at the R.A. and Leger Galleries. His work is represented in the Tate Gallery, Imperial War Museum, Liverpool, Manchester, Oldham and Johannesburg.
lit: Brinsley Burbidge, Waters

BEACH, Alice fl.1890s – 1935
London flower painter, exhibited R.A. 1898-1935
lit: Desmond

BEAR, George Telfer 1874 –
Scottish artist born in Greenock who studied at Glasgow School of Art and painted flowers in oil and pastel. Exhibited R.S.A., G.I., R.Cam.A. and other venues in this country and abroad.
lit: Brinsley Burbidge, Waters

BEDFORD, John Bates fl.1848 – 1886
London artist who painted flowers and portraits. Exhibited forty-one flower paintings at the R.A., also showed at B.I., S.S. and other venues.
lit: Brinsley Burbidge

BEESLEY, Anne fl.1774 – 1783
Flower painter wife of the still-life artist Robert Beesley. Exhibited Free Society.
lit: Brinsley Burbidge

BEKENS, Annie fl.1920s
Watercolour painter and etcher of flowers, studied at the Royal College of Art. Lived in London and exhibited R.A., in the provinces and abroad.
lit: Brinsley Burbidge, Waters

BELL, Ada fl.1880 – 1903
London painter of flowers and landscape. Exhibited flower paintings R.A., S.S., N.W.C.S., G.G., N.G. and other venues.
lit: Brinsley Burbidge, Desmond, Waters, Wood

BELL, Lucy Hilda, R.M.S. fl.1885 – 1920
Miniature painter who specialised in floral subjects. Lived in London and exhibited R.A., R.I., R.B.A., R.M.S. and Walker Art Gallery, Liverpool
lit: Waters

★BELL, Nicola, S.F.P. 20th century
Nicola Bell has been painting since childhood although she had no formal art training. She specialises in botanical and flower painting; as a keen gardener she finds most of her subjects in

BELL, Nicola. Late autumn flowers.

BELL, Nicola. (left) January flowers.

her own large garden near Salisbury. She is a Founder Member of the Society of Floral Painters and also belongs to the Salisbury Group of Artists and the St Ives Society of Artists. She exhibits with all these societies and the Society of Botanical Artists, and has also exhibited at the Royal West of England Academy, Bristol, the Royal Horticultural Society, the Linnean Society, the Small Pictures Exhibition, Salisbury, the Chelsea Group of Artists, the Flower Gallery, Kings Road, the Wykeham Gallery, Stockbridge and in Sweden.

BELL, Vanessa 1879 – 1903
One of the famous Bloomsbury set, sister of Virginia Woolf. Trained as a painter under Sir Arthur Cope and the R.A. Schools. Mainly decorative work but painted some flowers, the best known being 'Chrysanthemums' in the Tate Gallery.
lit: Brinsley Burbidge, Waters

BELLAMY, A.S. fl.1860s and 1870s
London painter of flowers and fruit who exhibited R.A., S.B.A. 1868-74.
lit: Brinsley Burbidge, Desmond

BENHAM, Thomas C.S. fl.1878 – 1904
London born painter who also lived in Portsmouth and Suffolk and who included flowers among many other subjects. Exhibited R.A., N.W.C.S., G.G. and other venues.
lit: Brinsley Burbidge, Desmond, Waters, Wood

BENNETT, Eve Reid 20th century
Eve Reid Bennett graduated in design from Edinburgh College of Art, in art teaching from Moray House College of Education and in Vancouver, Canada, studied painting and printmaking. She has taught and exhibited both

in Scotland and in Canada where she lived for fifteen years and her work is in collections in Canada, Japan, the U.S.A., Australia, Greece (where she has spent many summers and found much of her subject matter) and the U.K. In 1985 she returned to Edinburgh and developed her interest in the botanical side of flower painting and instituted classes for adults at the R.B.G. where she taught for six years. She now works as a freelance artist based at the R.B.G. where she carries out commissions for botanists. She works in watercolour on paper and vellum and her work has been reproduced in the *New Plantsman*.
lit: Sherwood

BENNETT, Miss S.F. fl.c.1820 – 1830
Known from an album of watercolour paintings of flowers, insects and shells dated between 1822 and 1829 and bearing the bookplate of Miss Bennett.
lit: Waters

BENSON, Nellie fl.1879 – 1901
London painter of flowers and portraits who exhibited regularly at the R.A.
lit: Brinsley Burbidge

BENSTEAD, J. fl.1809 – 1813
London artist who exhibited many flower paintings R.A.
lit: Brinsley Burbidge

BERRY-BERRY, Francis fl.1883 – 1888
London artist who painted flowers and landscapes. Exhibited R.A., S.S., N.W.C.S., N.G. and other venues.
lit: Brinsley Burbidge

BICKNELL, Charles fl.1880 – 1890
Book illustrator of plants. Made drawings for

BINNS, Evelyn. Old roses.

BLACKADDER, Elizabeth. Poppies and black cat.

Flowering Plants and Ferns of the Riviera and Neighbouring Mountains and *Flowering Plants of the Riviera.*
lit: Brinsley Burbidge

BIDDLE, Winifred Percy, S.W.A. **1878 -**
Painter in oil and watercolour of flowers, gardens and portraits. Born Kingston-on-Thames, studied at Lambeth School of Art 1899-1910 and at Kingston Technical Institute. Elected A.S.W.A. in 1949 and S.W.A. in 1950. Later lived at East Molesey, Surrey. Exhibited R.A., R.I., N.S., S.W.A. and in the provinces.
lit: Waters

BIDDULPH, Edith **fl.1880s**
London flower painter, exhibited R.A. and N.W.C.S.
lit: Desmond

BILLINGSLEY, William **1758 - 1828**
Born Derby, died Shropshire. Apprenticed to Duesbury at Derby in 1774 where he worked until 1796 when he joined the Pinxton factory. He established potteries at Mansfield in 1800, Torksey in 1803, Nantgarw in 1813 and Coalport in 1820. He specialised in painting roses for which he became widely known.
lit: Brinsley Burbidge, Chaffers, Desmond, Murdoch, Mitchell

BINNS, Elizabeth **fl.1882 - 1893**
Worcester artist who exhibited flower paintings R.A. and S.B.A.
lit: Brinsley Burbidge, Desmond

★BINNS, Evelyn **1945 -**
Cornish artist Evelyn Binns now lives and works in

North Hertfordshire. The discipline she acquired working initially as a graphic designer has combined with a lifelong love of flowers and she works as a dedicated flower painter combining artistic quality with botanical accuracy. Her paintings are usually life size and painted from life with particular attention to exact colour and natural habit; her subjects range from wild plants of the hedgerow to more exotic hothouse specimens.

Her first solo exhibition was in 1994 at Mount Edgcumbe in Cornwall, home of the National Camellia Collection. She has also exhibited at numerous venues in the South-west of England, at Hampton Court Palace Flower Shows, the R.H.S. Exhibitions, Flora '96 and '98, the National Camellia Society Shows and Flowers and Gardens Exhibitions at Le Mur Vivant. She has three times been awarded R.H.S. Gold Medals and her watercolours are commissioned by collectors from all over the world.
lit: Lester

★BLACKADDER, Elizabeth, R.A., R.S.A., R.S.W., R.G.I., D.B.E. **1931 -**
Elizabeth Blackadder, the first woman to become an Academician of both the R.A. and R.S.A., was born in Falkirk and studied at Edinburgh University and Edinburgh College of Art (M.A. Hons. Fine Art). In 1954 she was awarded a Carnegie Travelling Scholarship and the Andrew Grant Post-Graduate Scholarship, in 1955 a Travelling Scholarship for nine months in Italy, and has since added many other awards. As well as Membership of the R.A., R.S.A., R.S.W. and R.G.I., she is an Honorary Member of the Royal West of England Academy, the R.W.S. and the Royal Society of Painters-Printmakers, an Honorary Doctor of Herriot Watt University, University of Edinburgh, University of Aberdeen

and the University of Strathclyde and an Honorary Fellow of the Royal Society of Edinburgh.

From 1962 to 1986 she was a lecturer in Drawing and Painting at Edinburgh College of Art and between 1959 and 1998 held fifty-one solo exhibitions, mainly in London and Scotland but also in Florence, Canada and New York and the more prestigious provincial galleries in the U.K. Over the same period she participated in nearly forty group shows including several exhibitions of flower paintings. Elizabeth Blackadder works in oil, watercolour and pastel and it would be hard to find a subject not included in her repertoire. At the same time many people, myself included, see her flower paintings in watercolour as being rather special. (See pages 93-96.) Her work is represented in over fifty important public collections in this country and abroad and in countless private collections. She was created a Dame of the British Empire on 14 June 2003.
lit: Macmillan, Sherwood

BLACKHAM, J. **fl.1860s and 1870s**
Birmingham flower painter. Exhibited R.A. 1868 and S.B.A. 1867-74.
lit: Brinsley Burbidge, Desmond

BLACKLOCK, Nellie **1889 -**
Born London. Painted flowers in watercolour and exhibited at the R.I. and in the provinces. Married the artist W.K. Blacklock.
lit: Waters

★BLACKMAN, Jacqui, S.F.P. **20th century**
Jacqui Blackman, who has lived most of her life in Lincolnshire, took a two year City and Guilds course after leaving school, leaving it to join the W.R.A.F. There she gained the equivalent of

BLACKMAN, Jacqui. White lily.

H.N.D. as a draughtswoman which led her later to the position of manager of the Drawing and Records Office of Soar Division, part of the Severn Trent Water Authority.

Painting has always been part of her life and she now teaches and runs workshops in the Midlands and North, also gives private tuition. She frequently demonstrates at the Artist and Illustrators Show, Patchings, the N.E.C. and at art shows and to art societies.

Her interest was fired at a very early age through her grandfather who started her off in watercolour, her main medium for many years. She

now works in watercolour, pastel, oil pastel, acrylic, oil and gouache. She has produced a video on *Flower Painting in Oil* and is a Member of the S.F.P. with whom she exhibits. Her work has also been shown at the Royal Birmingham Society of Artists, the Derby Open, the Leicester City Open and other venues in the Midlands and the South of England.

BLACKWELL, Elizabeth fl.1737 - 1774
Botanical artist who published *A Curious Herbal* with her own drawings and engravings to pay off the debts of her imprisoned husband who wrote the text. Competent in her way but only semi-professional. (See pages 37-40.)
lit: Blunt and Stearn, Brinsley Burbidge, de Bray, Desmond, Grant, Kramer
Colour Plate 13

★BLAKE, Elisabeth, S.F.P. 1946 -
Elisabeth Blake was born in Devon, the great granddaughter of Walter Hayward Young, the postcard artist known as 'Jotter'. Her father was in the R.A.F., which meant she attended several schools. As far as art training was concerned she was, after a Foundation Course at Luton College of Art, accepted for a three year Diploma course at Goldsmiths' College, London. Art work became rather sporadic after marriage in 1969 and bringing up her sons, but she is now painting seriously again. Her interest in flowers and gardening has led her to concentrate exclusively on painting flowers and gardens.

She works mainly in watercolour in a rather detailed style but also uses pastels and oils. She exhibits with the S.F.P. and participates in many local exhibitions. She also produces a range of greetings cards.

BLAMEY, Marjorie. Bluebell wood.

★BLAMEY, Marjorie 1918 -
Marjorie Blamey was born in Ceylon, the daughter of an English doctor, and came to England as a very young child. At the age of forty-eight, after a busy life married to a farmer, she renewed an early interest in flower painting. From a painting seen in a local exhibition interest in her work grew and grew and her 'hobby' turned into a professional career.

Wild flowers in their natural setting became her speciality and, with her husband retired from farming, she travelled widely seeking her subjects all over this country and overseas. She has worked regularly in the Herbarium at Kew, the only source of rare plants, and was honoured to be invited to mount an exhibition at the Royal Botanic Gardens in 1989.

She has now illustrated (and in some cases, with her husband, written) over thirty books on plants and provided 2,400 colour plates for Christopher Grey-Wilson's *The Illustrated Flora of Britain and Europe*. She has three times been awarded R.H.S. Gold Medals and the Gold Certificate of the Alpine Garden Society. (See pages 74-78.)
lit: Blamey, *Saga Magazine*
Colour Plates 41 and 42

BLAND, Beatrice Emily, N.E.A.C.
** 1864 - 1951**
Lived in London and Lincoln and trained at Lincoln School of Art and the Slade under Professor Tonks. Painted flowers and landscapes; one flower painting is in the Tate Gallery. Exhibited R.A. and N.E.A.C.
lit: Brinsley Burbidge, Waters

BLATHERWICK, Lily, R.S.W.
** fl.from 1877 (d.1934)**
Lived in Helensburgh and painted flowers. A collection of her paintings of orchids is in the V. and A. She exhibited R.A., R.I., N.W.C.S., G.G., N.G.
lit: Brinsley Burbidge, Waters

BLAKE, Elisabeth. Fuchsia.

BLAKE, Elisabeth. Poppies.

BOOTH, Araceli. A touch of spring.

BLIGH, Jabez fl.1860 - 1880
Lived in Worcester and Gravesend and painted flowers, fruit and fungi. Exhibited R.A., S.B.A., N.W.C.S.
lit: Wood

BLUNT, Wilfrid, A.R.C.A. 1901 - 1987
Studied at the Royal College of Art and became drawing master at Eton. Curator of Watts Gallery, Compton, from 1959. Author of *The Art of Botanical Illustration,* 1950. Work (watercolour) in the Hunt Institute.
lit: Brinsley Burbidge, Evans and Evans, Stearn

BOGDANY, Jakob 1660-1724
Although born in Hungary, Jakob Bogdany spent most of his life and died in London. As a painter of flowers and exotic birds he was employed as a court painter by William III.
lit: Jeremy Wood

BOLTON, James D. 1758 - 1799
Halifax botanist and talented botanical painter in watercolour; trained under Clowes. Produced and illustrated *An History of the British Proper Ferns and Filices Britanniae* (Leeds 1785) and *An History of the Fungusses growing about Halifax* (Huddersfield 1788-91). Work is in the British Museum.
lit: Blunt and Stearn, Brinsley Burbidge, Desmond, Grant, Rix

BOND, George c.1806 - 1892
Regular gardener/artist at Kew who produced many drawings, mainly of succulents, 1,700 of which are at Kew.
lit: Blunt and Stearn, Brinsley Burbidge, Mabey

BONNEAU, Florence Mary fl.1920s
Born in London and studied at Heatherley's, later lived at Walberswick in Suffolk. Painted mainly flowers and some landscapes. Exhibited R.A. and S.S.
lit: Waters

★BOOTH, Araceli, S.F.P. 1940 -
Araceli Booth lives in Hampshire and has exhibited her delightfully colourful flower paintings in many south of England galleries. Largely self taught, she works in watercolour and pastel in a free, almost impressionistic, style, being a lover of colour and light. She is a Member of the S.F.P. and has exhibited with the Society and also with the R.W.S., S.W.A., S.B.A. and at the Bankside Gallery. In 1993 she won second prize in the Bockingford Exhibition and in 1996 the Edwin Young Trust prize.

★BOOTH, Raymond 1929 -
Studied at Leeds College of Art 1946-48 and 1950-52, the break being for National Service, trained as a teacher but, hating it, soon decided to go it alone as an artist — a painter plantsman as he calls himself. He paints both botanical specimens and full pictures of growing plants in their natural settings, often with small animals and birds. He has

had two major exhibitions with the Fine Art Society and his work has been exhibited in mixed exhibitions all over the world. Illustrated works include *The Camellia,* Urquhart 1956 and 1962, and *Japonica Magnifica* (text by Don Elick), 1992, a florilegium of Japan with over seventy magnificent plates. At the time of his 1991 exhibition at the Fine Art Society he said he had enough work to keep him fully occupied for another forty years.
 Already he is represented in the Hunt Institute, the Fitzwilliam Museum, Cambridge, the Ulster Museum, Belfast, the R.H.S. and the Shirley Sherwood Collection as well as many private collections. (See pages 96-99.)
lit: Sherwood, Skipwith
Colour Plates 51 and 52

BOSWORTH, John fl.1828 - 1839
Painted flowers, fruit and landscape. Exhibited S.F.P., R.A., R.B.A.
lit: Brinsley Burbidge, Desmond

BOULTON, William Treacher
fl.1857 - 1881
London artist who painted flowers and landscapes and exhibited R.A. and S.S.
lit: Brinsley Burbidge

BOWDEN, Mary fl.1871 - 1890
London artist. Painter of flowers who exhibited R.A., S.S. and other venues.
lit: Brinsley Burbidge

BOOTH, Raymond.

BOWLES, Edward Augustus 1865 – 1954
Born Enfield, London. Painted flowers in watercolour and illustrated his own books – *My Garden in Spring,* 1914, *My Garden in Summer,* 1915, *My Garden in Autumn and Winter,* 1934, *A Handbook of Narcissus,* 1922, *A Handbook of Crocus and Colchicum for Gardens* and *Snowdrops and Snowflakes,* 1956, with Margaret Stones. He also contributed to the R.H.S. *Journal, Gardener's Chronicle, The Garden,* R.H.S. *Daffodil and Tulip Year Books.* His work now in the Hunt Institute includes Bouquet of Mixed Flowers and Hydrangea Macrophylla.
lit: Blunt, Brinsley Burbidge, Desmond, Rix

BOWLEY, Miss S. fl.1828 – 1834
London artist who painted flowers and exhibited S.S. and N.W.C.S. lit: Brinsley Burbidge

BOYD, Agnes S. fl.1860s to 1890s
Lived in Edinburgh, later Chelsea. Painted flowers, still life and some landscape.
lit: Harris and Halsby

★BRASIER, Jenny, F.S.B.A. 1936 –
Always interested in drawing and painting flowers and plants, Jenny Brasier, who lives in Cornwall, has been working professionally in this field for twenty years. Inspired by the late Wilfrid Blunt, she describes herself as self taught with long hours of solitary struggle, but I would add that there is considerable natural talent as the common denominator.

She exhibits regularly with the S.B.A. and R.H.S. and has been awarded four R.H.S. Gold Medals. She has also exhibited with the Hunt Institute, the Smithsonian Institute, Washington, the R.B.G., Kew, the V. and A., the Shirley Sherwood Collection, the Natural History Museum, Aberystwyth University, Camden Arts Centre, the Mall Galleries, the Westminster Gallery, the Hillier Gardens and Arboretum, Fairlynch Museum, Devon, and the Chapter House, Guildford Cathedral.

She has been Artist in Residence at Liverpool Museum, Nature in Art, Gloucester and the Natural History Museum, also taught at or lectured to Nature in Art, Gloucester, the Northern Society of Botanical Artists, the V. and A., Leicestershire Society of Botanical Illustrators, Dartington Hall, the Chelsea Physic Garden, the Gloucestershire Society for Botanical Illustration, the R.B.G., Kew, and in Rheda-Wiedenbruk, Germany.

Her work has been published in *Hosta, the Flowering Foliage Plant* (30 ills.), Grenfell, 1990, *R.H.S. Dictionary of Gardening,* 1992, *An Approach to Botanical Painting in Watercolour,* Evans and Evans, 1993, *The Art of Botanical Illustration,* Blunt and Stearn, 1994, *The Gardener's Guide to Growing Hostas,* Grenfell, 1996, The Shirley Sherwood Collection, 1996, and in the *Journal of Arboriculture,* the R.H.S. *Garden Magazines,* the *New Zealand Gardener* and *Watercolours, Drawings and Prints Magazine.*

At the time of writing she is working on an on-going series of plates depicting different forms of species cyclamen for the *Cyclamen Society Journal.* Her work is held in collections world wide.
lit: Blunt and Stearn, Grenfell, Evans and Evans, Sherwood

BRETT, Rosa fl.1858 – 1881
Painted flowers, fruit and foliage and some landscape, sister of John Brett, A.R.A. Always considered herself an amateur but her flower paintings could hold their own with many professionals. Exhibited R.A. 1858-1881. Most of her surviving work is in family collections.
lit: Brinsley Burbidge, Wood

BRIDGE, Elizabeth, R.I. 1912 – 1996
Elizabeth Bridge was born in Moreton-in-Marsh and gained a scholarship to Hornsey College of Art.

BRASIER, Jenny. *Cyclamen hederifolium.*

BROBERG, Lynne. Cheiranthus.

Her very beautiful, traditional but individual, flower paintings have been exhibited at the R.A., R.I., R.S.A., S.W.A. and the Paris Salon where she received Honourable Mention. She was elected a member of the R.I. in 1959, also R.O.I. Her work, mainly in oil, has been reproduced in particular by the Scottish greeting card company, Valentines of Dundee. A group of her works was included in a 1997 sale of Modern British Painters.

★BROBERG, Lynne, N.D.D., A.T.D.
20th century
Lynne Broberg was born and educated in Wales before moving with her family to Surrey and attending Wimbledon School of Art and, later, the Institute of Education, London University, which led to an early career teaching art. Many years later, following an inspirational visit to Munich, she returned to her own painting, specialising in botanical and floral subjects. Many of these she now publishes in her own business and distributes to galleries, interior designers and collectors in many parts of the world. Some of her more complex works take hundreds of hours to complete; as well as interesting designs she is fanatical about botanical accuracy. Originals and prints are exhibited in many countries in Europe, also Japan, the U.S.A. and Australia. Lynne Broberg is the holder of several R.H.S. Medals and has exhibited at seven Chelsea Flower Shows.

In winter when flowers are scarce she takes occasional breaks from flower painting to draw and paint animals in and around her husband's veterinary practice.
Colour Plate 69

BROOK, Caroline W. fl.1870s and 1880s
London flower painter, also painted landscapes. Exhibited R.A., S.F.P., S.B.A. and other venues.
lit: Desmond

BROOM, Marion. Irises and peonies in a glass vase.

BROOKSHAW, George early 19th century
Flower painter and illustrator, especially of his own books, *Every Lady her own Drawing Master*, 1801, and *A New Treatise on Flower Painting*, 1816. He had a free but botanically accurate style, usually painting growing flowers with muted colouring; he is reported to have disliked gaudy flowers. He maintained that some of his lady pupils became so good that he sometimes mistook their work for his own!

He also produced *Pomona Britannica*, 1812, and other rather splendid fruit books. There are 104 hand coloured engraved plates of his work in the Horticultural Repository.
lit: Blunt and Stearn, Brinsley Burbidge, Mabey, Sitwell

***BROOM, Marion fl.1920 - 1960**
Norfolk born painter in oil and watercolour, painted flowers, also some landscapes and interiors. Also studied at the Royal College of Music for four years and sang in opera. She exhibited R.A., R.I., R.O.I., R.Cam.A., R.W.A. Lived latterly in Buckinghamshire
lit: Waters

BROTHERSTON, Daphne, F.S.B.A. 1920 -
Always having loved drawing and painting, Daphne Brotherston started to take it seriously after her family left home and she started studying at Epsom A.E.C. She specialises in flower drawing with watercolour tint and botanical painting. She is a Founder Member of the S.B.A. with whom she exhibits regularly. She has also exhibited with the R.H.S. (Silver Gilt Medal), Hampton Court Flower Show, Fairfield Hall, Croydon, the S.G.F.A., Knapp Gallery and

other venues. Her work has been reproduced for greetings cards and her drawings of trees have been bought by the R.H.S. for the Lindley Collection.

BROWN, Alexander Kellock, A.R.S.A., R.S.W., R.I. 1849 - 1922
Born Edinburgh and studied at Glasgow School of Art and Heatherley's, also painted landscapes.

BROWN, Alison. *Helleborus niger.*

Exhibited flower paintings R.A., S.S., N.W.C.S., G.G., R.S.A. Most of his work is in Scotland.
lit: Brinsley Burbidge, Waters, Wood

***BROWN, Alison Forbes, S.F.P.**
** 20th century**
Alison Brown was born in Scotland but grew up in Kenya and Southern Rhodesia where she developed a strong interest in natural history. This in turn led to her interest in botanical art manifested in exquisitely detailed watercolours over pencil on acid free paper or vellum.

After Rhodesia and some years in full time work, she gave up work to take a Diploma in Botanical Painting with commendation for her project on Fuchsia species at the English School of Gardening at Chelsea Physic Garden. As an early member, she is active on the committee of the Chelsea Physic Garden Florilegium where she arranges programmes for meetings as well as other duties. Exhibition venues include the S.F.P.'s various exhibitions, the Chelsea Physic Garden, the R.H.S. where she has earned Silver Gilt and Gold Medals, the Hunt Institute, and Gallery 51 in Great Russell Street, London. She is currently (1999) undertaking part time Natural History Illustration at Booth's Natural History Museum through Brighton University.

BROWN, Helen fl.1883 - 1903
London artist who exhibited flower paintings R.A. and N.W.C.S.
lit: Brinsley Burbidge, Desmond

BROWN, Nathaniel fl.1705 - 1777
Listed by Grant as a flower painter but seems to have exhibited mainly portraits.
lit: Brinsley Burbidge, Grant

BROWN, Peter fl.1776 - 1791
Member of the Incorporated Society of Artists. Some authorities claim that he may have studied flower painting under Ehret but this is not substantiated. He became Court Botanical Painter to the Prince of Wales. Exhibited R.A. 1776-1791, also the Free Society and Society of Artists. Four of his paintings are in the Kew collection.
lit: Blunt and Stearn, Brinsley Burbidge, Desmond

BRUCE LOW, Mabel, R.B.A., S.W.A.
** 1883 - 1972**
Painted flowers in watercolour and some landscapes. Born Edinburgh and studied under Loudon and Sickert at Westminster Art School; also attended Edinburgh College of Art and the London Art School. Latterly lived in Bournemouth. Exhibited R.A., R.S.A., R.B.A., N.E.A.C. and other venues. Her flower paintings are in several public and private collections.
lit: Waters

BULLEID, Anna Eleanor (née Austin), A.R.W.A. 1872 -
Painted flowers and landscape in oil and watercolour. Lived in Somerset and exhibited R.I. and R.W.A. She became a Member of a Group of Australian Artists in Europe in 1925 but the connection with Australia is unclear.
lit: Waters

BURY, Priscilla. *Lophospermum scandens.*

BULLEID, George Lawrence, A.R.W.S.
1858 - 1933
Born in Glastonbury, died Bath. Painted flowers and exhibited R.A., O.W.C.S., N.W.C.S. and other venues. Work is in the collection of the Harris Museum and Art Gallery, Preston.
lit: Brinsley Burbidge, Desmond, Waters

BURBIDGE, Frederick William
1847 - 1905
Born Lewisham, died Dublin. Primarily a botanist but illustrated his own books — *The Art of Botanical Drawing,* 1873, and *The Narcissus,* 1875, very practical books but uninspiring in appearance. He also did some magazine illustration for *The Garden* and there is some of his work at Kew. In 1879 he was appointed Curator of the Dublin Botanic Garden.
lit: Blunt and Stearn, Brinsley Burbidge

BURGESS, Jane Amelia fl.1840s
London flower painter, daughter of John Carl Burgess. Exhibited R.A., S.B.A. 1843-48.
lit: Brinsley Burbidge, Desmond

BURGESS, John Carl 1798 - 1863
Drawing master son of the portrait painter William Burgess, painted flowers and landscape. In 1811 published *A Practical Treatise on the Art of Flower Painting.* Exhibited R.A., R.I., R.B.A.
lit: Brinsley Burbidge, Desmond

BURGIS, Thomas fl.1760s
One of the artists employed by Sir Joseph Banks to make finished drawings of plants sketched by Sidney Parkinson.
lit: Desmond

BURGOYNE, Elizabeth c.1752 - 1809
Little known but has some flower paintings in the Broughton Collection, Fitzwilliam Museum, Cambridge. Could she be the same person as Mrs Montague Burgoyne to whom Curtis dedicated Vol.1 of his *Botanical Magazine, 1797?* He wrote '…she was not less esteemed for her social and domestic virtues than admired for the accuracy with which she draws…the beauties of Flora'.
lit: Brinsley Burbidge, Desmond, Grant, Scrace

BURR, Edith fl.1840s - 1880s
Daughter of H.G. Burr, physician and mycologist. Drew nineteen plates for Hogg and Burr's *Herefordshire Pomona* 1878-85. Drawings are at Hereford Cider Museum.
lit: Brinsley Burbidge, Desmond

BURRINGTON, Arthur Alfred, R.I.
1856 - 1924
Somerset artist, studied at South Kensington Art School, the Slade, in Rome and in Paris. Exhibited flower paintings and some landscapes R.A. (1888-1918), R.I., S.B.A. and other venues.
lit: Desmond, Waters

BURROUGHS, Victoria 1930 - c.1984
Born in London, daughter of the famous BBC producer, Lance Sieveking; later lived near Snape in Suffolk and in Woodbridge. The only formal training she had was at the Flatford Mill Centre courses but she had a natural talent for painting flowers in watercolour, particularly wild flowers which came alive under her brush. She exhibited at the Minories, Colchester, and in Woodbridge, but always had to be persuaded to show her work about which she was unduly modest — I think she always felt in the shadow of her famous and extremely outgoing father. Her output was limited by poor health and the family retains most of her unsold work. I was one of many who were saddened by the untimely death of an artist whose warmth under a shy exterior was personified in her flowers.

★BURY, Mrs Edmund fl.1829 - 1867
Mrs Bury was an extremely talented amateur flower painter born into a wealthy and privileged family. She started when very young to draw the exotic and beautiful plants to be found in abundance on the family estate. Later she

contributed to Maund's *Botanist* and *Botanic Garden* between 1837 and 1846 and illustrated many botanical books including *A Selection of Hexandrian Plants* (fifty-one plates of amaryllis and lilies engraved by R. Harvill), *Figures of remarkable forms of Polycyctius* (original drawings now in Liverpool City Library donated by her granddaughter) and many others in company with other illustrators. Her work is in the Kew Collection, the Broughton Collection, Fitzwilliam Museum, the Garden Library, Washington, D.C. and was exhibited at the National Book League in London in 1950. (See pages 51-52.)
lit: Blunt and Stearn, Brinsley Burbidge, Coats, Grant, Kramer, Rix, Sitwell
Colour Plates 22 and 23

BUSH, Flora, A.R.W.A. fl.1920s
Kent painter of flowers in watercolour. Studied at South Kensington, later moved to Bristol.
lit: Waters

BUTLER, Mary E. fl.1867 - 1909
London artist who spent some years in Natal painting the native flowers. Exhibited R.A., R.I., S.B.A., N.W.C.S. and her work is represented in the V. and A.
lit: Brinsley Burbidge, Desmond

BYATT, Edwin, R.I. 1888 - 1948
Painter of flowers, also landscape and still life. Worked for a firm of lithographers and in the studio of James Howall. Exhibited R.A., R.I., Paris Salon.
lit: Brinsley Burbidge, Waters

BYRNE, Anne Frances, A.R.W.S.
1775 - 1837
London artist, daughter of engraver William Byrne. Exhibited flower paintings R.A. from 1796, also B.I., S.S. and O.W.C.S. where she was the first woman artist to be admitted. Two of her paintings are in the V. and A.
lit: Brinsley Burbidge, Clayton, Desmond, Grant, Roget

BYRNE, Letitia fl.1799 - 1848
London artist who painted flowers and landscape and exhibited twenty-one flower paintings R.A.
lit: Brinsley Burbidge

BYWATER, Elizabeth fl.1879 - 1897
London painter of flowers who exhibited many works at the R.A. also N.W.C.S., S.S., G.G. and other venues.
lit: Brinsley Burbidge, Desmond, Wood

CADELL, Francis Campbell, R.S.A.
1883 - 1937
Born and lived in Edinburgh, trained at Edinburgh School of Art and later studied in Paris and Munich. Founder Member of the Society of Eight, 1912, and contributed regularly to their exhibitions for some years. Exhibited flower paintings R.S.A., becoming Associate in 1931 and Member in 1936.
lit: Brinsley Burbidge, Waters

CAFFIERI, Hector, R.I., R.B.A.
fl.1875 - 1901 (d.1932)
London artist who specialised in painting flowers, fruit and fish. Studied in Paris under Lefèbvre and lived for some time in France. Exhibited many works R.A., R.B.A., R.I., N.W.C.S., G.G. and Paris Salon.
lit: Brinsley Burbidge, Waters, Wood

CALDERON, Philip Hermogenes, R.A.
1833 - 1898
London artist who painted flowers, fruit, portraits, domestic and historical scenes much influenced by the Pre-Raphaelites. Exhibited 100 works at the Royal Academy of which he became a Member. Also exhibited R.I., S.B.A., G.G., N.C. and other venues.
lit: Brinsley Burbidge, Desmond, Wood

*CAMBERS-HADFIELD, Su, S.F.P. 1948 -
Educated privately in Leicester, Su Cambers-Hadfield went on to Loughborough College of Art and Design to study for a Diploma in Art and Design. Following this she worked for some time as a designer in the hosiery industry until a change of direction prompted her to attend Southfields College for a course in botanical illustration for which she has an obvious talent.

She exhibits with the S.F.P., the R.H.S. (Silver Gilt Medal), the Leicestershire Society of Botanical Artists and many galleries.

CAMERON, Elizabeth
1915 -
Scottish artist who trained from 1938 at the Slade and St John's Wood Art School. Her art training was interrupted by the Second World War in which she served in the A.T.S. While stationed near Edinburgh she managed to get several paintings into the R.S.A. in spite of the limited time available. She married in 1945, after which family, farm and business left little time for painting, although she never gave up altogether.

In the '70s she took up botanical painting seriously, working every day on flowers from her garden. She has had several one-man exhibitions in London at the Malcolm Innes and Leger Galleries and contributed to the 5th International Exhibition at the Hunt Institute. She has also had solo exhibitions in New York and Boston and exhibited in many mixed shows in this country and abroad including one solo at the Lennox Gallery, London, in 1999, in her mid-eighties.
lit: Sherwood

CAMERON, Katherine, R.S.W., A.R.E.
1874 - 1965
Born in Glasgow and studied at Glasgow School of Art and in Paris. Engraved flowers and illustrated her own rather fanciful flower books including *Flowers I Love,* 1916. She painted flowers in watercolour, both large arrangements and studies of single flowers. Exhibited R.A., R.S.A., R.S.W. and in France. Her work is represented in the Tate Gallery and other collections.
lit: Brinsley Burbidge, Desmond, Grant, Harris and Halsby, Waters

CAMERON, Leslie
fl.1880 - 1891
Brighton flower painter known only through a few exhibits at the R.A.
lit: Brinsley Burbidge

CAPEL, Mary
d.1782
Daughter of the Earl of Essex, she married Admiral J. Forbes in 1758. She was taught to paint flowers by G.D. Ehret. A collection of her flower drawings was sold at Sotheby's in 1976.
lit: Desmond

CARDEN, Lilian
fl.1898 - 1902
Brighton flower painter who exhibited R.A.
lit: Brinsley Burbidge, Desmond

CARLINE George F., R.B.A.
1855 - 1920
Born Lincoln, later lived in Oxford and London and died in Assisi. Studied at Heatherley's, later in Paris and Antwerp. Painted garden scenes as well as flowers and exhibited R.A., S.B.A., N.W.C.S., R.I. and other venues including fifty-nine works at the Dowdeswell Galleries. Work represented at the V. and A.
lit: Desmond, Waters

CARMAN, H.A.
fl.1860s and 1870s
Lived in Crayford, Kent, and painted flowers and fruit. Exhibited S.B.A. 1867-73.
lit: Brinsley Burbidge, Desmond

CARRINGTON, Patty
fl.1883 - 1887
Worcester flower painter who exhibited N.W.C.S. 1883-87
lit: Brinsley Burbidge, Desmond

CASE, Bertha
fl.1873 -1923
Maidstone flower painter who exhibited mainly locally but also at the Paris Salon 1911-1913.
lit: Brinsley Burbidge, Desmond

CATESBY, Mark
1679? - 1749
Born Sudbury, Suffolk, died London. Author and illustrator of *A Natural History of Carolina, Georgia, Florida and the Bahama Islands,* 1730-47, and other botanical and natural history books and writings. He was a keen collector of plants and competent botanical artist and etcher, always working from living plants. Appointed F.R.S. in 1733. Original drawings now in the Royal Library, Windsor (see page 28).
lit: de Bray, Blunt and Stearn, Brinsley Burbidge, Desmond, Hulton and Smith, Rix
Colour Plate 3

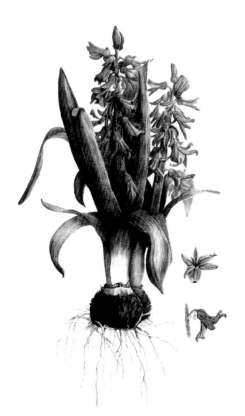

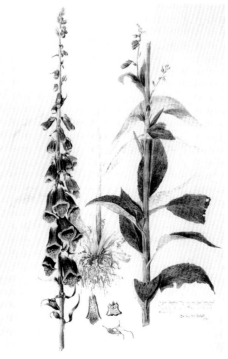

CAMBERS-HADFIELD, Su. Blue hyacinth.

CAMBERS-HADFIELD, Su. *Digitalis.*

CATLOW, Marie Agnes c.1807 – 1880
Trained in nature, zoology and entomology. Wrote and illustrated many books including *Popular Field Botany,* 1847, *Popular Garden Botany,* 1855, *Popular Greenhouse Botany,* 1857, and, with her sister, *The Children's Garden and what they made of it.*
lit: Brinsley Burbidge, Kramer

CATON, Joyce, S.F.P. **20th century**
Before her marriage in 1942 studied Fine Art at Hornsey School of Art after which she spent many years in drama and theatrical work. She returned to fine art later after studying under Slade-trained Marlene England. She decided that flower painting was her metier and tried to learn all she could about the subject. She now exhibits regularly in local exhibitions and with the Society of Floral Painters of which she is a Founder Member.

CHADWICK, Paxton **1903 – 1961**
Naturalist, artist, botanist and cartoonist, Paxton Chadwick was born in Manchester and later lived in Suffolk. He attended Manchester Grammar School passing, at eighteen, the School of Art Local Examinations and gaining four excellents and two first class. From there he went to Manchester School of Art and, after his training there, took a studio of his own starting a highly successful career in illustration and design. When some textile designs were rejected in Manchester because of the buyers' insistence on French chic, he was so infuriated that he found himself a French agent who sold the designs in Manchester for far, far higher prices than any British designer could hope for! In 1933 he moved to Leiston in Suffolk as Art Teacher at the controversial school, Summerhills, where he stayed until 1941 when the school was evacuated and he was called up for military service. Also in 1941 he married a fellow Summerhills teacher, Lee Bonsence, now a well-known writer, who to this day keeps her husband's studio unchanged since his death from cancer in 1961.

After war service Paxton Chadwick resumed illustration including three King Penguins, *Reptiles and Amphibia, British Butterflies* and *Crown Jewels,* three Puffins, *The Puffin Book of Wild Flowers,* also *Pond Life* and *Wild Animals.* He contributed to many magazines and journals and produced for Cassells a series of Natural History Pantoscope Books. At the time of his death he was working on a British Flora, also for Cassells. It is widely accepted that his illustrations of wild flowers constitute the cream of his work.

He exhibited paintings of wild flowers and animals in watercolour in Manchester, London, Liverpool, Paris and Vancouver and retrospective exhibitions have been held in Manchester, Aldeburgh, King's Lynn, Woodbridge and Gainsborough's House, Sudbury. His work is now in a number of important collections.
lit: Saville, Walpole

de CHAIR, Patricia **1944 –**
Patricia de Chair is a self-taught but extremely competent floral artist working in watercolour who only started to paint seriously when her children went to boarding school. As the wife of an army officer, she has moved around a great deal and exhibiting has in the nature of things

been sporadic but successful, especially in an exhibition at the Malcolm Innes Gallery, London, in 1993. Her work is in a number of collections including the Shirley Sherwood Collection.
lit: Sherwood

CHALMERS, George Paul **1833 – 1878**
Scottish painter, born Montrose and studied at Trustees' Academy, Edinburgh. Painted flowers and portraits. Exhibited R.A. Work represented in National Gallery of Scotland permanent collection.
lit: Brinsley Burbidge, Desmond

CHANDLER, Alfred **1804 – 1896**
By trade a nurseryman who also painted flowers and fruit. Exhibited R.A. and in Philadelphia. Work was reproduced in Booth's *Illustrations and Descriptions of the plants which comprise the Natural Order of Camellieae,* and his work is represented in the Broughton Collection, Fitzwilliam Museum, Cambridge.
lit: Blunt and Stearn, Brinsley Burbidge, Desmond

CHANNON, Mrs M.E. **fl.1850s and 1860s**
London artist who exhibited flower studies R.A. and S.B.A.
lit: Brinsley Burbidge, Desmond

CHARLES, James, N.E.A.C. **1851 – 1906**
Studied at Heatherley's, London, and in Paris. Exhibited flower paintings among other subjects at the R.A., S.S., G.G., N.G., and the Paris Salon.
lit: Brinsley Burbidge, Desmond, Grant, Waters, Wood

CHARLOTTE, H.M. Queen **1744 – 1818**
Keen gardener and collector of plants, also a talented flower painter who was taught by Francis Bauer (see page 37).
lit: de Bray, Blunt and Stearn, Brinsley Burbidge, Desmond, Mabey, Scott-James

CHARTERS, Isabella M. **fl.1894 – 1936**
Painter and illustrator of flowers, lived Leicester and was a member of the Leicester Society of Art. She was an art mistress by profession but at the same time illustrated many books on floral subjects and her work was published in *Amateur Gardening, The Garden* and R.H.S. manuals, She held Silver and Bronze R.H.S. Medals. Exhibited S.W.A., also in Liverpool and Nottingham and in 1936 had a one-man show, mainly of flowers, in Burton-on-Trent.
lit: Jeremy Wood

CHASE, Jessie **fl.1880s**
Artist from Kilburn, London. Member of the Society of Lady Artists and also exhibited N.W.C.S.
lit: Brinsley Burbidge, Desmond

CHASE, Marion Emma, R.I. **1844 – 1905**
Daughter of the artist, John Chase. Trained by her father, Margaret Gillies and Henry Warren. Versatile artist and illuminator best known for her watercolour drawings of flowers. Exhibited in London and the provinces. In 1879 she became a Member of the Institute of Artists in Watercolour and in 1888 was awarded the Silver Medal of the

Botanical Society. Main exhibition venues were R.A., R.I., R.B.A., S.S., N.W.C.S. (205 works). Her work is represented in the V. and A. and the Aberdeen Art Gallery. (See page 47.)
lit: Brinsley Burbidge, Clayton, Desmond, Grant, Waters

CHASE, William Arthur **1878 – 1944**
Born in Bristol but later lived in London. Studied art at C. and G. School of Art, London, and Regent Street Polytechnic. Became a designer of memorial windows and flower painter. Exhibited R.A. His work has been reproduced in a number of books on flowers and floral art. He painted a great deal abroad.
lit: Brinsley Burbidge, Waters

CHECKLEY, Mrs C. **fl.1828 – 1868**
London artist who exhibited flower paintings R.A., B.I., S.S.
lit: Brinsley Burbidge

CHEYNEY, Emma **fl.1880s and 1890s**
Lived Redhill, Surrey. Painted flowers and exhibited R.A., S.B.A. and N.W.C.S.
lit: Brinsley Burbidge, Desmond

CHEYNEY, Lucy **fl.1830 – 1860**
London artist who exhibited flower paintings R.A. and S.S.
lit: Brinsley Burbidge

CHILDS, Agnes **fl.1850s – 1870s**
London artist who exhibited paintings of flowers and birds' nests at the S.B.A. from 1852-1871.
lit: Brinsley Burbidge, Desmond

CHOLINE, Gerard **1875 – 1917**
Born India and studied art at the Slade. Member of the N.E.A.C. who painted flowers and landscape.
lit: Brinsley Burbidge, Desmond

CHRISTIE, Janet **1939 –**
Janet Christie trained at Edinburgh College of Art gaining a Diploma in Drawing and Painting and then spent two years at Aberdeen Teacher Training College. She has taught botanical painting at Norwich Adult Education Centre, Peebles, Scotland (regular courses), and the R.B.G., Edinburgh. Exhibiting with the R.H.S. gained her a Silver Medal in 1982 and the Grenfell Medal in 1985. A Founder Member of the S.B.A., she resigned in 1996.

She has had solo exhibitions at the Maddermarket Theatre, Norwich, two at the Broughton Gallery, near Edinburgh, and at the Clarendon Gallery, London. Group exhibitions include R.W.S. (six times), Flowers and Gardens Exhibition, Mall Galleries (three times), S.B.A. (three times), annually at the Broughton Gallery, near Edinburgh, R.S.A. Galleries, Edinburgh (nine), Open Eye Gallery, Edinburgh (four), Stenton Gallery, East Lothian (three) and at galleries at King's Lynn, Norfolk, Ballater, Scotland, Peebles, Scotland, Tenbury Wells, Dunkeld, Cockermouth, and a number of galleries in both Edinburgh and Glasgow. She works in watercolour, flower painting being the most important aspect of her work, although she does paint other subjects albeit usually with the introduction of flowers.

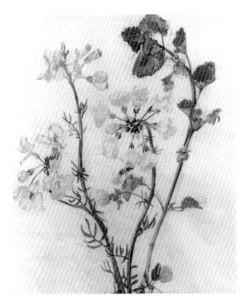

CHURCHYARD, Ellen. Wild flower study.

CLARE, Vincent. Flowers in a basket with a bird's nest on a mossy bank.

CHRISTIE, Robert 19th century
Pupil of Lefèbvre and T. Robert Henry. Painted flowers and exhibited R.A. 1891 and the Salon des Artistes Français.
lit: Brinsley Burbidge

CHURCHILL, Susan Stewart, Duchess of Marlborough 1767 - 1841
Wife of George Spencer, 5th Duke of Marlborough, who was an accomplished painter of flowers; her paintings are now at Blenheim.
lit: Desmond, Soames

★CHURCHYARD, Ellen c.1827 - 1909
Several offspring of the eccentric lawyer/painter Thomas Churchyard, 1798-1865, also painted with varying degrees of competence. Ellen Churchyard alone could be classed as a flower painter; her output was not large, partly because of her refusal to paint after her father's death, but her studies of wild flowers have a fascination and delicate charm all of their own.
lit: Blake, Day, Morphey
Colour Plate 30

CLARE, George 1835 - 1890
Birmingham artist, one of three brothers who painted flowers in natural settings, often with bird's nests and other natural features rather in the style of W.H. Hunt. The writer and critic John Ruskin thought very highly of this work. George Clare exhibited R.A., B.I., S.S. and other venues largely in the Midlands. (See page 44.)
lit: Blunt and Stearn, Brinsley Burbidge, Desmond, Grant, Mitchell, Waters, Wood
Colour Plate 19

CLARE, Oliver 1853 - 1927
Birmingham artist, brother of George Clare, who painted in a very similar manner, perhaps with rather more freedom. Exhibited R.A., S.B.A. and other venues. (See page 44.)
lit: Brinsley Burbidge, Desmond, Mitchell, Waters, Wood

★CLARE, Vincent 1855 - 1925
Birmingham artist, brother of George and Oliver Clare, who painted in a rather similar style to his brothers but with less professionalism. (See page 44.)
lit: Waters, Wood

CLARK, Francis fl.1853 - 1865
London flower painter who exhibited R.A., B.I. and S.S.
lit: Brinsley Burbidge, Desmond

CLARK, Sue 1947 -
Sue Clark spent her childhood in East Anglia and trained for four years at Colchester School of Art as an illustrator and was introduced to etching and lino cutting. She then spent some time travelling in Europe and for several years lived in France where she taught and painted in watercolour. On her return to this country she rediscovered printmaking while continuing to paint watercolours. She focuses on flowers in all their diversity of colour and settings from wild flowers of the hedgerow to hothouse specimens. Sometimes these evolve into still life with the addition of pieces of china, vegetables or fruit.

She has exhibited widely including at the Kew Gardens Gallery, Hampton Court Flower Show and her first solo exhibition of 'Favourite Flowers' was held at the Museum of Garden History in 1997. Her work has frequently been reproduced as greetings cards.

CLARK, William fl.1820s and 1830s
Botanic artist to the Horticultural Society of London. Contributed sixty-one etchings to Morris's *Flora Conspicua*, 1825-30, fifty-two to Stephenson and Churchill's *Medical Botany*, 1827-31, and a few plates to the *Pomological Magazine*.
lit: Desmond, Sweet

CLAYTON, Harold. Still life.

COKER, Deirdre. Sunflowers.

CLARKE, Kate **fl.1863 - 1884**
Painted flowers and landscape and exhibited B.I.,
S.B.A. and other venues.
lit: Brinsley Burbidge, Desmond

CLARKE, Minnie E., A.R.M.S. **fl.1920s**
London artist who painted flowers and
miniatures. Studied at Lambeth School of Art
and in Paris. Exhibited R.A., R.I., S.W.A. and
abroad.
lit: Waters

CLAUSEN, Eleanor M. **fl.1880s and 1890s**
London flower painter who exhibited S.B.A. and
G.G.
lit: Brinsley Burbidge, Desmond

CLAUSEN, Sir George, R.A., R.W.S., R.I.
 1852 - 1944
Born in London of Danish descent, studied at
South Kensington and later in Paris under
Bouguereau. Painted many subjects but flowers are
particularly well executed. In 1868 and '70 he
received gold medals for design. In 1904 he was
appointed Professor of Painting at the Royal
Academy Schools, later becoming Director of the
Schools. His flower paintings are illustrated in many
catalogues and originals are in permanent
collections in Cardiff, Walthamstow and
Westminster. He was knighted in 1927.

He exhibited R.A., R.I., S.S., P.W.C.S.,
N.W.C.S., G.G., N.G. and other venues.
lit: Brinsley Burbidge, Desmond, Waters, Wood

***CLAYTON, Harold** **1896 - 1979**
Born London and studied at Hackney, Harrow,
Hornsey and St Martin's School of Art; tutored
by Norman James. Known almost solely for his
magnificent flower paintings in the 17th century
Dutch style which have been widely exhibited in
this country and abroad and reproduced as Fine
Art prints, notably a very fine series of limited
editions by Frost and Reed. He worked mainly
in Hampstead and Suffolk but spent some time
in Cyprus between 1965 and 1974 when he was
rescued by a Royal Navy helicopter following
the Turkish invasion. The last three years of his
life were spent in his much loved Devon where
he died peacefully in his sleep. His work is in
important collections all over the world. (See
pages 101-102.)
Colour Plates 53 and 54

**CLIFFORD, Elizabeth, b.1810, Mary Anne,
b.1815, Charlotte, b.1816, Catherine, b.1822
and Constance, b.1828**
Five remarkable ladies who lived at Frampton
Court, Gloucestershire, with their aunt,
Charlotte Anne Purnell, b.1791, and drew and
painted over 300 of the wild flowers growing in
the countryside around them. These they put
into scrapbooks which were 'discovered' in an
attic in 1892. (See pages 59-61.)
lit: Mabey

COBBETT, Edward John **fl.1830s - 1840s**
London artist who exhibited flower paintings
and landscape R.A., B.I., S.B.A.
lit: Brinsley Burbidge, Desmond

COCKBURN, Jane Alison **1946 -**
Jane Cockburn was born in Fife and now lives in
Edinburgh where she has either lived or been based
for most of her life. She studied botanical illustration
under Anne-Marie Evans and obviously backs up
her training with a great deal of natural talent. As

well as her own work, she teaches and lectures on
botanical painting at a number of venues including
the V. and A. and R.B.G., Kew. She exhibits regularly
in London and Edinburgh and has been awarded
the R.H.S. Silver Grenfell Medal.
lit: Evans and Evans

***COKER, Deirdre, S.F.P.** **1939 -**
Deirdre Coker, although always good at and
interested in art and flowers, only took up painting
seriously after a career in nursing. In the 1980s she
took A-level art and history of art and went on to
study at Southampton College of Art, achieving
the Higher Certificate of Painting. Later she
studied with the Open College of the Arts and
gained their certificate in 1993. She prefers water-
colour for her flower paintings which are big, bold
and colourful. She has been made a Member of
the Society of Floral Painters and exhibits with the
Society as well as independently. Her work has
been reproduced as greetings cards.

***COKER, Norman, F.S.B.A.** **1927 -**
Norman Coker, who lives in Essex, paints mainly
in oils with a special interest in flowers and gardens.
The mood of his paintings, he says, is more
important than the detail although they are painted
with great care and with special attention to the
play of light and shade. On a personal note, I find
his garden paintings magical.

Much of his life has been spent teaching advanced
art, mainly to adults, and he has exhibited in London,
Amsterdam, Dublin, Singapore and Nairobi as well as
annually with the S.B.A., a one-man show at the
Beecroft Gallery, Essex, the McEwan Gallery, Ballater,
Scotland and the Frinton Gallery, Essex. His work is
in many private collections world-wide including
those of H.R.H. the Princess Royal, Felicity Kendall
and Air Marshal Sir David Atkinson K.B.E.

His work has been reproduced by Felix
Rosenstiel's, Fine Art Publishers, the Medici
Society and Canterbury Design Reproductions,
also in Sue Burton's *The Encyclopaedia of Flora*.

In 2000 Norman Coker achieved the S.B.A.'s
highest honour – the Founder President's Award
inaugurated in 1995 to commemorate the

COKER, Norman. Flag irises.

COKER, Norman. Garden study.

Society's 10th Anniversary. Six hundred and seventy flower artists from all over the world were represented at the annual exhibition at Westminster Central Hall, so it was a proud moment when Suzanne Lucas presented the award 'for the loveliest painting in the Exhibition'.
lit: Burton

COLE, Joseph **fl.1770 - 1782**
London artist who exhibited flower paintings R.A. and the Society of Artists.
lit: Brinsley Burbidge

COLE, Raymond Vicat **fl.1892 - 1904**
London artist who painted flowers and landscape and exhibited R.A. and other venues.
lit: Brinsley Burbidge, Desmond

COLE, Thomas William, A.R.C.A. 1857 -
Born Shrewsbury, studied at Shrewsbury School of Art and the Royal College of Art. Became Headmaster of Ealing High School. Painted flowers which he exhibited R.A., R.I. and R.B.A.
lit: Brinsley Burbidge, Waters

COLLINGS, Martine, S.B.A. 20th century
Martine Collings has been fascinated by nature from earliest childhood and has an exceptional talent for expressing her love for flowers in various forms of painting in the most artistic sense, commissioned illustration and strictly botanical work. Her client list includes B.B.C. Worldwide, Crabtree and Evelyn, Disney Corporation, *Encyclopedia Britannica* and Rob Doulton for whom she has designed some most exquisite presentation china plates. Her book illustrations include those for *The Border Book, The R.H.S. Encyclopedia of Herbs, The Birdfeeder Garden* (Dorling Kindersley), *The Gardener's Guide to Shrubs, The Low Allergen Garden* (Mitchell Beazley), *The Weekend Gardener* (Reader's Digest Pub.).

Martine Collings is a Member of the Society of Botanical Artists and the Association of Illustrators and exhibits her paintings regularly in London with the S.B.A., R.H.S. and in other venues. She has also had two solo exhibitions in Sussex, exhibited with the Linnean Society and won major awards from the R.H.S. In 1996 she was awarded the President's Honour Gold Medal for the best painting in the S.B.A. London exhibition. Her work is in many collections world-wide especially, after the U.K., in the U.S.A. where she lived and worked for several years.

COLLINGWOOD, W. Graham
 fl.1880 - 1904
Lived in the Lake District near Windermere and Coniston. Painted flowers and landscape and exhibited R.A., N.W.C.S., S.S., G.G. Work is in the Harris Museum and Art Gallery, Preston.
lit: Brinsley Burbidge, Desmond

COLLINS, William W., R.I. 1863 - 1951
Born Kensington and studied at Lambeth School of Art and in Paris. Painted flowers to a very high standard as well as some landscapes and seascapes. Exhibited R.A., S.S., N.W.C.S., N.G.
lit: Brinsley Burbidge, Desmond, Waters

COLVIN, Miss 18th century
Seven charming flower drawings by this artist were bequeathed by Lord Fairhaven to the Broughton Collection, Fitzwilliam Museum, Cambridge. Beyond this nothing is known of her.
lit: Scrace

COMBES, Grace Emily fl.1880s
London artist who exhibited flower and bird paintings N.W.C.S. and S.B.A.
lit: Brinsley Burbidge, Desmond

CONNARD, Philip, C.V.O., R.A., R.W.S., N.E.A.C. 1875 - 1958
Born Southport and later lived in Richmond, Surrey. Won a scholarship to the Royal College of Art, later the British Institute Prize, and went on to study in Paris. Painted some flowers including floral designs for textiles, also portraits and landscape. Taught at Lambeth School of Art. Member of the N.E.A.C. 1909, R.A. 1925 and became Keeper of the R.A. in 1945. Exhibited R.A., N.P.S., R.W.S., N.E.A.C. and Leicester Galleries. Work is now in the Tate Gallery, London, and the Durban Museum and Art Gallery, South Africa.
lit: Brinsley Burbidge, Waters

CONSTABLE, Isobel fl.1857 - 1862
Daughter of the famous John Constable, R.A., who was a Member of the Society of Lady Artists and exhibited flower paintings R.A.
lit: Brinsley Burbidge, Constable (Freda), Desmond

CONSTABLE, John 1776 - 1837
Although not generally known as a flower painter, John Constable made a few significant studies of flowers, the best known being the large oil sketch of poppies (Study of Poppies) in the V. and A. The V. and A. also have another oil sketch, Study of Flowers in a Glass Vase, and one of wild flowers. There are two in the Paul Mellon Collection, Hollyhocks, in oil, and a pencil Study of Flowers. Flowers in a Basket in pencil and watercolour is in the Ipswich Museums' Collection.
lit: Baskett, Blunt, Brinsley Burbidge, Constable, Day, Fleming-Williams, Leslie, Parris, Peacock, Reynolds

COOK, Emily Anne fl.1881 - 1889
London flower painter who exhibited R.A. and S.B.A.
lit: Brinsley Burbidge, Desmond

COOK, Frederick T.W., R.W.A. 1907 -
Born London but later lived in Cornwall, trained at Hampstead School of Art. Painted mainly flowers but also some land and seascapes in oil and gouache. Exhibited R.A., R.W.A., Redfern Gallery and many other venues. Work has been reproduced in many magazines and periodicals and is represented in the National Gallery, Plymouth Corporation, Leicester and Trafford.
lit: Brinsley Burbidge

COOK, Jean, S.F.P. 1940 -
Jean Cook started painting on early retirement and, although she emphasises her amateur status, her flower painting has improved to the extent that she has been made a Member of the S.F.P. Her 'signature' is a small greenfly somewhere on all her paintings.

COOK, Nellie fl.1880s and 1890s
London flower painter who exhibited R.A., S.B.A. and N.W.C.S.
lit: Brinsley Burbidge, Desmond

COOKE, Ellen Miller fl.1880s and 1890s
London flower painter who exhibited R.A., S.B.A.
lit: Brinsley Burbidge, Desmond

COOKE, George 1781 - 1834
Drew many plates for Conrad Loddiges' *Botanical Cabinet,* 1813-1833. He always worked on a small scale; W.B. Hensley of the *Kew Bulletin* summed up his work: 'the figures are neat and always pretty but the work has not the slightest claim to the title "botanical"'.
lit: Blunt and Stearn, Desmond

COOKSON, Catherine Teresa
 mid-19th century
British painter who specialised in painting Indian flora. She illustrated initially *Flowers Drawn and Painted after Nature in England* in 1830, then her own *Flowers Drawn and Painted in India,* 1834-35.
lit: Blunt and Stearn, Kramer

COOMBS, Jill 1935 -
Jill Coombs lives and works in Sussex and trained at West Sussex College of Art where she studied ceramics and textile design as well as illustration and typography. She has since worked as a freelance artist for the Royal Botanic Gardens, Kew, preparing illustrations for the floras of Iraq, Qatar and Egypt. In the mid-eighties she was orchid artist for the R.H.S. Her painting of an Odontioda was part of the Kew Gardens Gallery exhibition, Treasures of the Royal Horticultural Society, in 1993. She designed their Chelsea Plate and has been awarded three Gold Medals.

Of her work Jill Coombs writes: 'On a personal note, I have seen and marvelled at the work of past botanical illustrators ever since I was at College and made mental notes to try it myself one day. Eventually, some twenty years later and as a result of having some interesting plants in my own garden, I found time for detailed studies and observation, both close up and in their natural habitat.

'My approach is to try and catch the "character" of the plant, in addition to recording as much fine detail as possible. The driving force is to "get it right". Just occasionally this almost happens.'

From her record and what I personally know of her work, the word 'occasionally' is distinctly out of place.

Jill Coombs has illustrated *Plant Portraits* by Beth Chatto and *Herbs for Cooking and Health* by Christine Grey-Wilson. She has also prepared illustrations for many botanical publications including *Curtis's Botanical Magazine,* Brian Mathew's *The Crocus, Flower Artists of Kew, The Natural History of the British Isles* and *Country Life.*

Her teaching experience includes botanical illustration for the West Sussex County Council Adult Education Service and for the English

COTTERILL, Anne. Roses in a copper measure.

COTTERILL, Anne. Snowdrops.

Gardening School at Chelsea Physic Garden. Her work has been exhibited at the National Theatre, Kew Gardens Gallery, Chelsea Physic Garden, the Association of Sussex Artists, Broughton Gallery, Scotland, and in 1994 she was invited with two other artists to stage an exhibition of botanical watercolours at the Kew Gardens Gallery. Her latest solo exhibition was at Mount Edgcumbe House, Cornwall, in May/June 2000. Also in June 2000 she led a group to Wergen, Switzerland, for Cox and Kings, to paint plants in their natural habitat.

Her work is in private collections in the U.S.A., Australia, Japan and Britain, including the Shirley Sherwood Collection, the R.B.G., Kew, the R.H.S. and the Hunt Institute.
lit: Sherwood, Stearn

COOPER, Emma (née Wren)
fl.1837 – 1870s
Born in Hertfordshire and studied at Heatherley's. Painted flowers rather in the style of W.H. Hunt and the Clares. Member of the S.L.A. Exhibited Dudley, Crystal Palace, Alexandra Palace and other venues. Produced *Plain Words on the Art and Practice of Illustration* in 1868.
lit: Clayton, Desmond

COOPER, Gerald, A.R.C.A. 1898 – 1975
Born in London and, after war service in the Observer Corps and the Royal Flying Corps, studied at West Bromwich School of Art and, later, at the R.C.A. In 1924 he started teaching at Wimbledon School of Art becoming Principal from 1930-1964 when Wimbledon had about 2,000 students.

He exhibited for thirty years at the R.A., also N.E.A.C., N.S. and many of the major provincial galleries; he was an Associate of the R.C.A., a

Member of the National Society of Painters and of the National Committee on Art Education. He was also for some time a Ministry of Education Examiner of Drawing and Painting.

In spite of so many interests and responsibilities, he was acclaimed by many as being perhaps the greatest British flower painter of his time who also produced some very eminent and well known pupils. (See pages 101-102.)
Colour Plate 55

CORKLING, Miss May fl.1870s and 1880s
Born Manchester. Exhibited studies of flowers and foliage R.A., G.G., S.L.A., Dudley Gallery and other venues.
lit: Clayton, Desmond

COUTTS, Michael. Flower study.

(See pages 112-115.)

***COTTERILL, Anne 1934 –**
Anne Cotterill is a native of the Scottish Borders and trained from 1953-56 at Edinburgh College of Art under William Gillies. A travelling scholarship to Europe in 1957 gave her the opportunity for broader study of great painters, notably Chardin who became a strong influence. Now living in Somerset, the wealth of wild flowers around her and those from her large untidy (she says) garden provide her with plenty of subject matter.

She has had numerous exhibitions in Somerset; also from 1994 she has had an annual solo exhibition with Thompson's Gallery Aldeburgh, and Spring and Christmas shows at Wykeham Gallery, Stockbridge. Her 1998 exhibition at Thompson's London Gallery was an immediate sell out. Her exhibitions always attract queues of collectors and demand always exceeds supply. She and her daughter run a publishing company specialising in reproductions of her work as limited editions and greetings cards. (See pages 112-115.)
Colour Plates 63 and 64

COURT, Emily d.1957
Born Essex and studied at the Slade under Tonks, Russell and Wilson Steer Painted in oils, primarily flowers, and exhibited R.A., R.I., N.E.A.C. Was awarded the Carnegie Institute Flower Prize.
lit: Brinsley Burbidge, Waters

***COUTTS, Michael 20th century**
Michael Coutts was born in Hertfordshire and trained initially in forestry and biology gaining a degree in forestry, a Ph.D. in microbiology and a D.Sc. in plant physiology. His real interest, however, lies in painting which he has pursued wherever his work in science has taken him. In 1994 he retired to paint full time.

Although he does paint other subjects, flowers and fruits in oil or pastel are his main concern. The catalogue introduction to his latest exhibition states that he produces 'some of the most exquisite flower paintings to be found'. He is particularly interested in colour and light and in the contrasts between the soft irregularity of flowers and the smooth perfection of the porcelain or glass containers. Interestingly he attends life classes regularly to maintain his high standard of draughtsmanship.

He exhibits at the Edinburgh Gallery, the Francis Iles Gallery, Rochester, the Catto Gallery in London and the Broughton Gallery, near Edinburgh. He also shows at the R.S.A.

CRABB, J. fl.1830s and 1840s
Painter of flowers and fruit; exhibited R.A., B.I., S.B.A.
lit: Brinsley Burbidge, Desmond

CRABB, W.A. fl.1820s – 1850s
Exhibited flower paintings R.A., R.I., N.W.C.S.
lit: Brinsley Burbidge, Desmond

CRABTREE, Philippa 1704 – c.1820
Born Bishopsgate, London. Painted flowers and exhibited R.A. 1786 and '87.
lit: Brinsley Burbidge, Desmond

CRANSTON, Wendy. Potted narcissus.

★CRANSTON, Wendy, F.S.B.A. 1946 –
Wendy Cranston was born in Bromley, Kent, and has had both a lifelong fascination with plants and the urge to draw and paint. She trained at Ravensbourne College of Art and Design but, although she always did some general painting in oils, bringing up a family curtailed her artistic activities. In 1975 the family moved to a home surrounded by open countryside and she started collecting and drawing the wild plants around her, later painting them in watercolour and successfully exhibiting in various galleries. Through the Federation of British Artists she heard about the Society of Botanical Artists and became a Founder Member in 1986.

Since then she has been exhibiting and undertaking commissions for both botanical illustrations and more structured flower paintings. She works primarily in gouache which, for her, expresses best her feeling for her subjects. As well as flowers she has recently added fruit and vegetables as closely related subjects.

CRESSWELL, Henrietta fl.1875 - 1887
London artist, exhibited flower paintings R.A., S.B.A., N.W.C.S., G.G., and other venues.
lit: Brinsley Burbidge, Desmond

CROME, Emily 1801 –
Born in Norwich, daughter of John Crome, co-founder of the Norwich Society of Artists. Emily made many studies of indigenous flowers which she exhibited at the S.B.A. and in Norwich.
lit: Day, Desmond, Walpole

CROME, John 1768 - 1821
Not generally considered a flower painter but he made some studies of wild flowers which are carefully introduced into many of his landscapes. His Study of Burdock is in Norwich Castle Museum.
lit: Blunt and Stearn, Brinsley Burbidge, Clifford, Day, Hemingway, Mallalieu, Moore, Walpole

CROME, Vivian fl.1858 - 1883
Son of the Norwich School painter, William Henry Crome, and grandson of John Crome. Lived in London and painted flowers. Exhibited R.A. and B.I.
lit: Brinsley Burbidge, Day, Desmond, Walpole

CROSSMAN, The Hon. Mrs fl.1880s
Botanical artist. A collection of eighty-seven watercolours of Cape flowers was in the hands of a Preston dealer in 1962. Present whereabouts are not known.
lit: Brinsley Burbidge, Grant

★CROSTHWAITE, Sally, S.B.A. 1944 –
Sally Crosthwaite has always loved flowers and as a child spent hours painting wild flowers by the river bank while her father fished. At school she filled her Nature Note Book with paintings of wild flowers — it was exhibited in London when she was only eleven years old. In her early twenties she exhibited flower paintings at the Drapers' Hall, London, the Miranda von Kirschberg Gallery, London, and the Paris Stock Exchange.

From 1971-1992 she was kept busy looking after a husband, three children, four ponies, a dog and cat, orphan lambs and sixty bantams, but developed her flower painting again when she took a two year course in botanical illustration at the English Gardening School gaining a Distinction. A further two year course at the Chelsea Physic Garden resulted in a Distinction in 1996. She became a Member of the Chelsea Physic Garden Florilegium Society.

She is also a Member of the Society of Floral Painters and the Society of Botanical Artists. Her work was selected for the Contemporary Botanic Artists of the World exhibition at the Tryon and Swan Gallery, Cork Street, London, in 1998 and for the permanent collection of the Hunt Institute. In 2002 she received an R.H.S. Gold Medal for eight paintings of Iridaceae.

She has also exhibited flower paintings at the Midhurst Gallery, Sussex, Gallery 90, Guildford, The Gallery, South Audley Street, London, the Chelsea Physic Garden exhibitions, the Spring Tulip Festival and the Summer Rose Festival at Pashley Manor, East Sussex, the S.B.A. Exhibitions, Gallery 27, Cork Street, London, the Schuster Gallery, Maddox Street, London, the Malcolm Innes Gallery, Bury Street, St James's, London, the R.H.S. Exhibitions, the Westminster Gallery and Sofiero Castle, Helsingborg, Sweden.

CROSTHWAITE, Sally. Three botanical studies.

CROUCH, Helga. Snakeshead fritillary and snowflakes.

★CROUCH, Helga, F.S.B.A., S.F.P., F.L.S.
1941 –
Born in London, now living in Essex, Helga Hislop has also lived in Wales and Australia. She trained at Cardiff College of Art, gaining Distinction in Art and Design in 1962, and the Central School of Arts and Crafts, London, gaining a Graphic Design Diploma in 1964.

She was inspired to become an artist by the work of Albrecht Dürer and her own need to communicate what she saw as the miracle of nature. She rightly maintains that art seems to put us in touch with values beyond the everyday familiar and material existence and acts as a valuable and necessary reminder of these values.

Helga Hislop delights in searching out and portraying the wild flora that appears in her garden and the surrounding countryside and always hopes her work will convey her delight and wonder at the fragile, delicate and intricate beauty of wild flowers and fruits. My own impression of her work is that she succeeds admirably.

She has exhibited mainly in London at the Miles Fairhurst Gallery, the Mall Galleries, the Linnean Society, the Westminster Gallery, Kew Gardens, the R.H.S. and the Shirley Sherwood Collection, also Dorking Hall, Surrey, Guildford House, and the Hunt Institute. She has been awarded the R.H.S. Silver Gilt Medal and her work is in many private collections.
lit: Sherwood

★CROWE, Barbara, R.I., S.W.A., S.B.A.
20th century
Barbara Crowe was born in Wirral, Cheshire, and from the time she was six years old she was drawing and painting under her mother's tuition and she excelled in art at both school and college.

After leaving college she was apprenticed to the commercial artist, Edward Swann, where she also wrote verses and stories for children which she illustrated. Much of this work was published in *Child Education* and she also illustrated for Dean's and other children's book publishers. After leaving Swann she attended Bath Court, a School of Lithography in Fleet Street, and, for a short time, Croydon School of Art.

After she married the solicitor, Ronald Crowe, the couple produced four children, one boy and three girls, and Barbara Crowe was constantly sketching and drawing them; she loved drawing children and, with ready-made subjects to hand, could readily indulge her talent in this sphere. Ronald Crowe, however, was a keen and enthusiastic gardener and persuaded his wife by way of a change to paint some of his treasured flowers. This started Barbara Crowe's enthusiasm for flower painting which, along with some landscapes, continues to this day.

For a long time Barbara Crowe has been giving flower painting demonstrations and classes to art societies, also courses and teaching in colleges. She has exhibited widely, becoming a Member of the R.I., S.W.A. and S.B.A., working in both watercolour and oil. She has contributed articles on flower painting to *The Artist* and *Leisure Painter* and a video has been made of her method and technique of flower painting. Her work has frequently been reproduced as greetings cards and in books, including Ron Ranson's *Watercolour Impressionists*.

Although her work is not strictly impressionist, it has a delightful freedom which in no way compromises the realism of the flowers concerned. Some unusual combinations of species add to the interest of her work.

CRUICKSHANK, William 1844 – 1922
Painted flowers and still life, especially game. Exhibited R.A. and S.S. Work is in the Harris Museum and Art Gallery, Preston.
lit: Brinsley Burbidge, Desmond, Grant, Wood

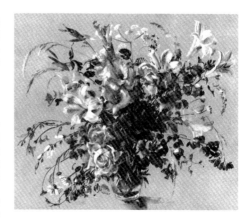

CROWE, Barbara. Flower study.

CUNDELL, Nora L.M., N.S. 1889 – 1948
Born and lived in London but spent some time in the U.S.A. Studied at Blackheath Art School and Westminster Technical Institute under Sickert and later at the Slade. Painted flowers, also some figures and landscape. Exhibited R.A., N.E.A.C. and the Paris Salon. A Memorial Exhibition was held at the R.B.A. Galleries.
lit: Brinsley Burbidge, Waters

CURTIS, Charles M. 1795 – 1839
Norwich artist who painted flowers and exhibited S.S. and N.W.C.S. Work reproduced in Wallich's *Plantae Asiaticae Rariores,* 1830-32, Lindley's *Pomologia Britannica,* Brown's *Miscellaneous Botanical Works,* 1866-68, Stephenson's *Medical Botany,* 1827-31, and *Curtis's Botanical Magazine.*
lit: Brinsley Burbidge, Desmond, Rix

CURTIS, John fl.1790 – 1872
Pupil of W. Marlow, lived in Twickenham. Painted flowers and landscape, exhibited R.A., O.W.C.S.
lit: Brinsley Burbidge

CUST, Lucy fl.1810 – 1815
Another totally unknown artist other than a very lovely watercolour, *Paeonia suffrutiosa,* bequeathed by Lord Fairhaven to the Broughton Collection, Fitzwilliam Museum, Cambridge. It was exhibited at the V. and A. in 1979.
lit: Desmond, Scrace

CUST, Lady Mary Anne 1800 – 1882
Wife of the military historian Sir Edward Cust (1794-1878). She made 205 drawings of plants and fish on a voyage to the West Indies in 1839 and Madeira in 1866. These drawings are now in the British Museum.
lit: Desmond

D

DAFFARN, William George fl.1872 - 1900
Prolific London painter of flowers, also landscape and genre, who exhibited regularly at the R.A., R.B.A., N.W.C.S. and other venues.
lit: Brinsley Burbidge, Waters, Wood

★DALBY, Claire, R.W.S., R.E. 1944 -
Claire Dalby, daughter of an old friend and distinguished watercolour painter, the late Charles Longbotham, R.W.S., was born in St Andrews, Fife, and educated at Haberdashers' Aske's School, Acton. In 1962 she was awarded the E.T. Greenshields Memorial Scholarship and from 1964-67 studied at the City and Guilds of London Art School. In 1973 she was elected to the R.W.S., becoming a full Member in 1977, and in 1978 she was elected to the Royal Society of Painter-Printmakers (R.E.), becoming a full Member in 1982. In 1984 she became a Member of the Society of Wood Engravers and was Vice-President of the R.W.S. from 1994-98. In 1994 she was awarded the Jill Smythies prize by the Linnean Society of London for published botanical illustrations and in 1995 the R.H.S. Gold Medal.

Among the many publications for which she has provided illustrations those she herself considers the most important of all are two Lichen Wall Charts, each illustrating some 500 different species and enlarged portions of most, for the Natural History Museum and BP Educational Service, *Lichens and Air Pollution,* 1981, and *Lichens on Rocky Seashores,*

1987. Other publications include the 1977 edition of the *Observer's Book of Lichens* by K.L. Alvin, *Biological Illustration — a Guide to Drawing in Black and White in Field Studies* vol.5 (with C.H. Dalby), *Colour Identification Guide to Grasses, Sedges and Ferns,* F. Rose 1991, *Crucifers of Great Britain and Northern Ireland* by T. Rich 1991, *Flora of Australia,* vol. 54 1992, *Women Engravers,* P. Jaffé 1988, *Images from Nature,* Natural History Museum 1998, and *Claire Dalby's Picture Book,* 1989. Other interesting commissions include a painting of the 'Charity' Rose commissioned by the National Gardens Scheme for their 70th Anniversary, a fungus painting commissioned by the British Mycological Society for their Centenary Celebrations and four paintings of wild plants commissioned by Surrey County Council for the Norbury Park Project.

Jointly with her husband, Claire Dalby has run more than sixty botanical illustration courses including a number at Kew and the R.B.G., Edinburgh. She has also taught and exhibited at various summer schools and gives private tuition at home in botanical illustration and wood engraving.

In addition to exhibiting regularly with the R.W.S., R.E., S.W.A. and frequently at the R.A., Claire Dalby has to date had nine solo exhibitions, the most important being two at the Consort Gallery, Imperial College, the Natural History Museum, the Linnean Society and the Shetland Museum, Lerwick. She has participated in nearly sixty group exhibitions in the U.K. and overseas. Her work is in many private collections and has been purchased by the Ashmolean Museum, Oxford, Australian Biological Resources Study, Canberra, Hunt Institute, Fitzwilliam Museum, Cambridge, Imperial College, London, National Library of Wales, National Museum and Gallery of Wales, Cardiff, History Museum, London, Royal Collection,

Windsor, Science Museum, London, Shetland Museum, Lerwick, Shetland Arts Trust, and the V. and A.
Colour Plate 70

DALE, Patricia 1930 -
Patricia Dale trained at Putney School of Art and is a professional freelance illustrator specialising in botanical painting and working mainly in watercolour. She exhibits widely in this country, Germany and the U.S.A. She shows regularly at the R.H.S. exhibitions and in 1995 designed the R.H.S. Chelsea plate; she has also shown with the Hunt Institute. Her work is in many private collections including the Shirley Sherwood Collection.
lit: Sherwood

DALTON, Edwin fl.1818 - 1844
London artist who exhibited flowers and portraits R.A.
lit: Brinsley Burbidge

DALZIEL, Herbert fl.1880s and 1890s
Lived in London and Devon. Exhibited flower and still life paintings R.A., S.B.A., N.W.C.S., G.G., N.G. and other venues.
lit: Brinsley Burbidge, Desmond

DARNELL, Antony William
fl.early 20th century
Produced horticultural books — *Winter Blossom for the Outdoor Garden,* 1926, and *Hardy and Half-hardy Plants,* 2 vols., 1929 and 1931. These were illustrated by himself.
lit: Blunt and Stearn, Brinsley Burbidge

DAVIES, Mary 1919 -
Mary Davies was born in Shotley, near Ipswich. After war service in the W.R.N.S., she graduated from the University of Wales (B.Sc. 1950) and a year later gained the Cambridge Certificate of Education in Botany and History of Art. After eighteen years of teaching she retired to become a professional flower painter. Since 1970 her work has been published by a number of British firms and in the U.S.A. and Australia. Work is in many private collections.

DAVIES, William H. fl.1818 - 1838
London painter of flowers and still life. Exhibited R.A.
lit: Brinsley Burbidge

DAVIS, Miriam fl.1884 - 1893
London flower painter who exhibited flowers and fruit paintings R.A., R.I., S.B.A., N.G. and other venues.
lit: Brinsley Burbidge, Clayton, Desmond

★DAVIS, Pamela, V.P.R.M.S., S.W.A., F.S.B.A. 20th century
Pamela Davis studied commercial art at Twickenham School of Art subsequently working for a London studio. After her marriage she developed a freelance connection working on a variety of subjects and designs.

In 1970 she abandoned commercial art to specialise in painting flowers and the English countryside. She works in all media and in a

DALBY, Claire. 'Star Gazer' lily.

DALBY, Claire. *Pulsatilla vulgaris.*

164

DAVIS, Pamela. Sunflowers.

traditional style with careful attention to detail. She is Vice-President of the Royal Society of Miniature Painters, a Member of the Society of Women Artists and a founder member of the Society of Botanical Artists. Her work is used extensively for reproduction on greetings cards and calendars.

Pamela Davis was a finalist in the Hunting Group art prizes in 1982, 1983 and 1984; she received the distinction of an Honourable Mention in the Golden Bowl award at the R.M.S. exhibition in 1985, 1986, 1987, 1988, 1989 and 1990 and was winner of the Gold Memorial Bowl award in 1991. Her work was judged best in show in the Hilliard annual exhibition in 1987 where she received the Suzanne Lucas Award, best in show international section Ulster Society of Miniaturists in 1987, second in the Fairman members subject award in 1992 and Llewellyn Alexander Subject miniature award in 1994.

DAVIS, Valentine, R.B.A. 1854 - after 1900
Born Liverpool and studied art with Ford Madox Brown. Painted flowers and some landscapes. Exhibited R.A. for twenty-five years, also Liverpool and Glasgow.
lit: Brinsley Burbidge, Desmond, Wood

★DAWE, Peggy 1924 -
Peggy Dawe was born in Croydon, later moved to Wallingford where she attended the County School for Girls. During the war she worked for the Air Ministry. Although she had no formal art training, Peggy Dawe has painted flowers professionally for many years working in various media until the last fifteen years during which she has specialised in botanical painting in watercolour. She always paints from life and is kept busy executing commissions for private collectors wanting portraits of their special plants.

She exhibits regularly at the R.H.S. shows, the S.F.P. shows, the Society of Women Artists and the Society of Botanical Artists as well as local galleries and is a Painting Member of the Chelsea Physic Garden Florilegium Society.. Her paintings have frequently been reproduced as greetings cards and by horticultural firms. She has produced illustrations for the *Gardener's Guide to growing Hardy Geraniums* by Trevor Bath and Joy Jones.

Peggy Dawe is a keen gardener and her garden provides much of her subject matter.

DAWSON, Elizabeth 1851 - 1876
Little known artist who exhibited flower and fruit paintings R.A., R.I. and S.B.A.
lit: Desmond, Wood

DEAN, Pauline M. 1943 -
Pauline Dean was born in Brighton and now lives in Guildford. After a career in nursing and bringing up a family, she turned to flower painting in 1984 with A levels in Art and Botany. She is now the sole tutor of Botanical Art at the R.H.S. Gardens at Wisley and she holds five R.H.S. Gold Medals. As well as undertaking private commissions she has had illustrations published in many books and magazines including *The New Plantsman* and *Curtis's Botanical Magazine*. Her work has also been widely reproduced as greetings cards and notecards. She designed three winter plates in the R.H.S. Collectors' series and the 1996 Chelsea Flower Show plate.

She featured in The Totworth Chestnut, one of the BBC's series *Meetings with Remarkable Trees,* and has exhibited at the Chelsea Flower Show, the Botanic Garden in Geneva and with the Guildford Art Society. She has had solo exhibitions at the Guildford House Gallery and in Geneva and a shared exhibition with Jenny

Brasier at Kew Garden Gallery. Her work is represented in collections in the U.K. and abroad including the Linnean Society, the R.H.S. Lindley Library, the Hunt Institute, and the Shirley Sherwood Collection.
lit: Sherwood

DELANY, Mary 1700 - 1788
Society lady who evolved her own system of floral mosaics, a type of collage using hundreds of tiny pieces of coloured paper in floral designs fixed to an appropriate background. Nearly 1,000 of these are in the British Museum. (See page 40.)
lit:Blunt and Stearn, Brinsley Burbidge, Clayton, Fulton and Smith, Rix, Scott-James

DENMAN, Gladys, A.R.M.S. 1900 -
Born Liverpool and trained at the Slade under Professor Tonks and Wilson Steer. Painted flowers, sometimes in miniature. Exhibited R.I. and Society of Miniaturists 1951-53 — clematis, cyclamen, irises, roses.
lit: Brinsley Burbidge, Desmond, Waters

DEVER, Alfred fl.1859 - 1876
London artist. Painted flowers and some interiors. Exhibited R.A. and S.B.A.
lit: Brinsley Burbidge, Desmond

DICK, Isobel Elizabeth fl.1920s
London flower painter, trained in London and Paris and worked abroad a great deal. Exhibited R.A.,S.W.A.
lit: Waters

DICKSON, Evangeline Mary Lambart 1922 - 2004
Born in Sheffield but studied art in Suffolk under Anna Airy (q.v.)) and Violet Garrod which ensured her a good grounding in immaculate draughtsmanship which is characteristic of her work. After then she made a lifelong career as a watercolour artist and illustrator. Although she painted many subjects, including landscapes, many natural history subjects and, some years ago, a well-researched and equally well-painted series of historical wagons, she painted flowers beautifully, particularly the indigenous wild flowers of East Anglia. For many years she was an Honorary Warden for three nature reserves under the auspices of the Suffolk Trust for Nature Conservation.

DAWE, Peggy. *Primula wanda.*

She exhibited regularly in London and East Anglia including at the R.W.S., R.I. and other prestigious venues. She had two one-man shows at Clarges Gallery in London and in Woodbridge and Snape. She also exhibited regularly with the Ipswich Art Society of which she was a prominent member for many years, some as President. Her illustration work included a calendar for W.S. Cowell, illustrations for William Collins and Dobson Books and for greetings cards. Her most impressive floral illustrations were those for Lee Chadwick's book *In Search of Heathland* – Lee Chadwick, writer, is the widow of Paxton Chadwick (q.v.).

Her work is in many important private collections in the U.K. and also in Australia, Canada, Egypt, France and U.S.A.
Colour Plate 71

DICKSON, Lalia C.P. **1913 –**
Edinburgh artist who studied book illustration and stained glass at Edinburgh College of Art, later taking up botanical illustration under the influence of Nora Paterson. Made many commissioned studies including a number for the Medici Society and the illustrations for *Flora of Turkey* by R.H. Davis. Her work is represented internationally in a number of private collections. Exhibited R.S.A. R.S.W., S.S., R.I. and other venues.
lit: Brinsley Burbidge

DIXON, Samuel **d.1769**
Lived in London but studied at the Dublin Academy's Drawing School. Best known for his miniatures but also painted flowers which he exhibited mainly in Dublin. In 1748 he is known to have executed a set of flowerpieces in *basso relievo*. In 1757 he opened a picture shop in London, retiring to Dublin in 1768.
lit: Brinsley Burbidge, Desmond, Nelson and Brady

DOE, E. **fl.1823 – 1848**
Worcester artist who painted flowers and exhibited R.A. and S.B.A.
lit: Brinsley Burbidge, Desmond

DOLLAND, Anstey W. **fl.1874 – 1889**
Painted many flower studies and also some figure work. Exhibited R.A. and S.S.
lit: Brinsley Burbidge, Grant

DOUDING, Miss M.A. **fl.1818 – 1847**
Known to have exhibited flower paintings at the R.A.
lit: Brinsley Burbidge, Grant

DOUGLAS, Jean, Dip.A.E., S.B.A., S.F.P. **1927 –**
Jean Douglas, who lives in Sudbury, Suffolk, studied art at teacher training college and later studied for and obtained the University of London Diploma in Art Education. Now working exclusively as an artist, she exhibits regularly with the S.B.A. and S.F.P. and participates in other mixed exhibitions in London and East Anglia. She has also had two solo exhibitions.

Jean Douglas is passionate about flower painting, particularly the work of Henri Fantin-Latour. In her own work her aim is to capture something of the dramatic effect of light on flowers and foliage and the interplay of their wonderful contrasting colours. Although she has worked in most media she now works primarily in pastel which she finds a versatile and rewarding medium. She is a keen gardener and grows almost all her subjects.

Jean Douglas was elected a Member of the S.B.A. in 1991 and of the S.F.P. in 1998. He work has also been reproduced by greetings card publishers.

DOUIE, Lady Frances Mary Elizabeth (née Roe) **1866 – 1965**
Born Amritsar, died Oxford. Collected and painted flowers and had native plants sent to her from Amritsar to paint. She is said to have painted between four and five thousand flower studies, some of which are in the Kew Collection.
lit: Desmond

DOW, Thomas Millie **1848 – 1919**
Born Glasgow and often classed as one of the famous 'Glasgow Boys'. Studied in Paris at the Ecole des Beaux-Arts and the Atelier of Carolus Duran, travelled extensively to broaden his artistic outlook and study the paintings of a variety of artists. He enjoyed Italian landscape and allegoric subjects although he was himself a decorative painter specialising in flower studies. Although he continued to exhibit in Scotland, in 1896 he and his wife moved to Cornwall for health reasons; he became a leading light in the St Ives colony and was for a time President of the St Ives Art Club. As well as in Scotland and St Ives he exhibited in all the principal London galleries and many provincial venues. He became a Member of the N.E.A.C.
lit: Whybrow, Waters

***DOWLE, Elisabeth** **20th century**
Elisabeth Dowle, who lives in Sussex, took a Foundation Course in Fine Art at Croydon College of Art, subsequently becoming a freelance botanical illustrator. She likes to concentrate on one genus at a time and has produced over thirty paintings from life of varieties of fuchsia, viola, and auricula and is working her way through the family of old-fashioned dianthus. She is also an enthusiastic painter of fruit and has worked on several important pomonas.

Elizabeth Dowle works in the main in watercolour on vellum or pen and ink. She has contributed illustrations to *The Living Countryside, Successful Gardening, Practical Gardening* and *Garden Answers* and published works which include her illustrations are *A Field Guide to Crops*, de Rougemont 1989, *The New R.H.S. Dictionary of Gardening, The Book of Apples,* Morgan 1993, *Orchids,* Arnold 1993, *The Herb Bible,* McHoy 1994, *Violas and Violettas,* Fuller 1994, *Fuchsias,* Ridding 1994, *A Taste of Honey,* Charlton 1995, *A Dash of Mustard,* Holder 1995, *Your Backyard Wildlife Year,* Schneck 1996, *Your Backyard Herb Garden,* Smith 1997, *Complementary Therapies,* Albright 1997, *A Pinch of Herbs,* Holder 1997, *The New Oxford Book of Food Plants,* Vaughan 1997 and *Bulbs in Bloom,* Peter Arnold, 1999.

As well as many private commissions others include Wellcome Institute, Williams and Phoa, Suttons Seeds Ltd. and Hatton Associates. Her paintings are in the Lindley Library, Kensington

DOWLE, Elisabeth. *Auricula* 'Walton Heath'.

Palace, the Hunt Institute, the Shirley Sherwood Collection and many private collections. She held a solo exhibition, Hortus, in October 2000. She is a Member of the Society of Botanical Artists and has been awarded seven R.H.S. Gold Medals and Certificates of Botanical Merit S.B.A. 1999 and 2001.
lit: Sherwood
Colour Plates 72 and 73

DRAKE, Miss S.A. **fl.1818 – 1847**
Lived in Middlesex. One of the most outstanding botanical artists of the 19th century of whom little is known personally but whose work continues to be admired by all those who move in botanical circles and many outside. She was a close friend of Lindley and contributed to his *Sertum Orchidaceum*, 1838, and *Ladies Botany*, 1834, also Bateman's *Orchidaceae of Mexico and Guatemala*, 1837. She contributed 1,100 botanical studies to Sydenham Edwards' *Botanical Register* and 300 illustrations to Dr Hamilton's *Plantae Asiaticae Rariores*, 1830-32. Many examples of her work can be seen at Kew and some are in the British Museum. (See pages 48-50.)
lit: Blunt and Stearn, de Bray, Brinsley Burbidge, Desmond, Mabey, Kramer, Rix, Sitwell

DRESSER, Ada **fl.1880s**
London artist who exhibited flower paintings R.A. and S.B.A.
lit: Desmond

DUFF, John Robert Keitley, R.I., R.E. **1862 – 1938**
Trained at the Slade and worked in oil, watercolour and pastel, also excelled as an etcher. Painted flowers, country subjects and genre. Exhibited R.A., R.I., S.B.A. and other venues.
lit: Brinsley Burbidge, Desmond, Waters

DUFFIELD, Mary Ann (née Rosenberg)
1819 - 1914
Born in Bath, daughter of the artist Thomas Elliott Rosenberg. Primarily a painter of flowers in watercolour for which she became well known and was awarded a Silver Medal by the Society of Arts in 1834. She married another flower painter, William Duffield. In 1861 she was elected a Member of the Royal Institute of Painters in Watercolour for her delicate and beautifully detailed flower studies. She wrote a treatise on flower painting called *The Art of Flower Painting,* 1856, which ran into several editions. Her work has also been reproduced by the Medici Society and other publishers. She exhibited from 1848 to 1912 R.A., S.S., N.W.C.S., G.G. and her work can be seen in the V. and A.
lit: Brinsley Burbidge, Bénézit, Medici Society, Wood

DUFFIELD, William **1816 - 1863**
Born Bath and died in London. Studied under George Lance and painted and exhibited flowers and still life. Exhibited R.A. and S.S. Work is in collections in Leicester and Sutherland.
lit: Brinsley Burbidge

DUNCAN, Emily **fl.1880s and 1890s**
London artist who exhibited flower and figure paintings R.A. and S.B.A.
lit: Desmond

DUNCANSON, Thomas **fl.1822 - 26**
Gardener who worked at Kew and, as a talented amateur artist, made many drawings of plants, especially succulents.
lit: Blunt and Stearn, Brinsley Burbidge, Mabey

DUNCOMBE, Miss E. **fl.1820s - 1840s**
Lived West Ham, London. Painted flowers and exhibited R.A., S.B.A., N.W.C.S.
lit: Brinsley Burbidge, Desmond

DUNKLEY, Anthea Munchley, S.B.A. 1945 -
Anthea Dunkley was born on the Isle of Wight, educated privately and studied at Southampton College of Art. She works as a scientific illustrator (botanical and geological), University illustrator/cartographer, muralist and botanical painter. She exhibits with the S.B.A., S.F.P. and Wessex artists. Commissioned work is in the Department of Geology, Southampton University and other educational establishments and in private collections in the U.K., Egypt, Japan, Israel, Syria, U.S.A., France and Australia. Her work has been reproduced in various scientific journals and florally on greetings cards.

DURHAM, Cornelius B. **1828 - 1876**
Flower painter also thought to have painted portraits. John Day, who was a keen collector and grower of orchids, commissioned Durham to paint his collection of which, from 1862, Durham painted 300. Some of these are now in the Fitzwilliam Museum, Cambridge. He also exhibited R.A.
lit: Brinsley Burbidge, Desmond, Rix, Scrace

DYKES, Elsie Katherine **d.1933**
Elsie Dykes, who was killed in a railway accident in 1933, edited and illustrated her husband's notes on tulip species after he was killed in a motor accident. She produced all fifty-four colour plates for the publication but, sadly, her husband received no recognition for his part. Elsie Dykes was also employed by the R.H.S. making drawings for records.
lit: Blunt and Stearn, Kramer

EALES, Jennifer, S.F.P. **20th century**
Jennifer Eales was born in Devon and has been painting and drawing since childhood. She has always been fascinated with botany and plant structure. 'A' level art led on to formal art training at the West of England College of Art.

Her artistic career was slowed down while bringing up a family but was resumed later after attending adult education classes at Sutton College of Liberal Arts, Surrey. During this time her personal style established itself and she has been painting and exhibiting flowers in watercolour both in local exhibitions and with the S.W.A., S.B.A. and S.F.P. Many of her works are in private collections in the U.K. and on the Continent.

EARL, Phoebe **1790 - 1863**
Daughter of the painter James Earl. Flower painter to Queen Adelaide. Exhibited R.A. 1820-1854.
lit: Desmond

★EARLOM, Richard **1742 - 1822**
Lived in London and studied engraving under Cipriani. He engraved a series of flower studies after van Huysum and van Os, also Reinagle's the Superb Lily for Thornton's *Temple of Flora* which is now in the Ghent Museum.
lit: Blunt and Stearn, Brinsley Burbidge, Foshay, Fulton and Smith, Scrace

EARLOM, Richard. A flower piece – after Jan van Huysum.

EDEN, Lady Margaret Ann. *Cobaea scandens.*

EASTLAKE, Caroline fl.1868 – 1873
Exhibited paintings of wild flowers at various venues, one example now in the V.and A.
lit: Brinsley Burbidge, Desmond

EATON, Mary 1873 – 1961
Born in Coleford and trained as a draughtsman and watercolourist, initially designing for Royal Worcester Porcelain. She spent some years in the U.S.A. where she was artist to the New York Botanical Gardens from 1911 to 1932; she also contributed 640 paintings to the U.S. magazine *Addisonia.* She worked mainly in watercolour. She returned to England in 1947 where she continued to exhibit with the R.H.S. as she had done since 1922, even while living abroad She was twice awarded the R.H.S. Silver Grenfell Medal. She also illustrated a number of flower books and her work is represented in the N.Y.B.G. collection, the National Gallery, Washington, and the Hunt Institute.
lit: Blunt and Stearn, Brinsley Burbidge, Kramer

★EDEN, Lady Margaret Ann 1939 –
Lady Eden was born and lives in London. She was an Art Scholar at Westonbirt School and trained at Byam Shaw School of Art and in the studio of Bernard Adams, Oil Portraiture. In 1977 she became director of a private girls school and, in 1993, turned to botanical illustration, for which she has enormous talent, and soon made rapid strides; her tutor, Anne-Marie Evans, regarded her as a star pupil. She has exhibited at the Chelsea Physic Garden, the Alpine Gallery, the Hunt Institute, Swann Tryon

Gallery, Ursus Gallery, New York, and in 1996 had a sell-out one-man exhibition with Spink and Sons, London. Her work is represented in the Hunt Institute and in a number of private collections including those of Shirley Sherwood, the Earl of Mansfield and Arabella Lennox-Boyd.

EDWARDS, Brigid 1940 –
Brigid Edwards was born in London and started her career as a TV producer and director. Discovering the work of the Bauer brothers and Ehret inspired her to change direction; she started to paint flowers and for the last ten years or so has worked as a botanical illustrator. She is clearly one of the most talented botanical painters currently working.

She exhibits regularly with the R.H.S. and has been awarded two Gold Medals; she has also exhibited with the Hunt Institute, the R.A. and other venues. In 1994 she had a successful exhibition at Kew Gardens Gallery and in 1995 a solo exhibition at Thomas Gibson Fine Arts, Old Bond Street, resulted in the entire collection being sold before the exhibition even opened.

She often works in watercolour on vellum, a ground which seems always to bring out the jewel-like quality of good flower paintings. She provided all the illustrations for John Richards' *Primulas* (1994) and her work is in many private collections including the Shirley Sherwood Collection.
lit: Sherwood

EDWARDS, C.A. fl.1792 – 1797
Buckinghamshire artist who is known to have exhibited four flower paintings at the R.A.
lit: Brinsley Burbidge, Desmond, Grant

EDWARDS, John, F.S.A. 1763 – 1812
Brentford painter who illustrated his own *British Herbal,* 1770, and *A Collection of Flower Drawings after Nature disposed of in an Ornamental and Picturesque Manner,* 1783-95. His flower painting was decorative if a little over stylised, maybe accounted for by the fact that he also designed for a calico printer. Exhibited R.A., B.I., Society of Artists, Free Society and the Harris Museum and Art Gallery, Preston.
lit: Blunt and Stearn, Brinsley Burbidge, Desmond

EDWARDS, Mary Ellen 1839 – 1900
Born Kingston-on-Thames and painted flowers and interiors. Exhibited many works R.A., S.S. and other venues as Mrs John Freer, Mrs John Staples or some times just 'Edwards'.
lit: Brinsley Burbidge, Desmond

EDWARDS, Sydenham Teast c.1769 – 1819
Son of a Welsh schoolmaster, he studied botanical painting under William Curtis. For some time he supplied drawings for *Curtis's Botanical Magazine* but eventually he fell out with Curtis and started his own *Botanical Register* in opposition. He also illustrated Curtis' *Flora Londinensis,* 1777-98, and R.W. Dickson's *Complete Dictionary of Practical Gardening,* 1805-07. He exhibited R.A. His work is represented in the V. and A., British Museum, R.B.G., Kew, and Frost and Reed.

lit: Blunt and Stearn, de Bray, Brinsley Burbidge, Desmond, Fulton and Smith, Grant, Mabey, Rix

EDWARDS, William Henry Camden fl.1773 – 1835
Born in Monmouthshire but died in Bungay, Suffolk. Engraved plates for Hooker and Roxburgh's *Young Artists' Guide to Drawing and Painting Flowers in Watercolour.* 1820. Exhibited flower paintings R.A. 1793-1841, also S.B.A.
lit: Brinsley Burbidge, Desmond

EDWARDS, Yvonne, S.B.A. 1942 –
Yvonne Edwards was born in South Australia although she has spent most of her life in England, now living near Salisbury. Tutored by John Wilkinson, Anne-Marie Evans, Joan Osborne and Michael Hickey, she paints and exhibits botanical watercolours especially with the S.B.A. (she holds their certificate of Botanical Merit) and the S.F.P.

A passionate plantswoman, she grows all her plant subjects in her own garden. She has a particular interest in the flora of Australia and the great Ferdinand Bauer who first portrayed them.

EILOART, E.G. fl.1859 – 1862
London flower painter who exhibited R.A. and S.B.A.
lit: Brinsley Burbidge, Desmond

ELGOOD, George Samuel, R.I., R.O.I. 1851 – 1943
Born Leicester and studied at the R.C.A. Painted gardens and landscapes, especially gardens on which he was an authority. Italian gardens had a special interest and he spent much time in Italy. He also wrote on gardens and exhibited in London, mainly R.I.
lit: Brown, Waters

ELLIS, Alice Blanche fl.1870s and 1880s
Herefordshire artist. Drew plates for Hogg and Graves' *Herefordshire Pomona* 1876-1885. Exhibited flower paintings S.B.A.
lit: Brinsley Burbidge, Desmond

ELLIS, Lionel, N.S., A.R.C.A. 1903 –
Born Plymouth where he studied at the College of Art, also at the Royal College of Art and in Paris and Italy. Painted flowers, also landscapes and animals in oil and watercolour, but executed commissions for flower paintings from the Medici Society and Pallas Gallery. He supplied illustrations for magazines and periodicals, exhibited R.A., N.E.A.C., N.G. and other venues and held a one-man show at the Redfern Gallery in 1932.
lit: Brinsley Burbidge, Medici Society, Waters

ELLIS, Thomas fl.1840s and 1850s
London artist who exhibited fruit and flower paintings R.A. and S.B.A.
lit: Brinsley Burbidge, Desmond

ELMER, William fl.1778 – 1799
Son of still life artist Stephen Elmer, A.R.A., who trained him. Painted flowers, fruit and still life.
lit: Brinsley Burbidge, Desmond, Grant

ELMORE, Edith fl.1877 - 1887
Kensington, London, artist who exhibited flower paintings R.A. and S.B.A.
lit: Brinsley Burbidge, Desmond

ELVIN, Keith, B.Sc., S.B.A., U.A. 1924 - 1998
Keith Elvin graduated in science at the University of Bristol after polio ended a service career and spent twenty-five years as a priest-schoolmaster in Cornwall. Following early retirement in 1978, he studied with an artist in Cornwall for five years, from then on concentrating fully on painting in oil and watercolour. He specialised in flower and garden painting.

He had eight one-man shows over fifteen years, three joint exhibitions and participated in a number of mixed exhibitions including those of the R.H.S., R.S.A. and the R.I. He was awarded the Premier Prize at Falmouth Art Festival 1986, the Grenfell Medal of the R.H.S. in 1992 and the Max Grumbacher Oil Painting Prize in 1995. The Medici Society holds the copyright of over twenty works which have been reproduced in a variety of ways including an all Elvin calendar for 1996.

ELWES, Cecilia (née Forsyth) 1874 - 1952
Flower painter in oil and watercolour who studied in Cornwall under Stanhope Forbes and Lamorna Birch and in Switzerland. She exhibited in most London galleries, also in Liverpool and on the Continent. Her work is represented in *Flower Painting in Watercolour,* Pitman 1932.
lit: Brinsley Burbidge, Desmond, Waters

★ENSOM, Ainslie, Dip. A.T.D., S.F.P. 1947 -
Born in Liverpool, brought up and educated in Shropshire, Ainslie Ensom took a degree in Fashion and Textile Design at Ravensbourne College of Art. After moving to Bath she spent many years designing and making silk clothes, often painted or embroidered with floral designs.

In 1994 a year's course at the Chelsea Physic Garden led to the English Gardening School's Certificate in Botanical Illustration with Distinction. She has since exhibited in Bristol, London, Hampshire and Sweden and her work is now held in private collections from Washington to Dubai. As a Member of the Chelsea Physic Garden Florilegium Society she has helped illustrate the Garden's publications and she was awarded an R.H.S. Gold Medal in 1999.

ENSOR, Mary (Mrs Henry Ensor)
 fl.1871 - 1874
Birkenhead artist who exhibited small colourful flower paintings, usually wild flowers growing in profusion, at Suffolk Street. (See page 47.)
lit: Brinsley Burbidge, Desmond, Wood

EVANS, Anne-Marie 20th century
Anne-Marie Evans modestly wonders if she qualifies for entry in this book, classing herself as a teacher rather than a painter but, without the skill and talent apparent in her own work, which is in a number of important collections, there is no way she could impart this skill to others. She maintains that anyone, however 'ungifted' they believe themselves to be, can achieve a competent standard if properly taught, although some of her star pupils have achieved much more than competence.

Anne-Marie Evans gained a Distinction in Painting at Bath Academy of Art and an M.A. with Distinction at De Montfort University. She is now Director of the Diploma Course in Botanical Painting at the Chelsea Physic Garden (the first certified course in the U.K.), takes master classes annually at the New York Botanical Gardens and also, since 1998, the Anne-Marie Evans Certificate Course at the N.Y.B.G. She takes one or two courses a year at the Isabel O'Neil School for the Painted Finish, master classes annually at the Melbourne School of Botanical Painting, short courses and specialist lectures in botanical painting at the V. and A. and various other master classes and workshops in the U.S.A. and in this country. She is also Director of Summer School at the Old Manor House, Market Overton, which has been running since 1983. She has organised numerous exhibitions for her students in this country and the U.S.A. and is the keynote speaker at many important functions as far away as Japan. She contributes to many magazines and other publications, features in radio and TV programmes and is a firm believer that botanical painting should be regarded as Fine Art. I hope this book shows that I agree.

Anne-Marie is a Fellow of the Linnean Society, Honorary President of the Chelsea Physic Garden Florilegium Society, Honorary Director of the American Society of Botanical Artists and Founder President of the Leicestershire Society of Botanical Illustrators.

ENSOM, Ainslie. Studies of iris.

EVANS, Marjorie, R.S.W. fl.1892 - 1895
Known to have lived in Richmond and Aberdeen. Painted flowers in watercolour and exhibited R.A. and other venues.
lit: Brinsley Burbidge

EVERARD, Barbara Mary Steyning 1910 -
Born Barnstaple, also lived in Farnham, Surrey. Painted flowers both botanically and in more traditional style. Worked in Malaya 1938-42 and again from 1946-50. In 1976 she was awarded the Churchill Travelling Fellowship to paint endangered plants in Malaysia and in 1986 she formed the Barbara Everard Trust for Orchid Conservation. She illustrated *Flowers of the Mediterranean,* 1965, and *Wild Flowers of the World,* 1970, and her work has been reproduced by the Medici Society with whom she exhibited. She has also done freelance work for the R.B.G. at Kew.
lit: Brinsley Burbidge, Desmond, Mabey, Scrace, Stearn

169

FAIRMAN, Sheila, R.M.S., F.S B.A., S.W.A., H.S.F. **1924 -**
Sheila Fairman lives at Leigh-on-Sea, Essex. In 1939 she won a scholarship to Southend College of Art where she returned in 1969 to resume her broken career in painting. She paints many subjects in all media, particularly miniatures, being a Founder Member of the Hilliard Society of Miniaturists and a full Member of the Royal Society of Miniature Painters since 1981. She was also elected a Founder Member of the S.B.A. in 1986. Her beautiful flower paintings are in a traditional style. Although she paints all flowers her main interest is in wild flowers which, to her gardener's despair, are allowed to flourish in the garden.

Her flower paintings have frequently been reproduced as greetings cards and she has exhibited with the R.A., S.W.A., S.B.A., R.S.M., R.P.S., Royal Society of Marine Painters, R.I., R.O.I. and the Medici Gallery, Llewellyn Alexander Gallery, London, Veryan Gallery, Cornwall, Carningli Gallery, Wales and she has had a solo exhibition at the Burwood Gallery, Wells.

Awards include Hunter Group Art Prizes finalist 1981 and '83, major prize 1982, R.M.S. runner-up award 1982, Hilliard Society best in exhibition 1985, R.M.S. Gordon Drummond award 1985, and Gold Memorial Bowl 1989, the Llewellyn Alexander Award 1991, '94, '95, '97 and '98.

FARLEIGH, John, R.B.A., R.E., S.M.P., S.W.E. **1900 - 1965**
Art Master at Rugby School 1920-25 before turning freelance as painter, lithographer, engraver, designer of posters, murals, etc., as well as illustrating (mainly flower) books, e.g. Sitwell's *A Country Garden,* 1939, and his own *Old Fashioned Flowers.* Exhibited R.A. from 1937.
lit:Brinsley Burbidge, Desmond, Waters

FARRER, Ann (Annie), B.A. **1950 -**
Ann Farrer is one of the country's leading botanical artists of our time. She graduated from the University of Manchester in 1972 (English Literature and History of Art) and in 1974 commenced work at the R.B.G., Kew, where she has worked on numerous Floras including *Flora Zambesiaca, Flora of Tropical East Africa, Flora of Aldabra,* also the *Kew Bulletin* and *Curtis's Botanical Magazine.* Other books on which she has worked include *Flora of the Balkans, Vegetation of Europe, Docks and Knotweeds* (B.S.B.I.), *Umbellifers* (B.S.B.I.), Collins *Field Guide to the Grasses, Sedges, Rushes and Ferns of Britain and Northern Europe,* the Kew monograph on *Arum* and many others. She has recently completed 148 pages of drawings for *The Grasses of Bolivia* (R.B.G. Kew, 1998) and has worked on a monograph on *Biarum* for Kew as well as a series of *Arisaema* paintings for a private collector and several other private commissions.

In 1977 Anne Farrer received a Churchill travelling Fellowship to go to the Himalayas to draw for an O.U.P. book, *Flowers of the Himalaya.* This was the start of her passion for travel in the region and she is an occasional trek leader for Exodus Expeditions, mainly to the Himalayas. She teaches the Kew two-week course on botanical illustration, at the Chelsea Physic Garden and privately.

She has exhibited at Kew and the Peter Scott Gallery, Lancaster University. She was the first person to receive the Jill Smythies award for botanical illustration from the Linnean Society in 1987 and has received six Gold Medals from the R.H.S. She painted orchids for the R.H.S. Orchid Committee and in 1991 produced a series of six paintings of plants from the endangered rain forest made into a set of prints for Kew.

Of her own approach to her work, Ann Farrer writes 'In my teaching of botanical illustration I always tell my students that everything matters, to take nothing for granted. I believe that if you are lazy in one part of your painting/drawing, your attitude of mind will reflect throughout your work. I am particularly keen on accurate drawing as a vital ingredient.

'I am not interested in stylised perfection and feel subtle detail of form, colour and nuances of light are what hold my interest and love of botanical illustration after twenty-five years.

'I love painting subjects not generally classified as beautiful — grasses, bamboos, Arisaemas, conifers, dead leaves, twigs, the colours of autumn and winter. During the last few years I have paid much more attention to light. Before this, I tended to see the subject *through* the light, in what I believed was the strictly scientific approach, but I am now fascinated by light and see it as augmenting a precise representation.

'I never feel anything I have done comes up to my own hopes at the start of a picture. My work as a trek leader has given me distance, literally, from my work, and enabled me to get it in perspective when in danger of it taking over too much of my life, as well as indulging my love of mountains and walking in them.'

Ann Farrer's work is in the Hunt Institute, the Shirley Sherwood collection and in private collections throughout the U.K., U.S.A., Belgium, Singapore, France and Australia. (See page 72.)
lit: Desmond, Sherwood, Stearn

FAWKES, Madeleine C. **1880 - 1954**
Born Leighton Buzzard, Beds.; studied art at Newlyn under Stanhope Forbes, also at the Slade and in Paris. Painted flowers, portraits and landscape but, during visits to her brother in South Africa, painted the flowers of the region and was awarded an R.H.S. Gold Medal for paintings of the wild flowers of Lesotho. She lived latterly in London and exhibited R.A. and R.P.S. Some of her paintings are in the Botanic Gardens, Cape Town.
lit: Brinsley Burbidge, Desmond, Waters

FERGUSON, William Gouw **1632 - 1695**
Born in Scotland where he studied art before travelling to France and Italy via The Hague where he lived from 1661-68, paying his rent in paintings. He painted flowers and still life, very much under the Dutch influence. His work is represented in The Hermitage, Leningrad. (See pages 22 and 25 (n.).)
lit: Brinsley Burbidge, Desmond, Harris and Halsby, Mitchell

FIRTH, Annette. Irises.

FIELD, Francis **fl.1875 - 1884**
Oxford artist who exhibited flower paintings R.A., S.B.A., N.W.C.S.
lit: Brinsley Burbidge, Desmond

FIELDING, Mary Anne (née Watson)
 fl.1815 - 1835
Member of the O.W.C.S. where she exhibited flower paintings under M.A. Watson or Mrs T.H. Fielding. She illustrated her husband's *Sertum Plantarum.*
lit: Brinsley Burbidge, Desmond

FILDES, Lady Fanny **fl.1875 - 1884**
Born Fanny Woods, she married the well-known portrait painter, Sir Luke Fildes, R.A. Painted mainly fruit and flowers and exhibited R.A. and other venues.
lit: Brinsley Burbidge, Desmond, Waters

★FIRTH, Annette, N.D.D., F.S.B.A.
 20th century
Annette Firth has, as she says, 'drawn and painted ever since she knew which end of the brush to dip in the paint'. Encouraged by her parents, she did so whenever she could.

After war service in the W.A.A.F. she was given an ex-service grant to The Central School of Arts and Crafts where she gained the N.D.D. for textile design after three years. When she married a man who loved plants and hunting for them in various European mountains, she was encouraged by him to paint their finds. She was also accepted for the Annual Botanical Illustration Course at Flatford Mill, then under John Nash, R.A.

After her husband's death, she obtained a teaching diploma from Whitelands College and teaches botanical illustration in Cirencester, Gloucester, Missenden Abbey, Flatford Mill and Kings Combe Field Centre. Her work has been published by the Medici Society, Parnassus Gallery and the Mother's Union and her cards, *12 months in Araby's Garden* and *An Alphabet of Roses,* have raised over £20,000 for various charities.

FISHER, Alexander **fl.1820s**
Painted flowers and mythological subjects and exhibited at various venues. His work is represented in the V. and A. and the British Museum.
lit: Brinsley Burbidge

FITCHET, Valerie. Poppies.

FITCH, John Nugent　　　**1840 – 1927**
Born Glasgow, died London. Nephew of Walter Hood Fitch and followed in his uncle's footsteps. He lithographed about 2,000 plates for *Curtis's Botanical Magazine,* illustrated the *Floral Magazine* from 1878-81, and Warner and Williams' *Orchid Album,* 1882-97. (See page 48.)
lit: Blunt and Stearn, Desmond, Stearn

FITCH, Walter Hood　　　**1817 – 1892**
The most famous and most prolific botanical artist and engraver of the period. He was 'discovered' by Sir William Hooker, Regius Professor of Botany, Glasgow, who took the young man south with him when he (Hooker) was appointed Director of Kew. Fitch was official artist at Kew for many years, produced all the plates for the *Botanical Magazine* for nearly forty years as well as abundant freelance work for other journals. For the Hookers he illustrated *Icones Plantarum* (485 plates), *Rhododendrons Illustrated, Flora Antarctica* 1844-47, *Flora Novae Zelandiae,* 1833-55, *Botany of the Antarctic Voyage of H.M. discovery ships Erebus and Terror,* 6 vols. 1844-60, *Niger Flora,* 1849, *The Rhododendrons of Sikkim Himalaya,* 1849-61, *Victoria Regia,* 1851, *A Century of Orchidaceous Plants,* 1851, *A Century of Ferns,*1854, *Illustrations of Himalayan Plants,* 1855, *Flora Tasmaniae,* 1855-60, *Filices Exoticae,* 1857-59, *A Second Century of Ferns,* 1860-61, and *British Ferns,* 1861. He also illustrated Elwes' *Monograph of the Genus Lilium,* 1880, and supplied 1,295 wood engravings for George Bentham's *Handbook of the British Flora,* 1865. (See page 48.)
lit: Blunt and Stearn, de Bray, Brinsley Burbidge, Fulton and Smith, Mabey, Rix, Sitwell, Stearn

★FITCHET, Valerie, S.F.P.　　　**1939 –**
Daughter of a keen amateur landscape painter, Valerie Fitchet has always drawn and painted. Although not encouraged at school, she made good use of her talent as a student nurse and it helped greatly in exams. After bringing up her family she resumed her interest and attended evening classes and workshops, residential and daily, taking A level art and Certificate and Diploma Courses. She says she has only ever wanted to paint flowers and works in all media but enjoys watercolour most of all.
　　She exhibits with the S.F.P. and the Mosaic Group and has had several successful solo exhibitions. Her work is in collections in the U.K., Channel Islands, North America, Germany, Spain and North America.

FITZJAMES, Anna Marie　　　**fl.1852 – 1876**
Pupil of W.H. Hunt and studied flower painting under V. Bartholomew. Exhibited flower paintings R.A. and S.F.A. Became a Member of the Society of Lady Artists.
lit: Brinsley Burbidge, Desmond, Clayton

FLEMWELL, George Jackson　1865 – 1928
Specialist painter of Swiss flowers whose work in this field was reproduced in several books prior to the First World War. He exhibited in most London galleries but died in Switzerland.
lit: Blunt and Stearn, Desmond, Waters

FORREST, Nancy　　　**1907 – 1997**
Studied at Sunderland College of Art and Craft. Worked mainly in watercolour with flowers as her predominant subject although she also painted some landscape and portraits under Anna Airy.
lit: Ipswich Art Society

FOSTER, Christine, S.B.A.　　　**1947 –**
Christine Foster was born in Cheshire and educated at Winsford Grammar School. From a small child she was keen on drawing and painting and her love of gardening and plants inspired her painting of flowers, mainly in watercolour. She is unduly modest about her work which she has exhibited and sold at many local exhibitions and with the S.B.A. She was made a Member in 1987.

FOSTER, John Ernest　　　**1877 – c.1965**
Born in Hull and lived for some time in Yorkshire before moving to Dedham in Suffolk. Studied at the Royal College of Art and painted flowers which he exhibited at the R.A., in the provinces and the Paris Salon. There is a flower painting in Dedham Church dedicated to his memory.
lit: Brinsley Burbidge, Desmond, Waters

FOWLE, Miss Bertha, R.M.S.　　　**1895 –**
Studied at Gravesend School of Art and painted flowers, landscape and miniatures. Elected Member R.M.S. in 1954. Exhibited R.A., R.I., R.M.S.
lit: Waters

FRAMPTON, Mary　　　**1773 – 1846**
Dorchester artist who produced four volumes of drawings of Dorset plants.
lit: Desmond

FRANCK, Helen　　　**fl.1883 – 1911**
London painter of flowers and still life. Exhibited R.A., S.S., N.W.C.S. and other venues.
lit: Brinsley Burbidge, Desmond, Grant

FRANCOM, Daniel　fl.early 18th century
Footman to the Duchess of Beaufort who was taught flower painting by the Dutch artist Kickins. He drew many of the plants in the Duke of Beaufort's collection and there are 110 pages of his originals in the Beaufort collection.
lit: Brinsley Burbidge, Desmond

★FRASER, Lady Ann　　　**1936 –**
Lady Fraser always wanted to go to art school but this was not encouraged and it was only when her four sons left home that she was able to start painting seriously. She joined Sir Robert Philipson's Special Drawing and Painting Course at Edinburgh College of Art in 1981 for four years and in 1985 she studied for a further year at the Royal Edinburgh Botanic Garden with John Mooney and Paul Nesbit.
　　Sir Charles and Lady Fraser are both keen gardeners and collectors of interesting plants which provide a wonderful range of subjects for the artist who works in a conservatory studio attached to her home and looking out on the beautiful garden. She had her first solo exhibition in 1991 at the Malcolm Innes Gallery in London which sold out and in Edinburgh she has exhibited at The Open Eye Gallery, the Kingfisher Gallery, the R.S.W., the Broughton Gallery and Malcolm Innes Edinburgh branch. She participated in a prestigious exhibition of Botanical Artists of the World at the Tryon Gallery, Cork Street, and in the 1999 Scotland's Gardens Exhibition at Inverleith House, R.B.G. Edinburgh. Her work has also travelled the world with the Shirley Sherwood Collection travelling exhibition.
lit: Sherwood

FRISWELL, Emma　　　**fl.1850s and 1860s**
London painter of flowers and fruit who exhibited R.A., S.B.A., B.I.
lit: Desmond

FRY, L.A.　　　**fl.1880s**
Eltham, London, artist who exhibited flower paintings R.A., S.B.A.
lit: Brinsley Burbidge, Desmond

FURSE, Paul　　　**1904 – 1976**
Great-nephew of Marianne North who made some flower paintings for the Royal Horticultural Society.
lit: Blunt and Stearn, Fulton and Smith, Rix

FRASER, Lady Anne. Tulips from the garden at Shepherd House.

GABRIEL, Loveday. Fruiting Fig.

Ficus carica 'Brown Turkey'

***GABRIEL, Loveday, S.F.P.** 1931 –
Although in her fifties before she started painting seriously, under the guidance of some excellent teachers and with an abundance of natural talent Loveday Gabriel is an accomplished flower painter working in all media. She paints both botanically and in a much looser vein; her lush meadows of wild flowers as well as more staid bouquets are all immensely satisfying. She has participated successfully in a number of exhibitions, including those of the S.F.P. in the U.K., Sweden and Jersey. She had a solo exhibition in Petersfield in 1995 and an exceptionally successful one in Kensington in 1997.
Colour Plate 74

GADSBY, William Hippon, R.B.A.
1844 – 1924
Born in Derby and studied at Heatherley's and the R.A. Schools, also in Italy. His wide repertoire included flowers which he exhibited R.A.
lit: Waters

GAINSBOROUGH, Elizabeth d.1769
Mother of Thomas Gainsborough, R.A. who is known to have painted flowers in the style of Vidal. One of Thomas Gainsborough's own plant studies is in the British Museum.
lit: Brinsley Burbidge, Desmond, Grant

GALLOWAY, Samuel fl.1827 – 1835
London artist who exhibited flower paintings R.A., S.B.A., N.W.C.S.
lit: Brinsley Burbidge, Desmond

GANDY, Celia fl.1826 – 1836
London artist who exhibited flower paintings in the R.A. under Mrs Gandy or her maiden name of Spencer. Her sister Hannah (fl.1829-33) also exhibited flower paintings R.A.
lit: Brinsley Burbidge, Grant

GARRETT, Dorothy Mabel Ellen 1908 –
Born Ipswich and studied at Ipswich Art School under George Rushton. Painted mainly flowers but some landscape. Exhibited R.A., R.I. and in many provincial galleries and others abroad including the Paris Salon. She had solo exhibitions in Ipswich and Bury St Edmunds.
lit: Ipswich Art Society, Waters

GARSIDE, Helen 1893 –
Botanical illustrator much admired by Wilfrid Blunt who compared her delicate and subtle watercolours to those of Dürer. She had the ability to make beautiful 'the meanest weed'.
lit: Blunt and Stearn, Desmond

GARTHWAITE, Anna Marie
fl.1726 – d.1763
Born in York but came to London to work as a textile designer at Spitalfields. Over 700 of her designs incorporating flowers, leaves and branches are in the V. and A.
lit: Brinsley Burbidge, Waters

GARTSIDE, Miss fl.1781 – 1808
Lancashire artist who exhibited flower paintings R.A. and other venues. Made one contribution to *Curtis's Botanical Magazine*.
lit: Brinsley Burbidge, Desmond, Grant, Scrace

GEMMELL, Mary fl.1876 – 1893
Flower painter who exhibited R.A., R.B.A. and other venues.
lit: Brinsley Burbidge, Desmond

GERE, Margaret, N.E.A.C. 1878 –
Born Leamington Spa, studied at Birmingham School of Art and later at the Slade. Painted flowers and figures. Member of the N.E.A.C. 1925 where she exhibited regularly. She held a one-man show at the Carfax Gallery in 1912.
lit: Brinsley Burbidge, Desmond, Waters

***GETHIN, Jackie, S.B.A.** 20th century
Jackie Gethin attended Southampton College of Art in the 'sixties, then found herself following an extremely talented and attractive fellow student to Poole and Bournemouth College of Art to do a C.I.C. in Industrial Ceramics. After three years she found herself to be not very good at designing pots but her flower paintings were in constant demand. She gave up the pots (and the attractive but deeply flawed fellow student) and has been painting flowers ever since.

Army life with her officer husband and bringing up three children slowed things down as far as painting was concerned but now, post army, she spends most of her time painting and framing her own work. Flowers have been joined by birds and animals and many of her designs have been reproduced on greetings cards and gift wrap.

Flowers in watercolour still take precedence and she exhibits regularly with the S.B.A. as well as in galleries in Rochester, Kent, and Beaulieu, Hampshire.

GIBSON, Julia 1931 –
Julia Gibson was born in Barnsley. educated in Ilkley and Whitby, and went to art school in Barnsley. Although her interest in the visual arts stayed with her, she actually became a professional musician until her career was halted after an operation for R.S.I. Art work again took over although she maintains that all her painting is influenced by music. Her keen interest in gardening and sketching led her to making floral collages backed by hand-painted silk.

Julia Gibson first exhibited in 1984 when the Halifax Building Society sponsored an exhibition of her work. In 1985 Elgin Court commissioned six card designs and exhibitions of collages were held in Spain and Wales in 1986. Painting soon took over from collage, flowers in a landscape being the major source of inspiration. In 1992 she started serious study with Peter Welton (Emeritus Professor of Fine Art, Simon de Montfort) who encouraged the use of pure watercolour without drawing. The sense of pattern characteristic of her work has led to commercial commissions for cards and other items. She was elected to the Yorkshire Watercolour Society and also exhibits in Wales, Devon and Yorkshire. She is represented by Artlink Gallery in Beverley.

GETHIN, Jackie. Field poppies.

GIBSON, Wendy. Spray of winter flowers.

★GIBSON, Wendy, S.F.P. 1930 –
As a teacher of home economics and needlework, Wendy Gibson decided to take some art classes in order better to express her embroidery ideas on paper. Flower painting in watercolour became such an absorbing interest that she was soon concentrating all her energies in that area along with gardening to encourage her subjects.

Wendy Gibson works both in a free, wet in wet, style as well as more botanically. She is a Member of the S.F.P. and exhibits with the Society. A number of her flower paintings have been reproduced as greeting cards.

GLASS, Pauline, R.B.S.A. 1908 –
Birmingham oil painter of flowers, still life and portraits. Studied at Birmingham College of Art and Beaux-Arts, Brussels. Exhibited R.A., R.O.I., R.P., R.B.A., W.I.A.C.and the Paris Salon.
lit: Brinsley Burbidge, Desmond, Waters

GLIDDON, Kate Edith 1883 –
Born Twickenham, spent many years in Sussex. Studied at the Slade under Brown and Tonks and painted flowers in watercolour. Exhibited R.A., N.E.A.C., R.W.S.
lit: Waters

GLOAG, Isobel Lilian 1865 – 1917
Born Kensington and trained at St John's Wood Art School, the Slade and in Paris. Painted flowers and her work is in the collection of Paris Art Moderne.
lit: Brinsley Burbidge, Waters

GODDARD, G.H. fl.1837 – 1844
London artist who exhibited flower paintings R.A. and S.B.A.
lit: Brinsley Burbidge, Desmond, Grant

GODDARD, James fl.1800 – 1855
London flower painter who exhibited extensively at the R.A., B.I., S.B.A. and many other venues.
lit: Brinsley Burbidge, Desmond, Grant, Wood

GONNE, Mrs Anne 1816 – 1850s
Born Devon and studied flower painting at the R.H.A., Dublin. Modelled wax flowers.
lit: Brinsley Burbidge, Desmond

GORE, Frederick Spencer, N.E.A.C.
 1878 – 1914
Born Epsom and later lived in Richmond and Harrow. Studied at the Slade and painted flowers, landscape and ballet. Founder Member and first President of the Camden Town Group. Became Member N.E.A.C. in 1909.
lit: Brinsley Burbidge, Desmond, Waters

★GOSS, Margaret, S.F.P. 20th century
Gained Distinction in School Certificate Art in 1950, G.C.E. in Advanced Art in 1951, became full time student at Stoke-on-Trent College of Art later in 1951. Passed Intermediate Examination in Art and Crafts in 1953, went on to six months' training in free-hand pottery painting at the Susie Cooper Pottery and was later accepted as a designer by a firm in Longton.

In 1958 Margaret Goss attended a teacher training college after which she taught in Junior Schools and Adult Education until 1994. Since then she has turned her talents to flower painting, is a Member of the S.F.P. and has had much of her work reproduced as greetings cards.

GOULD, Pauline, S.F.P. 1942 –
Gained Distinction in Art at Brentwood Teacher Training College in the 'sixties and went on to teach in primary and secondary schools, finishing her teaching career as Head of Art in a special needs school.

Since early retirement Pauline Gould has concentrated on painting, particularly flowers for which she has a great love. She studied (in retirement) under Kevin Raynor at the Winchester Towers Art Centre and has been successfully exhibiting her flower paintings in all media.

GRAHAM, W. Josephine fl.1880s and 1890s
Exhibited some flower paintings N.W.C.S. during the 1880s. Contributed to F.H. Davey's *Floral Cornwall,* 1909.
lit: Brinsley Burbidge, Desmond

GRANGER, Margaret, S.B.A. 1939 –
Margaret Granger, on completion of a City and Guilds Course in 1977, devised a technique of using paint with embroidery on fabric to make small pictures of gardens and landscapes which were sold at Liberty's, London, a number of galleries in the U.K. and in the U.S.A. She has always had a passion for flowers, especially irises, and began to develop flower painting seriously in the early 1980s. One of her interesting commissions was to paint Bob Nicholls' bearded irises for use as a trophy by the Iris Society.

Her watercolours of flowers are usually shown alongside her embroideries, all inspired 'by the richness of colour and the deeper spiritual aspects of nature'. As well as participating in many mixed exhibitions all over the country, Margaret Granger exhibits regularly with the S.B.A. and has shown at the Mall Galleries, Westminster Gallery, the Barbican Gallery and Leeds City Art Gallery. In 1987 she exhibited thirty-two works at the Medici Gallery, London and in 1988 twenty works at the same gallery. The Medici Society have reproduced many of her flower paintings as greetings cards and their flower calendar. She was elected to Membership of the S.B.A. in 1988.

GRAY, Dorothy, R.M.S. 1901 –
Lived in London and Bexhill on Sea and painted floral miniatures on ivory. Exhibited R.A., R.M.S., S.W.A. and Foyles Art Gallery.
lit: Brinsley Burbidge, Waters

GREEN, Amos 1735 – 1807
Born Halesowen, later moved to Bath and died in York. Painted flowers, fruit and some landscape, examples being in the V. and A. and the British Museum.
lit: Brinsley Burbidge, Grant

GREEN, Richard Grafton 1848 –
Born Essex, studied at Heatherley's and painted flowers as well as landscapes and portraits. Exhibited R.A., R.I., R.B.A. and in the provinces.
lit: Waters

GREENBANK, Arthur fl.1888 – 1898
Painter of flowers and figures, exhibited R.A., S.B.A., N.W.C.S. and other venues.
lit: Brinsley Burbidge, Desmond

GREENWOOD, Lawrence 1915 – 1999
Lawrence Greenwood's artistic talent was recognised at an early age and he was invited at the age of twelve to attend Saturday morning art classes at the Fielden School of Art. Initially his interest was in landscape painting but his love of the hills led him to a fascination with mountain flowers. He joined the Alpine Garden Society in 1964 and the Scottish Rock Garden Club in 1968, the year in which he seriously turned his attention to painting flowers.

Lawrence Greenwood exhibited at the R.H.S., the International Alpines Conference and had an exhibition of his paintings at the Perth Show every year from 1971 to the end of his life. He also exhibited regularly at the Stirling Show, for twenty-two years at the A.G.S.

GOSS, Margaret. Hellebore.

GRIERSON, Mary Anderson. *Cibotium baronetz*

Summer Show North and many commercial galleries in England and Scotland. He had four exhibitions at Cluny House and one in Manchester and his work has been shown at Kew with the Shirley Sherwood Collection and, in 1992, with the Hunt Institute's International Exhibition of Botanical Art. Dr Sherwood has remarked on his unique ability to paint accurate portraits of flowers from plant hunters' transparencies producing 'watercolours which have amazed the botanists and gardeners who have seen them'.

His work has been widely reproduced in various journals and is in a number of private and public collections including the Shirley Sherwood Collection and the Hunt Institute who recently added the last painting he did before his death.
lit: Sherwood
Colour Plates 75 and 76

GREENWOOD, Leslie 1907 - 1987
Born Wood Green, London, son of Charles Greenwood, architect and artist, by whom he was trained. A very detailed painter of flowers both decorative and botanical from all over the world. Many of his works have been reproduced by the Medici Society and Royle Publications; he also illustrated Perry's *Garden Flowers of the World,* 1972, and *Flowers of the World, paintings by Leslie Greenwood,* 1977, and designed twelve plates for Wedgwood.

He exhibited with the R.I., R.B.A. and the R.H.S. by whom he was awarded two gold Medals. His work is represented in the Hunt Institute.
lit: Brinsley Burbidge, Desmond, Medici Society

GREVILLE, Dr Robert Kaye 1794 - 1866
Friend of Sir Joseph Hooker and author of *Scottish Cryptogamic Flora* published in six volumes 1823-28. He executed many of its 360 plates himself representing algae and fungi. He

also illustrated W.J. Hooker's first fern book, *Icones Filicum,* 1829-31. As well as being a highly regarded naturalist, he produced very clear and expressive drawings.
lit: Blunt and Stearn, Brinsley Burbidge, Desmond, Mabey, Rix

GREY, Edith fl.1890s
Artist from Newcastle upon Tyne who exhibited fruit and flower paintings R.A. and N.W.C.S.
lit: Brinsley Burbidge, Desmond

GREY-WILSON, Christopher 1944 -
Botanist and botanical illustrator, one-time editor of the *Botanical Magazine.* He was on the staff of the R.B.G., Kew, for some time from 1967 and received an R.H.S. Gold Medal for botanical painting in 1970. He illustrated his own *The Genus Dionysia in the Wild and in Cultivation,* 1970, and has contributed to *Flora of Tropical Africa, Gardeners' Chronicle* and the *Journal of the Alpine Garden Society.*
lit: de Bray, Brinsley Burbidge

★GRIERSON, Mary Anderson 1912 -
Born in North Wales of Scottish parentage, Mary Grierson has been keen on drawing and painting since childhood. After the Second World War, during which she worked as a cartographical draughtswoman, she attended a course by John Nash, R.A., and soon embarked on a career as a botanical illustrator.

In 1960 she was appointed botanical artist at the R.B.G., Kew, and illustrated many of Kew's scientific works and floras; she also contributed many plates to *Curtis's Botanical Magazine* and the *Icones Plantarum.* In 1972 she retired as Senior Botanical Illustrator and went freelance, travelling widely and painting flora of other countries as well as Great Britain. She received commissions from the Israeli Nature Reserve Authority, the World Wide Fund for Nature and the Pacific Tropical Garden, Hawaii.

She illustrated Hunt's *Orchidaceae,* 1973 (40 col. plates), Stearn and Brickell's *An English Florilegium,* 1987, and *Trees and Shrubs Hardy in the British Isles,* Grey-Wilson's *The Genus Cyclamen,* 1988, Mathew's *The Crocus,* 1982, and *Hellebores,* 1989. She has also contributed to the *Country Life Book of Orchids,* the *Kew Bulletin* and many other publications.

Mary Grierson was awarded the Gold Veitch Memorial Medal by the R.H.S. as well as four Gold Medals for Botanical Illustration and received an Hon. Degree from Reading University. In 1967 the Post Office used her designs on a set of postage stamps depicting flora of the British Isles and she produced a series of paintings of tulip species for a Dutch bulb company. Her work has featured in many exhibitions and is in public and private collections in the U.K. and abroad. In 1998 she was awarded the prized Victoria Medal of Honour.

Mary Grierson is also an expert embroideress and, a rather nice connection, derived one of her designs from a composition by Marianne North. (See page 68.)
lit: de Bray, Desmond, Rix, Scrace, Sherwood, Stearn
Colour Plates 36 and 37

★GRIFFITHS, Gillian 1946 -
Always a hobby painter with a passionate love of flowers, Gillian Griffiths actually worked as a secretary with the South Wales Police for twenty-three years. In 1982 she went on a five day non-vocational course in botanical illustration at West Dean College, Chichester, tutored by Margaret Petterson, and those five days 'changed my whole life. What had been a sometime hobby became an all-time obsession'. In 1986 a series of botanical paintings entered in the R.H.S. Exhibition earned her a Gold Medal and in 1988 her first solo exhibition resulted in a sell-out in four days.

At that point Gillian Griffiths gave up her job and now concentrates fully on her botanical and flower painting. She participates in many mixed exhibitions and has an annual show of her own at the local Heritage Coast Centre. She has been awarded a further two Silver Gilt Medals from the R.H.S. and has taught flower painting to adults for the past thirteen years. Her work is now in a number of public and private collections.

'I enjoy experimenting with all forms of watercolour techniques to paint my flowers, but my initial training in botanical illustration underpins all my work. My main technique now is to paint on coloured paper with watercolour and a small amount of body colour to achieve greater atmospheric effects, but I also still enjoy painting botanic studies in pure watercolour.'
lit: Sherwood

GRIFFITHS, Gwenny 1867 -
Welsh artist, pupil of le Gros in London and the Julian Academy in Paris. Painted flowers and portraits and exhibited flower paintings R.A., S.B.A. and other venues.
lit: Brinsley Burbidge, Desmond, Grant, Waters

GRIFFITHS, Miss Kate fl.1770s
Artist from Winchfield, Hampshire, who painted flowers and exhibited R.A. and the Free Society.
lit: Brinsley Burbidge, Desmond, Grant

GROSE, Millicent S. fl.1870 - 1890
Oxford artist who exhibited flower paintings R.A., S.S., N.W.C.S.
lit: Brinsley Burbidge, Desmond

GROVES, Christine, S.F.P. 1933 -
Christine Groves' artistic career started with dressmaking and design and, after joining her local art society, painting portraits and landscape in oils. As time went on she turned to watercolour, concentrating mainly on floral studies from the flowers of her own garden. A twelve-month study at Turnford College, Hertfordshire, led to her first, highly successful, solo exhibition in 1980.

In 1984/5 she studied on-glaze painting on porcelain after which she obtained a teaching post at a college for adult education. Soon she was sending her hand-painted porcelain and watercolour flower paintings all over the world. For nearly twenty years she has been providing designs for a number of greetings card and print publishers and now issues her own greeting cards and prints in addition.

GRIFFITHS, Gillian. *Euphorbia martinii.*

GUERIN, Anne Marie (née Edmonds)
fl.1870s
Born Bradford on Avon, exhibited flower paintings R.A. and S.B.A.
lit: Brinsley Burbidge, Clayton, Desmond

GUILLOD, Bessie **fl.1876 - 1893**
London artist who exhibited B.A., S.B.A. and other venues.
lit: Brinsley Burbidge, Desmond

GWATKIN, Major Joshua Reynolds Gascoigne, M.A.Cantab., J.P. **1855 - 1939**
Descendant of Joshua Reynolds; took a Master's degree at Cambridge, then joined the army, first becoming a captain, then major, in the Royal Wiltshire Yeomanry. A keen ornithologist and taxidermist, he only took up watercolour in his sixties. He found he had a natural talent for the medium and, with some botanical knowledge, became an extremely competent botanical artist. Over 1,000 of his watercolour drawings are catalogued in *Paintings of Flowering Plants,* mainly British. Some of the drawings are in the collection of the Linnean Society.
lit: Brinsley Burbidge, Desmond, Waters

GWENNAP, Thomas **fl.1920s**
London painter of flowers and fruit who

exhibited R.A., B.I., S.B.A.
lit: Brinsley Burbidge, Desmond

GWYNNE-JONES, Allan, R.A., R.P., N.E.A.C. **1894 -**
Born Cirencester, trained at the Slade under Tonks and McEvoy. Became Professor of Painting at the Royal College of Art until 1930, later a teacher at the Slade. Painted flowers as well as some landscapes and portraits and exhibited R.A. and other venues. Work is in the collection of the Queen, the Tate Gallery, British Museum and the V. and A.
lit: Brinsley Burbidge, Desmond, Waters

GYLES, Pauline, R.M.S., F.S.B.A.
20th century
Born and still living in Dorset, Pauline Gyles started her artistic career hand colouring portrait photographs in watercolour to such a high standard that they could be taken for paintings rather than tinted photographs. From the early seventies she has specialised in miniature and botanical painting. She was a Founder Member of the S.B.A. and was appointed Hon. Secretary of the R.M.S. in 1999. She exhibits regularly with both societies and in galleries in London and the provinces.
In 1994 she gained the prestigious Gold Bowl Memorial Award for the best miniature in the R.M.S. Annual Exhibition.

HADFIELD, Miles **1903 - 1982**
Born Birmingham and studied at Birmingham University, following initially an engineering career but switching to freelance writing and illustrating his own works using pen and watercolour. Illustrated *The Gardener's Companion,* 1936, *Everyman's Wild Flowers,* 1938, *Pioneers in Gardening,* 1955, and *Gardening in Britain,* 1960.
lit: Brinsley Burbidge, Desmond

HAGUE, Josephine, N.D.D., B.A. (Hons.)
1928 -
Josephine Hague, one of our most brilliant botanical artists, first qualified in textile design at Liverpool College of Art, later having one of her examination designs accepted by the V. and A. for their collection of contemporary textiles. She has designed textiles for the U.S. and Japanese markets as well as the U.K.
In 1979, after bringing up her family, she started flower illustration for many authors and publishers of cards, calendars, etc. including Royle Publications, the Ariel Press (set of eight paintings 'Country Flowers'), limited edition plates for Wedgwood/R.B.G., Kew, designs for Kew plates, cups and saucers and a set of nine

wild flower plates for the Bradford Exchange. She designed the commemorative plate for the 1998 Chelsea Flower Show issued by the R.H.S. in Honour of the 50th Birthday of H.R.H.Prince Charles, Prince of Wales, and, for the Hunt Institute, the cover for the *Catalogue of the 9th International Exhibition of Botanical Artists and Illustrators,* 1998.
As well as exhibiting regularly with the R.H.S. and the R.B.G., Kew, she has exhibited her flower paintings and botanical illustrations in mixed or solo exhibitions in major London galleries as well as in Liverpool, Wirral, the U.S.A., Tokyo, Sydney, South Africa and Scotland. Her work is in a number of important public and private collections.
In 1981 and '82 she was awarded the R.H.S. Grenfell Silver Gilt Medal for Botanical Drawings and Flower Paintings respectively, in 1984 the Large International Gold Medal by the International Garden Festival and in 1985, '86 and '88 the R.H.S. Gold Medal and the Silver Lindley Medal for each year.
lit: Sherwood, Stearn

HAIG, Elizabeth **late 19th century**
Although nothing seems to be known about this lady, there is a collection of her flower paintings at the Royal Botanic Gardens, Edinburgh.
lit: Brinsley Burbidge, Desmond

HAMMOND, Gertrude Demain, R.I.
fl.1880s and 1890s, d.1952
Trained at Lambeth School of Art and the

R.A.Schools. Exhibited flower paintings R.A., S.B.A., R.I., N.W.C.S. Worked mainly in watercolour and illustrated a number of books.
lit: Brinsley Burbidge, Desmond, Waters

HANBURY, Ada **fl.1876 - 1887**
London painter of flowers and fruit who exhibited R.A., S.B.A., N.W.C.S.
lit: Brinsley Burbidge, Desmond

HANBURY, Blanche **fl.1876 - 1887**
Sister of Ada, also exhibited paintings of fruit and flowers R.A., R.B.A., N.W.C.S.
lit: Brinsley Burbidge, Desmond

HANCOCK, Margaret **1945 -**
Studied at the Royal College of Art under Professor Carel Weight, Ruskin Spear and Peter Blake. Painter of flowers and fruit, exhibits R.A. and other venues.
lit: Brinsley Burbidge

***HARDCASTLE, Audrey, S.B.A.** **1934 -**
Audrey Hardcastle was born in Yorkshire and pursued a teaching career until 1981 when her interest in botany and talent for painting decided her to become a full-time botanical artist. Working in watercolour, acrylic and coloured pencil, she has exhibited with the S.B.A. of which she is a Member, the S.F.P. and the Linnean Society of London, as well as other venues in this country and in Wales, Johannesburg, Sweden and the U.S.A. Her work is in the collection of the Hunt Institute.

HARDCASTLE, Audrey. Slipper Orchid.

She received the S.B.A. Certificate of Botanical Merit and the St Cuthbert's Mill Award in 1995 and 1997 respectively.

HARDCASTLE, Charlotte
fl.1850s and 1860s
London flower painter, exhibited R.A., B.I., S.B.A.
lit: Brinsley Burbidge, Desmond

HARDMAN, Emma W. fl.1885 - 1935
Lived Potters Bar, Hertfordshire. Exhibited flower and garden paintings as well as some landscape and portrait subjects at the R.A., S.B.A., N.W.C.S., Paris Salon and other venues.
lit:Brinsley Burbidge, Desmond, Waters

HARDWICK, John Jessop, A.R.W.S.
1831 - 1917
Born in London, died Thames Ditton, Surrey. Encouraged by Ruskin and Rossetti, he exhibited many flower paintings at the R.A., S.B.A., G.G. and O.W.C.S., of which body he became a Member. He also illustrated magazines. His work is in the collection of the Harris Museum and Art Gallery, Preston.
lit: Brinsley Burbidge, Desmond, Hardie

HARDY, William Wells fl.1818 - 1856
Exhibited flower paintings R.A. and S.S.
lit: Brinsley Burbidge, Desmond

HARKER, Ethel 20th century
Studied at Chester School of Art and privately. Painted flowers, still life and portraits. Exhibited Walker Art Gallery, Liverpool.
lit: Brinsley Burbidge

HARRE, M. Elaine, S.B.A. 20th century
Elaine Harre is not strictly speaking a flower painter but the fact that she is a Member of the S.B.A., exhibiting regularly with them and the R.H.S., and the fact that her beautiful work is based on strictly accurate drawings surely entitles her to a place in this book. Her work consists of producing botanically accurate and very decorative engravings on glass. She specialises in alpine flowers and works from the drawings she makes while walking in the Alps and Pyrenees.

She has been engraving since 1975 and is an Associate Fellow of the Guild of Glass Engravers with whom she exhibits regularly.

***HARRELL, Shirley, S.W.A., B.W.S., S.F.P., F.I.G.A. 20th century**
Shirley Harrell, sister of Alwyn Crawshaw, started her artistic career as a fashion designer and part-time lecturer, retiring and restarting after bringing up her family. In 1978 she was appointed Head of Art and Related Studies at the College of Adult Education in Manchester but after nine years retired in order to pursue a full-time painting career. She participates in many mixed exhibitions and has had solo shows in London, Manchester and Plymouth. Although she paints a variety of subjects, her floral work is exceptionally attractive and has been widely reproduced as limited edition prints and greetings cards.

Her awards include Artists in Cornwall Best Watercolour in Show, Society of Floral Painters Chairman's Trophy and second place for Best Painting in Exhibition, 1997, Devon Art Society Hilda Carter Trophy for best flower painting in watercolour, 1998, and the British Watercolour Society Rowland Hilder Shield.

***HARRIGAN, Elspeth 1938 - 1999**
Born in Scotland, where she spent her life, Elspeth Harrigan attended Glasgow School of Art 1956-60 and gained a Diploma in Graphic Art and Printmaking. She was a specialist flower painter and botanical illustrator and a long list of awards includes R.H.S. Bronze and Silver Medals and a Bronze Medal from the Orchid Festival, Glasgow. She illustrated *Wild Plants of Glasgow* by Dr James Dickson and the cover of the *Guide to Crarae Garden*. Her solo exhibitions were held in Peebles, 1988, Stenton, 1989 and Kelvingrove, 1991. She also showed in group exhibitions in Ayr, Broughton, Flying Colours Gallery (with her artist husband James Harrigan) and 41 Gallery, Edinburgh, five venues in Glasgow and in Peebles, Stenton and Tolquhon as well as Thompson's Gallery in London.

HARRIS, Frances Elizabeth Louise (née Rosenberg) 1822 - 1883
Daughter of the Bath artist, Thomas Elliot Rosenberg. Painted flowers and genre and exhibited 139 works at the N.W.C.S. of which she became a Member. Also exhibited R.A.
lit: Brinsley Burbidge, Desmond

***HARRIS, Julie c.1920 -**
Julie Harris is best known as the Oscar, Bafta and British Academy Award winning costume designer of 120 films including Bond films, romances, wartime drama and many more. From time to time she has also 'dabbled' in painting and, since her retirement after fifty-six years of dressing the stars, has been taking her flower painting seriously. A natural artistic talent has combined with a passionate love of flowers to produce quite remarkable results and she has received a number of gratifying commissions. An

HARRELL, Shirley. Still life with cyclamen.

HARRIGAN, Elspeth. Strelitzia.

exhibition at Sotherans in 1994 resulted in further commissions from Michael Caine and other film friends and several from the Sultan of Oman. Her entire remaining collection of costume sketches has been bought for the British Film Institute archives by Paul Getty.
Colour Plate 77

HARRISON, Maria, A.R.W.S.
 fl.1845 - 1893
Member N.W.C.S. and S.B.A. Exhibited paintings of flowers and fruit R.A., B.I., S.B.A. and an astonishing 439 O.W.C.S.
lit: Brinsley Burbidge, Clayton, Desmond

HARRISON, Mary P. (née Rossiter)
 1788 - 1875
Although her interest in painting was discouraged by her parents, when her husband became ill and unable to work her talent came into its own and she was successful enough to support them in reasonable comfort. She painted compositions of wild flowers, birds' nests and fruit, her special interest being roses and primroses. She also drew orchids for *Curtis's Botanical Magazine.* She exhibited R.A., B.I., S.B.A., N.W.C.S. and in Paris. Her work is in the Queen's Collection.
lit: Brinsley Burbidge, Clayton, Desmond, Kramer

HART, M. **fl.1820s and 1830s**
Botanical artist who contributed 800 plates to the *Botanical Register,* also to R. Sweet's *Cistineae,* 1825-30, and *Geraniaceae,* 1820-30.
lit: Brinsley Burbidge, Desmond

HART-DAVIES, Christine, R.M.S.,
F.S.B.A., S.F.P. **20th century**
Christine Hart-Davies read Fine Art and Typography at Reading University and worked for several years with a London design group being mainly responsible for the design and production of educational books. In 1975, after a time spent sailing and travelling in Europe and North Africa, she settled in Dorset and began to combine her twin interests of painting and natural history, soon becoming well known for her botanical watercolours.
 Christine Hart-Davies has travelled widely in Europe, Australia and the Americas studying and

painting the native flora. She holds an R.H.S. Gold Medal and a World Orchid Conference bronze for her paintings of Australian and European native orchids. In 1993 she joined an expedition to Sumatra to paint plants of the rain forest and mountain areas, the results of which were part of a three-man exhibition at Kew in 1994. Another special interest is in mosses and lichens for which she has four times been awarded an R.H.S. Gold Medal.
 Her major exhibitions include Medici Gallery (miniatures, botanical subjects, habitats and gardens) 1984, '85, '87 and '92, Spring Hill Gallery, Brisbane (solo) 1984 and '85, 'Flowers for a Festival', Bath, 1985 and '86, Creative 92 Gallery, Queensland (solo), 1985, Young Masters, Brisbane (solo) 1987, (shared) 1989, Peter Hedley Gallery, Wareham, 1987, '89, '91, '92, Chris Beetles Countrylife Gallery, London, 1989 and '90, 7th International Exhibition of Botanical Art and Illustration, Hunt Institute, 1992, World Orchid Conference, Glasgow, 1993, Kew Gallery, 1994, Shirley Sherwood Collection, R.B.G. and touring, 1996, and Towngate Art Centre, Poole (solo) 1997. She has also exhibited with the S.B.A. (of which she is a Founder Member and was Hon. Sec. 1985-95), the Royal Institute of Painters in Watercolour, the R.M.S., Hilliard Society of Miniaturists and the Paris Salon. She has also illustrated many books including *A Year in a Victorian Garden* and has contributed illustrations to the *Kew Magazine* and the *R.H.S. New Dictionary of Gardening.* Her work is in many collections, notably the Hunt Institute and the Shirley Sherwood Collection.
 Wherever possible her paintings are made from life and on her many travels she has worked extensively in the field in a variety of habitats. Her subject matter is drawn from the cultivated or exotic specimens grown in parks, gardens and greenhouses as well as from native flora.
lit: Sherwood

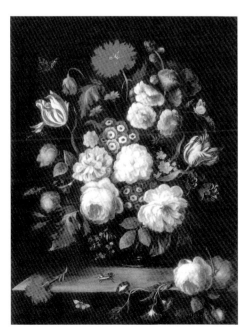

HARRIS, Julie. Flower piece.

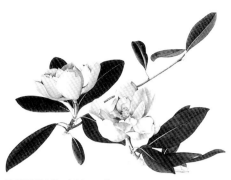

HAYDEN, Toni. Magnolia.

HARTLAND, Gertrude **1865 - 1954**
Flower painter, mainly of daffodils in the nursery of W.B. Hartland, 1887-1897
lit: Desmond

HASTIE, Grace H. **1855 - 1930**
London painter of flowers in watercolour and some landscape. Member of the Society of Lady Artists. Exhibited R.A., N.W.C.S., S.B.A., G.G., N.G. and other venues.
lit: Brinsley Burbidge, Desmond, Waters, Wood

HATCH, Ethel C., S.W.A. fl.1920 - 1960
Kensington watercolour artist, flower painter, studied at the Slade under Tonks and Wilson Steer. Exhibited R.A., N.E.A.C., S.W.A. and the Paris Salon.
lit: Brinsley Burbidge, Waters

HATTON, Helen Howard fl.1870s and 1880s
London artist who exhibited flower paintings R.A. and S.B.A.
lit: Brinsley Burbidge

HAY, Alfred **1866 - 1932**
Although a Professor of Electrical Technology in Bangalore, he spent most of his spare time sketching local plants. His collection of drawings of Bangalore plants was donated to Kew. Mabey comments on the technical mind brought to his rendering of the structure of the plants.
lit: Desmond, Mabey

HAY, Cecil George Jackson **1899 -**
Flower painter born in Kent but studied at Glasgow School of Art. Later lived in London and exhibited R.A., R.S.A., N.E.A.C.
lit: Waters

***HAYDEN, Toni, F.L.S., S.B.A.** **1938 -**
Toni Hayden trained at Norwich School of Art 1954-55, taking a full time graphic design course specialising in calligraphy. Since then she has taken a number of different courses as her career developed. She started as a poster writer for a Norwich store and subsequently worked as display assistant, window dresser, artworker, graphic and interior designer and part-time teacher, all broadening her artistic experience. After raising her family she became graphic designer and artist combining her design work

HEGEDÜS, Celia. *Iris pseudacorus.*

HEGEDÜS, Celia. *Fritillaria imperialis.*

with fine art drawing, painting and exhibiting. She has also taught flower painting, always her main fine art interest, in private classes and adult education.

Toni Hayden has had over thirty solo exhibitions, mainly in Norwich but also seven in London, one in Gorleston and one in Henley. She has exhibited in a large number of group exhibitions including the S.B.A., R.H.S., and the Hunt Institute. She is a Member of the S.B.A., the American S.B.A., the Association of Illustrators and is a Fellow of the Linnean Society. She holds an R.H.S. Grenfell Medal, two Grenfell Silver Medals and a Grenfell Silver Gilt Medal. In 1995 she won the S.B.A. St Cuthbert's Mill Award

Toni Hayden's work is in such important public collections as the British Museum, the V. and A., the Hunt Institute, the Shirley Sherwood Collection, London University (QMC), John Innes Institute and many private collections. She is fluent in Italian and Japanese and her work has been exhibited in Tokyo.

HAYWARD, Alfred Frederick William, R.O.I. 1856 - 1939
Born in Canada, came to London in 1875 to study at West London Art and R.A. Schools. Later he moved to Winchester and then to St Ives, Huntingdonshire. Exhibited flower paintings and portraits R.A., S.S., G.G., N.G., R.S.A., Paris Salon and other venues.
lit: Brinsley Burbidge, Desmond, Waters

HEATHER, John fl.1760s
Colchester artist, exhibited flower paintings at Free Society of Art, London.
lit: Brinsley Burbidge, Desmond, Grant

*HEGEDÜS, Celia, S.B.A. 1949 –
Celia Hegedüs was born and lives in London and is a flower painter of international repute. While observing the strictest accuracy, she concerns herself with depicting the character and 'presence' of individual flowers in portraits rather than seeking to represent an idealised view. Her work has been compared with that of Dürer, Hugo van der Goes and Pieter van Kouwenhoorn.

Celia Hegedüs paints on vellum on specially prepared board using mainly watercolour with some bodycolour. Her work has regularly been exhibited with the R.A., S.B.A. and the R.H.S. where she has been awarded three Gold Medals. She has also exhibited in group exhibitions at Offer Waterman, R.B.G., Kew, Spring Fair, Olympia, Tryon and Swann and has had a solo exhibition at Waterman Fine Art in 1995 and at Offer Waterman in 1999. Her work is in numerous collections in the U.K., Europe, America and the Middle East.
lit: Sherwood

*HEMS, Margaret, F.S.B.A., S.F.P. 1931 –
Margaret Hems was born and now again lives in Essex where she spent a happy childhood and developed a strong love of the countryside and its wild flowers and animals. She has also always been interested in art and artists and while at school entered the Royal Drawing Society

examinations and passed each grade with honours. She did not seriously take up art again until, at the age of thirty-three, she gave up a career as a fashion and photographic model.

She and her husband moved to Somerset and roaming the fields and woods around their home rekindled her interest in wild flowers and she started to study flower painting seriously under Mary Grierson at the Flatford Mill Centre. Like many younger artists, she was inspired by Mary Grierson's own work and this proved the start of a highly successful flower painting career. She has exhibited her work in many galleries in England and Wales and with the S.B.A. of which Society she is a Founder Member, also the R.H.S. from whom she received a Grenfell Medal.

Margaret Hems paints both in a botanical manner and decorative flower studies. Her work has frequently been reproduced on greetings cards and is in collections in the U.S.A., Scandinavia, Saudi Arabia, Europe, Australia and New Zealand.
Colour Plate 79

HENDERSON, Peter Charles fl.1799-1829
Contributed fourteen plates to Thornton's *Temple of Flora* (see page 28) and some to *The Seasons or Flower Garden,* 1806. Also painted portraits and miniatures. Produced a *Treatise or General Instruction for Drawing and Painting Flowers.*
lit: Blunt and Stearn, de Bray, Brinsley Burbidge, Desmond, Fulton and Smith, Rix, Sitwell
Colour Plate 5

*HENTALL, Maurice, F.R.S.A., S.B.A., C.B.M. 20th century
Maurice Hentall studied at Hornsey College of Art until he joined the R.A.F. After the war he established a studio in London carrying out commissions in show business and publicity. He was a great success in this work, some of his most important work including a book cover design for presentation to the Queen and Birth of a Star for the Festival of Britain — a giant contemporary design for a sculpture which was

HEMS, Margaret. Anemones.

HENTALL, Maurice. Begonias.

unveiled by Earl Mountbatten of Burma. In 1951 he was elected a fellow of the R.S.A.

After twenty years as Managing Director of Artique Studios Limited, he retired on health grounds and returned to fine art including flower painting. He was elected a Member of the S.B.A. in 1987 and later received the Certificate of Botanical Merit. His work has been purchased by a number of publishing houses including the Medici Society and Gordon Fraser and is in collections in Europe, the U.S.A., Australia and New Zealand. He exhibits at the R.A., the Mall Galleries, the Llewellyn Alexander Gallery and Westminster Central Hall, as well as many provincial galleries.

HERBERT, William 1778 – 1847
One of the artists who produced paintings for the *Botanical Magazine* after Sydenham Edwards left and before W.J. Hooker took over.
lit: Blunt and Stearn

HESELTINE, Julia 1933 –
Daughter of Anna Zinkeisen (Mrs Guy Heseltine) who, like her mother (q.v.), specialises in portrait painting but who also produces some very beautiful flower paintings in the same immaculate style.
lit: Walpole, Waters
Colour Plate 78

HEWLETT, James 1768 – 1836
Son of a gardener, he lived mainly in Bath but died in Isleworth, Middlesex. Highly successful artist noted for his superior flower studies in the style of van Huysum, also watercolour sketches of flowers. Contributed to *Menthae Britannicae,* 1798. Exhibited R.A., S.B.A., B.I., O.W.C.S. and other venues (see page 27).
lit: Brinsley Burbidge, Desmond, Grant, Mitchell

HIBBERT, Phyllis, R.W.S. 1903 –
Lived Lytham St Anne's, Lancashire. Painted flowers in oil and watercolour and exhibited R.A., R.I., R.B.A., R.W.S., the Paris Salon and in the provinces. Work represented in the Harris Museum and Art Gallery, Preston
lit: Brinsley Burbidge, Desmond, Waters

HICKEY, Michael, F.L.S., F.S.B.A.,
M.I.Hort., F.R.H.S., B.S., B.I. 20th century
Michael Hickey first trained and worked in horticulture. He attended the Sussex College of Agriculture and obtained credit in the R.H.S. examination in General Horticulture in 1951. He became a horticultural student at the University Botanic Garden, Cambridge, from 1952-54, obtaining their qualification and worked in horticulture becoming Chief Plant Propagator at one of the nurseries in Brighton Parks and Gardens Department. He also worked for a short time in Coventry Parks Department, later being in charge of a six acre private garden.

He next qualified as a teacher at St Paul's Teacher Training College, Cheltenham, receiving a distinction in his special study of General Science and Biology, then added a supplementary course on the teaching of art. He held various teaching posts including evening classes, short courses and working parties until 1982 when he left full-time teaching to become a part time lecturer and free-lance botanical illustrator. He has since held many courses in botanical illustration as well as botany and horticulture.

He was invited by the Director of Cambridge University Botanic Garden to illustrate and co-author *100 Families of Flowering Plants,* 1981, a definitive work used by students of botany at institutions all over the world; a second edition followed in 1988 with 200 illustrations. He also illustrated *A New Key to Wild Flowers* by John Hayward, 1987, with 800 illustrations and illustrated and co-authored with Clive King *Common Families of Flowering Plants.* He has contributed illustrations to many other books and publications in similar vein and, in a number of cases, also co-authored.

Michael Hickey has exhibited with the Botanical Society of the British Isles (Natural History Museum) 1978 and 1996, the R.H.S. Exhibitions, 1978, 1980 and 1983, regularly at the S.B.A. exhibitions, Cheltenham and Gloucester College of Higher Education, 1991 and '92 and the Linnean Society of London 1991, the 7th International Exhibition of Botanical Art and Illustration, Carnegie Mellon University, Pittsburgh, 1992, and the Gloucester-shire Society of Botanical Illustration Exhibitions 1995 and 1996. He was awarded the Silver Lindley Medal in 1978 and the Silver Gilt in 1980 by the R.H.S. and is a Member of the Linnean Society, a Founder Member of the S.B.A., an elected Member of the Institute of Horticulture, the first Hon. Member of the Chelsea Physic Garden Florilegium Society and Founder Chairman of the Gloucestershire Society for Botanical Illustration. He is a Fellow of the R.H.S., a Member of the Botanical Society of the British Isles, the National Council for the Conservation of Parks and Gardens and the Gloucestershire Wildlife Trust.

HILDER, Edith 20th century
Wife of Rowland Hilder who collaborated with him to produce the *Shell Guide to Flowers of the Countryside,* 1955. Hilder designed the advertisements etc. while Edith painted the flowers, her own particular speciality. Some of these paintings went on exhibition, were reproduced as wall charts for schools and finally published in book form by the Phoenix Press. Edith Hilder added flowers to other publications of her husband's as well as painting and exhibiting in her own right and having her work reproduced on greetings cards and calendars.
lit: Brinsley Burbidge, Lewis

HILL, James Stevens, R.B.A., R.O.I., R.I.
** 1854 – 1921**
Born Exeter and trained at the R.A. Schools. Exhibited flower paintings and landscapes at the R.A., R.I., S.S., N.W.C.S., G.G. and other venues.
lit: Brinsley Burbidge

***HILL, 'Sir' John c.1716 – 1775**
Recognised to some extent as the joker in the pack, he was an interesting artist and illustrator mainly of his own books on herbal plants. Having initially trained as an apothecary, he had a lifelong interest in botany and herbal medicine. He admitted that his illustrations were designs rather than botanical renderings; for all that they had a character of their own. The original drawings for *Exotic Botany* are at Alnwick Castle, other pencil drawings of plants are at Kew. (See pages 34-37.)
lit: Blunt and Stearn, Mabey

HILL, 'Sir' John. Botanical studies.

HODGSON, Josanne. Geraniums.

***HISLOP, Helga -** *see* **CROUCH**

HODGKIN, C. Eliot 1905 - 1987
Eliot Hodgkin was born near Reading and educated at Harrow and Oxford, after which he studied art at Byam Shaw and the R.A. Schools. His family were Quakers of intellectual bent and it may well have been this upbringing that made him such a self-effacing individual, averse to any form of self-promotion, whose talent is less recognised than it should be even now.

Hodgkin's early work was, surprisingly, on a large scale, oils on canvas and a number of murals. It was about 1940 that he reversed and started working on the small scale egg tempera paintings for which he is best known. These often had a slightly surreal feel in their attention to detail and often for the rather bizarre subject matter found on bombed sites and other unlikely places. It was after this phase that his interest turned to the flowers and plants which are by far the most attractive aspect of his work.

Tempera is a medium little used today but is ideal for small detailed flower studies allowing for clear but not hard edged definition and, through its unique texture, soft and delicate shading. Hodgkin once wrote '…what I want to paint are the things that have been seen so often that people no longer notice them or, if they are noticed, they are no longer thought beautiful'. Eliot Hodgkin made that beauty come to life.

On a personal note, the first flower study of his I ever saw was the most exquisitely rendered little piece imaginable — a scattered row of hyacinth bells apparently dropped, as it were, from the main flower. One might have passed by the rather staid and heavy complete bloom but each of those little florets was just so beautiful that one could only look and marvel. Again his own words could have applied to that very painting — 'I try to show things exactly as they are, some of their mystery and poetry, and as though they were seen for the first time'.

Eliot Hodgkin was a keen gardener and travelled widely in his search for rare plants; he had a wonderful collection of alpines. For a time he taught at Westminster School of Art and he wrote several books including, just after the Second World War, *A Pictorial Gospel*. He exhibited at the R.A., Leicester Galleries, Wildensteins and in New York. His work has been reproduced for greetings cards, book illustrations, etc.
lit: Brinsley Burbidge, Medici Society, Synge, Waters

HODGSON, Edward 1719 - 1794
Born Dublin but later lived in London. Exhibited flower paintings Society of Artists and Free Society.
lit: Brinsley Burbidge

***HODGSON, Josanne, S.B.A. 1932 -**
As a child Josanne Hodgson was always drawing and painting which led to her studying art at Southport School of Art and taking up printed textile design, first in Manchester and London and later freelance from home while her children were growing up. Later she took up watercolour flower painting and exhibiting. She has exhibited with the S.B.A. since 1988, also the North Wales Society of Botanical and Fine Watercolour Artists as well as a number of private galleries. She also paints to commission and has had her work reproduced by publishers of greetings cards.

HOFLAND, Thomas Christopher
** 1777 - 1843**
Born Worksop, Nottingham, and later lived in Leamington, Wiltshire. Painted a number of subjects which included many botanical flower studies. Founder Member of the Society of British Artists 1820. Exhibited R.A., B.I., S.B.A.
lit: Brinsley Burbidge, Desmond

***HOLDAWAY, Diana, S.F.P. 1938 -**
After leaving school, Diana Holdaway attended the Reigate College of Art and Design and studied under a number of nationally known watercolourists. She specialises in flower painting in watercolour and exhibits widely in the south of England and also with the S.B.A. and S.F.P.

HOLDEN, Edith 1871 - 1920
Edith Holden was born and still lived in Worcestershire when she wrote and illustrated *The Diary of an Edwardian Lady* which has proved such a success since it was 'discovered' in the mid-1970s. She had had an art school training and worked as an illustrator, her drawings and paintings of natural history subjects appearing in several books.

It is in her 1906 diary that her flower paintings appear when used to decorate the diary entries. They are not great paintings botanically but decorative, pretty and, in most cases, well observed.

Tragically Edith Holden was drowned while trying to reach buds from a chestnut tree. By that time she was married to the sculptor, Ernest Smith, and living in Chelsea.

HOLDEN, Samuel fl.1834 - 1849
Botanical artist who specialised in orchids. He made 438 plates for Paxton's *Magazine of Botany*, 1836-1849, although Blunt describes his work as having 'a cold brilliance that is impressive rather than attractive'. He exhibited R.A. and his work is well represented in the V. and A.
lit: Blunt and Stearn, Brinsley Burbidge, Desmond

HOLGATE, Jeanne 1920 -
Became official artist to the Orchid Committee, R.H.S. She exhibited at the 5th Orchid Conference and was awarded a Silver Trophy. She

has also been awarded four R.H.S. Gold Medals and the Society holds over 500 of her orchid paintings. She has exhibited her work both in the U.K. and U.S.A. where she lived and worked for a number of years. She has contributed illustrations to a number of books and other publications and her work is in the collections of the Queen, the Queen Mother and the Hunt Institute, as well as many private collections and, of course, the R.H.S.
lit: Brinsley Burbidge, Sherwood

HOLLAND, James, R.W.S., R.B.A.
** 1799 - 1870**
Born Burslem and was taught flower painting by his mother who painted flowers on porcelain, a craft in which Holland himself trained professionally. He came to London in 1819 where he concentrated on more traditional flower painting and teaching. He was noted for the brilliance of his colouring, contributed two plates to *Curtis's Botanical Magazine* and was a Member of the S.B.A. and O.W.C.S. He exhibited at the R.A. from 1824-65, also B.I., O.W.C.S., S.B.A., N.W.C.S. and other venues. His work is represented in the Fitzwilliam Museum, Cambridge, and the V. and A.
lit: Brinsley Burbidge, Desmond, Scrace, Wood

HOOKER, Harriet Anne 1854 - 1945
See **THISELTON-DYER, Lady Harriet Anne**

HOOKER, Sir Joseph Dalton 1817 - 1911
Born Halesworth, Suffolk, son of Sir William Jackson Hooker, gained medical degree at Edinburgh University. Primarily a scientific botanist and explorer but became Director of the R.B.G., Kew, 1849-51. He was not without illustrative talent which he developed of necessity

HOLDAWAY, Diana. Spring flowers.

HORNE, Rosemary. Christmas roses.

HUCKVALE, Iris. Saint Paulia.

while discovering and collecting 'new' plants all over the world. His own (thirty) illustrations were used in his important work *Rhododendrons of Sikkim – Himalaya,* the field studies having been lithographed and hand coloured by W.H. Fitch who in many cases redrew them, equally accurately but in rather more artistic vein. Fitch carried on lithographing and improving Hooker's drawings in many other works, a source of enormous gratitude on Hooker's part. Hooker's own topographical sketches are both interesting and informative; many of them are reproduced for the first time in Ray Desmond's *Sir Joseph Dalton Hooker,* published by the Antique Collectors' Club in 1999. (See pages 47-48.)
lit: Blunt and Stearn, de Bray, Brinsley Burbidge, Desmond, Mabey, Rix, Stearn

HOOKER, William 1779 - 1832
Pupil of Franz Bauer who did a certain amount of work for the Horticultural Society of London and whose work is represented in the R.H.S. collection and Oscott College, Birmingham, and reproduced in Salisbury's *Pomona Londonensis.* He was no relation to the famous botanist Hookers.
lit: Blunt and Stearn, Brinsley Burbidge

HOOKER, Sir William Jackson 1785 - 1865
Born Norwich; became Regius Professor of Botany, Glasgow, in 1820, Director of R.B.G., Kew, 1841-65. Although principally a highly respected scientific botanist he was not without talent as a botanical illustrator; what he lacked in artistry per se he made up for through his vast botanical knowledge and accuracy of detail. He used his own illustrations in many of his numerous botanical works and from 1826 for nearly ten years took on the illustrating of *Curtis's Botanical Magazine* in order simply to keep it going. He also provided some drawings for *Flora Londinensis* 1817-28 and actually exhibited two works, both fruit, at the R.A. (See page 47.)
lit: Blunt and Stearn, de Bray, Brinsley Burbidge, Desmond, Fulton and Smith, Mabey, Rix, Stearn

HOPKINSON, Miss Anne E.
 fl.1870s and 1880s
Lived Forest Hill, London. Exhibited flower paintings R.A., S.B.A., N.W.C.S., and was awarded a Gold Medal by the Society of Female Artists in 1879.
lit: Brinsley Burbidge, Desmond

HORNBY, Nicole 1908 - 1988
Nicole Hornby was born and trained in London, also in Florence. She painted delicate watercolours of flowers grown in the garden she and her husband created at Pusey House, Oxfordshire.
 Her main exhibition venues in her heyday were the Trafford Gallery, London, and the Bodley Gallery, New York. She had an extensive solo exhibition in 1988 at Partridge's Gallery in London. Her work is mainly in private collections including that of Dr Shirley Sherwood.
lit: Sherwood

HORNCASTLE, Jane A. fl.1863 - 1869
London artist who exhibited flower paintings R.A., S.B.A., and the Royal Society.
lit: Brinsley Burbidge, Desmond

***HORNE, Rosemary, S.F.P. 1940 -**
Rosemary Horne was educated at a school in the New Forest where her love of and interest in wild flowers developed. She graduated in pharmacy and worked before marriage in a hospital pharmacy.
 In 1978 she started flower painting in watercolour, soon dividing her time between the on-going project of illustrating the wild flowers of Hampshire and fulfilling an almost continuous flow of commissions. She also exhibits in local exhibitions and regularly with the R.H.S. who, on each occasion, have awarded her a medal. She received a Silver Gilt for a composite painting of Hampshire's wild orchids which has since been made into a limited edition print marketed by the Hampshire Wildlife Trust to raise funds for protection of the county's endangered species, notably the red helebore. A number of her flower paintings have been made into greetings cards.

HOUGH, William fl.1857 - 1894
Lived in Coventry and London. Painted flowers and birds rather after the style of W.H. Hunt. Exhibited R.A., N.W.C.S., B.I., S.B.A. His work is represented in the V. and A. and Glasgow Art Gallery.
lit: Desmond, Wood

HOWELLS, Pat. Alstroemeria.

***HOWELLS, Pat, N.D.D., A.T.D., S.B.A.**
 1929 -
Pat Howells was born in London but trained at Cardiff College of Art and gained the N.D.D. and the Teacher's Diploma; she still lives in Wales. She gave up teaching in 1974 to concentrate on her own painting which includes landscape and still life as well as flowers, although often these have a floral or botanical connection. To quote: 'I am not a picture factory. I paint my personal reaction to various stimuli be they figures, objects, mountains, etc. As an artist I do not categorise myself because tomorrow may bring a thought process I wish to explore. Flowers, plants, gardens, gardeners, fields of poppies have always been a source of inspiration — sometimes just involving the colour, structure or pattern. I cannot ever imagine it coming to an end.'
 Pat Howells has had one-man exhibitions at Wilmas Gallery, Coventry, Albany Gallery, Cardiff, Gallery 20, Brighton, Mozart Gallery, Brighton, Vaughan College, Leicester University, Artists in Residence, Leominster, and has participated in many exhibitions, often of floral or botanical paintings, at Cross Fine Art, Bristol, Mall Galleries, London, Welsh Group Open Exhibition, Albany Gallery and Oriel Gallery, Cardiff, Halsworthy Gallery, London, Museum of Wales, Cardiff, Chalk Farm Gallery, London, Coach House Gallery, Guernsey, Retford Craft Centre, Westminster Gallery, London, White Room Gallery, Harlech, Burford House Gallery, Tunbridge Wells, Bristol University and the exhibitions of the S.B.A.

***HUCKVALE, Iris, R.M.S., S.B.A.**
 20th century
Coming from an artistic and musical family, Iris Huckvale's involvement with painting and drawing goes back to early childhood. Many years ago she became a Member of the R.M.S., painting small birds and mammals, but gradually she found that their habitats were becoming more and more important to her and this eventually led to her painting only botanical subjects. She is still primarily a miniaturist and uses miniaturist techniques in oil and polymin.
 As well as with the R.M.S. she exhibits with the S.B.A. and R.H.S. and other galleries in London and the provinces and in 1997 was awarded a Silver Medal from the R.H.S. for eight leaf studies.

HUGHES, Trajan fl.1709 - 1716
Known for a few flower paintings painted in the
Dutch manner, probably influenced by Marseus
van Schriek. A painting of foxgloves is in the
collection of Lofts Hall, Saffron Walden. (See
page 28.)
lit: Brinsley Burbidge, Grant, Mitchell

HUGHES, William 1842 - 1901
Born Lanarkshire, died Brighton and had also
lived in London at some time. Studied under
George Lance and William Hunt and painted
flowers and still life. Exhibited R.A., S.B.A.,
B.I., G.G. and other venues. Work is in the
collection of the Hull Museum and the Cape
Town Museum, South Africa.
lit: Brinsley Burbidge, Desmond, Waters,
Wood

HULME, Frederick Edward 1841 - 1909
Born Hanley, Staffordshire, and died Kew.
Became Art Master at Marlborough College
1870 and Professor of Drawing at King's College
1885. Drew and painted flowers and illustrated a
number of books including his own *Familiar
Garden Flowers,* 1879-89, and *Familiar Wild
Flowers,* 1875-1900. Work is represented in the V.
and A.
lit: Blunt and Stearn, Brinsley Burbidge,
Desmond

HUMPHREYS, Henry Noël 1810 - 1879
Born Birmingham and died London. Artist and
designer of gardens, also wrote books on coins.
Contributed flower drawings to Mrs Loudon's
British Wild Flowers, 1846, *Floral Cabinet* and
Magazine of Exotic Botany, 1837-40, *Garden,* 1872.
Work is in the Hunt Institute.
lit: Blunt and Stearn, Brinsley Burbidge, Scott-
James, Desmond and Wood

HUMPHRIES, Josephine fl.1890s
Painted orchids at the Royal Botanic Gardens,
Glasnevin, in the 1890s.
lit: Desmond

HUNT, Eva E. fl.1880s and 1890s
Greenwich flower painter who exhibited R.A.,
S.B.A., G.G.
lit: Brinsley Burbidge, Desmond

HUNT, Mrs Janet fl.1800 - 1820
Drew plants in Penang, 1802-08, and Calcutta,
1817-22. Drawings from India and Malaya are in
the collection at Kew.
lit: Brinsley Burbidge, Desmond

★HUNT, William Henry, R.W.S.1790 - 1864
Lived in London. He was apprenticed to John
Varley then, in 1808, was accepted as a student at
the Royal Academy. He was one of the young
artists befriended by Dr Monro along with John
Sell Cotman, Girtin and J.M.W. Turner among
others He specialised in floral compositions with
fruits and birds' nests playing a prominent part – as
his health was poor and he was unable to get about
very much, these were ideal subjects for him. He
was exceptionally good at blending his colours
effectively and was much admired by John Ruskin.
He became a Member of the O.W.C.S. and the
Amsterdam Royal Academy. Exhibited R.A., B.I.,
O.W.C.S. His work is represented in the V. and A.,
Amsterdam, Dublin, Glasgow, Liverpool, Leicester,
Manchester and the Harris Museum and Art
Gallery, Preston.
lit: Brinsley Burbidge, Desmond, Hind, Wood

HUNTER, George Leslie c.1878 - 1931
Scottish artist who painted flowers, portraits and
landscape. Went to Canada in his younger days
and studied art in San Francisco, Paris and

London, eventually settling in Glasgow. He
exhibited in London, Glasgow, Paris, New York,
San Francisco and Toronto. His work is in
collections in Glasgow, Edinburgh, London and
Paris.
lit: Brinsley Burbidge, Waters

HUNTER, May Ethel 1878 - 1936
Lived in Yorkshire but studied in Newlyn,
Cornwall, and in Paris. Painted flowers and
portraits.
lit: Waters

HUNTER, William fl.1913 - 1940
Lived in Glasgow and studied at Glasgow School
of Art. Painted flowers as well as some landscape
and figures. Exhibited mainly in Scotland.
lit: Harris and Halsby

**HUTCHINSON, John, O.B.E., F.R.S.,
F.L.S., V.H.M., V.M.M.** 1884 - 1972
Born Wark on Tweed, died Kew. Joined the
R.B.G., Kew, as an apprentice having a talent
for botanical drawing. He also worked as a
taxonomic botanist. He was appointed to the
Herbarium in 1905, went through the Indian
and African sections and was appointed
Keeper of the Kew Museum 1936-48 when
he retired. He went on drawing and painting
long after his retirement and illustrated his
own books, *The Families of Flowering Plants,*
1926 and '34, *Common Wild Flowers,* 1945,
British Flowering Plants, 1948, *Evolution and
Phylogeny of Flowering Plants,* 1969, *A Botanist
in South Africa* (where he had spent some
time), 1946, and *British Wild Flowers,* 1972. His
work is in the collections of Kew and the
Hunt Institute.
lit: Blunt and Stearn, Brinsley Burbidge,
Desmond, Stearn

HUNT, William Henry. Still-life of
primroses and a bird's nest.

INCE, Miss A.C. 1868 –
Born Cardiff and studied at Westminster School of Art and the Slade. Poor eyesight meant that she had to give up flower painting for more general work but she restarted in 1933 and exhibited for a time in London and the provinces.
lit: Waters

INCE, Evelyn Grace, A.R.W.S., R.B.A. 1886 – 1941
Born in India but later lived in Hitchin, Herts., where she died. Studied at Byam Shaw and Vicat Cole Schools. Painted flowers as well as portraits and landscape; one of her flowerpieces is in the Tate Gallery. Exhibited R.A., R.W.S., N.E.A.C.
lit: Brinsley Burbidge, Desmond, Waters

INGLIS, Jane fl.1859 – 1916
Painted flowers and landscape. Exhibited R.A., S.B.A., N.W.C.S., B.I. and the Paris Salon.
lit: Brinsley Burbidge, Desmond, Waters, Wood

IRLAM, Suzette, S.F.P. 1948 –
Suzette Irlam started painting while living in Switzerland, from 1976 experimenting with acrylics and different styles. Back in England she resumed a nursing career while painting in her spare time. Inspired by the much loved flowers in her garden, she now paints and exhibits flowers in watercolour and was recently made a full Member of the Society of Floral Painters.

JACKSON, Emily fl.1875 – 1897
Lived Carshalton, Surrey. Exhibited flower paintings Royal Society, S.B.A., N.W.C.S., G.G. and other venues.
lit: Brinsley Burbidge, Desmond, Wood

JACKSON, Ernest, A.R.A. 1872 – 1945
Born Huddersfield, died Oxford. He was apprenticed to a firm of lithographers in Leeds and during the First World War was in charge of propaganda lithography for the Ministry of Information. Later he studied in Paris becoming an occasional flower painter. He became an Instructor of Drawing at the R.A. Schools.
lit: Brinsley Burbidge, Desmond

JACOMB-HOOD, George Percy, R.B.A., R.E., R.O.I., N.E.A.C. 1877 – 1929
London artist who exhibited some flower paintings and domestic scenes R.A., G.G., N.G. and other venues after training at the Slade and in Paris. He was also an etcher and sculptor.
lit: Brinsley Burbidge, Desmond, Waters, Wood

★JAMES, Bridgette, S.B.A. 1949 –
Growing up in rural East Anglia and developing a passionate love of the wild flowers and insects of the hedgerow led Bridgette James to take up a career as a flower painter which has, justifiably, been a real success. She exhibits regularly with the S.B.A., the Society of Wildlife Artists and in other group exhibitions as well as having one-man shows at the Alpine Gallery, London, the Wildlife Gallery, Lavenham, the Country Works Gallery, Montgomery, and the Napier Gallery, St Helier, Jersey. Her illustrations have been included in the Puffin Factfinder Series, Readers' Digest publications, Cassell's *Plants to Transform Your Garden, My First Encyclopaedia, Kingfisher, Center Parcs Flower Power* and innumerable magazines and journals.

In 1992 the Sultan of Oman commissioned her to paint a botanical and wildlife study for his new palace, one of fifteen works she has painted for His Majesty's private collection. Two large panels showing palm trees are displayed in the Sharjah Desert Park Natural History Museum in the United Arab Emirate. Her reputation continues to grow mainly on account of the quality and charm of her detailed watercolours of flowers, often accompanied by dragonflies, ladybirds and native British butterflies.
Colour Plate 80

JAMES, Edith Augusta 1857 – 1898
Born Eton, Berkshire, died Tunbridge Wells. Studied in Paris and painted flowers and other subjects. Exhibited R.A., S.B.A. and in Paris. Work is represented in the V. and A.
lit: Brinsley Burbidge, Desmond

JAMES, Francis Edward 1849 – 1920
Born Willingdon, Sussex, died Torrington, Devon. Painted flowers and landscape and became particularly noted for his paintings of white flowers on white ground. His work is represented in the V. and A., the British Museum, Birmingham and South Africa.
lit: Blunt and Stearn, Brinsley Burbidge, Desmond, Waters

★JAMES, Joyce, S.F.P. 1932 –
Born in Lancashire and educated at Merchant Taylor's School, Crosby, Joyce James has lived in Hampshire since 1971. She has painted for many years and always been interested in drawing plants, although artistic activity took a back seat while she brought up her family.

She now works in a voluntary capacity at the Sir Harold Hillier Arboretum near Romsey, collecting specimens from the Gardens and the two National Collections held at the Arboretum and assisting the botanist with pressing and mounting specimens and recording details of the plants collected. This work also provides her with an unrivalled source of material for her own drawing and painting. She exhibits her flower and plant paintings with the S.F.P. and with local groups.

JAMES, Bridgette. Lords and Ladies with Scarce Chaser.

JAMES, Joyce. *Acer pseudoplatanus.*

JAMISON, Isobel　　　　fl.1872 - 1889
Flower painter of St Helen's, Lancashire, who exhibited R.A., S.B.A., N.W.C.S. and other venues.
lit: Brinsley Burbidge, Desmond

JEFFERY, Annie　　　　fl.1884 - 1890
Lived Hayward's Heath and London and exhibited flower paintings R.A. and S.B.A.
lit: Brinsley Burbidge

JEKYLL, Gertrude　　　　1843 - 1932
Born London, died Godalming, Surrey. Trained as an artist at Kensington School of Art but when her sight deteriorated too far for her to paint, she became a flower painter with real flowers. (See pages 62-63.)
de Bray, Brinsley Burbidge, Desmond, Jekyll, Lewis, Rix

JELLEY, James Valentine, F.S.B.A.
　　　　　　　　　　fl.1885 - 1918
Lived in Birmingham and painted flowers and landscape. Exhibited R.A., S.B.A., N.W.C.S., G.G. and provincial venues.
lit: Wood

JENKINS, Anne　　　　fl.1876 - 1885
London flower painter who exhibited R.A., S.B.A. and other venues.
lit: Brinsley Burbidge, Desmond

JENKINS, Blanche　　　　fl.1872 - 1894
London artist. Member of the Society of Lady Artists. Painted flowers and domestic subjects. Exhibited R.A., S.S., G.G., N.G. and other venues. Work in a public collection in Leeds.
lit: Brinsley Burbidge

JENKINS, Eveline A., B.Sc., F.R.S.A.1893 -
Cardiff artist who painted in oil and watercolour, often simply using black and white. Became botanical artist at the National Museum of Wales 1936-1959. Exhibited mainly in Wales and her work is in the Monmouthshire Education Committee's collection.
lit: Brinsley Burbidge, Desmond

JOBSON, Henry　　　　fl.1873 - 1877
Tottenham artist who exhibited flower paintings S.B.A. and other venues
lit: Brinsley Burbidge, Desmond

JOHN, Augustus E., R.A., P.R.P., N.E.A.C., R.Cam., A.L.G.　　　　1878 - 1961
A distinguished portrait painter all too rarely associated with flower paintings of which he produced a number of significant examples. Usually they were painted in a fairly traditional manner although he seems to have preferred to concentrate on a particular flower rather than a mixed bouquet. John's clever use of light is effectively demonstrated in his flower paintings, giving them a wonderful *joie de vivre.*

Augustus John studied at the Slade and travelled widely, painting in many different countries. He exhibited widely also and his work is in many public and private collections in the U.K. and overseas.
lit: Brinsley Burbidge, Mitchell, Rothenstein, Waters

JOHNSON, Isaac　　　　1754 - 1835
Worked in Woodbridge, Suffolk, as an antiquarian draughtsman and map maker. He also painted some beautiful flower studies in the Dutch manner; his work is reminiscent of van Huysum and he is said also to have been influenced by Ehret. (See page 28.)
lit: Blatchley and Eden, Desmond, Scrace, Walpole and Williams
Colour Plate 8

JOHNSON, Janet　　　　fl.1880s and 1890s
Edinburgh painter of flowers who exhibited with the Scottish Society of Artists.
lit: Harris and Halsby

JONES, B. Kaye, S.F.P.　　　　1940 -
After a spell of suffering from cancer, Kaye Jones wrote and illustrated (with paintings of flowers) three books about her experiences in the hope of helping others. The publication of these books set her on a career in flower painting which has flourished ever since. She exhibits with the S.F.P., of which she is a Member, and in local exhibitions. Her designs have been used for greetings cards by a number of publishers including twenty-three by the Medici Society.

JONES, Marilyn　　　　1947 -
Marilyn Jones worked for some years in the Natural History Museum Department of Botany prior to an art training at Camberwell School of Art. Her work in the Museum had obviously inspired a more artistic botanical approach. Her flower studies in watercolour are both botanical in observation and decorative.

She exhibits largely in Wales, also with the R.H.S. in London where she has gained a Silver Gilt Medal.

JONES, Sally　　　　1946 -
Sally Jones was born in Cornwall, trained at Hull College of Art and Bath Academy of Art gaining a Diploma in Art and Design. After marriage and the arrival of four children, artistic activity was confined to teaching at evening classes until after a move to Scotland in 1982 she was able to concentrate fully on her botanical painting. The rich natural habitat of Dumfries and Galloway provided both subjects and inspiration.

Sally Jones works in pure watercolour, no black or white, and always from living plants. She has a particular interest in endangered species and rain forest woody plants from tropical and temperate zones. She feels the need to draw the attention of the public to the loss of these plants and their habitats and the effect this will have on all of us.

Important commissions have included Study of Daphnes for Vicky Jardine-Paterson, six paintings of Rare Ferns and six of Rare and Ancient Conifers for Dr Chris Page, R.B.G., Edinburgh, specimens from New Caledonia, Japan and Chile for the *New Plantsman,* work for Steve Spongberg, U.S.A., the International Conifer Conference, and Kew Gardens who have bought some of her rare species paintings and drawings for the permanent collection.

She has had solo exhibitions at Gracefield Arts Centre, Dumfries, Craigdarrach House and

JORDAN, Maureen. Hydrangeas by the chair.

Threave House (National Trust) and has participated in a number of other exhibitions including the British Museum, the R.B.G., Edinburgh, Broughton Gallery, Biggar, Malcolm Innes Gallery, Edinburgh, and the Edinburgh Festival Fringe as well as being involved in many botanical projects.

***JORDAN, Maureen, N.D.D., S.B.A., U.A.**
　　　　　　　　　　1941 -
Now living in London, Maureen Jordan lived in Yorkshire until 1961 and trained at Kingston-upon-Hull College of Art. For most of her life she has been a freelance interior and graphic designer involved with designs for shops, exhibitions, hotels and office refurbishments. She is now a full-time artist, very involved with colour and texture, her favourite medium being pastel sometimes mixed with watercolour, acrylic and metallic to produce beautiful bold and vibrant effects in her radiant and eye-catching flower paintings and figure studies.

Her flower paintings have been reproduced as greeting cards and prints and some of the works produced for her solo exhibition in New York have been reproduced by Amcel of California for their 1998 and '99 calendars and a range of greetings cards. Her work has also been reproduced in *Artists and Illustrators Magazine* and *The Art of Drawing and Painting;* books include *British Contemporary Art* 1993, *How to Paint and Draw,* 1994, *Skin Colours,* 1995, *Pastel Solutions,* 1995, *Pastel School,* 1995, *Painting Shapes and Edges,* 1996, *The Reader's Digest Complete Guide to Drawing and Painting,* 1997, *The Encyclopedia of Flower Painting Techniques,* 1997, and *The Beginner's Guide to Pastel,* 1997.

She has exhibited with the Pastel Society, the National Trust, the National Society of Painters,

JOWETT, Jenny. *Helleborus orientalis* seedling.

the United Society of Artists, the S.B.A., the Chelsea Art Society, Britain's Painters 1991 and '92 (Westminster Gallery), the Society of Women Artists, Art Mart (Islington), and New Trends '94 (Hong Kong). Her work is always on show in other exhibitions in London and the provinces and for the last three years she has shared a two-man show at the Llewellyn Alexander Gallery, London, and held a one-man show at Jensen Fine Art, New York. Not surprisingly, for her work has a vitality and radiance all of its own, she is represented in private collections in the U.K., France, Jersey, U.S.A., Australia, South Africa, Hong Kong, Taiwan and Japan.

JORDAN, William 1884 -
Born and lived in Devon and painted flowers in watercolour. Exhibited R.A., R.W.A. and in Liverpool.
lit: Waters

JOWETT, Jenny, N.D.D., F.S.B.A. 1936 -
Jenny Jowett, who lives near Reading in Berkshire, has painted seriously since childhood,

eventually specialising in botanical work. At twelve she won a national painting competition and on leaving school was accepted by the Slade. Her keen interest in botany and agriculture led her to taking N.D.D. at Studley College, Warwickshire.

She works from her home where her large garden provides much of her material and now has a studio where she holds spring and autumn courses which are in great demand. In 1986 she was invited to take over the botanical illustration course run by the British Field Studies Council at Flatford Mill, only the third person to occupy this unique position since John Nash, R.A., created the course in 1947. She also runs occasional courses abroad and teaches widely on the history of botanical illustration and plants.

Jenny Jowett works in pure watercolour in great detail but is equally concerned with the composition and habit of the plant and reproducing its delicacy and transparency. She has also studied lithography and from 1978-1982 published hand-coloured lithographs for Christie's Contemporary Art, London, on her own press and now has her work printed in limited editions and publishes her own cards.

She exhibits regularly with the S.B.A. and R.H.S. and has won two Silver, three Gold and four Silver Gilt Medals. In 1992 she designed the R.H.S. Chelsea plate. She has also had ten one-man shows – the West Mills Gallery, Berkshire, the Bladon Gallery, Hampshire, the Parkhouse Gallery, Avon, Cakethorpe School, Oxon., John Magee Gallery, Belfast, Cherrington Park, Gloucester, the Chelsea Gardener, London, Ascot, Berks., Ewhurst Park, Hants., and five times at the Newbury Spring Festival as well as participating in many mixed exhibitions.

Jenny Jowett's work has been reproduced in *Curtis's Botanical Magazine, The Plantsman* and the books *The Glory of the English Garden* and *The White Garden*. She has also illustrated a book on the genus Paeonia for the R.B.G., Kew. Her work is represented in the Lindley Library, London, the Hunt Institute and in private collections throughout the U.K., China, Japan, U.S.A. and South Africa.
lit: Sherwood

JOWETT, Percy Hague, C.B.E., A.R.C.A., R.W.S. 1882 - 1935
Born Halifax. Became Head of the R.C.A., London. Painted some flowers of which examples are in the Harris Museum and Art Gallery, Preston, and in Birmingham.
lit: Brinsley Burbidge, Desmond, Waters

★JOYCE, Paula, F.S.B.A. 20th century
Paula Joyce, albeit self taught, paints flowers in watercolour to a very high standard concentrating on realism and botanical accuracy. She left a very busy office job to spend more time painting and teaching which she has been doing along with her other work for forty years. She now teaches botanical art at her local Design Centre as well as painting for commissions and exhibitions.

She was a Founder Member of the S.B.A. and Hon. Sec. at the time of writing. Her work has been reproduced as greetings cards and notelets for the Gardeners' Royal Benevolent Society and in wild flower books published by the Medici Society. Paula Joyce has had several one-man shows, mainly locally in Surrey, and participated in mixed shows up and down the country. She also exhibits with the S.B.A. and the R.H.S. who have awarded her eighteen Grenfell Medals and she has exhibited twenty-one times at the Chelsea Flower Show.

JOYCE, Paula. Oriental poppies.

K

KEBLE-MARTIN, Rev. William, B.A.Oxon. M.A., F.L.S. 1877 - 1969
Born in Radley, died in Devon, having lived wherever his priestly duties took him in between, Keble-Martin became a national figure at the age of eighty-eight when his *Concise British Flora in Colour* was published and became a bestseller. He was educated at Marlborough College where he developed a keen interest in botany and plant life and later read botany as his degree subject at Oxford. His ambition was to illustrate every wild flower in the British Isles and, between his clerical duties which took up most of his time, he worked on this project for sixty years.

Around his various parishes and on holidays further afield Keble-Martin collected his subjects and painstakingly drew and coloured them. It must have seemed a real reward for achievement when the book became such a resounding success. A year later, in 1966, he was awarded an honorary degree as Doctor of Science at Exeter University. Shortly afterwards he was asked to design four postage stamps which were issued in 1967, the year before he published his autobiography *Over the Hills*.
lit: de Bray, Desmond, Keble-Martin

KEIR, Sally, S.B.A., S.F.P. 20th century
Family commitments meant that Sally Keir was unable to embark on her artistic career until the age of forty-three when she went to college to study for a degree in design at Duncan of Jordanstone College of Art, Dundee. Although she specialised in jewellery and silversmithing, she was painting at the same time and for a number of years

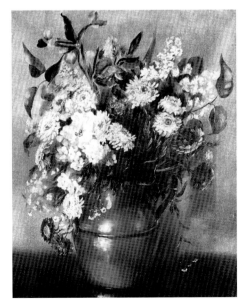
KENNEDY, Cecil. A still life of summer flowers in a jug.

this has developed side by side with the jewellery interest. Initially she worked in watercolour in the densely pigmented, solidly coloured Scottish tradition but later changed to gouache in order to achieve still greater colour density. She concentrates mainly on larger than life, finely detailed flower paintings paying great attention to light and shade and some times backlighting. The combination of vivid colours, strong light and shade and dark backgrounds makes for a dramatic, almost three-dimensional effect.

Sally Keir has exhibited in galleries in London, Bristol, Warwick, Shropshire, the Lakes and Scotland as well as the S.B.A., S.F.P., the International Exhibition of Small Works in Toronto, the R.M.S., S.W.A., Discerning Eye and the Britain's Painters annual exhibitions where she has twice won prizes.

In January 1989 she first exhibited with the R.H.S. and gained a Silver Grenfell Medal. She has since gained two more Silver Medals, a Gold and a Silver Gilt. Since being elected to the S.B.A. in 1989 she has been selected to exhibit at Rufford, Stowe, Hampton Court and the Linnean Society. At the Diamond Jubilee of the Alpine Garden Society she won both the best painting in show award and first prize in her class.

Sally Keir's work has been used to illustrate books on painting and drawing, also postcards and greetings cards. She has a contract with a large American Poster Company and her work has been accepted by the Post Office for use on stamps. Her work is represented in the Hunt Institute and in the Shirley Sherwood Collection and has exhibited at the Tryon Gallery in London and Hani Behn's new gallery in Coburg, Germany.
lit: Sherwood

KELLY, Nicholas fl.1810 - 1831
Edinburgh artist known to have exhibited flower paintings R.A.
lit: Brinsley Burbidge

***KENNEDY, Cecil** 1905 -1997
Born Leighton. One of the most professional of 20th century flower painters, he studied art in London, Paris, Antwerp and Zürich. Exhibited widely including R.A., R.S.A. and other important venues in London and the provinces as well as the Paris Salon where he was awarded a Silver Medal in 1956, Gold in 1970. His work is in the collection of the Queen Mother, the Merthyr Tydfil Art Gallery and many private collections as well as being frequently reproduced as Fine Art prints and greetings cards. (See pages 101-107.)
lit: Brinsley Burbidge, Hardie, Waters
Colour Plates 56 and 57

KENWORTHY, Esther fl.1881 - 1882
Lived in Ealing, Middlesex, and exhibited a few flower paintings R.A. and S.B.A.
lit: Brinsley Burbidge, Desmond

KEYS, John 1797 - 1878
Lived in Derby all his life and decorated Derby porcelain with flower designs. He also taught flower painting.
lit: Brinsley Burbidge, Desmond

KEYSE, Thomas 1721 - 1800
Started the Bermondsey Spa Gardens which he ran as owner manager. He also painted flowers which he exhibited R.A. and the Free Society of Artists of which he became a Member. For much of his life he lived in Southwark but died in Bermondsey. His work is in the Fitzwilliam Museum, Cambridge. (See page 27.)
lit: Bénézit, Brinsley Burbidge, Desmond, Grant, Mitchell

KIDD, Mary Maytham 20th century
In 1938 Mary Maytham Kidd decided to visit her old Roedean headmistresses who were retired and living in the Cape. She was captivated by the wealth and variety of wild flowers (the Cape Peninsula is known to have over 2,600 species of flowering plants at least 150 of which are now rare or threatened species) to the extent that, knowing from school her artistic ability, one of the ex-teachers suggested that she should illustrate a book on Cape wild flowers.

Many years later, when an author had been found and the watercolour drawings botanically approved, the book was published by the Botanical Society of South Africa containing 814 of Mary Kidd's charming drawings. It has since run into several editions and I am the proud possessor of a signed copy of the 1983 new edition given me by Mary herself.

KILBURN, William 1745 - 1818
Born Dublin, died Wallington. Trained as a calico designer but later turned to botanical painting, making a number of contributions to *Curtis's Botanical Magazine* and Curtis' *Flora Londinensis*. His work is in the R.B.G., Kew, and the V. and A. (See page 32.)
lit: Blunt and Stearn, de Bray, Brinsley Burbidge, Desmond, Mabey, Rix
Colour Plates 10 and 11

KIMBER, Sheila Victoria, R.M.S. b.1925, fl. to 1955
Painter in oil and watercolour of plant portraits. Awarded the R.H.S. Gold Grenfell Medal for twenty-three orchid paintings for *Flora of Asia*. Illustrated *A Handbook of Orchids*. Exhibited Calcutta and Tunbridge Wells. Work in the Hunt Institute.
lit: Brinsley Burbidge, Waters

***KING, Christabel Frances** 1950 -
One of the most eminent of today's botanical painters, Christabel King graduated with honours in botany in 1971, following graduation with two years' training in scientific illustration at Middlesex Polytechnic 1972-74. She has made illustrations for *Curtis's Botanical Magazine* since 1975 and was assistant to the Editor until going freelance in 1984. She also teaches botanical illustration at Capel Manor Horticultural and Environmental Centre at Enfield. In 1990 the Margaret Mee Amazon Trust Scholarship Scheme was set up under which Brazilian botanical artists could study in the Herbarium at Kew. Christabel King has acted as tutor to eight of these artist scholars and in 1994 she visited Brazil herself giving courses in

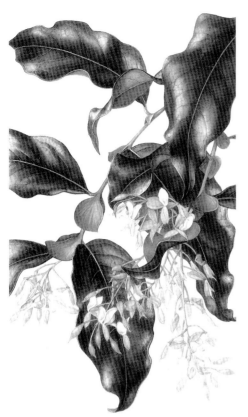

KING, Christabel. *Zollernia splendens.*

Rio de Janeiro and São Paulo and at a research station in Para. After this visit she drew a selection of mainly Amazonian plants, some of which have since been on display in the office of the Director of the R.H.S. In 1987 she had also been on a High Altitude Africa Expedition to the Ruwenzori Mountains of Uganda where she recorded in paintings some of the unique flora of these mountains.

As well as her on-going illustrations for the *Botanical Magazine,* Christabel King's illustrations have been included in *Flowering Plants of the World,* Heywood 1978 (fourteen plates), *Orchideenatlas,* Bechtel, Cribb and Launert 1979, *All Good Things Around Us,* Pamela Michael 1980 (eighty-seven paintings), *World Book Encyclopedia,* U.S.A., *Kew Magazine Monographs* (twelve paintings in each of three), *Africa's Mountains of the Moon,* Guy Yeomans 1989 (thirteen illustrations).

She exhibits with the S.B.A. and at Kew and has had exhibitions of her own at Agnews, Old Bond Street, Spelman's Bookshop, York, and 'Ruwenzori' at the Royal Geographical Society. She has been awarded two Grenfell Silver Gilt Medals and the Linnean Society Jill Smythies Award for Botanical Illustration in 1989.

Her work is, of course, in the Kew Collection and in the Hunt Institute. (See page 72.)
lit: de Bray, Mabey, Sherwood, Stearn

KING, William **fl.1761-1767**
Totteridge botanical artist who drew and painted flowers and plants in Peter Collinson's garden. Exhibited F.S.A. Work is in the British Museum.
lit: Blunt and Stearn, Brinsley Burbidge, Desmond, Grant

KIRKPATRICK, Ethel **fl.1888 – 1919**
Studied at the R.A. Schools and the Central School of Arts and Crafts. Exhibited flower paintings, also landscape and marine, R.A., R.I., R.B.A., S.B.A. and N.W.C.S.
lit: Brinsley Burbidge, Desmond, Waters

KIRKPATRICK, Ida Marion fl.1876 – 1900
London painter of flowers and marine subjects, sister of Ethel Kirkpatrick. Studied at the R.F.S. and in Paris. Exhibited R.A., R.B.A., R.I., R.O.I., S.W.A., S.B.A., W.I.A.C., N.W.C.S. and other venues.
lit: Brinsley Burbidge, Desmond, Waters

KNAPPING, Margaret Helen, W.I.A.C.
 fl.1876 – 1890
Lived in Blackheath, London, and St Ives where she became a member of the St Ives Society of Artists. Trained under Aubrey Hunt in Paris and Belgium. Painted flowers and landscape and exhibited R.A., N.W.C.S., R.B.A., R.I., S.B.A. and other venues.
lit: Brinsley Burbidge, Desmond, Waters

***KNELLER, Marianne, F.S.B.A.**
 20th century
Marianne Kneller is best known for her wonderful paintings of rhododendrons. The species has been a lifelong study for her and, under the patronage of Edmund de Rothschild, she has for the past fifteen years worked from her studio at Exbury Gardens, home of the world's most exotic collection of rhododendrons. Visited by over 140,000 people annually, these incredible gardens are an enormous tribute to Edmund de Rothschild's dedication and effort since the Second World War and his skill at hybridising rhododendrons and azaleas to produce an even greater variety of beauty and colour.

These blooms are being immortalised by Marianne Kneller whose work has been made widely known to the public through *The Book of Rhododendrons,* published in 1995 by David and Charles and containing fifty of her paintings, and a limited edition of exotic studies published by Collingwood Fine Arts in association with Exbury Gardens.

Marianne Kneller won a scholarship to Southampton Preparatory Art School at the age of eleven, going on to become a professional botanical flower painter. She is a Founder Member of the S.B.A. and exhibits regularly with the Society and with the R.H.S. who have awarded her the Grenfell Medal, Silver Gilt and Gold Medals and the Lindley Medal in recognition of her contribution to the science of the rhododendron species.

Although rhododendrons are her present speciality she paints other flowers with the same care and skill working to private commission as well as for Exbury and designs for greetings cards, posters and prints. In 1994 she designed the famous Chelsea Flower Show plate depicting an arrangement of spring flowers called Chelsea Springtime.

She has appeared on TV and talked on the radio about Exbury Gardens and her work there.

KNIPE, Eliza **19th century**
Born Liverpool, painted flowers and miniatures.
lit: Brinsley Burbidge

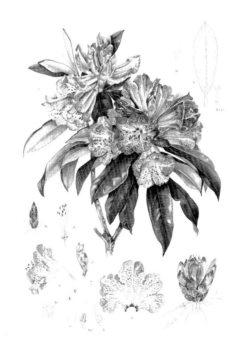

KNELLER, Marianne. Rhododendrons.

L

LACEY, Mary Elliott, A.T.D., S.W.L.A.
1923 - 2004
Mary Lacey is undoubtedly best known for her wonderful studies of African and other wild animals, but her flower paintings in watercolour and gouache show the same care and accuracy and have frequently been reproduced by the Medici Society, Royle and other publishers.

Born in Birmingham, Mary Lacey trained at Birmingham College of Arts and Crafts 1939-45, taught for seven years at Mansfield School of Art and two years at Wolverhampton College of Art before becoming a freelance artist and illustrator. As well as four one-man shows in London, she exhibited regularly with the Society of Wildlife Artists (of which she was a Founder Member in 1963), also the Mall Galleries, Tryon Gallery and other venues throughout the U.K., U.S.A., Paris, Luxembourg and the Channel Islands.

She illustrated regularly for Hamlyns, Readers Digest, *Leisure Painter* and many other publications including some in the U.S.A. and Germany. She illustrated eleven jigsaws for James Hamilton, including the BBC Kingdom of the Bears series, and produced four large posters of the Amazonian Rain Forest. Her work is in many private collections including sixteen in that of the Sultan of Oman.
Colour Plates 80 and 81

***LADELL, Edward** **1821 - 1886**
Well-known painter of flowers with still life. Lived in Colchester before moving to Devon, probably on health grounds. Exhibited R.A. for thirty years, also B.I., S.S. and other venues. Work is in the collection of the Exeter Memorial Museum, Sheffield and Reading Art Galleries and other public and private collections. (See page 44).
lit: Brinsley Burbidge, Day, Desmond, Lewis, Mitchell, Wood
Colour Plate 18

LADELL, Ellen **mid-19th century**
Second wife of Edward Ladell who painted in a very similar style, often indistinguishable from that of her husband. Represented in the collection of the Bristol Art Gallery. (See page 44.)
lit: Brinsley Burbidge, Desmond, Lewis, Mitchell, Wood

LAING, Isabella **fl.1960s and 1970s**
Twickenham artist who painted flowers and fruit and exhibited R.A., S.B.A. and other venues.
lit: Brinsley Burbidge, Desmond

LAMBERT, James Junior **fl.1769 - 1788**
Son of the Lewes landscape painter George James Lambert. Painted some landscapes but mainly flowers which he exhibited R.A. and F.S.A.
lit: Brinsley Burbidge, Desmond, Grant

***LANCASTER, John** **1913 - 1984**
Born in India to English parents, John Lancaster started painting seriously after a career in the Hongkong Police, R.A.F. and, after the war, as a private pilot.

Always interested in drawing and painting and a great admirer of the Dutch tradition, he was a natural flower painter and, although he did some exhibition work, most of his paintings were commissioned, 'advertised' by word of mouth for their exceptional quality. They are in numerous private collections and have been reproduced as greetings cards and fine art prints including some very fine limited editions. (See pages 107-110.)
Colour Plates 58-60

LANCE, George **1802 - 1864**
Born Essex and died Birkenhead. Painted flowers and fruit, trained under Haydon at Liverpool Academy and at the R.A. Schools. Worked in oil, watercolour and pencil and exhibited R.A., B.I., S.S., N.W.C.S. and other venues, especially in Liverpool. His work is represented in the V. and A., in Melbourne, Australia, and Liverpool.
lit: Brinsley Burbidge, Desmond, Wood

LANGHORNE, Joanna Asquith **1945 -**
Daughter of the painter, John Asquith Langhorne, Joanna Langhorne, now one of our most prominent botanical artists, has always been encouraged to draw and paint. She studied graphic design at the Central School of Art, London, and went on to work for a time at the Freshwater Biological Association making zoological drawings for identification. She attended several courses in botanic illustration at Flatford Mill Field Centre and was appointed official artist at the R.B.G., Kew, in 1973 where she stayed until going freelance in 1980, later moving to the Lake District where she was able to extend the variety of her subject matter.

Joanna Langhorne has illustrated five books – *Vegetation of East Africa,* Lind 1974, *Gardeners' Book of Trees,* Mitchell 1981, *In Search of Wild Asparagus,* Lancaster 1983, *Conifers,* Rushforth 1987, *The Hardy Euphorbias,* Turner 1995 – and contributed to a further ten. She has also illustrated for *The Kew Bulletin, The Plantsman,* and *Curtis's Botanical Magazine* and has work in published collections of *Botanical Art — The Art of the Botanist,* Rix 1981, *The Flower Artists of Kew,* Stearn 1990, and *Contemporary Botanical Artists,* Shirley Sherwood 1996.

She has had two solo exhibitions in Cumbria, also one at the R.H.S. when she was awarded the

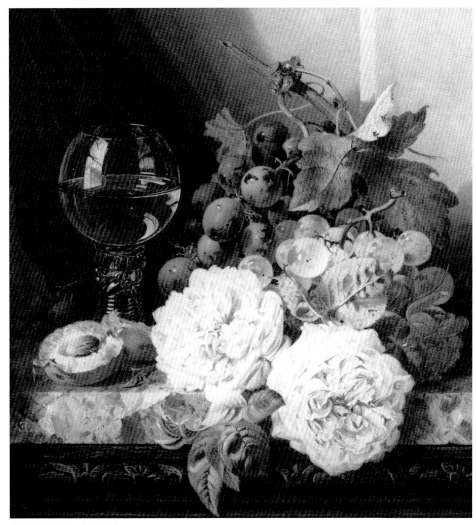

LADELL, Edward. Still life.

LANCASTER, John. Early spring flowers.

LANCASTER, John. Summer flowers.

Lindley Medal and one at the Chelsea Physic Garden. She has also participated in a number of shared exhibitions in London, Scotland and the U.S.A. She has taught at the Flatford Mill Centre, the R.C.A. and the R.B.G., Kew.

Joanna Langhorne's work is in the Freshwater Biological Collection, the Hunt Institute and the R.B.G., Kew, as well as numerous important private collections including the Shirley Sherwood Collection. (See pages 68-70.)
lit: Mabey, Rix, Sherwood, Stearn
Colour Plate 38

LASSERSON, Mary, S.B.A. 1942 –
Mary Lasserson, although she has always loved drawing and painting, worked as a nurse for a number of years until she joined a botanical art class at Sutton College of Liberal Arts and went on from there. She works mainly in coloured pencils treating her subjects in great detail and in their natural habitats. She works to private commission and exhibits with the S.B.A. and other venues.

LAVRIH, Cherry-Anne 1946 –
Trained at Brighton College of Art gaining a Degree in Art and Design and in 1966 won the R.A. David Murray Landscape Painting award. She was appointed Head of Art at Whyteleafe Grammar School for Girls and later, after bringing up her family, taught at St Paul's Girls' Preparatory School, London. In 1986 she gave up teaching to concentrate on botanical painting and a year later was appointed Orchid Artist to the R.H.S. painting orchids for historical records. She has also made many drawings of plants for the R.B.G., Kew.
lit: Stearn

LAW, Mrs W. fl.1854 – 1862
London artist who exhibited flower paintings R.A., R.B.A. and B.I.
lit: Brinsley Burbidge, Desmond

LAWFORD, Mrs Rowland fl.1866 – 1882
London artist who exhibited flower paintings S.B.A. and other venues.
lit: Brinsley Burbidge, Desmond

***LAWRANCE, Mary (and as Mary Kease)**
 fl.1790 – 1831
Teacher of botanical drawing and illustrator. Produced in 1799 a folio monograph on roses, *A Collection of Roses from Nature,* containing ninety hand coloured etchings which, according to Blunt, received 'rather undeserved fame'. Also illustrated *Sketches of Flowers from Nature,* 1801, and *A Collection of Passion Flowers coloured from Nature,* c. 1797, in this case rather vivid nature and, again to quote Blunt, 'coarse in quality'. Exhibited R.A. and her work can be seen in the Kew collection. (See page 40.)
lit: Blunt and Stearn, Desmond, Foshay, Mitchell, Sitwell
Colour Plate 14

LAWSON, Constance B. fl. 1874 – 1892
Wife of Cecil Gordon Lawson who also painted flowers. Both exhibited flower paintings R.A., S.B.A., N.W.C.S., G.G.
lit: Brinsley Burbidge, Desmond, Stearn

LAWSON, Elizabeth R. (née Stone)
 fl.1852 – 1888
Lived in London and Brighton and exhibited flower paintings S.B.A., G.G., N.G.
lit: Brinsley Burbidge, Desmond

LEACH, Miss E. fl.1808 – 1834
Lived Merton and Great Bookham, Surrey. Exhibited flower paintings R.A. and an album of flower paintings was sold at Gorringes, Lewis, in 1962.
lit: Brinsley Burbidge, Desmond

LEACH, J. fl.1792 – 1794
Merton artist known to have exhibited flower paintings R.A.
lit: Brinsley Burbidge

LEADER, Mrs B.W. (née Eastlake)
 1878 – 1885
Wife of Benjamin W. Leader, painted flowers and exhibited R.A.
lit: Brinsley Burbidge, Desmond c.1797.

LAWRANCE, Mary. Frontispiece of *A Collection of Roses from Nature.*

LENEY, Sheila. Last roses of summer.

LENEY, Sheila. Primroses and violets.

LEWIS, Olga Blandford. Rudbeckia.

LEAMAN, Doris Easterbrook **1897 –**
Born Torquay and later lived in Bournemouth. Studied at Torquay School of Arts and Crafts, St John's Wood and Regent Street Polytechnic. Taught at South Devon Technical College 1942-44. Painted flowers and exhibited R.A., R.W.A., N.E.A.C., S.M.A., U.A.
lit: Desmond, Waters

le BAS, Edward, R.A., L.G., N.S., A.R.C.A.
 1904 – 1966
Well-known painter and architect who studied at R.C.A. and worked in many countries as well as the U.K., mainly in London and Brighton. Painted in oils many subjects; Martin Hardie praised particularly his flower paintings.
lit: Hardie, Waters

LEE, Ann **c.1753 – 1790**
Taught by Sidney Parkinson from the age of thirteen. Very talented and considered by the famous entomologist Fabricus to be the best natural history painter in England at that time. Daughter of the nurseryman, James Lee, for whom Parkinson worked for a time illustrating his exotic plants. (See page 37.)
lit: Brinsley Burbidge, Desmond, Grant, Mabey

***LENEY, Sheila, S.B.A.** **1930 –**
After exhibiting successfully for two years at the Flowers and Gardens Exhibition, Mall Galleries, Sheila Leney started seriously flower painting in 1982 and became a Member of the S.B.A. in 1987. She also paints flowers on fabric and finds her subjects in her own garden and the Surrey countryside. She exhibits regularly with the S.B.A., the Linnean Society, Hampton Court and a number of galleries in Surrey and Sussex. Her work is now in many collections in this country and overseas.

LENTZ, J.F. **fl.1825 – 1831**
London flower painter who exhibited R.A. and S.B.A.
lit: Brinsley Burbidge, Desmond

***LESTER, James, S.B.A.** **20th century**
Painter and illustrator, James Lester trained at Dover and Canterbury College of Art and for many years pursued a successful London career as art director and illustrator in advertising and publishing. All through his working life he has been painting and in 1988 he moved to Devon and has since worked as a professional painter from his studio in Otterton.

He works in watercolour, oil and pastel and, although he paints other subjects, his main interest is in botanical subjects for which he has received many commissions; he was elected to the S.B.A. in 1986. Although his work is strictly botanically accurate, it can also be described as decorative for his subjects are presented in such an attractive manner that they represent the best of both worlds. He is co-author and illustrator of a book on botanical painting, *Painting the Secret World of Nature,* published by Search Press in 1987.

James Lester, as well as exhibiting with the S.B.A., has exhibited at the R.I., R.B.A., R.W.A. and many other galleries in London and the

LESTER, James. Study of iris.

South of England. Since 1989 he has had his own gallery in East Devon.
Colour Plate 82

LEWIS, Anne Madeline **fl.1880 – 1922**
Watercolour painter of flowers, architectural subjects and landscape. Exhibited R.A., R.B.A. and other venues and also worked and exhibited in France.
lit: Waters

***LEWIS, Olga Blandford, S.B.A.**
 1917 – 2003
Olga Blandford Lewis started painting as a small child. During the Second World War she illustrated injuries for records and continued with medical work for a time after the war before turning to flower painting and botanical work. Exhibiting with the R.H.S. resulted in four Silver Medals, two Silver Gilt and an impressive ten Grenfell Medals. She also exhibited at the R.A., R.I., Forty Hall Museum, London, The Linnean Society, the Lindley Library, the International Flower Show, Hampton Court; three exhibitions at the Natural History Museum resulted in nearly forty paintings being accepted for the Botanical Library's permanent collection. In 1998 twenty-six paintings of international fruit were accepted by the Natural History Museum (who now have sixty of her works) and in 1999 twenty cacti were accepted by the Lindley Library for exhibition and then for their archives (they now have over fifty of her works). She also produced a collection of bulb plants for the Lindley Library.
Colour Plate 84

***LINDSAY, Rosemary, S.B.A. 20th century**
Rosemary Lindsay initially trained in architecture but later turned mainly to plant and flower illustration. She exhibits with the S.B.A. and R.H.S. where she has consistently received

awards and she has had several one-man exhibitions as well as participating in group shows. Commissioned work includes drawing for the R.H.S., *New Plantsman* and the R.H.S. *Plant Registers* as well as private commissions. Under her company Aria Cards she has published postcards and greetings cards of her work.

LINNELL, Mary fl.1828 – 1881
Daughter of the eminent artist, John Linnell; lived Reigate, Surrey. Made many watercolour studies of flowers under the influence of John Ruskin. Exhibited S.B.A.
lit: Blunt and Stearn, Brinsley Burbidge, Desmond

LINTON, J. fl.1814 – 1854
London artist. Exhibited thirty-one flower paintings R.A. as well as in other venues.
lit: Brinsley Burbidge, Desmond

***LLOYD, Elizabeth Jane** 1928 – 1995
Godchild of Sir Edwin Lutyens, trained at Chelsea School of Art and the R.C.A. under Ruskin Spear. Both her father and grandfather were architects and her mother was a painter. Elizabeth Jane Lloyd specialised in flower painting and botanical studies, combined sometimes with still life. She held her first one-man show at the Royal Festival Hall in 1953; also in the same year she had her first painting accepted for the R.A. where she exhibited annually for the rest of her life.

She taught art at various schools from the mid-1950s until, in 1965, she started teaching the foundation course at Chelsea School of Art and St Martin's; not long before her death she

LINDSAY, Rosemary. Love-in-a-mist seedheads.

LLOYD, Elizabeth Jane. 'The lustre vase.'

was made head of the portfolio preparation course. She also taught privately as well as exhibiting widely, including a number of solo exhibitions, two at Kew Gardens. It is less widely known that she undertook scene painting for a few films and gave lectures in a number of countries including India and the U.S.A. Her work is represented in the Gulbenkian Trust collection and the Nuffield Foundation as well as many private collections including the Shirley Sherwood Collection.
lit:Blunt and Stearn, Sherwood

LLOYD, Katherine Constance
 fl. from 1930
Oil painter of flowers and portraits. Trained at the Slade under Tonks and Steer. Exhibited R.A., R.P., N.E.A.C. and other venues.
lit: Waters

LODDIGES, George 1784 – 1846
Lived in London. Primarily a botanist but illustrated his own work and made what Blunt calls 'trim little plates' for Conrad Loddiges' *Botanical Cabinet* 1818-1833. Some of his drawings are in the British Museum.
lit: Blunt and Stearn, Brinsley Burbidge, Desmond

LOUDON, Jane Webb 1807 – 1858
Jane Webb Loudon was a remarkable and enterprising lady who, at seventeen, was left to support herself after the death of her parents. She decided to write a novel which somehow attracted the attention of the eminent writer and editor, John Loudon. Whatever the fate of the novel, John Loudon married her. He inspired in her an interest in gardening as well as writing and she helped him with editing and research. As a friend of John Lindley, Jane enlisted his help in the field of botanical illustration and, as well as illustrating her husband's books, she both wrote and illustrated many of her own. The books and the Loudons themselves became very popular and they appear to have had a good social life and travelled extensively.

John Loudon, who was twenty-four years older than his wife, died at the age of sixty from a serious lung condition. As neither of them were able to work during his illness, Jane was left in

greatly reduced circumstances. She soldiered on, however, working on her books and becoming editor of a magazine called *The Ladies Companion at Home and Abroad*.

Her books include *Instruction on Gardening for Ladies* (20,000 copies), *My Own Garden, The Ladies Flower Garden, Ladies Flower Garden of Ornamental Annuals, Botany for Ladies, Ladies Ornamental Flower Garden, The Ladies Flower Garden of Ornamental Bulbous Plants, The Ladies Flower Garden of Ornamental Perennials,* a series on wild flowers and another on ornamental greenhouse plants. She was certainly the most important of the ladies of that era who chose to write, illustrate and publish their own books.
lit: Blunt and Stearn, Brinsley Burbidge, Desmond, Kramer, Rix

LOUDON, Terence 1900 –
London painter son of the artist W. Mouat Loudon. Painted flowers and portraits in oil and exhibited R.A., R.P., R.O.I., R.W.A.
lit: Brinsley Burbidge, Hardie, Waters

LOWENTHAL, Bertha fl.1888 – 1919
London artist who exhibited flower paintings R.A., S.B.A., N.W.C.S., and other venues.
lit: Brinsley Burbidge, Desmond, Waters

***LUCAS, Albert Dürer** 1828 – 1918
Son of Richard Cockle Lucas, sculptor. Specialised in small, very detailed mixed bouquets of flowers, foliage and ferns, sometimes with butterflies and insects. Trained at Westminster School of Art and exhibited B.I., S.B.A. and other venues. (See pages 44-47.)
lit: Brinsley Burbidge, Desmond, Waters, Wood

LUCAS, Samuel 1805 – 1870
Painted flowers, birds and landscape. Flower paintings included a collection of the flora of Hitchin. Exhibited R.A., B.I., S.S.
lit: Brinsley Burbidge

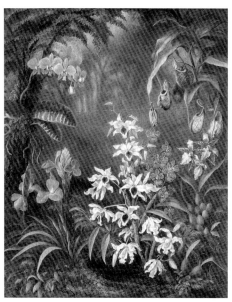

LUCAS, Albert Dürer. Orchids.

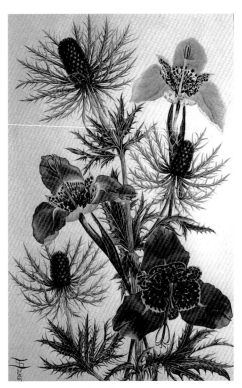

LUCAS, Suzanne. Eryngium.

***LUCAS, Suzanne, F.L.S., P.R.M.S., F.P.S., F.R.H.S. (Gold Medallist), Médaille de la France Libre 1915 –**
Suzanne Lucas, Founder President of the S.B.A. and a truly remarkable lady, was born in India where exotic flowers and butterflies inspired an urge to paint them at a very early age.

After formal education at Roedean she travelled extensively in Europe (her mother considered travel to be the finest education) including Belgium, the Rheinland, Switzerland and France. Monte Carlo in the springtime was followed by flower set journeys through the Middle East after which she attended and graduated from Edinburgh University.

Later in the 1930s she spent time in the Dolomites in order again to paint flowers. After this she and her mother studied German at Munich University. During this time, in 1936, they met Hitler at lunch in a café but, although initially mesmerised by him, the horror of the Nazi movement soon came home to them. They spent some time in the Grossglockner region, climbing and painting the mountain flowers, then moved on to Berlin where they stayed with the eminent Egyptologist, Professor Schaeffer. It was when the Professor's anti-Nazi son was brutally murdered that Suzanne almost broke down and her mother took her away to Sicily to paint the wealth of flowers there. After a week of Easter celebrations in Rome followed by time in Florence and Lake Como, they joined her father in Egypt where he was serving with the R.A.F. All through these and other exhilarating travels Suzanne was painting the indigenous flowers and, while in Egypt, continued travelling around and painting up to and beyond her marriage to Captain Louis Lucas of the Suez Canal

Company, a loyal follower of General de Gaulle.

Although they spent the war based at the Free French Headquarters in England the couple returned to Egypt a few years before the Suez crisis blew up. It was a hair-raising time during which, more than once, they narrowly escaped death by bomb or bullet. Suzanne's husband, now Admiral Lucas, had become Head of Navigation of the Suez Canal, in many ways an unenviable and dangerous position but, against all the odds, she went on searching out and painting flowers. They returned to Paris on her husband's retirement where she was able fully to indulge herself in her highly professional miniature paintings and her watercolours of flowers, butterflies and other small creatures. She exhibited at the Paris Salon, the R.A., R.I. and many other venues in London as well as mounting several one-man shows, mainly also in London. She later became the first woman President of a Royal Society when she was elected by the Royal Society of Miniature Painters.

Her husband died in 1978 and Mrs Lucas returned to England, still continuing painting and exhibiting. Suddenly, in the 1970s, she fell irrevocably in love with toadstools which have provided her primary and favourite subject ever since. These exquisite paintings, covering a vast range of toadstools, many as beautiful as the flowers that had previously been of such interest, were soon being exhibited regularly and annual exhibitions at the R.H.S. have earned her thirteen Gold Medals. It was for the quality and perfection of her toadstool studies that she was elected a Fellow of the Linnean Society. In 1985 she founded the S.B.A. in whose exhibitions her toadstools have featured ever since and they have also been widely shown in the U.S.A. where she is an Honorary Director of the American Society of Botanical Artists and has acted as judge for the Georgia Miniature Society. She has received many accolades for her beautiful, again perfectionist, miniature paintings on the ivory which was so plentiful during her time in Cairo and of which she laid in a good stock from the Egyptian bazaars.

Suzanne Lucas' acclaimed book *In Praise of Toadstools* was published in 1992 and contained 140 colour reproductions of her toadstools with accompanying descriptions. So determined was she that more and more people should be made aware of the sheer loveliness of so many of these 'little people' that she invested £110,000 of her own money in the project. The fact that Volume II has since been published with 163 further coloured illustrations of her paintings speaks for itself.

'Toadstools,' she maintains, 'are the unconsidered people of the Third Kingdom'.
Colour Plate 85

LUCKAS, Joy Heather, S.B.A. 1926 –
After attending school in Cambridge Joy Luckas spent the war years in the drawing office of the Telephone Manager, Cambridge. After the war she worked in the Fine Art Department of Valentines of Dundee until her marriage. With a busy doctor husband and a family, art took a back seat for a while but later she took up botanical painting in watercolour and started exhibiting with the S.B.A. and the R.H.S. She has been awarded one Bronze and five Silver Gilt Medals. She also exhibits with the Linnean Society, the Kent Nature Reserve and in Chester and Wales and works to private

commissions. She has work in the R.H.S. permanent collection and in the Hunt Institute.

***LUDGATE, Eleanor, S.F.P. 1950 –**
With an artist father and step-brother and other talented family members it is not surprising that Eleanor Ludgate has been drawing and painting since she was three years old. She trained in fabric painting at Guildford College of Art for three years but on moving to Devon was so inspired by the beauty of the countryside that she started painting wild flowers and wildlife. Her wild flower work was soon discovered by greetings card publishers and has also been reproduced as prints, calendars and book illustrations and as designs for Suttons Seeds.

She has had and participated in many exhibitions including the Bankside Gallery, Mall Galleries, the Medici Gallery, and galleries at Henley-on-Thames, Frinton and Slimbridge. She is a Founder Member of Nature in Art at Wallsworth Hall, Gloucester, and a Member of the S.F.P. with whom she exhibits widely. In 1990 Eleanor Ludgate opened her own gallery in Sidmouth, Devon, where she can be seen working on commissions from all over the world and with a display of her own original paintings, prints and greetings cards.

LUDOVICI, Marguerite fl.1876 – 1895
Exhibited flower paintings R.A., S.S. and other venues.
lit: Brinsley Burbidge

LUGARD, Charlotte Eleanor 1859 – 1939
Miniature and flower painter and collector of plants including a collection from South Africa. Drew many plants collected by her husband E.J. Lugard. Exhibited R.A.
lit: Brinsley Burbidge, Desmond

LUPTON, Edith fl.1871 – 1893
London artist who exhibited flower paintings R.A., S.B.A. and other venues.
lit: Brinsley Burbidge, Desmond

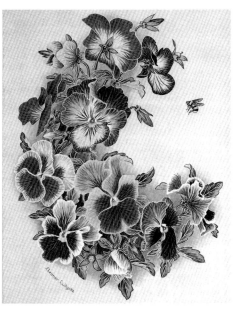

LUDGATE, Eleanor. Pansies.

McALLEN, Monica M.D., F.R.C.P., S.B.A
20th century

Monica McAllen took up botanical painting seriously after her retirement as a hospital consultant physician. She studied under Anne-Marie Evans for several years and quickly gained recognition for her work. She has exhibited and sold widely in the U.K. and overseas, has gained a Gold and two Silver Gilt R.H.S.Medals and two Certificates of Merit from the S.B.A.

Her style is to paint life-size accurate botanical studies on a white ground. Her paintings have been acquired by the Chelsea Physic Garden and the R.H.S. and she is at present preparing a book on the clematis species. Her work has also been reproduced as greetings cards.

McDOUGALL, Jillian Margaret 1940 –

Studied art under George Maynard from 1952-55, then Canterbury College of Art until 1958 where she studied flower painting under Bernard Willis, A.R.C.A., 1958-60 at Thanet Art School. For a time she worked in the studio of Sir Nicholas Seekers at West Cumberland Silk Mills making textile designs, then from 1961 she became a freelance flower painter.
lit: Brinsley Burbidge

McEVOY, Mary 1870 – 1941

Born Mary Edwards, Freshford, Somerset, and married fellow painter Ambrose McEvoy. Painted flowers and portraits after training at the Slade and exhibited R.A., N.E.A.C. and the Chenil Galleries.
lit: Brinsley Burbidge, Desmond

McEWEN, Elizabeth. Japanese anemones.

McGIRR, Barbara. Irises.

*McEWEN, Elizabeth A., S.B.A., R.U.A., U.W.S., U.S.W.A. 1937 –

Has lived all her life in Belfast. Trained at Belfast College of Art followed by teacher training at Reading University. Taught art for a number of years but has painted full time since 1974. She specialises in botanical subjects, often in natural settings or as part of a still life.

She is a Member of the Ulster Watercolour Society, the Ulster Society of Women Artists and an Academician of the Royal Ulster Academy. Winner of the Royal Ulster Academy Gold Medal in 1991, the R.U.A. prize in 1997 and has three times been the winner of the Northern Ireland Rose Society Painting Competition.

McEWEN, Rory, B.A.Cantab. 1932 – 1982

Born in Berwickshire, great grandson of John Lindley. From a very young child he painted flowers, encouraged later at Eton by Wilfrid Blunt, the then Art Master – 'perhaps the most gifted pupil to pass through my hands'. He painted flowers in watercolour on vellum with a skill and finesse that is matched only, perhaps, by such masters as Redouté, Ehret and the Bauer brothers.

At Cambridge he met Sacheverell Sitwell who further influenced his great love of flowers. He illustrated Moreton's *Old Carnations and Pinks,* 1955, and *Auriculas,* 1964, also Blunt's *Tulips and Tulipomania,* 1977. From 1962 he was exhibiting all over the world including New York with great success and his work is represented in the Hunt Institute. His untimely death is an inestimable loss to the art and botanical worlds.
lit: Blunt and Stearn, de Bray, Brinsley Burbidge, Desmond, Rix, Sherwood

MacFARLANE, John R. 1836 – 1918

Little known flower artist who made plates for nurserymen and horticultural journals.
lit: Blunt and Stearn

*McGIRR, Barbara, S.B.A., S.F.P.
20th century

Barbara McGirr studied textile design at Belfast College of Art, then completed her studies at Reading University where a scholarship in her final year led to a year's travel in Italy. For the next three years she worked full time for the textile industry and won two more national textile competitions which enabled her again to travel extensively in Italy and in Turkey. Since then she has worked as a freelance designer for Sandersons, John Lewis, Marks and Spencer, Colefax and Fowler, Textra and Liberty's, as well as producing wallpaper collections for New York. She has taught in art schools in England and Israel.

After moving to Ely in 1974 she put her botanical skills to work on illustrating floral and natural history subjects for Longmans, Collins,

MACKINTOSH, Charles Rennie. Begonias.

Cambridge University Press and others. She has been commissioned to illustrate a plan of Marjorie Fish's garden in Somerset and Blooms of Bressingham have commissioned flower portraits of new species for their catalogues. Her textile design, which continues, includes linen for Vantona in conjunction with the World Wildlife Fund for their Natural History Collection.

Barbara McGirr has had eight one-man shows at the Old Fire Engine House, Ely, and exhibitions in Bury St Edmunds, London and Cambridge. She exhibits regularly with the S.B.A. and S.F.P., Hampton Court Palace International Flower Show, the S.W.A. and has also exhibited at the International Botanical Art Exhibition, Johannesburg, and sold paintings to a gallery in Tokyo.

MACIRONE, Cecilia fl.1855 – 1859
London artist who exhibited flower paintings R.A., B.I., S.B.A.
lit: Brinsley Burbidge, Desmond

MACKENZIE, Daniel fl.1790s
One of the first engravers to specialise in botanical illustration. Made engravings from some of the drawings produced on Cook's first voyage and for Roxburgh's *Plants of the Coast of Coromandel*, 1795-1820.
lit: Mabey, Rix

***MACKINTOSH, Charles Rennie**
1868 – 1928
Famous Scottish architect, artist, designer of furniture and textiles of strikingly individual manner. Although perhaps fewer people know him as a flower painter than an architect, almost all his design work contains plant forms in some way. His pure watercolours are magic; whether botanical or stylised, abstract or traditional, they bear the Mackintosh hallmark and are a joy to behold. Many of them are in the Hunter Museum, Glasgow. (See page 62.)
lit: Robertson, Scott-James, Waters
Colour Plates 31 and 32

MACKLEY, George E., F.R.S. 1900 -1983
Born Tonbridge and became a school teacher and wood engraver. Trained at Central School of Arts and Crafts and published several books on wood engraving. Also illustrated Colt's *Weeds and Wild Flowers*. Work is in the Hunt Institute.
lit: Brinsley Burbidge, Desmond

***McMURTRIE, Mary 1902 –**
Mary McMurtrie studied at Gray's School of Art in Aberdeen and still lives close to the city. For over forty years she maintained a nursery specialising in alpines and old garden flowers. Her collection includes wild flowers of Scotland, the Algarve and Kenya, all subjects of her delightful watercolours, although her greatest favourites are the old Scots roses.

She has had many exhibitions of her watercolours in Scotland, England and France and her published work includes a series of small books on Algarve flowers, shrubs and trees. Her latest books, *Scots Roses of Hedgerows and Wild Gardens* and *Scottish Wild Flowers,* published by Garden Art Press in 1998 and 2001, are supreme examples of her ability to depict not only the botanical aspect of the flowers, but their elusive, ephemeral personalities.

MACTAGGART, Sir William, P.R.S.A.
1903 –
Scottish artist, great-grandson of the famous William McTaggart, who painted, mainly in oils, still life, flowers and landscape. Studied at Edinburgh College of Art and on the Continent. He was a Member of S.S.A., P.S.S.A. (1934-36), A.R.S.A., and P.R.S.A. 1959. He first exhibited at the R.S.A. in 1929 and held his first solo exhibition in Edinburgh the same year. He exhibited widely in Scotland and overseas and was knighted in 1962. His work is in public and private collections in many countries, although his home was always in Edinburgh.

McMURTRIE, Mary. Cherry.

MADDISON, Eileen. Specimen orchid.

MacWHIRTER, Agnes b.1837, fl.1870s
Edinburgh artist who exhibited flower paintings R.A. and in Dudley and Liverpool.
lit: Brinsley Burbidge, Clayton, Desmond

***MADDISON, Eileen, S.B.A. 20th century**
Eileen Maddison trained in illustration at the Central School of Art, London, and after many years spent teaching and freelance illustrating, she started to specialise in botanical painting which she describes as sheer self-indulgence. She is kept busy with commissions and exhibitions, working in very fine detail and with a high standard of botanical accuracy.

She exhibits with the S.B.A. and R.H.S. from whom she has a Silver Gilt Medal. Many other exhibition venues include Pashley Manor Gardens in Sussex and the American Daffodil Convention in Pittsburgh, U.S.A., both by invitation.
Colour Plate 86

MAGNUS, Rose fl.1859 – 1890
Manchester artist who exhibited flower paintings S.B.A. Work represented in Sheffield Museum.
lit: Brinsley Burbidge, Desmond

MAGUIRE, Adelaide Agnes fl.1852 – 1876
London painter of flowers and children. Exhibited R.A.
lit: Desmond

MAGUIRE, Bertha fl.1880s and 1890s
Sister of Adelaide Agnes who exhibited flower paintings N.W.C.S.
lit: Desmond

MAHONEY, Charles, R.A., A.R.C.A., N.E.A.C. 1903 – 1968
Lived in Kent and London, trained at Beckenham School of Art and the R.C.A. under Sir John Rothenstein.Later taught at the R.C.A. himself from 1928-1953. Painted flowers as well as other

subjects and exhibited N.E.A.C., R.B.A. and other venues. Work represented Tate Gallery and in Sheffield, Leeds and Newcastle.
lit: Brinsley Burbidge, Waters

MAITLAND, Anne Emma, W.I.A.C.
fl.1920 – 1950
Lived in Kent and London. Painted flowers in both oil and watercolour and exhibited R.A., R.I., R.B.S.A., G.I., Paris Salon.
lit: Waters

MANISCO, Katherine 1935 –
Katherine Manisco is a British flower painter now living in the U.S.A. She trained at the Slade, London University, and at the Accademia dell'Arte in Florence. From 1977 she spent ten years as art director of Wells, Rich and Greene. She has exhibited widely in the U.K. and U.S.A. including three one-man shows in New York, one with the Horticultural Society of New York. Other venues include the R.H.S., London, the R.B.G., Kew, several galleries in New York and the Hunt Institute. She has been awarded the R.H.S. Grenfell Silver Medal. She has been featured in *Elle Decor, New York Magazine* and *Town and Country* and her work is in the permanent collections of the V. and A., the Fitzwilliam Museum, Cambridge, the Hunt Institute, the Shirley Sherwood Collection and many private collections. She is a Member of the American Society of Botanical Artists and the Chelsea Physic Garden Florilegium Society.
lit: Sherwood

MANN, Cathleen S., R.P., R.O.I., N.S., W.I.A.C. 1896 – 1950
Daughter of artist, Harrington Mann. Studied at the Slade and in Paris. Married the Marquess of Queensberry and, later, J.R. Follett. Lived London and exhibited flowers and portraits R.A., R.P. and other important galleries. Work is in several public collections in the U.K. and overseas.
lit: Waters

***MANNES-ABBOTT, Sheila, F.S.B.A, F.L.S. 1939 –**
Sheila Mannes-Abbott was born in Hillingdon and at the age of thirteen was awarded a scholarship to Ealing School of Art for a portfolio of flowers in watercolour. Her career has been spent largely as a freelance botanical artist and she was a Founder Member of the S.B.A. in 1986. She gives one and two day courses in watercolour flower painting and is a visiting lecturer at Brunel University. She is a keen conservationist and flowers of the countryside are often joined in her painting by small wild animals and insects. With Phil Drabble she produced *Four Seasons: The Life of the English Countryside* in 1981.

She has had one-man shows at Reading Fine Art Gallery, Furneux Gallery, Wimbledon, Noel Gregory Gallery, Farnham Common and Bohun Gallery, Henley-on-Thames, and has also exhibited regularly with the S.B.A., R.H.S., R.A. and R.W.S. She was awarded the R.H.S. Grenfell Silver Gilt Medal in 1974 and 1978, R.H.S. Gold Medal in 1997 and the S.B.A. Medalife Award in 1990. Her work is in numerous private collections including those of Dr Shirley Sherwood and General Sir Hugh

Beach and in the Hunt Institute.
Her work has been reproduced on greetings cards, fabric, puzzles, china designs, social stationery and collectors' plates and commissions include Athena International, the B.B.C., Boots, Coalport, Franklin Mint, the National Trust, the Royal Society for Nature Conservation and many more. Her work was also represented in *The Royal County: a Commemoration of the Silver Jubilee of H.M. Queen Elizabeth II.* Her current ongoing project is a major, large format book with upwards of fifty-five full page illustrations of species and hybrid irises. Sheila will only work from live specimens, as all good flower painters should, so it takes many seasons to accumulate enough work.
lit: Sherwood, Drabble
Colour Plate 87

MARGETTS, Ada fl.1861 – 1863
Oxford artist who exhibited flower paintings R.A., B.I., S.B.A. Her sister Mary, who lived in London, also exhibited flower paintings N.W.C.S.
lit: Brinsley Burbidge, Desmond

MARGITSON, Maria 1832 – 1896
Norwich flower painter who was taught by Eloise Harriet Stannard. She was the niece of John Berney Ladbrooke. Exhibited S.B.A. and B.I. as well as in Norwich.
lit: Brinsley Burbidge, Day, Desmond, Moore, Walpole

MARKS, George fl.1870s and 1880s
Painted flowers and landscape and exhibited R.A., S.B.A., N.W.C.S. and other venues.
lit: Brinsley Burbidge, Desmond

MARSHAL, Alexander c.1639 – 1682
It has been suggested he may have been the son of the Dutch flower painter Otto Marcellis but I think this is questionable. Notable work is the beautiful album of flower paintings in the Royal Collection at Windsor. (See pages 15, 22-25.)
lit: Blunt and Stearn, de Bray, Brinsley Burbidge, Fisher, Fulton and Smith, Mabey, Rix, Scott-James, Desmond and Wood
Colour Plate 1

MARSHALL, Rose fl.1879 – 1890
London artist who exhibited flower paintings R.A., S.B.A., G.G. and other venues.
lit: Brinsley Burbidge, Desmond, Wood

MARSTON, Mabel G. fl.1885 – 1893
London artist who exhibited flower paintings R.A. and S.B.A.
lit: Brinsley Burbidge, Desmond

MARTIN, Dorothy 1882 – 1949
Trained at Wolverhampton School of Art and the R.C.A., became Art Teacher at Roedean 1916-1946. Prolific flower painter who made 450 sheets of 300 drawings of wild flowers in Keswick during the war. There is a collection of 300 of her flower drawings in the Lindley Library, R.H.S. She exhibited occasionally but preferred to concentrate on her personal work.
lit: Blunt and Stearn, Brinsley Burbidge, Desmond, Rix

MARTIN, Maggie, B.Ed., Cert.Ed., S.F.P. 1927 –
Maggie Cooper, who has lived in London, Essex, Staffordshire and Dorset, graduated from Birmingham and Wolverhampton Teacher Training College. As well as teaching biology and later becoming Deputy Head of a large comprehensive school, she has illustrated King Penguin books and other publications.

On retirement she returned to serious painting and became involved with many wildlife concerns. She has exhibited her botanical painting with the S.B.A., S.F.P. and R.H.S. as well as in Dorchester, Salisbury and other venues. She is fascinated by the intricacies of plant forms and aims to give them detailed expression. She illustrated a Millennium Calendar to celebrate the rare plants of the Chesil Beach and a book designed to celebrate a unique and unspoilt Dorset Valley Farm – Kings Combe Meadow.

MARTINEAU, Clara fl.1873 – 1890
London artist who exhibited flower paintings R.A., S.B.A. and other venues.
lit: Brinsley Burbidge, Desmond

MASON, Josephine, W.I.A.C. fl.1915 – 1950
Painted flowers and still life, exhibited R.A., N.E.A.C., W.I.A.C. Lived in Chelsea.
lit: Waters

MASSON, Francis 1741 – 1805
Born Aberdeen, died Montreal. First job was as under-gardener at Kew where his skill and enthusiasm for botany attracted the attention of Sir Joseph Banks. He was a keen collector of plants especially when, encouraged by Banks, he started travelling widely – South Africa, the Canary Islands, Spain, Morocco, the West Indies and more. He introduced many new plants into this country including the stapeliae of South Africa. As well as collecting and sending plants back to Kew, he was illustrating all the time. His most noted illustrations are for *Stapeliae Novae,* 1796-7, published in four parts. His work is in the British Museum. (See page 34.)
lit: Blunt and Stearn, Brinsley Burbidge, Coats, Desmond, Mabey, Rix

MANNES-ABBOTT, Sheila. Miniature dwarf bearded iris 'Maharba'.

MATHEWS, Alister. Blackthorn, sloes.

***MATHEWS, Alister, B.Sc., S.B.A., S.W.A.**
1939 -
Alister Mathews lives and works in Hitchin, Hertfordshire, and is an enthusiastic gardener and painter of the more unusual species of flowering plants and fungi. She graduated in botany and is a Member of the S.B.A., S.W.A. and an R.H.S. Silver Medallist. All her paintings are in watercolour, drawn and painted in natural light from fresh material to give accuracy of colour and shape. Her work has been included in exhibitions at The Country Life Gallery, the Linnean Society, Chelsea Flower Show, the Rufford Art Centre, Nottingham, the Malcolm Innes Gallery, Durham Museum, Burford House, Tenbury Wells, Hitchin Museum, the 8th International Exhibition of Botanical Art at the Hunt Institute and annually at the Westminster Gallery. Her work is represented in the Shirley Sherwood Collection and in the Hunt Institute.
lit: Sherwood

MATTHEWS, C. early 19th century
Illustrated many plates for William Baxter's (Curator of Oxford Botanic Garden) work on the British flora.
lit: Blunt and Stearn

***MAUND, Miss and Miss S.**
early 19th century
Little is generally known of these ladies in spite of their famous father, Benjamin Maund, of *The Botanic Garden* and Maund's *Botanist* but, along with such prominent artists as Miss Drake and Mrs Withers, they provided him with many highly skilled and botanically accurate illustrations. No doubt they received stringent botanical instruction from their father. (See page 52.)
lit: Kramer, Maund
Colour Plates 24-26

MAW, George 1839 - 1912
Born London, by trade a tile manufacturer. He grew and made an extensive study of the crocus and in 1886 produced his *Monograph on the Genus Crocus* illustrated by himself. Ruskin described his crocus drawings as 'most exquisite and quite beyond criticism'. (See pages 50-51.)
lit: Blunt and Stearn, Brinsley Burbidge, Rix, Stearn

MAWSON, Elizabeth Cameron
fl.1877 - 1892
Artist of Gateshead, Durham, who exhibited flower paintings R.A., S.B.A., N.W.C.S. and other venues.
lit: Brinsley Burbidge, Desmond, Waters, Wood

MAZELL, Peter fl.1761 - 1797
Basically an engraver who worked for various artists and authors including Sowerby and Thornton. He also painted flowers himself and exhibited R.A.
lit: Mitchell

MEAD, Rose 1868 - 1946
Born Bury St Edmunds, studied at the Slade and in Paris. Best known for flower paintings and interiors, also some portraits. Exhibited R.A., R.P., Paris Salon and other venues. A commemorative exhibition of her work was held in Bury St Edmunds in 1955.
lit: Ipswich Museums Service

***MEADOWCROFT, Audrey, S.B.A. 1932 -**
Audrey Meadowcroft, an Honours graduate in Art Education, has now retired after many years of teaching, both in schools and adult education, and concentrates on her own painting. Although a Founder Member of the S.B.A., like many others she prefers not to be constrained by the strictures pure botanical painting demands but to present her flowers in a more decorative style. Living in the Wye Valley in unspoilt countryside, there is an abundance of wild flowers to give inspiration to

MAUND, Miss S. *Solanum augustifolium.*

MEADOWCROFT, Audrey. In the garden.

the painter as well as garden and conservatory species and all of these she incorporates into her paintings, sometimes with trees, rocks, insects and even small animals. A Member of the Watercolour Society of Wales, Audrey Meadowcroft has exhibited widely in Wales including St David's Hall, the National Museum of Wales and with the Royal Cumbrian Society, the S.B.A., R.W.S., as well as other commercial galleries in England.
Colour Plate 88

MEADOWS, Gillian Audrey 1946 -
Edinburgh botanical artist and illustrator whose work has been reproduced in many scientific publications
lit: Brinsley Burbidge

MEDHURST, Doreen, S.B.A., R.M.S.,
S.W.A. 1929 -
Although always keen on painting as a hobby, Doreen Medhurst, who lives in Kent, started painting seriously in 1969. Flowers and gardens are her subjects, especially in miniature, and she is a Member of the R.M.S., S.W.A. and the S.B.A. She prefers gardens and more decorative studies to botanical work although she is quite competent in this field.

She exhibits with the three societies with which she is involved, also in other London galleries, Alfriston, Sevenoaks and Limpsfield.

***MEE, Margaret Ursula, M.B.E., F.L.S.**
1909 - 1988
Born Chesham, Buckinghamshire, attended Camberwell School of Art and St Martin's. Passionately fond of travel and of painting rare and unusual plants in more exotic countries, she is best known for her studies of flowers of the Amazon forests, the subject of her book *In Search of Flowers of the Amazon Forest* published shortly before her tragic death.

Margaret Mee had exhibitions at the Natural History Museum, 1980, Missouri Botanic Garden, 1986 and Kew, 1988. She was awarded the M.B.E. in 1975, elected a Fellow of the Linnean Society in 1986, awarded the Order of Cruzeiro do Sol (Brazil), Honorary Citizenship of Rio de Janeiro and a Guggenheim Fellowship. For ten years she was an Honorary Associate of the Botanical Museum, Harvard University. (See pages 80-84.)
lit: de Bray, Brinsley Burbidge, Mabey, Morrison, Sherwood, Stearn
Colour Plates 43 and 44

MEE, Margaret. *Mormodes amazonicum.*

MEEN, Margaret fl.1770 – 1824
Born Bungay, Suffolk, but later lived in London where she taught drawing of plants and insects in the 1770s. She was an extremely gifted and very industrious amateur painter who painted many exotic plants at Kew and her illustrations of those from the collection of the Earl of Tankerville are in Kew Herbarium. In 1790 she started a serial publication, *Exotic Plants from the Royal Gardens at Kew,* which she had planned bi-annually but only two issues were actually published – ten plates are now at Kew which show 'outstanding talent and vision'. She exhibited at the R.A. from 1775-85. (See page 37.)
lit: Blunt and Stearn, Brinsley Burbidge, Desmond, Mabey, Rix

MEREDITH, Louisa Anne 1812 – 1895
Born Birmingham, died Melbourne. Illustrated her own books, *The Romance of Nature,* 1835, *Wild Flowers,* 1838, and *My Home in Tasmania,* 1852-3.
lit: Blunt and Stearn, Brinsley Burbidge, Desmond

METHUEN, Lord (Paul Aylsford, 4th Baron), M.A.Oxon., R.A., R.W.S., Hon. R.I.B.A. 1886 – 1974
Born Corsham, later lived and died in Bath. Studied under Sickert and painted some landscapes but mainly flowers, especially magnolias and orchids which he cultivated. He was a Member of the Royal Fine Art Commission, 1928-45, and a trustee of both the Tate and National Galleries. He exhibited R.A., R.W.S., Lancaster Galleries, Colnaghi's and the Paris Salon and his work is represented in the Tate Gallery, the Contemporary Art Society and the Musée National d'Art Moderne, France.
lit: Brinsley Burbidge, Desmond, Tate Gallery, Waters

MILES, Annie Stewart fl.1888 – 1894
London artist who exhibited flower paintings R.A. and S.B.A.
lit: Brinsley Burbidge, Desmond

MILLER, Bunty 1919 – c.1987
Bunty Miller, the daughter of and later the wife of an Indian Army officer, was born in India, educated at an English boarding school and later at finishing school in Switzerland where she first made good use of her exceptional talent for drawing and painting which became such an important part of her life. Considering that she had no formal training, that talent could perhaps better be described as genius.

Bunty Miller's work fascinated me for many years as I followed it mainly through her exhibits in the Royal Academy (always sold) and through contacts with the Medici Society who published her work as greetings cards. The exquisite detail and perfection of execution were magnetic, whatever the subject. She was an accomplished portrait painter and had a number of distinguished sitters; her little still life subjects seemed chosen as exercises in sheer craftsmanship and skill but to me her flower studies which qualify her for entry in this book are the most delicate and charming of all. I particularly remember a spray of violets which one could almost smell, a cluster of hellebores and a nosegay of snowdrops. Bunty Miller exhibited at the R.A. for twenty-nine successive years, also at the R.P.S., R.S.A. and the Paris Salon.
lit: Brinsley Burbidge, Goodman

MILLER, Henrietta fl.1884 – 1889
Member of the Society of Lady Artists who exhibited flower paintings R.A., S.B.A., N.W.C.S., G.G.
lit: Brinsley Burbidge, Desmond

MILLER, James 18th century
Brother of John Frederick Miller who helped him complete Parkinson's unfinished sketches.
lit:Blunt and Stearn, Rix

MILLER, John Frederick, F.S.A.
 fl.1768 – 1794
Son of John Sebastian Miller who assisted him in the completion for Sir Joseph Banks of Parkinson's unfinished sketches. He also went to Iceland with Banks and Solander as draughtsman. He illustrated Weston's *Universal Botany* and collaborated with his brother on the floral *Illustratio Linneai,* 1770-77. His drawings of Icelandic plants are in the British Museum. (See pages 30-32.)
lit: Blunt and Stearn, de Bray, Brinsley Burbidge, Desmond, Mabey, Rix, Stearn

MILLER, John (formerly Johann Sebastian Müller) c.1715 – c.1790
Authorities vary considerably on his exact dates, also place of birth – Blunt and Williams say Nuremberg, Bénézit says London. In any event he settled in London in early life. He was one of the artists employed by Banks to finish Parkinson's incomplete sketches and he illustrated his own

Illustratio Systematis Sexualis Linnaei, 1777-89, with 108 hand coloured engravings which were highly praised by Linnaeus himself. He also compiled for Lord Bute *Botanical Tables containing the Different Familys* [sic] *of British Plants* of which a copy is in the Lindley Library. He was awarded the Society of Arts premium in 1766 and exhibited at the R.A and the Society of Arts. There are over 1,000 of his drawings in the Natural History Museum and he is also represented in the Oxford Department of Botany. (See page 30.)
lit: Blunt and Stearn, Brinsley Burbidge, Desmond, Graves, Mabey, Rix, Sitwell
Colour Plate 9

MILLER, Kathleen Helen 1904 –
Lived in Ipswich and Woodbridge, Suffolk, and trained at Ipswich School of Art. Painted flowers and landscape and exhibited R.A. and in the provinces.
lit: Waters

MILLER, Sophie fl.1892 – 1894
Wife of Philip Home-Miller. Exhibited flower paintings R.A. and N.W.C.S.
lit:Brinsley Burbidge, Desmond

MILLS, Mrs C. 18th century
Obviously a very capable lady but of whom little is known other than an album of drawings dated 1792 in the Broughton Collection, Fitzwilliam Museum, Cambridge.
lit: Mitchell

***MILLS, R.** fl. early 19th century
Known (probably only) for drawings from Maund's *Botanist, The Botanic Garden* and Coates and Westcoll's *The Floral Cabinet and Magazine of Exotic Botany* (three vols. 1831-46). Work is in the Fitzwilliam Museum, Cambridge. (See page 52.)
lit: Brinsley Burbidge, Desmond, Scrace
Colour Plates 28 and 29

MILLS, R. *Grevillea perruginea.*

MINTON, Lorna **20th century**
Lorna Minton trained as a photographer but subsequently returned to her first love of painting and is a well-known botanical artist and illustrator. She has had work published as a wide range of greetings cards as well as calendars, jigsaw puzzles and in books and magazines. Her original works are in numerous private collections in the U.K. and overseas.

She has exhibited widely including the R.H.S.,. of which she is a Gold Medallist, the British Mycological Society, a number of provincial galleries and in Tasmania and Copenhagen. She also works to commission.

MITCHELL, Mrs James B. **fl.1879 - 1897**
Wife of the portrait painter James B. Mitchell. Exhibited flower paintings R.A., G.G. and other venues.
lit: Brinsley Burbidge

MITCHELL, Miss M.D. **fl.1876 - 1892**
London artist who exhibited flower paintings R.A., G.G., S.B.A. and other venues.
lit: Brinsley Burbidge, Desmond

MOGGRIDGE, John Traherne 1842 - 1874
Born in Wales, died in France. Drew the illustrations for his *Flora of Mentone*, 1864-74; he spent his winters on the Riviera for health reasons. He drew with a beautifully light touch, Blunt says 'with great faithfulness and delicate charm the flowers of the Riviera'. Some of his drawings and letters are now in the Kew Herbarium. (See page 51.)
lit: Blunt and Stearn, Brinsley Burbidge, Desmond

MOON, Henry George **1857 - 1905**
Born London and studied at art school but first worked in a solicitor's office before, in 1880, joining the staff of *The Garden* as illustrator. He also illustrated Sanders' orchid folio *Reichenbachia, Orchids Illustrated and Described*, 1888-94 (he married Sanders' daughter), Robinson's *English Flower Garden*, 1883, and his *Flora and Sylva*. It had been at Robinson's instigation that he joined *The Garden*. Later in life he turned to landscape painting – Blunt suggests that methods of reproduction of the time did not respond to his style of painting and he became disillusioned with floral illustration. He exhibited R.A. and his work is represented in the Hunt Institute and the British Museum.
lit: Blunt and Stearn, Brinsley Burbidge, Desmond, Rix, Waters

MOORCROFT, Mary **fl. 1936**
Competent watercolour painter of flowers and some landscapes. Showed work locally in the Manchester area easily accessible from her home in Moss Side.
lit: Jeremy Wood

MOORE, E. Beryl **c.1930 -**
Worcestershire artist Beryl Moore has been a natural painter since her school days and on leaving school spent two years in Italy studying flower painting with an artist and his wife, Aubrey and Lena Waterford, just outside Florence. A brief spell at Westminster School of Art was interrupted by the war in 1939 but after the war she gained valuable experience with Royal Worcester Porcelain.

After three years she left to get married and bring up a family but, after her husband's death in 1977, she took a course at Flatford Mill Field Centre under Mary Grierson and once again started flower painting in earnest. Beryl Moore has exhibited in many galleries and other venues up and down the country and regularly participates in R.H.S. exhibitions. She produces her own range of greetings cards, the designs for which are small works of art, mainly watercolours of wild flowers in their natural habitat. They are decorative designs, but of complete botanical accuracy, and I particularly admire her aptitude with wild flowers, reminiscent of Augusta Innes Withers.
Colour Plate 83

MORGAN, Alfred George **fl.1862 - 1904**
London artist who exhibited flower paintings and still life R.A., S.B.A., G.G., B.I. and other venues. Examples of his work are in the V. and A.
lit: Brinsley Burbidge, Desmond, Waters, Wood

MORGAN, Mary Vernon, F.S.B.A.
 fl.1860s - 1928
Daughter of Birmingham landscape painter. Painted flowers and landscape and exhibited R.A., S.B.A., the Royal Birmingham Society of Artists and other venues in the provinces and abroad.
lit: Brinsley Burbidge, Clayton, Desmond, Waters

MORGAN, Robert **1863 - 1900**
Artist and lithographer. Illustrated Fryer and Bennet's *The Potamogetons of the British Isles* and Trimen's *Flora of Ceylon,* made many drawings for the *Journal of Botany* and publications of the Linnean Society. Derived much help from studying the work of W.H. Fitch. Drawings in the British Museum collection. (See page 48.)

MORISON, Robert, M.A., M.D.
 1620 - 1683
Scottish physician and botanist who was instrumental in persuading the famous French flower painter, Nicholas Robert, seriously to take up botanical illustration.
lit: Blunt and Stearn, Brinsley Burbidge, Desmond, Fulton and Smith, Rix

MORRIS, Sir Cedric Lockwood
 1889 - 1982
Born Glamorgan, died lpswich, trained in Paris, Berlin and Rome. Established the East Anglian School of Painting and Drawing at Dedham and later Hadleigh.

His wonderful gardens at Higham and Benton End provided plenty of subject matter for his lush and often flamboyant flower paintings with their inspired use of colour and colour co-ordination. Exhibited widely in London, Paris, Rome, New York and many other venues.
lit: Brinsley Burbidge, Desmond, Morgan, Waters

MORTON, Henry **fl.1807 - 1825**
London artist who exhibited flower paintings R.A., O.W.C.S. and other venues.
lit: Brinsley Burbidge, Desmond

MORTON, J., the Elder **fl.1791 - 1807**
Painted flowers and landscape, exhibited R.A.
lit: Brinsley Burbidge, Grant

MOSER, Mary (also Mary Lloyd)
 1744 - 1819
Daughter of George Michael Moser (1706-1783), a Swiss jeweller who settled in England and taught drawing to George III. He was elected first Keeper of the R.A. where his daughter started exhibiting at a very early age continuing from 1768-1802. She was elected a Founder Member on the strength of her celebrated flower paintings when she was only twenty-four; sadly she had to give up painting in 1802 because of failing eyesight. She worked very much in the Dutch manner, after marriage signing herself Mary Lloyd. One of her commissions was to decorate a room for Queen Charlotte at Frogmore which was from then on referred to as 'Miss Moser's Room'. She was awarded the Society of Arts premium in 1758 and '59 and her work was admired by Sir Joshua Reynolds. She is represented in the Royal Collection, the V. and A., the R.A., the Courtauld Institute (Spooner Bequest) and the Fitzwilliam Museum, Cambridge. She died in Kensington. (See page 27.)
lit: de Bray, Brinsley Burbidge, Clayton, Desmond, Grant, Kramer, Mitchell, Pavière, Scrace, Williams
Colour Plate 6

MOSTYN, Marjorie, R.Cam.A., S.W.A.
 1893 -
Daughter of Tom Mostyn, R.O.I. Studied at St John's Wood Art School, R.A. Schools and painted flowers and portraits in oil and watercolour. Exhibited R.A., R.O.I., R.Cam.A., Paris Salon and in the provinces. Lived at St Ives, Cornwall.
lit: Waters

MOXON, Margaret Louisa **1863 - 1920**
Born London, died Hampshire. Her drawings of Swiss plants are in the Kew collection.
lit: Desmond

MUCKLEY, William Jabez, R.B.A.
 1837 - 1905
Born Audnam, Worcestershire, studied Birmingham, London and Paris. Taught art at government schools in Worcester and Manchester. Painted flowers and still life using strong, bright colours. Exhibited R.A., B.I., S.B.A., N.W.C.S., G.G. and other venues and produced *A Manual on Flower Painting*, 1885.
lit: Brinsley Burbidge, Desmond, Waters, Wood

MUIR, Anne Davidson, R.S.W., S.S.A.
 fl.1910 - 1960
Scottish artist. Studied at Edinburgh School of Art and painted flowers and portraits in oil and watercolour. Exhibited R.A., R.S.A., R.S.W., S.S.A. and the Glasgow Institute.
lit: Waters

MULCAHY, Meg, S.F.P. 1949 –
After twenty-five years pursuing the nursing career for which she had trained, Meg Mulcahy started attending classes in flower painting in watercolour. She has now been elected a Member of the S.F.P. and exhibits with the Society, the S.B.A. and locally in Hampshire.

MULLVEY, Mrs Matilda, R.B.A., S.W.A.
1882 –
Born London and trained at Heatherley's. Painted flowers and portraits and exhibited R.A., R.B.A., R.P., N.E.A.C., S.W.A., in the provinces and the Paris Salon where she was awarded the Silver Medal in 1938.
lit: Waters

NAFTEL, Isobel Oakley fl.1857 – 1891
Lived for some time in Guernsey, wife of the painter George Naftel. Painted flowers, landscape and portraits and exhibited R.A., S.S., N.W.C.S. and other venues.
lit: Brinsley Burbidge, Desmond, Grant

NAFTEL, Maud, A.R.W.S. 1856 – 1890
Daughter of Paul Naftel, studied art at the Slade under Duran and in Paris. Painted flowers and landscape and exhibited R.A., O.W.C.S., G.G.,

Nash, John.

MULREADY, Augustus E.
fl.1863 – 1886 (d.1886)
London painter of flowers, domestic scenes and genre. Member of the Cranbrook colony, exhibited R.A.
lit: Brinsley Burbidge, Grant, Wood

MURRAY, Lady Charlotte 1754 – 1808
Amateur botanical draughtsman whose work according to Blunt was 'rather dreary'. Died Bath.
lit: Blunt and Stearn, Desmond

MUTRIE, Annie Feray 1826 – 1893
Born Ardwick, died Brighton, studied at Manchester School of Design under Wallis.

N.G. and other venues. Produced a book called *Flowers and how to Paint Them* in 1886.
lit: Brinsley Burbidge, Desmond, Wood

★NASH, John Northcote, O.B.E., R.A.
1893 – 1977
Born Kensington, died Colchester, Essex. Became official war artist during the First World War and between the two wars taught at the Design School, Royal College of Art, Colchester School of Art and the Flatford Mill Field Centre where many flower artists were set off to a good start. He illustrated twenty-five books including his own *English Garden Flowers,* 1948, *The Native Garden,* 1961, and *Flower Drawings,* 1969. Other books included Dallimore's *Poisonous Plants,* 1927, Bates' *Flower Faces,* 1935, Hill's *Curious Gardens,* 1935, and *The Contemplative Garden,* 1940, Gathorne-Hardy's *Wild Flowers in Britain,* 1938, and *The Tranquil Garden,* 1958, Synge's *Plants with Personality,* 1938, and White's *The Natural History of Selborne.* He exhibited widely in this country and abroad and in 1967 there was a Retrospective Exhibition at the Royal Academy. His work is in a number of important collections including the Tate Gallery, the V. and A. and the Hunt Institute.
lit: Blunt and Stearn, de Bray, Brinsley Burbidge, Desmond, Hadfield, Lewis, Rix, Rothenstein, Waters

NASH, Mrs Kathleen (née Sparrow)
fl.1920s
Born Plymouth and painted still life and flowers. Exhibited R.O.I., R.W.A., R.B.S.A., S.W.A. and in the provinces.
lit: Brinsley Burbidge, Waters

NEWSOME-TAYLOR, Cynthia 1906 –
Trained at Hornsey College of Art as a fashion designer but later, in 1945, started freelance illustrating garden books at which she became highly successful. Her illustrations are reproduced in Hellyer's *Garden Plants in Colour, Perennial Plants for Small Gardens* and *Shrubs in Colour,* also the *Rochford Book of Houseplants.* Always she worked from living plants. She exhibited at the Hunt Institute and the R.H.S. (300 watercolours) and was awarded three R.H.S. Silver Medals and one Gold. Her work is in the Hunt Institute.
lit: Brinsley Burbidge, Desmond

Painted beautifully coloured, very ornate, flower studies embellished with glass, silver, tapestry and other accoutrements. She was one of the many lady artists admired by John Ruskin. Exhibited R.A., B.I. and in Manchester. Her work is in the Harris Museum and Art Gallery, Preston. (See page 47.)
lit: Brinsley Burbidge, Desmond, Mitchell, Wood

MUTRIE, Martha Darley 1824 – 1885
Sister of above, studied at Manchester School of Design. Exhibited flower paintings R.A., B.I., N.W.C.S., Manchester and other venues. (See page 47.)
lit: Brinsley Burbidge, Desmond, Wood

NICHOLL, Agnes Rose 1842 – 1890s
Lived in London, the youngest of a family of five artists. Exhibited flower paintings R.A., S.B.A. and other venues in this country and overseas.
lit: Desmond, Wood

NICHOLLS, John fl.1925 – 1945
Wolverhampton artist, started as a portrait painter but turned to flowers and exhibited R.A. and N.S.A.
lit: Brinsley Burbidge, Waters

NICHOLSON, Sue, S.F.P. 1941 –
Southampton artist who trained as a primary school teacher specialising in art. Her artwork derives from an interest in growing plants which she describes as 'an exploration of the abstract relationship of colour and form in flowers, normally through the medium of pastel'. She exhibits with the S.F.P. and the Pastel Society.

NICHOLSON, Sir William 1872 – 1949
Trained in London and Paris and initially became involved with graphic arts such as woodcuts, poster art and design. He resumed painting, for which he had been trained in later life, specialising in portraits and some still life, often with flowers in his own particular brand of '30s tradition.
lit: Brinsley Burbidge, Mitchell, Rothenstein

NICHOLSON, Winifred 1893 –
Born Oxford, later lived in Cumberland, daughter of the Earl of Carlisle. Studied at Byam Shaw School of Art and in Paris and married the painter, Ben Nicholson. Painted flowers and landscape mainly in oil and exhibited N.E.A.C. 1937-1943. Work is in collections in Manchester, Bradford, Melbourne, Australia, Pittsburgh, U.S.A., Venice, Paris and Edinburgh. She worked abroad a great deal.
lit: Brinsley Burbidge, Desmond, Waters

NIGHTINGALE, Leonard Charles
fl.1772 – 1795
London artist, painted flowers and domestic scenes. Exhibited R.A., S.B.A., N.W.C.S. and other venues.
lit: Brinsley Burbidge, Desmond

NISBET, Ethel C. **fl.1880s and 1890s**
London flower painter who exhibited R.A.,
S.B.A., N.W.C.S.
lit: Brinsley Burbidge, Desmond

NISBET, Noël Laura, R.I. 1887 – c.1955
London flower painter who worked in oil and
watercolour and whose work has been
reproduced in many publications. Studied at
the South Kensington School of Art where she
won three Gold Medals and the Princess of
Wales Scholarship. Exhibited R.A., R.I.,
R.O.I. and in Glasgow, Brighton and Canada.
lit: Brinsley Burbidge, Waters

NIVEN, Margaret Graeme, R.O.I., N.S.
 1906 –
London and Surrey painter of flowers,
landscape and portraits. Studied at Heatherley's
under Bernard Adams. Exhibited R.O.I., N.S.,
S.W.A., R.P. and other venues. Work is in
collections in Bradford and Cambridge.
lit: Brinsley Burbidge, Waters

***NOBLE, James (born E.A. Hollaway)**
 1919 – 1989
Norwich flower painter who was born into a
family of painters and decorators and worked
in the family firm while attending evening
classes in art at the Regent Street Polytechnic
1946-48. His drawing technique had been
helped during war service when he enjoyed
making drawings of army life and drawing (and
selling) charcoal portraits of his colleagues.
After the war he changed his style from an
impressionistic approach to one of extreme
traditionalism and flower portraiture in richly
coloured oils. He once told me he considered
himself to be an abstract painter because his
style of flower painting was so dependent on
shape – I cannot think that anyone looking at
his work would be moved to use such a
description!

His first one-man show was in a Bond Street
gallery in 1957 which quickly sold out and he
has also exhibited R.I., R.B.A., R.P., N.S.,
R.O.I., most Bond Street galleries, Eastbourne,
Norwich, Woodbridge and many other venues.
James Noble's flower portraits included the
Anna Zinkeisen Rose (see illustration) which
had been funded by the proceeds of this
author's biography.
lit: Walpole, Waters
Colour Plate 89

NODDER, Frederick Polydore fl.1773 –
Another of the artists engaged to make finished
drawings from the sketches of Sydney
Parkinson. He was appointed botanic painter
to H.M. Queen Charlotte in 1785. He drew
and engraved plates for Darwin's *Botanic
Garden,* 1789, and made some delicate plates
for Martyn's *Flora Rustica* 1791-5. Exhibited
R.A. and the Free Society. Some of his
drawings are in the Kew Collection and others
in the British Museum (Natural History). (See
page 30.)
lit: Blunt and Stearn, de Bray, Brinsley
Burbidge, Desmond, Rix

NOBLE, James. Anna Zinkeisen roses in a glass.

NOBLE, James. Pearl Drift.

NORMAN, Caroline H.
(The Hon. Caroline Grosvenor)
 fl.1874 – 1893
Lived in London and Devonport. Painted mainly
flowers and some birds and exhibited R.A.,
S.B.A., N.W.C.S., N.G. and other venues.
lit: Brinsley Burbidge, Desmond

NORTH, Marianne 1830 – 1890
Born Hastings and became a pupil of Valentine
Bartholomew. Traveller and flower painter who
painted the national flowers of many countries in
the world, sustaining many adventures in the
process. Painted in oil on canvas in the brilliant
colours suited to the tropical flowers and foliage
which had a special appeal for her. Kew allowed
her to build a gallery there to show over 800 of
her paintings now on permanent display. She
published her biography, *Recollections of a Happy
Life,* shortly before she died. (See pages 52-57.)
lit: Blunt and Stearn, de Bray, Brinsley Burbidge,
Mabey, Rix

NOWLAN, Carlotta, R.M.S. fl.1885 – 1891
Miniature painter, daughter of a portrait painter,
lived in Surrey. Exhibited flower paintings and
other miniatures R.A., R.M.S., N.W.C.S., R.I.
and other venues.
lit: Brinsley Burbidge, Desmond, Waters

NUNN, Shirley Anne, S.B.A. d.2001
Shirley Anne Nunn was born in Farnham, Surrey,
trained as a nurse, and followed this profession for
many years although she had always been
interested in botanical painting and in plants and
gardens generally. Her own charming garden in
Surrey was open to the public regularly for
charities of the National Garden Scheme.

Shirley Anne Nunn gave up nursing to pursue a
career in botanical painting which has been
exceptionally successful. Her first exhibition at
Sutton Library in 1982 sold over 60% of the works

and since then demand has grown steadily. In 1984
she first exhibited with the S.B.A., was made a
Member in 1988 and elected to the Council in
1992. In 1986 her paintings of Medicinal and
Culinary Herbs at the R.H.S. merited a Silver Gilt
Medal. Perhaps the most challenging of many
important commissions came from the Royal Phar-
maceutical Society (her husband is a pharmacist)
when she was asked to produce a memorial to the
late eminent pharmacist Harry Burlinson in the
form of a watercolour depicting plants that had
contributed to his work. The painting, 34in. x 42in,.
and on vellum, obviously necessitated a tremendous
amount of research and there were many problems
in sourcing the plants. The work, completed in 1993
(illustrated on page 127), is called the 'Botanical
Tablet', Burlinson having been an international
authority on tabletting.

1994 was taken up almost entirely with
producing fourteen paintings of medicinal plants
for the 1996 calendar of the National Pharma-
ceutical Association. The Board subsequently
purchased all the paintings which were exhibited
at the R.H.S. and awarded a Silver Grenfell Medal.

In 1996/7 Shirley Anne Nunn worked on a
series of paintings for a U.K. breeder of garden
Alstroemerias (Princess Lilies). As new hybrids
were developed they were named after members
of the Royal Family and her painting of the plant
was presented to the named member. A new
miniature hybrid 'Queen Elizabeth, the Queen
Mother' was officially named at the 1997 Chelsea
Show and Shirley Anne was present when her
painting was accepted by Princess Margaret on
behalf of the Queen Mother. Also in 1997 she was
one of three artists specially invited by the Hillier
Arboretum to exhibit at Jermyn House, Romsey,
an exhibition which was extremely successful.

In 1998 Shirley Anne Nunn became a member
of the Chelsea Florilegium Society and was
awarded a Gold Medal when a selection of mem-
bers' work was shown at the R.H.S. She has also
had many paintings reproduced as greetings cards
and calendars, especially by the Medici Society
and the National Council for the Conservation of
Plants and Gardens. She died in May 2001.
Colour Plate 90

NUTTER, Katherine M. fl.1883 – 1890
London artist who exhibited flower paintings
R.A., N.W.C.S., S.S.
lit: Brinsley Burbidge, Desmond

O

OAKLEY, Agnes Maria fl.1850s and 1860s
Daughter of a portrait painter. Painted flowers, especially roses, and exhibited S.B.A.
lit: Brinsley Burbidge

★OATES, Bennett 1928 -
Born in London and trained at Wimbledon School of Art under Gerald Cooper, who first inspired his interest in flower painting, and later at the R.C.A. His work was first accepted for the R.A. when he was only sixteen. He originally went into textile design where he was able to indulge his enthusiasm for flower painting as well as absorbing some useful disciplines and building up a financial base.

He has exhibited at most of the main London galleries and also with such respected provincial galleries as Stacy-Marks of Eastbourne and the Westcliffe Gallery, Sheringham. Here, too, he exhibits annually with the Guild of Norwich Painters that he founded in 1978. He also works to commission which keeps him well occupied – it seems that really good flower painters are rarely short of work but, paradoxically, are less well known than they should be, not having the need to exhibit so widely or undertake any form of personal advertising. (See pages 115-123.)
Colour Plates 65 and 66

O'CONNOR, Roderick 1860 - 1940
Studied in Antwerp, London and Paris. Painted still life and flowers as well as other subjects and exhibited mainly in France.
lit: Brinsley Burbidge, Waters

OFFORD, Gertrude 1880 - 1950
Norwich flower painter who exhibited R.A. 1895-1900.
lit: Brinsley Burbidge, Desmond, Waters

OATES, Bennett. Study in white.

OATES, Bennett. Flowerpiece.

OGDEN, Jane fl.1870s and 1880s
London artist who exhibited flower paintings R.A. and S.B.A.
lit: Brinsley Burbidge, Desmond

OGILVIE, Lilian L.
Lived in Edinburgh, painted flowers and some Scottish and French landscapes Exhibited S.S.A.
lit: Harris and Halsby

OGILVY, Susan, S.B.A. 1948 -
Susan Ogilvy trained as an occupational therapist followed by a Foundation Course at Luton College of Art in order to be able to practise art therapy. Fifteen years later her husband's three year posting to the Sultanate of Oman presented her with an ideal opportunity to start painting again. She worked on paintings of the local flora which were exhibited successfully in the Sultanate. She continued botanical painting on her return and was accepted by Jonathan Cooper of the Park Wall Gallery, Chelsea, as a regular and successful exhibitor including mounting two one-man shows. She has also exhibited with the S.B.A., R.H.S. (Silver Gilt Medal), Tryon and Swann, Cork Street, London, the Watercolour and Drawings Fair and the Shirley Sherwood Collection. Susan Ogilvy's work extends beyond the conventional botanical painting without compromising the rules – unusual settings add to the general interest and some include butterflies, insects and other such 'accessories.'
lit: Sherwood

O'NEALE, Jeffryes Hammett
** fl.1763 - 1772 (d.1801)**
Lived in London until 1768, spent time in Worcestershire and returned to London in 1770. Worked first for Wedgwood, then the Chelsea Porcelain Factory. Painted flowers, some birds and landscape, also miniatures which he exhibited at the Free Society from 1763-1772
lit: Brinsley Burbidge, Desmond, Grant

OSBORNE, Joan. *Magnolia Lilliiflora 'Nigra'.*

ORDERSON, Mrs T.E. fl.1825 - 1835
Brighton artist who exhibited flower paintings R.A. and S.S.
lit: Brinsley Burbidge

★OSBORNE, Joan, S.B.A., S.W.A. 1935 -
Although largely self-taught, Joan Osborne attended short courses on botanical illustration at West Dean College, near Chichester. She also completed a part-time course in natural history illustration at Bournemouth and Poole College. A lifelong love of flowers has inspired her choice of subject to which she adds butterflies and birds in watercolour and gouache, often on unusual papers. She teaches flower painting with a botanical theme to classes of pupils from the Ringwood and Fordingbridge areas which are extremely popular. She exhibits with the S.B.A., S.F.P., S.W.A. and R.H.S. She has been awarded an R.H.S. Silver Medal and two Certificates of Botanical Merit by the S.B.A.

OXLEY, Valerie, Cert.Ed. 1969, A.N.E.A.,
S.B.A 1947 -
Valerie Oxley is a qualified teacher, member of the Institute of Learning and Teaching in Higher Education, member of the Society of Botanical Artists and Vice-President of the Northern Society for Botanical Art. Until recently she was the Programme Director for the Diploma in Botanical Illustration at the University of Sheffield. Her own artwork has been exhibited widely and the Royal Horticultural Society has awarded her medals for her illustrations. Valerie is Chairman of the new Florilegium Society at Sheffield Botanical Gardens, whose aim is to record the planting in the Gardens for a historical archive. Valerie enjoys meeting and teaching students on residential courses throughout the country and is the Art Editor of the book *Wild Flowers of the Peak District* which includes watercolour illustrations by thirty of her adult students.

P

PAGE, Maud Mabel **1867 – 1925**
Born in London but moved to Cape Town in 1911 finding her own amusement and enjoyment in painting the local plants. In 1915 she met a leading authority on South African flora who taught her how to draw the plants from a botanical standpoint with the necessary accuracy and attention to the nuances of detail. Thanks to this teaching she became employed by the Bolus Herbarium, University of Cape Town, as a botanical artist. Her work includes 200 coloured drawings of misembryanthemums. Her work is reproduced in *Annals of the Bolus Herbarium,* 1916-28, *Journal of the Botanical Society of South Africa,* 1917-25, and Herre's *The Genera of the Misembryanthemaceae and Flowering Plants of South Africa.* Her work is represented in the University of Cape Town.
lit: Blunt and Stearn, Brinsley Burbidge, Desmond

***PAIGE, Jane Leycester, F.S.B.A.** **1936 –**
Jane Leycester Paige was born in Manchester, educated at Malvern Girls' College and Westhill Training College, Birmingham, where she gained a Froebel Diploma in Art. After her marriage to wild life artist, John Paige, in 1957 they lived in Aden, Uganda, Malaya and Singapore 1958-60, Uganda National Parks 1960-61 before returning to England, living first in Lincolnshire and, from 1970, in Northamptonshire.

Although she paints other subjects in both oil and watercolour, Jane Leycester Paige specialises in painting wild flowers in watercolour in their natural environment. She prefers to work in the field, making studies of growing plants in her sketch book before eventually working on a finished painting. Her sketch books are of tremendous importance to her.

From 1971-84 she taught at Stamford College for Further Education, in 1976 she started King's Cliffe Art Summer Schools and from 1978-90 ran Art Summer Schools for the National Association for Gifted Children. In 1984 she opened the Old Brewery Studios, King's Cliffe, running art classes for adults and children in conjunction with Oundle Adult Education in flower painting and botanical education. In 1992 she led flower painting holidays in Crete, Provence, Cyprus and Southern France for Wild Life Travel.

Jane Leycester Paige was elected a Founder Member of the S.B.A. in 1982, exhibits regularly with the Society and with R.I. and R.W.S. Her published work includes illustrations for *Practical Gardening* 1987-93, Geoffrey Smith's *Wildlife Gardening,* 1989, five illustrations for BBC publications and all the illustrations for *Thirty Small Gardens* by Tony Layrea 1993-1995. In 1993 she started work on the flowers of Provence giving rise to a developing interest in Mediterranean wild flowers. In 1994 she took part in the Artists for Nature Foundation Scheme

PAIGE, Jane Leycester. Pink and yellow.

in Extramadura, Spain, on which a book was published in 1998. She is also a Member of the Chelsea Physic Garden Florilegium Society.

PAKENHAM, E. Joyce **fl.1920s**
Painted flowers as well as landscapes and portraits. Born Chelmsford, trained Birmingham and Cornwall under Stanhope Forbes. Exhibited R.A., R.S.B. and Newlyn.
Waters

PALMER, Samuel **1805 – 1881**
Extremely well-known painter who married the daughter of John Linnell. He made, as well as a variety of other subjects, a number of familiar sketches of plants, flowers and grasses represented in the V. and A.
lit: Brinsley Burbidge, Wood

PARDOE, Thomas **fl.1820s**
Born Derby. Mainly a porcelain painter who assisted in painting a service for the Prince Regent. He also painted flowers conventionally.
lit: Brinsley Burbidge, Desmond

PARK, James Stuart **1862 – 1933**
Born Kidderminster of Scottish parents, died Kilmarnock. Trained at Glasgow School of Art and in Paris under Lefèbvre, Boulanger and Cormon. He painted some portraits but mainly flowers, beautiful arrangements painted with great care in brilliant colour and making full use of textural possibilities. He exhibited R.S.A., G.I. and elsewhere in Scotland with the Glasgow Boys.
lit: Brinsley Burbidge, Desmond, Harris and Halsby, Waters, Wood

PARKER, Ellen Grace **fl.1875 – 1893**
St John's Wood painter who exhibited flower paintings R.A., S.B.A. and other venues.
lit: Brinsley Burbidge, Desmond, Wood

PARKINSON, John **1567 – 1650**
Herbalist to Charles I. Made some plates for his own *Paradisi in Sole Terrestris,* 1629, and *Theatrum Botanicum,* 1640. Work is in the Linnean Society Collection. (See page 22.)
lit: Blunt and Stearn, de Bray, Brinsley Burbidge, Desmond, Rix, Scott-James

PARKINSON, Sydney **1745 – 1771**
Born Scotland, initially apprenticed to a wool draper but later trained at De la Cour's drawing school in Edinburgh and went into textile design. After his father's death he moved to London and started painting flowers, initially for the nurseryman, James Lee. Through various contacts he met Sir Joseph Banks which led to work drawing plants at Kew. Banks was so impressed that he invited Parkinson to join him on Captain Cook's voyage on H.M.S. *Endeavour* to draw plants in Madeira, Brazil and Tierra del Fuego. He produced twenty-one volumes of natural history drawings of which eighteen were botanical and comprised 955 drawings, 675 sketches and 280 fully finished paintings. (See page 30.)
lit: Blunt and Stearn, de Bray, Brinsley Burbidge, Fulton and Smith, Waters, Wood

PARKYN, John Herbert, R.W.A., A.R.C.A.
 fl.1884 – 1905
Born Cumberland, studied at the R.C.A. and in Paris. He became Head of Kingston-upon-Hull

School of Art and later Headmaster of Ayr Art Academy. He worked in oil, watercolour and pastel and exhibited flower paintings R.A., R.C.A., N.W.C.S. Latterly lived Galloway.
lit: Brinsley Burbidge, Desmond, Waters

PARSONS, Alfred, R.A., P.R.W.S.
1847 – 1920
Born Somerset, died Worcester, studied at Kensington School of Art. Best known for his delicate and sensitive watercolour drawings for Miss Willmott's *The Genus Rosa*. He became President of the Royal Society of Painters in Watercolour as well as being a Member of the R.A. Also illustrated Robinson's *Wild Garden*, 1870, and Freeman and Mitford's *Bamboo Garden*, 1896. Exhibited R.A., S.S., N.W.C.S., G.G., N.G., Paris and other venues. His work is represented in the Lindley Library, R.H.S., and in Bristol and Cardiff. (See pages 57-59.)
lit: Blunt and Stearn, de Bray, Brinsley Burbidge, Desmond, Rix, Stuart Thomas, Waters, Wood

PARSONS, Beatrice 1870 – 1955
Sister of Alfred Parsons. Studied at R.A. Schools and painted primarily flowers and views of gardens, usually to commission. Illustrated Calthorp's *Charm of Gardens*, 1910, and *Gardens of England*, 1911. Exhibited flower paintings R.A. and other venues. (See pages 57-59.)
lit: Brinsley Burbidge, Brown, Desmond, Waters, Wood

PARSONS, J.F. fl.1850 – 1888
London artist who exhibited flower paintings and figures R.A., G.G., N.W.C.S.
lit: Brinsley Burbidge

PARSONS, Letitia Margaret fl.1870 – 1910
Artist of Frome, Somerset, who exhibited flower paintings R.A. G.G., N.G. and other venues.
lit: Brinsley Burbidge, Desmond, Wood

PATERSON, James. Niphetos.

PATTERSON, Linda. Garden study.

PATERSON, Emily Murray 1855 – 1934
Edinburgh artist but spent much time in London where she studied and in Paris. She painted flowers and landscape and exhibited widely including abroad. Member of the Scottish Watercolour Society and the S.W.A.
lit: Brinsley Burbidge, Desmond, Waters

★PATERSON, James, R.S.A., P.P.R.S.W., R.W.S. 1854 – 1932
James Paterson, one of the leading lights of the famous 'Glasgow Boys', trained in Scotland and Paris and travelled widely in order to learn all he could about the Continental painters and their work. He painted both portraits and landscapes to an exceptionally high standard but he was also passionately fond of flowers, another favourite subject. He had a very personal way of painting flowers, whether as a single subject or in more traditional vases or bunches. Although his blooms, particularly the single specimens or sprays, had an absolutely true identity, they bore no resemblance to botanical studies *per se;* there is a lovely combination of freedom and realism. The French influence is there, perhaps somewhere between Chardin and Redouté, but, although his landscapes earned him the description of British Impressionist, there is no affinity with the sumptuous colourful bouquets of Renoir and other French Impressionists. He painted flowers in both oil and watercolour using both media in a similar manner. While the oils

seem quite light in substance, despite their brilliance, in his watercolours he used a strength of medium that gave it an unusual density and must have been quite difficult to handle – but Paterson enjoyed a challenge. His work is in many national collections, especially in Europe and as far away as Russia. The James Paterson Memorial Museum was opened in 1996 in his home village of Moniaive, Dumfriesshire, where a collection of original photographs of his flower paintings is held in the archives. (See page 19.)
lit: Harris and Halsby, Wallace, Walpole, Waters

PATERSON, William 1755 – 1810
Born Montrose and made the army his career but was also a keen artist, especially of natural life. He made three botanical excursions to South Africa sponsored by Lady Strathmore. He also illustrated his own *Narrative of Four Journeys into the Country of the Hottentots and Caffraria* in 1789. Three folios of 300 drawings of plants, insects and wildlife were acquired by a British bookseller in 1929.
lit: Brinsley Burbidge, Desmond

★PATTERSON, Linda, S.B.A., S.F.P. 1942 –
Linda Patterson was born in London, attended the Mary Boon Technical School for the Arts at the age of thirteen, went on to Hammersmith Art College and then studied life drawing and design at London Polytechnic. She followed a career in fashion design and modelling for many

years, also designing jewellery and fine art objects. Shop and store design and window display was another facet of her work.

Moving to Bournemouth in 1974 inspired her first love – painting – and although she paints a variety of subjects in various media her studies of flowers and garden scenes are her real speciality. She particularly enjoys working with pastels, especially for the garden settings because of the immediacy of the medium and its potential for making the most of natural light and shade. The importance to her of light rather identifies her with the Impressionists, many of whose delightful attributes she shares. She exhibits regularly with the S.F.P., S.W.A. and S.B.A. and with local groups. She also teaches and gives demonstrations and talks on painting with pastels and has won a number of prizes and awards for her work.

Linda Patterson serves on the Christchurch and District Arts Council and is currently studying for a degree in Art History. A number of her paintings have been reproduced as greetings cards.
Colour Plate 91

***PAUL, Meg, S.F.P.** c.1920 –
Born in Blackburn, Lancashire, and served four years during the war in the Women's Land Army, spending one winter as a shepherdess. Her interest in flower painting developed much later and she attended many study courses in the subject. She now exhibits with the S.F.P., S.B.A., Sadler Street Gallery, Wells, Sherborne Art Club and the Royal Bath and West. Her work has been reproduced as greetings cards and is in private collections in Japan, Australia, the U.S.A., France and South Africa as well as the U.K.

***PAYNE, Ernest** 1903 – 1994
Ernest Payne was born in Ixworth and showed early artistic talent; from school he went on to Bury School of Art as a pupil and trainee art teacher. At the age of fourteen in 1917 he gained four certificates in the Art Examinations. He decided that teaching was not his forte and took

a clerk's post in Ipswich in order to attend evening classes at Ipswich College of Art where the standard of teaching was higher than in Bury St Edmunds.

Initially he painted all manner of subjects and, in 1928, went to work for the Greene King Brewery where he was given a permanent post as painter of inn signs. The Eagle at Braintree was the first of many he painted throughout East Anglia and further afield. After war service he returned to Greene King becoming responsible for running the Company's publicity and advertising department. He was a Founder Member of the Bury St Edmunds Art Society in 1951 and served as Chairman for twenty-five years.

He retired from Greene King in 1968 after forty years' service to devote more time to his own painting, concentrating on the flower paintings for which he is best known. He worked in a very traditional style, vases of mixed flowers painted in great detail usually in gentle colours, perhaps a reaction from the bold colours of the inn signs. He exhibited widely, especially in East Anglia, and his work is in the collections of H.M. the Queen and the late President of the U.S.A., Lyndon Johnson. There are also several in the permanent collection of the Bury St Edmunds Art Gallery where a retrospective exhibition, *70 Years of Painting,* was held in 1991.
lit: Reeve, Waters

PAYNE, Florence fl.1880s
Oxford artist who exhibited flower paintings R.A. and N.W.C.S.
lit: Brinsley Burbidge, Desmond, Waters

PEARSE, Norah, R.W.S., S.G.A., S.W.A. fl.1930 – 1965
Member of Exeter Society of Artists who worked in oil, watercolour and aquatint. Exhibited flower paintings R.A., R.I., R.B.A., R.S.A., S.W.A. and the Paris Salon.
lit: Brinsley Burbidge, Waters

PEART, William fl.early 19th century
Essex artist who exhibited flower paintings R.A. for which he received a Gold Medal in 1815.
lit: Brinsley Burbidge, Desmond

PEEL, Maud fl.1870s and 1880s
Artist of Clitheroe, Lancs., who exhibited flower paintings R.A., S.B.A., N.W.C.S.
lit: Brinsley Burbidge, Desmond

PELLERTIER, A. fl.1816 – 1847
London artist who painted flowers, fruit and birds. Exhibited thirty-two paintings R.A., also O.W.C.S.
lit: Brinsley Burbidge, Desmond, Wood

PENNY, J.S. fl.1893 – 1913
London artist who exhibited some flower paintings R.A.
lit: Brinsley Burbidge, Desmond

PERKES, Muriel Kathleen (née Burgess) 1898 –
Watercolour painter of flowers and landscape. Studied at Clapham Art College. Lived in Surrey and exhibited R.I., R.Cam.A.
lit: Waters

PERMAN, Louise Ellen (Mrs James Torrance) 1854 – 1921
Born Glasgow and studied at Glasgow School of Art 1881-90. Specialised in flower painting, mainly in oils, and had a number of one-man shows in Scotland. Her work is in collections in Paris and Edinburgh, where she died.
lit: Harris and Halsby, Waters

PAYNE, Ernest. A still life of mixed summer flowers.

PAUL, Meg. Poinsettia.

PAUL, Meg. Hellebore.

PINDER, Brietta. Irises.

PERROTT, Mary, S.W.A., A.R.M.S.
fl.1920s
Flower painter who studied at Brighton Art School, Camden Art School and Regent Street Polytechnic. Lived in London and exhibited R.A., S.W.A., R.I., R.M.S. and the Paris Salon.
lit: Waters

PETHER, Abraham 1756 – 1812
Known as 'Moonlight' Pether because of his love of moonlight scenes — he was an astronomer and mathematician as well as artist. He contributed two plates to Thornton's *Temple of Flora* and the moonlit background to Reinagle's 'Nightblowing Cereus'. (See page 28.)
lit: Blunt and Stearn, de Bray, Brinsley Burbidge, Rix, Sitwell

PHILPOT, Leonard Daniel 1877 – 1976
Painter of gardens and flowers. Exhibited flower paintings R.A. from 1929 to 1951, also R.I. Work is in the Harris Museum, Preston, and the British Museum.
lit: Brinsley Burbidge, Desmond, Waters

★PINDER, Brietta, S.B.A. 20th century
Brietta Pinder's interest in botanical illustration began when she joined a botanical field club and started to paint wild flowers. This inspired an A level art course followed by a year's foundation course at Epsom School of Art and Design. She went on to complete three years in textile design at Croydon College of Art, obtaining a Chartered Society's Design Diploma. After leaving the College she worked as a freelance designer specialising in floral design for the home furnishing market. At the same time she continued to paint floral subjects in watercolour, exhibiting locally. Later she changed direction a little and started teaching, becoming a tutor in botanical illustration under the Surrey Adult Education Authority. She also teaches at Kew Gardens on a yearly basis.

Brietta Pinder exhibits regularly with the S.B.A. and in 1993 exhibited eight paintings with the R.H.S. gaining a Silver Medal. In 1998 she had a one-man show in Leipzig, Germany.

PITMAN, Janetta, R.A. c.1850 – 1910
Artist from Nottinghamshire who exhibited flower paintings and still life R.A., S.B.A., N.W.C.S., G.G. and other venues.
lit: Brinsley Burbidge, Desmond, Wood

PITTS, Frederick fl.1950s to 1980s
London artist who exhibited flower paintings and rural scenes R.A. and S.B.A.
lit: Brinsley Burbidge, Desmond

PLACE, Rosa fl.1850s and 1860s
Painted flowers and still life and exhibited R.A. and S.B.A.
lit: Brinsley Burbidge, Desmond

★POLLARD, Michael, S.B.A. 1948 –
Michael Pollard was born in Cambridge and soon displayed a precocious talent. At the age of five he was drawing with a natural eye for perspective and his first important commission, to paint a mural/fresco in the new hall of his junior school, came at the age of eleven. At the Harper Trust School, Bedford, teachers commissioned many paintings for themselves and he was allowed to instruct two fellow pupils to help them pass A level art. By seventeen he was showing work in the Bedford Gallery.

He spent a year after school with a Bedford art studio going on to study art and design at Luton School of Art and the R.C.A. He now works as a freelance artist and has illustrated many books – fairy tales, romantic and botanical – or both. His approach to flower painting is distinctly romantic – 'I am drawn to flowers that capture the heart; the Rose, the Lily, and flowers of springtime, snowdrops, bluebells and violets especially'. His hero, he says, is Pierre Joseph Redouté, 'whose works remain uniquely beautiful and unsurpassed to the present day'.

Michael Pollard strongly admires and respects traditional values in art, precise and accurate drawing, proper harmony of colour and compositional rules, hence an aversion to modern 'trendy' so-called art and a striving for perfection. He prefers to work in watercolour and also enjoys drawing, penwork and monochrome printmaking.

He exhibits annually with the S.B.A., of which he was made a Member in 1988. He has designed over 100 stamps for British Crown Colonies and Dependencies worldwide and his work is much sought after for reproduction as greetings cards.

POLLARD, Michael. Pink Perpetué.

POOLE, Elizabeth. Cyclamen.

★POOLE, Elizabeth, S.F.P. **1923 -**
Betty Poole started painting seriously in 1986
when she attended a flower painting course at
Fittleworth Residential College followed by
several other courses. She paints in watercolour
flowers from her garden and wild flowers,
exhibits with the S.F.P., of which she is now a
Member, and other venues and her work has
been reproduced as greetings cards.

POPE, Clara Maria (née Leigh)
 c.1750 - 1838
Daughter of an artist and married Alexander
Pope, an actor and painter of miniatures. Con-
tributed to Curtis' *Beauties of Flora,* 1806-20, and
illustrated his *Monograph on the Genus Camellia,*
1819. Gave drawing lessons and also exhibited
her own work including forty-one paintings at
the R.A. between 1796 and 1838, also B.I. and
S.S. Her paintings of paeonies are represented in
the British Museum. (See page 37.)
lit: Blunt and Stearn, de Bray, Brinsley Burbidge,
Desmond, Fulton and Smith, Kramer, Scott-
James, Sitwell, Wood

POPHAM, James Kidwell, P.S. **1884 -**
Chelmsford artist who painted flowers and
landscape in oil, watercolour and pastel.
Exhibited R.A., R.I., R.W.S., R.O.I., P.S.
lit: Brinsley Burbidge, Desmond, Waters

POULTON, James **fl.1844 - 1859**
Still life painter but used flowers in most of his
compositions. Little known as a person.
Exhibited R.A. 1894-59.
lit: Brinsley Burbidge, Wood

POWER, A. **fl.1740 - 1780**
Maidstone botanical artist who followed the style
of Ehret and made small paintings of flowers;
exhibited R.A. A collection of his watercolours is
in the V. and A. and there are also some at Kew.
lit: Blunt and Stearn, Brinsley Burbidge,
Desmond, Mabey

PRATT, Anne (Mrs John Pearless)
 1806 - 1893
Born Stroud of a keen gardener mother who
brought her up with a love of and interest in
plants. One Dr Dodd, a Scottish botanist friend,
encouraged the botanical interest and also
encouraged her to build up her own herbarium.
This led Anne Pratt to a strong desire to
illustrate starting with her own book, *Flowers
and their Association,* 1829. Altogether she
eventually wrote and illustrated about twenty
books including *Garden Flowers of the Year, Wild
Flowers, The Flowering Plants, Grasses, Sedges and
Ferns of Great Britain* (1855-66), and later *The
Ferns of Great Britain and her Allies.* She wrote
and illustrated five volumes covering the entire
British flora and wrote and illustrated floral
articles for women's magazines. Her style is said
to have been reasonably accurate but not strictly
botanical.
lit: Blunt and Stearn, Brinsley Burbidge, Coats,
Desmond, Kramer, Stearn

PRATT, John **fl.1882 - 1897**
Leeds artist who painted flowers and still life and
exhibited R.A. 1882-97.
lit: Wood

PRICE, Lydia Jemima **fl.1890s**
London artist, painted flowers and genre and
exhibited R.A., N.W.C.S.
lit: Bénézit, Brinsley Burbidge, Desmond

PROCTER, Alison, S.B.A. **20th century**
Alison Procter has been a professional floral artist
in sugarcraft which she teaches and demonstrates.
She has been invited to the U.S.A. (twice), Japan,
Holland and Germany to demonstrate and/or
judge the craft. She has also written two books
on the subject. She has at the same time been
painting flowers in watercolour and was made a
Member of the S.B.A. in 1989. She exhibits with
them annually, including twice showing
sugarcraft plants, and also exhibits locally. Several
of her delicate paintings have been reproduced as
greetings cards.

PROUT, Millicent Margaret Fisher
 1875 - 1963
Artist daughter of Mark Fisher, R.A. of Chelsea
and Sussex. Trained at the Slade after some
instruction from her father and taught at the
Hammersmith School of Arts and Crafts. Painted
flowers, landscape, cattle and figures and
exhibited in her very impressionist style at the
R.A. and N.E.A.C. She held a one-man show at
Beaux Arts in 1922.
lit: Brinsley Burbidge, Desmond, Waters

PURNELL, Charlotte Anne **b.1791**
Aunt of the Clifford sisters of Frampton (see
pages 59-61) who joined them in making their
painstaking collection of the local wild flowers.
Extremely talented, perhaps the best painter of
them all.
lit: Mabey

PURVES, Rodella **1945 -**
Rodella Purves ranks as one of the most
important botanic and floral artists of her time.
Born in Paisley, Renfrewshire, she attended St
Margaret's School followed by the East of
Scotland College of Agriculture, Edinburgh,
1962-4, where she obtained a diploma in
agricultural botany. She worked for the Dept. of
Agriculture for Scotland and the Dept. of
Agriculture, Palmerston North, New Zealand,
before joining the Royal Botanic Garden
Edinburgh, in 1969 and going freelance in 1976.

Rodella Purves has exhibited with the Scottish
Arts Council, the Hunt Institute, The Hunterdon
Art Centre, New Jersey, Galerie Bartsch and
Chariau, Munich, Broughton Gallery, Biggar, and
there was a one-man show at the City Art
Centre, Edinburgh, in 1996. She has been
awarded a Silver Medal as a Chelsea Flower
Show exhibit designer, a Gold for the same at the
Royal Highland Show and the Jill Smythies
Medal for Botanical Illustration by the Linnean
Society in 1998.

She works in watercolour, where possible
lifesize, and from living specimens only. Her
work has been published in *Curtis's Botanical
Magazine, The New Kew Magazine,* Elsvière Inter-
national Publications, *The Royal Botanic Garden
Notes* (Edinburgh), *The Plantsman, The Scottish
Plantsman, The New Plantsman* (R.H.S.),
*Department of Agriculture Bulletin, Plants and
Gardens, Country Life, The Rhododendron Species,*
Davidson vols. 1-4, *Flower Artists of Kew,* Stearn,
1990, *The Orchid Book,* Cullen, 1992, *The New
R.H.S. Dictionary of Garden Plants* and *The
European Garden Flora.* She appeared in the
Beechgrove Garden, BBC TV, in October 1991.
(See pages 72-74.)
lit: Brinsley Burbidge, Stearn
Colour Plates 39 and 40

RAISTRICK, Reinhild. Sunflowers.

★RAISTRICK, Reinhild, S.B.A., S.F.P. 1940 –
Reinhild Raistrick is a botanical artist living in Suffolk who has illustrated wild flowers in many parts of the world from the Mediterranean to Africa as well as the British Isles. In 1991-2 she was involved in painting flowers of the equatorial rain forests, Tanzania. A number of these paintings were purchased by Kew for their permanent collection and some of her work featured in *Curtis's Botanical Magazine.*

She exhibits locally and in London and with the S.B.A. and S.F.P. wherever they are showing. She has been awarded three Gold Medals by the R.H.S. for the series *Flowers of the African Rain Forest,* 1992, the series *Wild Orchids of East Anglia,* 1994, and *Fritillaria from the Cambridge University Botanic Garden,* 1996. She was awarded a further medal in 1998 for *Wild Flowers in Crete.* Her great love and interest is in illustrating wild flowers, even if it involves working in remote areas of the world. Some time was spent in Tanzania working on various species of the Saintpaulia (African violet). She has also worked on a series of snowdrops showing the various Galanthus species as well as some cultivars.
lit: Sherwood

RAMSDEN, Thomas fl.1883 – 1893
Leeds artist who exhibited flower paintings R.A., S.B.A.
lit: Brinsley Burbidge, Desmond

RAVILIOUS, Eric William 1903 – 1942
London artist, watercolourist, engraver and designer. Trained at Eastbourne College of Art and Design and the R.C.A. 1922-25. Much influenced by Paul Nash; illustrated several plant books although best known for his war painting and decorative murals. He was killed in action in the Second World War.
lit: Brinsley Burbidge, Waters

RAY, John 1627 – 1705
Said to be one of the greatest systemic botanists who illustrated some of his many botanical writings. (See page 22.)
lit: Blunt and Stearn, de Bray, Brinsley Burbidge, Desmond, Rix

RAYMOND, Charles 20th century
Appears only to be known for his illustrations in the six volumes of *Old Garden Roses* 1955-57.
lit: Brinsley Burbidge

★REES-DAVIES, Kay, S.B.A. 1936 –
Kay Rees-Davies lives in North Wales and was a teacher of music and drama until, in 1989, she discovered an aptitude for painting, specifically flowers and fruit. Her tutor tried to encourage her to submit work to the R.H.S. for their medal awards; her first award, a Gold Medal, was in 1991 and she has since earned a further five.

In spite of being a late starter, her highly professional work has taken her a long way. She has exhibited with the S.B.A., the Royal Birmingham Society of Artists, the Portico Museum and Gallery, Manchester, several Welsh galleries, Chester, Ludlow and Pittsburgh, U.S.A. in 1998. She has also participated in several important specialist exhibitions in London including, in 1999, an exhibition of Botanical Art at Waterman Fine Art, Jermyn Street. Her first solo exhibition was at Bodnant Garden in 1993, followed by two at Penrhyn Castle.

Her work is represented at the Hunt Institute, the Lindley Library, the Shirley Sherwood Collection and is in many private collections in this country, the U.S.A., Australia, Hong Kong, Germany Italy, Belgium, New Zealand and Switzerland. Her work has been published in *An Introduction to Drawing Flowers* by Margaret Stevens, *Curtis's Botanical Magazine* and *Plantas Endemicas de Carbo Verde* by Leyens.

As well as being a Member of the S.B.A. she is a Founder Member and Vice-President of the North Wales Society of Botanical and Fine Watercolour Artists (she has twice received the Society's Award for Botanical Illustration), and the Botanical Artists of Ness Gardens where she has been a tutor for several years as well as teaching her own regular classes in botanical art at Rhos-on-Sea, North Wales.
lit: Sherwood

REEVE, R.G. fl.1844 – 1848
Artist from Dorking, Surrey, who exhibited flower paintings R.A. and S.B.A.
lit: Brinsley Burbidge, Desmond

REEVE-FOWKES, Amy Constance 1886 –
Born Bournemouth and studied Bournemouth School of Art; later lived in Eastbourne. Painter of flowers in watercolour, exhibited R.A., R.B.A., R.I. and the provinces.
lit: Waters

REEVES, Marlene, S.F.P. 1932 –
Marlene Reeves from Cleethorpes, Lincolnshire, began drawing and painting at a very early age working in enamels, oils and watercolours. At the age of twenty-five the headmistress of her old school asked her to go back to teach art, music and needlework. She has attended various course at art colleges in Grimsby and runs her own art group and teaches in various media, including acrylics which she finds very rewarding as a flower painting medium. She organises and exhibits in many local shows and also exhibits with the S.F.P., of which she is a Member.

Her work is in many private collections in the U.K., U.S.A., Australia and Sweden and has been reproduced as greetings cards.

REINAGLE, Philip 1749 – 1833
Born Scotland, died Chelsea. He was a pupil of Allan Ramsay. Commissioned by Thornton to produce some of the illustrations for *The Temple of Flora* which were rather stylised but detailed flowers in unlikely settings. He exhibited over 100 works at the R.A. but these were mainly landscapes. His work is in the V. and A., the Fitzwilliam Museum, Cambridge, Shipley Art Gallery, Gateshead, and Lytham Hall, Lancashire. (See pages 15 and 28.)
lit: Blunt and Stearn, de Bray, Brinsley Burbidge, Desmond, Fulton and Smith, Mitchell, Rix
Colour Plate 4

REES-DAVIES, Kay. Tiger lily.

RICE, Elizabeth. Medlar, quince, rose, azarole, service tree, loquat.

REVEL, Lucy, S.W.A. (née Mackenzie)
1887 - 1961
Born Elgin but later moved to Edinburgh. Painted flowers and some portraits and became Director of the Glasgow School of Art 1925-32. Gained the Lauder Award in 1932.
lit: Harris and Halsby

REVILLE, James, R.S.W. **1904-**
Born Sheffield, later moved to Dundee. Painted flowers and still life in oil and watercolour.
lit: Harris and Halsby

RHEAD, George Wooliscroft **1855 - 1920**
London artist who painted flowers and classical subjects. Exhibited R.A., R.B.A., R.I. and S.B.A.
lit: Desmond, Waters

RHODES, Henry J. **fl.1869 - 1882**
London painter of flowers and figures who exhibited R.A., S.B.A.
lit: Brinsley Burbidge, Desmond, Graves

★RICE, Elizabeth, S.B.A. **1947 -**
Elizabeth Rice was born in Canterbury and trained at Exeter School of Art and Design 1963-65 and in wallpaper design with Sandersons 1965-70. She later became a freelance botanical illustrator although she also spent two years painting heraldic designs for the College of Arms.
 Botanical and flower painting is her real life work. She has participated in exhibitions with the S.B.A., R.H.S. (Gold Medallist), the Alpine Gallery, the Society of Wildlife Artists, Jersey Wildlife Preservation Trust, the Medici Gallery, the National Trust, other galleries in London and Scotland and has held a one-man show at the Sadlers Wells Theatre. Commissions include works for the

Princess of Wales, the Sultan of Oman, the Queen Elizabeth Cayzer, the Hunt Institute and the Medici Society, as well as numerous private commissions. Her work is reproduced in *Wild Flowers of the Mediterranean,* Burnie 1995, *Flowers,* Cowdrey 1994, *Field Guide to the butterflies and other insects of Britain,* Feltwell 1984, *Herbs for Cooking & Health,* Grey-Wilson 1987, *Wild Flowers of Britain and N.E. London,* Dorling Kindersley 1995, *Eyewitness Handbook of Mushrooms,* Laessoe 1998, *Tomorrow is too Late,* Perring, Franklin and Page 1990, *The New Oxford Book of Food Plants,* 1997, *The Living World,* Williams 1993, and on greetings cards and calendars. Her work is in the Bridgeman Art Library, London, the National Trust, Sissinghurst, the Hunt Institute, and a number of private collections.

★RICHARDS, Susan, S.F.P. **1950 -**
Started flower painting at an evening class and discovered an unexpected talent. Her tutor soon suggested that she applied to exhibit some paintings with the R.H.S. Her first collection was awarded a Silver Gilt Medal. She has since exhibited twice and both times been awarded a Silver Medal. She was also made a Member of the S.F.P. in 1998. What started as a hobby is now taking up most of her life.

RICHTER, Herbert Davis, R.I., R.O.I., R.S.W., R.B.A., R.B.C. **1874 - 1955**
Born Brighton and studied under Sir Frank Brangwyn, R.A., and John Swan, R.A. Worked in Bath as a designer and architect 1895-1906 but eventually became best known for his flower paintings. He was awarded Gold and Silver Medals at the Paris Exhibition in 1900 and the R.S.A.Medal in 1897. He published *Flower Painting in Oil and Watercolour* and exhibited regularly at the R.A. and all the main London galleries. In 1956 a Memorial Exhibition was held at the Fine Art Society, London, and his work is represented in the V. and A. and in Manchester, Harrogate and York.
lit: Brinsley Burbidge, Hardie, Waters, Wood

RICHARDS, Susan. Autumn.

RIMER, Louisa Serena **fl.1855 - 1875**
London artist who exhibited flower paintings R.A., B.I., S.B.A. and other venues.
lit: Brinsley Burbidge, Desmond, Wood

RISCHGITZ, Mary **fl.1882 - 1892**
London artist who exhibited flower paintings R.A., S.B.A
lit: Brinsley Burbidge, Desmond

RIVIERE, Alice **fl.1868 - 1872**
London artist, wife of William Riviere, R.A. Painted flowers and fruit and exhibited R.A., S.B.A. and other venues.
lit: Brinsley Burbidge, Desmond

ROBERTS, H. Larpent **fl.1863 - 1878**
London artist, painted flowers and landscape, his flowers being rather in the style of the Pre-Raphaelites. Exhibited R.A., B.I., S.B.A.
lit: Desmond, Wood

ROBERTS, Nellie **fl.1900 - 1939 (d.1959)**
Botanical artist who specialised in painting garden orchids and was appointed by the R.H.S. to do just that. This was her main work until the outbreak of war in 1914. She was awarded the V.M.M. in 1953.
lit: Blunt and Stearn, Desmond

ROBINS, Thomas the Elder of Bath
1716 - 1770
Originally he was a topographical draughtsman but many of his subjects had borders with beautiful floral decoration and he later went on to painting flower pieces as such. He always worked from nature with generally exquisite results. His work is in the Fitzwilliam Museum, Cambridge. (See page 34.)
lit: Blunt and Stearn, de Bray, Desmond, Fulton and Smith, Scrace
Colour Plate 12

★ROBINS, Thomas the Younger of Bath
1743 - 1806
Known for his botanical drawings in watercolour and flower studies in a similar style to that of his father. He produced a botanical sketch book of 109 leaves which is in the Broughton Collection, Fitzwilliam Museum, Cambridge. (See page 34.)
lit: Blunt and Stearn, de Bray, Brinsley Burbidge, Fulton and Smith

ROBINSON, Fanny **c.1802 - 1872**
In common with most people outside her family, I had never heard of Fanny Robinson, who lived in Norfolk, until 1999. Using the combined language of poetry and flowers, Fanny Robinson tells the story of a romantic tragedy, the details of which can only be surmised, in a leather-covered volume she called her *Book of Memory.* It is lavishly illustrated with her watercolours of flowers, their meanings apparently being part of the story, and the little poems under the flowers are written in careful Gothic calligraphy. Her family think this is her memory of an early lover who met with premature, probably accidental, death. The flowers are in a typically Victorian style, carefully observed but quite unscientific. Her great-great-nephew happened to show the volume to a friend who knew a publisher he thought it might interest. The upshot was

ROBINS, Thomas the Younger. Lily, virgin's bower and oleander.

RUSKIN, John. Sprig of a myrtle tree.

publication in 1999 of *The Country Flowers of a Victorian Lady,* obviously in the hope of replicating the outstanding success of the *Country Diary of an Edwardian Lady* (see page 180).

***RODDICK, Jan, S.F.P.** **20th century**
Jan Roddick has been painting and drawing all her life and professionally for a number of years. Her training was mainly at higher education and six years in a professional studio. She works mostly in watercolour but also in mixed media and pastel.

Although her main subjects are flowers, still life and some landscape, she enjoys sketching 'on the move' which she has practised in many countries round the world. She exhibits with S.F.P., R.H.S. and many local galleries and has had four solo exhibitions at Petworth House for the National Trust. She is a Founder Member of the S.F.P. and a regular contributor to the *Leisure Painter.* Her work has been reproduced by greetings card companies.

In her own studio she holds clinics and study days and also lectures and demonstrates at residential colleges. She believes that each artist should be helped to 'find his or her own style but, above all, should enjoy the fascinating medium of watercolour – a wonderful antidote to a stressful life and a constant challenge'.

ROSCOE, Margaret Lace (Mrs Edward)
 fl.1820s and 1830s
Botanical artist, daughter-in-law of the botanist, William Roscoe. Made some plates for his *Monandrian Plants of the Order Scitaminae,* 1824-29, and also illustrated *Floral Illustrations of the Seasons,* 1829-31.
lit: Brinsley Burbidge, Coats, Desmond

ROSENBERG, Charles **fl.1818 – 1848**
Painter and poet, son of Thomas Rosenberg, 1790-1825. Painted flowers, landscape and miniatures. Exhibited R.A., B.I., S.S.
lit: Brinsley Burbidge

ROSENBERG, George F. **1825 – 1889**
Lived in Bath and painted flowers and landscape. Published *A Guide to the Art of Flower Painting* in 1853. Exhibited R.A. and O.W.C.S. Work represented in the V. and A.
lit: Brinsley Burbidge

ROSENBERG, Mary, R.I. **1819 – 1914**
Daughter of a Bath drawing master and married another flower painter, William Duffield. Was made a Member of the R.I. in 1861 and awarded the Silver Medal of the R.S.A. in 1834. Exhibited flower paintings from 1848-1912 R.A., R.I., N.W.C.S., S.S. and other venues. Wrote and illustrated *The Art of Flower Painting* in 1856. Work is in the V. and A.
lit: Blunt and Stearn, Brinsley Burbidge, Clayton, Desmond

ROSS-CRAIG, Stella **1906 –**
Stella Ross-Craig, one of the greats of botanical illustration, was born in Aldershot and attended Thanet Art School and Chelsea Polytechnic School of London University. After botanical training she joined the staff at Kew working at the R.B.G. from 1929 to 1960 and also taking on freelance work. She produced numerous drawings for *Curtis's Botanical Magazine* and Hooker's *Icones Plantarum* (460 plates), her own *Drawings of British Plants,* thirty-one parts 1948-73 (1,286 high quality drawings), and *Flora of West Tropical Africa* (75 plates). She also provided

RODDICK, Jan. Patio pots. Watercolour.

illustrations for Johnstone's *Asiatic Magnolias in Cultivation,* 1955, Stern's *A Study of the genus Paeonia,* 1946, Supplement to Elwes' *Monograph of the genus Lilium,* 1938-40, and Sealy's *A Revision of the Genus Camellia,* 1958. She participated in many exhibitions of botanical art at the R.B.G., also the R.H.S., R.B.G., Edinburgh, and the Rijksherbarium, Leiden. Her work is in the R.H.S., the Hunt Institute and the Kew Collection holds over 3,000 drawings. The R.H.S. dedicated Vol. 182 of the *Botanical Magazine* to Stella Ross-Craig and her husband, Joseph Robert Sealy, for more than fifty years' association with the *Magazine.* (See pages 65-66.)
lit: Blunt and Stearn, Brinsley Burbidge, Fulton and Smith, Mabey, Rix, Stearn

ROUND, Frank Harold **1878 – 1958**
Frank Round was Assistant Drawing Master at Charterhouse for many years and during this time provided the illustrations for W.R. Dykes' *The Genus Iris,* 1913, sometimes under great pressure to finish a choice bloom when fresh while still keeping up with his classes. He also made a large collection of iris paintings for the Hon. W.C. Rothschild. The originals are now in the Lindley Library and the Natural History Museum and there is an album of forty-seven colour illustrations in the collection of the British Iris Society.
lit: Blunt and Stearn, de Bray, Brinsley Burbidge, Desmond, Rix

ROUPELL, Arabella Elizabeth (née Piggott)
 1817 – 1914
Born Shropshire, travelled to the Cape in 1843 where she painted the native flora. Illustrated *Species of Flora of South Africa by a Lady,* 1849, and *More Cape Flowers by a Lady* in 1864.
lit: Brinsley Burbidge, Desmond

ROWE, Ernest Arthur **1863 – 1922**
Primarily a painter of gardens rather than individual flowers, competent but rather stiff. Best known is his painting of the garden at Chequers, country residence of the British Prime Minister.
lit: Brown, Waters

***RUSKIN, John, M.A.** **1819 – 1900**
London writer, artist and art critic. Slade Professor of Fine Art, Oxford University, 1869-84. Made some delicate and sensitive

flower and plant drawings, exhibited O.W.C.S. and other venues. Work represented V. and A. (See pages 61-62.)

lit: Blunt and Stearn, de Bray, Brinsley Burbidge, Desmond, Fulton and Smith, Rix, Stearn, Wood

RUSSELL, Clarissa, S.F.P. 1939 –

Clarissa Russell, painter, restorer, lecturer and art teacher, trained at the Slade and the London Institute, London University. Her flower paintings show a special concern for colour and light and are generally executed in mixed media – pastel, watercolour and acrylic – for maximum effect. She exhibits with the S.F.P. and the Pastel Society as well as many other galleries. Her work is in a number of private collections in this country and abroad.

RUST, Graham Redgrave 1942 –

Born Hertfordshire, son of a barber who also dabbled in botanical painting. He trained at Regent Street Polytechnic, the Central School of Arts and Crafts and New York's National Academy of Art. He became known as the Pinstriped Painter because, unlike the general image, he was always neat and tidy with a taste for French suits.

By profession he was a muralist of distinction making decorative wall and ceiling designs for many stately homes in the U.K. and U.S.A., the best known probably being the 5,500sq.ft. mural, Temptation, at Ragley Hall which took ten years to complete. His mural work also appeared in a TV documentary in 1990 showing Michael Abraham's Quinlan Terry near Ripon. Work in the U.S. includes decoration for a private chapel.

At a more down to earth level he specialised in painting superb studies of flowers and vegetables, the subjects of a number of one-man shows and other exhibits along, sometimes, with animals and insects. He first exhibited at the R.A. at the age of twenty-three and has had twenty-two one-man shows including in Panama, Chicago, San Francisco and the Museum of Garden History, London. He has also exhibited with Hazlitt, Spink and Colnaghi in London and the Hunt Institute.

He has illustrated many books including, appropriately, Francis Hodgson Burnett's *The Secret Garden* and a new edition of Vita Sackville West's *Some Flowers*. His own books include *The Painted House* and *Decorative Design*. His work is in collections all over the world. (See page 65.)

lit: Sherwood

RYAN, Charles J. fl.1880s and 1890s

Lived in Bushy, Herts., and the Isle of Wight. Taught at Leeds School of Art and painted flowers and occasionally landscape. Exhibited R.A. and N.W.C.S. Work is represented V. and A. and seven watercolours of flowers are in the Department of E.I.D.

lit: Brinsley Burbidge, Desmond

RYDER, Margaret. Flower piece.

***RYDER, Margaret E., Hon., V.P.R.M.S., S.W.A., F.S.B.A., M.S., H.S.** 1908 – 1998

Born Sheffield, Margaret Elaine Wordsworth, and trained at Sheffield School of Art. Painter of flowers, portraits and landscape in oil, pastel and watercolour, but primarily miniatures on ivory. Freelance commercial artist in London and Manchester for over twenty-five years and miniaturist for fifty-seven years. Whether in miniature or as a large oil, Margaret Ryder's flower paintings are in a very beautiful traditional style, her larger work reminiscent of the 17th and 18th century Dutch painters.

Margaret Ryder drew and painted all her life, from the days of using the margins of her school textbooks to her last miniature painted at the age of ninety. She became Vice-President of the Royal Society of Miniature Sculptors and Gravers, was a Member of the S.W.A., S.M.A., S.B.A. and the Hilliard Society of Miniaturists. She exhibited regularly at the R.A., R.I., P.S., Manchester Academy, Aberdeen Society of Artists, as well as those institutions of which she was a Member. She also exhibited at the Paris Salon, in Perth, Australia, and Pittsburgh and Florida, U.S.A. She was President of the Sheffield Society of Artists and participated in their annual exhibition; she was also a Soroptomist and Member of the National Council of Women. From her correspondence and my acquaintance with her daughter, I know that she was not only a very talented lady who loved

her garden and made exquisite studies of its flowers, but a warm and generous person very much loved by her children, grandchildren and great-grandchildren.

Colour Plates 92 and 93

RYLAND, Henry 1856 – 1924

Lived in Biggleswade and in London. Studied at Heatherley's, the R.C.A. and in Paris under Constant, Boulanger and Lefebvre. Painted flowers, fruit and figures. Exhibited R.A., N.W.C.S., G.G., N.G. and other venues. Also designed stained glass.

lit: Brinsley Burbidge, Desmond, Waters

RYLAND, Irene, R.O.I., R.B.A., S.W.A.
 fl.c.1915 – 1930

Lived in London and studied art in Brussels, at Grosvenor Life School and the London School of Art under William Nicholson. Painted flowers amongst other subjects and illustrated several flower books. Exhibited R.A., N.E.A.C., Glasgow, Edinburgh, Hull, Brighton, Liverpool and other venues including the Paris Salon and in Toronto.

lit: Brinsley Burbidge, Hardie, Waters

RYLEY, J. fl.1950s and 1960s

London artist who exhibited flower paintings R.A., B.I., S.B.A.

lit: Brinsley Burbidge, Desmond

S

SADLER, Kate **fl.1878 - 1893**
Flower painter from Horsham, Sussex, who specialised in painting azaleas and chrysanthemums mainly in watercolour. Exhibited R.A., N.W.C.S., S.B.A. and other venues.
lit: Brinsley Burbidge, Desmond, Wood

SADLER, Thomas **fl.1878 - 1896**
London artist who exhibited flower paintings R.A., S.S. and other venues.
lit: Brinsley Burbidge

SALISBURY, Frank O., C.V.O., R.I., R.O.I., R.P. **1874 - 1962**
Born Harpenden, died London. Studied art under his brother, an artist in stained glass, and at the R.A. Schools. In 1896 he was awarded the Landseer Scholarship and went to Italy to study further. He was Master of the Worshipful Company of Glaziers 1933-34. He painted mainly portraits of important people in the U.K. and abroad and royal occasions but also some significant flower pieces. He illustrated with sixteen plates *In Praise of Flowers,* 1950. He exhibited R.A., R.I., R.P.G. and other venues in this country and in Paris.
lit: Brinsley Burbidge, Waters

SALMON, Helen Russell (Mrs Tom Hunt) **1855 - 1891**
Born Glasgow, daughter of an architect. Trained Glasgow School of Art and painted flowers and figures.
lit: Harris and Halsby

SANDERS, Rosanne, S.B.A. **1944 -**
Rosanne Sanders was educated at Roedean and High Wycombe College of Art and has made a highly successful career as a freelance botanical artist. She works in watercolour in her botanical work and, as a printmaker, in intaglio and relief. She has won four Gold R.H.S. medals and the Royal Academy Miniature Award in 1985. She has exhibited in group exhibitions at the Kew Gallery, Tryon and Swann, Cork Street, S.B.A., York Gallery, Tunbridge Wells, McEwan Gallery, Scotland, Devon Guild of Craftsmen, Thackeray Gallery, Kensington, the Hunt Institute, and the Franklin Mint Centre, U.S.A.

Her work has been reproduced as greetings cards etc. but she is best known for her own well-illustrated books – *The English Apple,* Phaidon 1988, *The Apple Book,* Philosophical Library, N.Y., *Portrait of a Country Garden,* Aurum Press 1980, *The Art of Making Wine,* Aurum 1982, *Little Book of Old Roses,* Appletree Press, and *Painting the Secret World of Nature,* Search Press. She collaborated with the Dartington Printmakers to produce *A Printmaker's Flora* which was purchased by the V. and A.

Commissions include work for H.M. Queen Elizabeth, Queen Elizabeth, the Queen Mother, the R.H.S., R.N.R.S. and a set of wild plant stamps for Barbados. Her work is in many public and private collections. She is a Member of the S.B.A. and the Devon Guild of Craftsmen where her work is on permanent display.
lit: Sanders, Sherwood
Colour Plate 94

SANDERS, Walter G. **fl.1882 - 1901**
London artist who exhibited flower paintings, mainly roses, R.A., S.B.A. and other venues.
lit: Brinsley Burbidge, Desmond, Waters, Wood

SARTAIN, Emily **fl.1932 - 1963**
Born in Oxfordshire and from 1932 to 1939 developed her talent for botanical illustration by drawing plants and flowers for R.H.S. records. She spent some time in Canada drawing the flora of British Columbia. Exhibited R.H.S. and in Vancouver and Montreal. Her work is in the R.H.S. collection and that of the Provincial Museum, Victoria, and she contributed illustrations to many periodicals and papers.
lit: Blunt and Stearn, Brinsley Burbidge, Desmond

SASS, Miss E. **fl.1798 - 1808**
All that is known of her appears to be the fact that she exhibited thirteen flower paintings R.A.
lit: Brinsley Burbidge

SASS, Henrietta **fl.1797 — 1808**
London artist who exhibited flower paintings and landscape R.A. and other venues.
lit: Brinsley Burbidge, Desmond

***SCHOFIELD, Sara Anne, F.S.B.A.** **1937 -**
Sara Anne Schofield was born in Twickenham, Middlesex, the daughter of two artists who

SCHOFIELD, Sara Anne. *Fritillaria meleagris.*

SCHOFIELD, Sara Anne. Flowers and grasses.

encouraged her in her childhood ambition to paint flowers. She trained at Twickenham College of Art where she also began freelance drawing for a West African Flora. She went on to work in the Herbarium of the R.B.G. at Kew.

While her family was young she worked on occasional private commissions and for herself with one major exhibition in the West of England. She has since had many exhibitions including three in London and has shown with most of the major societies in the U.K. She has been awarded two R.H.S. Gold Medals. Her work is represented in the Hunt Institute, the Shirley Sherwood collection and she has had several commissions for designs for royal commemorative plates for collectors of porcelain.
lit: Sherwood
Colour Plate 95

SCOTT, Katherine **fl.1872 - 1892**
London artist who exhibited flower paintings R.A., S.B.A., N.W.C.S. and other venues.
lit: Brinsley Burbidge, Desmond, Wood

SCOTT, Maria **fl.1823 - 1837**
Daughter of the Brighton landscape painter, William Scott. Painted some flowers, mainly orchids.
lit: Brinsley Burbidge

SCOTT, William Bell **1811 - 1900**
Pre-Raphaelite watercolourist who included flowers and fruit in a wide range of subjects. Exhibited R.A., B.I., S.S. and other venues. Work is in Laing Art Gallery, Newcastle, and the R.S.A.
lit: Brinsley Burbidge, Desmond, Wood

SCOTT-MOORE, Elizabeth, R.W.S., R.I. **1906 -**
Born, Kent, later lived in Surrey. Trained at Goldsmiths' College School of Art, Central

SHANKS, Una. Purple iris and blue poppy.

School of Arts and Crafts and in Italy. Painted flowers in watercolour as well as landscapes and portraits; had a one-man show entirely of flowers at Clarges Gallery. Altogether she has had fourteen one-man shows and exhibited R.A., R.W.S., R.I., R.P., N.E.A.C., in the provinces and the Paris Salon where she was awarded a Gold Medal.
lit: Brinsley Burbidge, Waters

SEBRIGHT, Richard 1868 – 1951
Painted flowers and fruit for Worcester porcelain 1890s to 1940s and exhibited flower studies R.A.
lit: Desmond, Loudon

SEDGEFIELD, Isobel M. fl.1880s and 1890s
London artist who exhibited flower paintings R.A. and S.B.A.
lit: Desmond

SELLARS, Pandora 1936 –
First trained as a textile designer at Hereford College of Art, then became an art teacher before becoming a freelance illustrator. Encouraged by Margaret Stones, who recognised her talent in the botanical field, she started regularly illustrating for *Curtis's Botanical Magazine*.

She specialised in painting orchids and other exotics inspired by the collection she and her husband accumulated. She has illustrated or contributed to many books including *Jersey Flora*, 1984, Cribb's *The Genus Paphiopedilum*, 1987, Ray Desmond's *A Celebration of Flowers*, 1986, Mabey's *The Flowering of Kew*, 1988, and *Flower Painting* by Clare Sidney, 1986. In 1987 she designed the Franklin Mint commemorative plate for the Prince of Wales Conservatory at Kew, the presentation painting for the Princess of Wales and stamps for the Jersey Post Office. She is an R.H.S. Gold Medallist. (See pages 78-80.)
lit: de Bray, Desmond, Mabey, Stearn

SERRES, Miss H. fl.1790 – 1800
Exhibited flower paintings R.A.
lit: Brinsley Burbidge

★SHANKS, Una 20th century
For many years Una Shanks taught art education and history of art but for some time now has been working full time as artist/illustrator finding subjects in her 'large friendly wild garden'. Plants and paintings grow together. She has a unique style and a great feeling for colour and colour coordination. Her method of working is best described by herself — I can only speak for the fascinating results. 'I enjoy detail but work on a bigger scale trying to control fine detail and larger areas of colour and pattern. Although I use plants as source material, I don't see myself as a botanical artist. I work in pen and ink and use layers of watercolour washes to add colour as the drawing progresses'. Una Shanks exhibits widely, especially in Scotland, and her work has been reproduced as greetings cards and for illustration.
Colour Plate 96

SHAW, Barbara, F.S.B.A. 20th century
Barbara Shaw has been a professional botanical painter since the 1960s and works exclusively to commission. She has formerly exhibited in many galleries and her work is in collections all over the U.K. and overseas. She is a Founder Member of the S.B.A. and was for many years associated with the R.M.S. She was awarded Bronze and Silver Grenfell Medals in 1977 and '78 and an R.H.S. Gold Medal in 1980. She has illustrated for *The Garden, The Plantsman, Country Life* and other publications and also illustrated *Foliage and Form*, Rakusen, 1970, and wrote and illustrated *The Book of Primroses* in 1990.

SHAW, Joshua 1776 – 1861
Born Sussex, painted landscape and some flowers. Exhibited R.A., B.I., S.B.A.
lit: Brinsley Burbidge, Desmond

SHEFFIELD, Mary fl.1808 – 1818
London artist who exhibited flower paintings R.A. and S.B.A.
lit: Brinsley Burbidge, Desmond

SHERINGHAM, George 1884 – 1937
Born London, died Hampstead. Painter of flowers and still life, he was a pupil of Harry Becker before going on to study at the Slade and in Paris.

He also did some textile and theatrical design and some illustrating. In 1925 he was awarded the Paris Grand Prix and in 1936 R.D.I. from the Royal Society of Arts. His work is represented in a gallery in Birmingham and other public collections and his work appears in a number of books. He exhibited in London and Paris.
lit: Brinsley Burbidge, Desmond, Hardie, Waters

SHERMAN, Albert John 1882 –
Born Truro, Cornwall, and studied at Truro Central Technical School. Painted flowers but after World War I settled in Australia and painted there. Became an Associate of the Royal Art Society of New South Wales.
lit: Waters

SHERRIN, John 1819 – 1896
Born London, died Ramsgate. Painter of flowers, fruit and animals, mainly in watercolour which he studied under W.H. Hunt. Exhibited R.A., N.W.C.S. and other venues and his work is represented in the V. and A.
lit: Desmond, Wood

SHRIMPTON, Ada M. fl.1880s and 1890s
London artist who painted flowers and domestic subjects, also practised engraving. Exhibited R.A., N.W.C.S., S.B.A.
lit: Brinsley Burbidge, Desmond

SHUBROOK, Laura A. fl.1889 – 1893
** and Minnie J. fl.1885 – 1899**
London sisters, both flower painters who exhibited R.A., N.W.C.S., S.S. and other venues.
lit: Brinsley Burbidge, Desmond, Wood

SHUCKARD, Frederick P. fl.1868 – 1901
Painted flowers and genre and exhibited R.A., S.S. and other venues.
lit: Brinsley Burbidge, Wood

SILAS, Louis F. fl.1900 – 1932
Painted flowers in a very decorative style. Reproduced in Richter's *Floral Art – Decoration and Design*.
lit: Brinsley Burbidge

SILLETT, Emma fl.1818 – 1833
Daughter of James Sillett who painted flowers and fruit after the style of her father. Exhibited Norwich but her work is quite rare.
Brinsley Burbidge, Day, Walpole

SILLETT, James 1764 – 1840
Norwich School painter. Lived in Norwich and King's Lynn; trained at the R.A. Schools and spent time in London painting stage settings at Drury Lane. Among many subjects, flowers were his strongest point. Exhibited R.A. and in Norwich. His work is in the V. and A., British Museum and Castle Museum, Norwich. (See pages 27-28.)
lit: Brinsley Burbidge, Day, Desmond, Desmond and Wood, Mitchell, Moore, Scott-James, Walpole
Colour Plates 7 and 33

SIMPSON, Eugénie fl.1883 – 1888
London artist who exhibited flower paintings R.A., S.S. and other venues.
lit: Brinsley Burbidge, Desmond

SMAIL, Elizabeth. Hyacinth with bulb.

SMALL, Julie. Alpine thistle.

SKEATS, Thomas fl.1875 - 1882
Southampton artist who exhibited flower paintings and landscapes S.B.A.
lit: Brinsley Burbidge, Desmond

SLOCOMBE, Alfred, R.C.A. fl.1862 - 1887
London flower painter who contributed plates to Hubbard's *The Ivy,* 1872, and exhibited flower paintings R.A., S.B.A., B.I., N.W.C.S. and other venues.
lit: Brinsley Burbidge, Desmond

★SMAIL, Elizabeth, F.S.B.A. 1942 –
Elizabeth Smail was educated in Ross-on-Wye and trained at Hereford College 1958-1962 gaining an Intermediate Certificate in Graphics and Textile Design. It was the use of plants as subjects for textile design that gave her an interest in botanical and flower painting. Until 1980 she was Head of Art in several schools, then gave up teaching to specialise in flower painting. She still gives a certain amount of freelance instruction in flower painting and botanical illustration.

Elizabeth Smail works mainly in watercolour, also gouache and pencil, and has exhibited with the S.B.A. of which she is a Founder Member, the Linnean Society, the National Trust, the Worldwide Fund for Nature in Art, and in galleries in Nottingham, Guildford, Wells, Southend-on-Sea, Winchester, Sevenoaks, Hereford and Tenbury Wells. She was the founder and organiser of the annual exhibition of flower painting, Sevenoaks Wildfowl Reserve. She is a Fellow of the Linnean Society and gained the Certificate of Botanical Merit, S.B.A., in 1993. Her work has been used for greetings cards and collectors' plates and has been reproduced in Sue Barton's *Encyclopaedia of Flower Painting Techniques.* She has work in the collection of the Hunt Institute, the Marine Society, London, and in many private collections.

SMALL, Florence Vera Hardy, P.S.
 c.1860 - 1933
Born Nottingham, died London. Trained under Bouguereau and Deschamps in Genoa, Berlin and Paris. Painted flowers as well as portraits and genre and exhibited R.A., S.S., P.S. and the Salon des Artistes Français.
lit: Brinsley Burbidge, Desmond, Waters, Wood

★SMALL, Julie A., S.B.A. 20th century
Julie Small originally trained as a teacher of biology and physical education but her long-standing interest in the natural environment led her to explore the techniques associated with botanical and wildlife art forms. She works in watercolour and more recently has turned her attention to using graphite pencil, a medium with which she has always felt a close affinity.

She exhibits regularly with the S.B.A. and has received two of the society's Certificates of Botanical Merit, also at other venues in London and Wales and locally in the Worcestershire area. The R.H.S. purchased one of her paintings for the Lindley Gallery and two others have been acquired by the Windlesham Arboretum, Kent. Her work is in a number of private collections and has been used in art book illustration.

★SMITH, Basil, M.C.S.D., M.S.T.D., F.S.B.A., M.G.M.A. 1925 –
Basil Smith was born and still lives in Sussex, attended School at the Xaverian School in Brighton, then the Brighton College of Arts and Crafts. His course there was interrupted by the war but resumed after demobilisation. He progressed into advertising, starting as a visualiser and ending as Art Director in four of London's top advertising agencies. Many of his assignments were in the realms of agriculture and horticulture, He also designed the Brooklands Automobile Racing Club badge and won the Edinburgh Festival Book Award for his Bugatti Book. After twenty years in advertising, during which time he won a number of top awards, he decided to go freelance.

He designed over four hundred First Day Covers for a client in America, including a series on fauna and flora, illustrated a number of books and designed covers, illustrated and designed stamps for the Post Office, illustrated flowers and vegetables for Reader's Digest and for many magazines. Botanical painting constitutes a large proportion of his work which has been exhibited all over the U.K. and U.S.A. and sold to clients all over the world.

In spite of having a wide repertoire, his exceptional flower and vegetable paintings make him one of the leading exponents of this particular art form.

SMITH, Caryl, S.B.A., S.F.P. 20th century
Caryl Smith has painted ever since she can remember, her inspiration being a great love of the countryside, wildlife and flowers. Her work has progressed from very detailed studies showing every detail to a more relaxed, looser style which is decorative but still completely true to nature. She usually works with living flowers and in pastel and watercolour.

She exhibits with the S.B.A., S.F.P., S.W.A., U.A., in galleries in the Cotswolds, Wiltshire and Sussex and with local societies. Her work is in collections in the U.K., U.S.A., Australia and Sweden and has been used by the Medici Society and other publishers as greetings card designs.

SMITH, Charlotte Elizabeth fl.1920s
Painted flowers and landscape in oil and watercolour and exhibited R.A., R.S.A., S.S. and Paris Salon.
lit: Waters

SMITH, Edwin Dalton fl.1823 - 1846
Botanical artist of Chelsea who produced some attractive work, usually on a very small scale. He

SMITH. Basil. Lavatera.

SMITH, Liz. Pink Roses.

illustrated Maund's *Botanical Garden* Vols. 1-6, Sweet's *Flora Australasia,* 1827-8, *British Flower Garden,* 1823-4 and *Florists' Garden,* 1827-32, also *Geraniaceae,* 1820-30. His drawings are in the B.M. and R.H.S.
lit: Blunt and Stearn, de Bray, Brinsley Burbidge, Desmond, Rix

SMITH, Frederick William 1797 - 1835
Artist of London and Shrewsbury. Botanical illustrator, illustrated Paxton's *Magazine of Botany,* 1834-37, *Florists Magazine* (which he also edited), 1834-36, and Sweet's *British Flower Garden,* 1834-35.
lit: Desmond

★SMITH, Liz, S.F.P., H.S. 20th century
Flower painter and miniaturist, Liz Smith exhibits with local societies as well as in London and abroad with the S.F.P. and the Hilliard Society of Miniaturists. She has won several trophies including the Peter Brown Award and the John Ashcroft Trophy, an award in the Dorchester Art Society Open Exhibition and a prize in an open competition sponsored by the Pegasus Housing Association. Her work has been published as greetings cards and has been acquired by clients from all over the U.K. and overseas.

SMITH, Marcella Claudia Heber, R.I., R.B.A., R.M.S., S.W.A. 1887 - 1963
London artist who trained in Washington, Philadelphia and in Paris. Exclusively painted flowers in oil and watercolour and exhibited R.I., R.B.A., R.M.S., S.W.A. and other venues. Published *Flower Painting in Watercolour* in 1955.
lit: Brookshaw, Brinsley Burbidge, Waters

SMITH, Matilda 1854 - 1926
Born India, died Kew. She was a cousin of Joseph Hooker who trained her as a botanical artist to replace Fitch when he left the *Botanical Magazine.* She became a hardworking and competent botanical artist but, in spite of help from John Nugent Fitch who lithographed (and enhanced) her drawings, she never quite reached Fitch's standard. She started making drawings for the *Botanical Magazine* in 1878 and from 1886-1923 she drew almost all the illustrations – some 2,300 in all. With W.H. Fitch she was a main contributor to Hooker's *Icones Plantarum* 1881-1921; she developed a useful talent for reconstituting and drawing from dried and flattened specimens. She was appointed official Kew artist in 1898 and also contributed plates to *Transactions of the Linnaean Society* and Balfour's *Botany of Socotra,* 1888. In 1891 Otto Kuntze renamed the genus *Naegelia Regel* (1848) *Smithiantha* for Matilda Smith and *Smithcella* was given by Dunn in 1920 to a genus of *Urticaceae* 'respectfully dedicated to Miss Matilda Smith'.
 During her time with the *Botanical Magazine* Matilda Smith had to endure some foul smelling plants which drew forth a special apology from the *Magazine.* One painting in 1881 made her so dreadfully ill that the idea of illustrating it had to be abandoned.
 In 1916 she was appointed President of the Kew Guild and in 1921 elected Associate of the Linnean Society of London and awarded the Veitch Memorial Medal.
lit: Blunt and Stearn, de Bray, Brinsley Burbidge, Desmond, Mabey, Rix, Stearn

SMITH, Sir Matthew Arnold Bracy, C.B.E. 1879 - 1959
Trained in Manchester, at the Slade and in Paris under Matisse whose influence shows markedly in his early works. Flower paintings, often with still life, were only part of a much wider repertoire including nudes and landscapes in oil. The Fauve influence gradually diminished and he developed a very personal style of modernism combined with realism. He exhibited with most major galleries in London and in Europe and the provinces and his work is in many public collections including the Tate Gallery where there was a retrospective exhibition in 1953. The R.A. mounted a Memorial Exhibition in 1968.
lit: Brinsley Burbidge, Mitchell, Waters

SMITH, Olive Wheeler fl.1878 - 1883
Lived Addiscombe, Surrey, and exhibited flower paintings R.A., S.B.A.
lit: Brinsley Burbidge, Desmond

SMITH, Rosa fl.1880s and 1890s
London artist who exhibited flower paintings R.A. and S.B.A.
lit: Brinsley Burbidge, Desmond

SMITH, Rosemary Margaret 1933 –
Botanic illustrator born in Cheshire but later lived in Edinburgh. Her work is published in many magazines and other publications including *Notes of the Royal Botanic Garden, Edinburgh, Scottish Rock Garden Club Journal, Flora Iranica* and the *Scotsman.* Books in which her illustrations can be found are Prime's *Experiments for Young Botanists,* 1971,

Hilliard and Burtt's *Streptocarpus, An African Plant Study,* 1971, and Fletcher and Brown's *History of the Royal Botanic Garden, Edinburgh,* 1970.
lit: Brinsley Burbidge, R.B.G. Edinburgh

SMITH, William 1707 - 1774
Lived in Sussex and painted flowers and fruit in the Dutch style.
lit: Brinsley Burbidge, Desmond

SMITH, Worthington G. 1835 - 1917
Started his career as an architect, later became an illustrator, turned to botany and made many monochrome drawings for the *Gardener's Chronicle* and *The Floral Magazine* which are now in the Natural History Museum. Although botanically correct, for their lack of sensitivity Blunt describes them as '…the zenith – or the nadir – of distasteful effrontery'.
lit: Blunt and Stearn, Waters

SMYTHE, Minnie, R.W.S. d.1955
Daughter of Leonard Smith, R.A., and lived in London. Trained in France and exhibited R.A. and R.W.S.
lit: Waters

SNELLING, Lilian 1879 - 1972
One of the country's most highly acclaimed botanical artists who enjoyed flower painting from early childhood. Worked at the R.B.G., Edinburgh, from 1906 making plant portraits for Sir Isaac Bailey Balfour, Keeper of the Botanic Garden and Professor of Botany at Edinburgh University. Between 1922 and 1952 became chief artist for the *Botanical Magazine* making most of the plates (740) during that time. Vol.169 was dedicated to her and the R.H.S. awarded her the Victoria Medal of Honour.
 Lilian Snelling studied lithography under Morley Fletcher and became the first artist since W.H. Fitch to combine the arts of illustration and lithography. She made fifteen plates for Stern's *A Study of the Genus Paeonia,* 1946, the originals of which are now in the Lindley Library, and also provided illustrations for Grove and Cotton's Supplement to Elwes' *Monograph of the Genus Lilium,* 1934-40. (See page 66.)
lit: Blunt and Stearn, de Bray, Fulton and Smith, Mabey, Stearn, Rix
Colour Plate 35

SODEN, Susannah fl.1880s and 1890s
Studied at Kensington School of Art and exhibited flower and fruit paintings R.A., S.L.A., S.B.A., Dudley Gallery and other venues.
lit: Clayton, Desmond

★SOMERVILLE, Stuart Scott 1908 - 1983
Born in Yorkshire, trained under his artist father, Charles Somerville. First exhibited at the R.A. at the age of seventeen and held his first London one-man show at twenty-two which was highly acclaimed both by the critics and the public. Working from his Chelsea studio, he continued exhibiting in London and Paris building up a considerable reputation in both capitals. In 1934/5 he went with the British Museum Expedition to the mountains of East Africa as

SOMERVILLE, Stuart Scott. Summer flowers.

SOMERVILLE, Stuart Scott. Delphiniums.

expedition artist after which many of the resultant works provided illustrations for Patrick Synge's book *Mountains of the Moon*.

After World War II he and his wife, Catherine, bought and renovated Newbourne Hall in Suffolk from where he worked for the rest of his life, mainly on his outstanding flower paintings, finding subjects in his large, well-filled garden. Although by no means a publicist, he always had commissioned work on hand through word of mouth 'advertising' and as time went on the need even to exhibit became less and less. For many years this was confined to supporting East Anglian galleries and the Festivals at Aldeburgh, Hintlesham and King's Lynn. Outside Suffolk he usually had work on show at Frost and Reed in Bond Street. (See pages 123-124.)
lit: Reiss, Synge
Colour Plate 67

SORRELL, Elizabeth, A.R.C.A., R.W.S.
1916 –
Yorkshire born artist who trained at Eastbourne School of Art 1934-38 and the R.A. Schools under Tristran until 1942. Although she painted many subjects, including a collection of old-fashioned dolls, her paintings of flowers and garden subjects in exquisite detail were quite superb. She exhibited R.A., R.W.S., N.E.A.C. and other venues, sometimes with her husband Alan Sorrell. Her work is represented in the Tate Gallery, Tower Art Gallery, Eastbourne and in Newport.
lit: Brinsley Burbidge, Waters

SOUDAIN, Annie, S.B.A. 20th century
Annie Soudain was born near Dover but spent her early childhood in Truro, Cornwall. She studied art for four years at Canterbury College of Art. She took an art teacher's diploma at Brighton College of Art and taught art at Brighton and, after a break while her children were young, at Hastings. She now teaches part time (as well as organising workshops for children and adults) in order to concentrate on her own work, particularly flower painting. She exhibits with the S.B.A., the Rye Society of Artists, the Guild of Sussex Craftsmen and other local galleries. She has had one-man shows at the Casson Gallery, Eastbourne College, two at Kirsten Kjaers Museum, Denmark, the Stables Theatre Gallery, Hastings and London's Barbican Library. Her work is in private collections in the U.K., France, Germany, Denmark, Switzerland, Australia, New Zealand and the U.S.A.

She works in watercolour, gouache and wax resist, also makes lino cuts. She was winner of the Talens/Frisk Purchase Prize at the 1992 Art in Nature exhibition and is regular artist-in-residence at Nature in Art (the International Centre for Wildlife Art), Gloucester. She was commissioned to paint six large panels for the cruise liner, *Saga Rose,* which were installed in 1997, and has carried out commissions for the National Trust. Her work has been reproduced as greetings cards and prints.

★SOUTHWELL, Sheila 20th century
Sheila Southwell was born in Birmingham but her painting career started in 1967 when she and her husband moved to Australia. There she started painting on porcelain, first as a hobby which triggered five years' training when she decided to take it seriously. Painting flowers on porcelain moved on to painting flowers in watercolour. Since returning to England in 1975 she has made a successful career in both categories and has written and illustrated five books on the subjects. She also teaches in adult education and holds her own courses.

Sheila Southwell is a Member of the S.F.P. and the British China and Porcelain Artists Association, is past chairman of the Downlands Art Circle and Founder President of the Southern China Painting Club. She paints in a charming style reminiscent of the late 19th century flower painters and exhibits widely as well as painting to commission. Her most important exhibition ran for six weeks at the Birmingham Art Gallery and Museum and her biggest commission was from Virgin Airways to paint five murals for their V.I.P. Terminal at Gatwick Airport. She contributes to *Flora, Leisure Painter* and other magazines and journals.

SOUTHWELL, Sheila. Floral design for decorated plate.

STANNARD, Eloise Harriet. Basket of flowers.
COURTESY JOHN DAY

SOWERBY, Charlotte Caroline 1820 - 1865
A little known member of the Sowerby dynasty but an excellent botanical illustrator possibly overshadowed by the male members of the clan. Contributed to Henderson's *Illustrated Bouquet* and other publications.
lit: Kramer

SOWERBY, James 1757 - 1822
Early botanical artist who studied at the R.A.Schools and contributed illustrations to many journals and other publications including 2,592 plates for *English Botany*. He contributed to *Curtis's Botanical Magazine,* Smith's *Exotic Botany,* 1804-5, Curtis' *Flora Londinensis.* He also produced *An Easy Introduction to Drawing Flowers from Nature,* 1788, *Florist's Delight,* 1789-91, and the extremely rare *Flora Luxurians,* 1789-91, said to be the only one in which he seriously concentrated on garden flowers and certainly a large scale and impressive publication. He exhibited at the R,A. from 1774-1790 and his work is represented in the British Museum. (See page 32.)
lit: Blunt and Stearn, de Bray, Brinsley Burbidge, Coats, Desmond, Fulton and Smith, Mabey, Rix, Stearn

SOWERBY, James de Carle 1787 - 1871
Eldest son of James Sowerby with whom he collaborated on *English Botany* and Hooker's *Supplement.* He also contributed to Loudon's *Encyclopaedia of Plants* and *Curtis's Botanical Magazine.* His drawings are in the British Museum and in the Department of Botany, Oxford. (See pages 32-34.)
lit: Blunt and Stearn, de Bray, Brinsley Burbidge, Desmond, Mabey, Rix

SOWERBY, John Edward 1825 - 1870
Son of Charles Edward Sowerby; made many botanical illustrations of wild plants.
lit: Blunt and Stearn, de Bray

SPARKE, Catherine Adelaide (née Edwards) 1842 -
Studied at Lambeth School of Art and the R.A. Schools. Painter and designer of Lambeth Pottery, also painted flowers and exhibited R.A. 1866-90, Dublin, N.W.C.S., G.G. and other venues.
lit: Desmond, Wood

SPENCER, Clem, B.A., S.B.A., S.F.P. 1924 -
Clem Spencer started his artistic career as a draughtsman followed by a lecturing post in naval architecture and other positions in design and management. All through these various positions he was painting in his spare time and in 1980 went professional. He specialises in flower painting, his subject matter being provided by his own award-winning garden designed in the 1960s. He is a Member of both the S.B.A. and S.F.P. and participates in all their exhibitions; he was awarded trophies in 1997 in England and in 1998 in Sweden. He has had many solo exhibitions, mainly at the Barbican Gallery in Plymouth and the annual exhibition he holds in his garden studio in aid of local charities. He also demonstrates to West Country Art Clubs, again in aid of charitable causes. His work has frequently been published as prints and greeting cards.

SPRY, William fl.1832 - 1847
London artist who exhibited flower paintings R.A., S.B.A., N.W.C.S. and other venues.
lit: Brinsley Burbidge, Desmond, Wood

SQUIRES, H. fl.1865 - 1875
Stratford artist who exhibited flower paintings R.A., R.I., S.B.A.
lit: Brinsley Burbidge, Desmond, Wood

STAGG, Pamela 1949 -
Pamela Stagg has a wide international reputation for her impeccable paintings of flowers, fruit and vegetables and has been acclaimed by reviewers of her exhibitions and serious botanists as 'in the front rank', 'head and shoulders above most botanical artists' and having 'outstanding talent'. Born in Nottingham, she trained and now lives in Canada and exhibits in England, Canada and the U.S.A. She also lectures regularly in both England and Canada. She has had four solo exhibitions at the Park Wall Gallery in London, two at the Civic Garden Centre, Toronto, one at the R.B.G., Hamilton, Ontario, and has participated in other exhibitions with the S.B.A., R.H.S. (Gold Medal), Tryon and Swann, London, British Iris Society, Denver Botanic Garden, Niagara Parks Botanical Gardens and the Hunt Institute. Her work is in collections in Britain, France, Canada and the U.S.A. including the Hunt Institute, Midland-Walwyn Capital Inc. and SkyDome Founders Club, Toronto, the Shirley Sherwood Collection and private collections include the Duke of Roxburghe, Sir John Nott and Philip Oppenheim. In 1992 she received a travel award from Ontario Arts Council and, as well as her R.H.S. Gold Medal, she holds the prestigious Grenfell Medal. Her work has been reproduced in over thirty books, magazines and periodicals.
lit: Gwyn, Sherwood

STANIER, Henry fl.1860-1864
Birmingham artist who exhibited fruit and flower paintings R.B.A. and S.B.A. Lived for a time in Spain where he painted some landscapes.
lit: Brinsley Burbidge, Desmond, Wood

*STANNARD, Eloise Harriet 1829 - 1915
Daughter of Alfred Stannard and niece of Mr and Mrs Joseph Stannard. A brilliant flower and still life painter by any standards, her work has realism, texture and finesse comparable to any of the seventeenth century Dutch artists. She spent her whole life painting for her work was in constant demand. She exhibited occasionally at the R.A., B.I., S.L.A. and in Norwich when pressure of commissions allowed. Her only pupil was Maria Margitson, niece of another Norwich School artist, John Berney Ladbrooke. (See pages 43-44.)
lit: Brinsley Burbidge, Clayton, Day, Desmond, Mitchell, Walpole
Colour Plates 17 and 34

STANNARD, Emily (Mrs Joseph) 1803 - 1885
Wife of Joseph Stannard and daughter of the artist Daniel Coppin. She was inspired by the Flemish and Dutch flower painters and in her youth spent time in the Rijksmuseum studying and copying the wonderful works there. She continued painting her beautiful sumptuous flower studies and still life throughout her long life. Exhibited B.I. and in Norwich (see page 43). She was awarded the Society of Arts Gold Medal for flower painting in 1820.
lit: Brinsley Burbidge, Day, Desmond, Mitchell, Moore, Waters, Walpole
Colour Plate 16

STANNARD, Emily 1827 - 1894
Daughter of Emily and Joseph Stannard. Painted flowers and still life and helped her mother in their Norwich teaching practice.
lit: Day, Moore, Walpole

STANNARD, Lilian 1884 - 1944
Daughter of artist Henry Stannard, R.B.A., two brothers and two sisters were also painters. Painted

STEPHENSON, Christine. Parrot tulips.

flowers and gardens and illustrated W.P. Wright's *Popular Garden Flowers.* Held an exhibition at the Mendoza Gallery in 1905, also exhibited R.A. 1902-1930, the R.I. and in Norwich.
lit: Brinsley Burbidge, Desmond, Waters

STANTON, Emily Rose, R.I. 1838 – 1908
Artist from Stroud, Glos., who exhibited paintings of flowers and birds R.A., R.I., N.W.C.S. and other venues.
lit: Brinsley Burbidge, Desmond, Waters

★STEPHENSON, Christine, A.T.D., S.B.A.
1937 –
Christine Stephenson was born in Winchester where she attended St Swithin's School and later trained at Bournemouth College of Art 1953-58. She was teaching, mainly in London, until she moved to Suffolk in 1994 to work full time as a botanical artist and illustrator. She produces botanically accurate and minutely detailed watercolours with a concern for composition, texture, richness of colour and dramatic tone.

She has exhibited with the R.H.S. gaining a Silver Medal in 1995 and Gold in 1997. She exhibits with the S.B.A. each year and has also exhibited at Goldsmiths' Gallery, London, Thompson's Gallery, Aldeburgh, Leiston Abbey, Suffolk, Cotton's Yard Gallery, Bratby Gallery and Lucy B. Campben Gallery, London. She has also worked on paintings for the Woottons of Wenhaston Catalogue and her work is in many private collections in the U.K. and overseas.

STERNDALE-BENNETT, Honor, R.I.
1886 –
Painter of flowers in watercolour who exhibited R.A., R.I., R.B.A., the Paris Salon and other venues.
lit: Brinsley Burbidge, Desmond, Waters

★STEVENS, Margaret, F.S.B.A.
20th century
Margaret Stevens was born in Devon and encouraged to paint by a very talented father. At the age of sixteen she was the youngest member of Brixham Art and Photographic Society and was accepted by the colony of artists which made Brixham the Devonian equivalent of St Ives.

Her early working life was spent in clerical posts with painting only a spare time occupation and after marriage she did not paint at all for twenty years during which time the family were living in Spain. After returning to England her husband became ill and she started to paint again. After his death in 1982 she started full-time work as a freelance artist and designer. She now holds thirteen R.H.S. Medals including the Gold and Silver Gilt Lindley Medal for work of exceptional scientific or educational merit.

She is a Founder Member and Executive Vice-President of the S.B.A. and exhibits with them regularly. She is also Founder President of the North Wales Society of Botanical and Fine Watercolour Artists, an Associate Member of the Society of Graphic Fine Art and a Member of the Hilliard Society. She has had a number of solo exhibitions and also exhibited with the S.W.A., R.M.S., the Gorstella Gallery, the Llewellyn

STEVENS, Margaret. Ispilante.
COURTESY AIDAN CUTHBERT

STEVENS, Margaret. Hibiscus.
COURTESY AIDAN CUTHBERT

Alexander Gallery, the Everard Read Gallery, Johannesburg, and the Linnean Society of London. Interesting commissions have included the R.H.S. Chelsea Plate for 1993, designs for the Princess Grace Foundation through Franklin Mint, a set of commemorative plates for the Royal British Legion entitled 'The Flanders Field' and many commissions for private clients including one for fifty paintings of old shrub roses in the style of Redouté painted over a five year period. She paints commercially for the Medici Society and for nine years has written and illustrated for the quarterly *This England*. In 1992 she illustrated the Paphiopedilum section of the *R.H.S. Dictionary of Gardening,* some of the illustrations later being used for an R.H.S. Manual on Orchids. Her own book, *An Introduction to Drawing Flowers,* was published in both the U.K. and U.S.A. in 1994. She still paints for private clients and her work is in collections throughout Europe, the U.S.A., Australia and the U.K.

Margaret Stevens holds regular day courses and an annual Summer School near her home in North Wales and teaches at Plas Tan y Bwich and Burton Manor College in about six courses a year. Her work is in the Hunt Institute.

★STEWART, Edna Doreen, R.S.H. G.M., S.F.P. **1936 –**
Edna Stewart was born in Northern Ireland, attended Londonderry High School and spent four years at Belfast College of Art, 1953-57, graduating with N.D.D. in printed and woven textiles. After teaching art and craft for two years, she went to London to gain experience in a textile studio moving on to designing hand-painted tapestry and

needlepoint. In 1964 she went back to Northern Ireland as Assistant Designer for B.B.C. TV. After marriage she spent two years in Pakistan returning to England in 1968 and back to designing needlepoint, hand-painted china and tiles.

Although flowers had played an important part as subjects for this work, the work of the artist Paul Gell inspired her to start flower painting as such which has been and still is extremely successful showing great talent and feeling for the subjects. She exhibits regularly with the S.B.A. and S.F.P., her work being both botanical and free style, with the R.H.S. (Gold Medallist), the R.W.S. and other group exhibitions.
Colour Plate 97

STEWART, Florence **fl.1880s**
London artist who exhibited flower paintings R.A., G.G.
lit: Brinsley Burbidge

STEWART, Edna Doreen. Hellebores.

STEWART, John Ivor, N.D.D., A.T.D., A.D.A.E. (Wales), F.S.B.A., P.S.
20th century

John Ivor Stewart was born in Northern Ireland and studied at Belfast College of Art 1956-60 and the University of Reading 1960-61. He also attended the Post-Graduate School of Art Education at the University of Wales 1973-74. He subsequently became Head of Art in various grammar schools and an independent school in Surrey. He has also tutored on a number of courses in the U.K. and France, having retired from full-time teaching in 1990.

John Ivor Stewart specialises in flower painting and nudes using a combination of acrylic and soft pastel well suited to his colourful, almost passionate, work. Of his flower paintings he says, 'The intensity of the painting's "life force" is of more interest to me than the linear botanical narrative which the composition might otherwise convey were it to be descriptive in a factual way. Each painting is concerned to acknowledge that the flower has "lived" and changed within a time scale and its own space. The distinctive nature of each flower influences the form of the painting's expression. This, I think, is illustrated by the treatment of the *Magnolia soulangeana* compared with the way in which the more fragile nature of the Shirley *Papaver rhoeas* is expressed. The overpowering energy of the "opium" *Papaver somniferum* is a totally different story. It is this story which now occupies my energies!'

He has had a number of one-man shows in Ireland and Surrey, participates in the S.B.A. and P.S. exhibitions, also the Société des Pastellistes, Paris, and the International Exhibition of Pastel Painting at Compiègne, France. Other venues include the New Ashgate Gallery and the Lizard Gallery, Farnham, Llewellyn Alexander, London, Garden Festival, Wales, Arlesford Gallery, Winchester, Ludlow Arts Festival, Oundle Gallery, Daler-Rowney, Bournemouth, Rooksmoor Gallery, Bath, Rufford Central Gallery, Newark, Century Gallery, Datchet, Royal West of England Academy and Galerie Amedro, Vetheuil.

Awards include in 1986 Major Prize for non-members Pastel Society (he was elected Member a year later), Major Daler-Rowney Award, Premier Award, Pastel Society, 1997. He was the first to receive the new Joyce Cuming Presentation Award at the S.B.A. exhibition, 1993.

His work has been reproduced in *Surrey County Magazine, The Artist, Art and Arts Review* and the *Beginner's Guide to Pastels* published by New Holland in 1997.

STIKEMAN, Annie fl.1880s
Artist of Blackheath, London, who exhibited flower paintings R.A., N.W.C.S., S.B.A.
lit: Brinsley Burbidge, Desmond

STIRLING, Nina fl.1880s
London artist who exhibited flower paintings R.A., S.B.A.
lit: Brinsley Burbidge, Desmond

STOCK, Edith A. fl.1880 - 1889
Flower painter of Richmond, Surrey. Exhibited R.A., S.B.A., N.W.C.S. and other venues.
lit: Brinsley Burbidge, Desmond

STOCKS, Katherine M. fl.1877 - 1889
London artist who exhibited flower paintings R.A., N.W.C.S. and other venues. Work is represented in the V. and A.
lit: Brinsley Burbidge, Desmond

STONES, Emily C. fl.1880s - 1920s
London artist who painted flowers in watercolour and exhibited R.A., S.B.A., R.I., R.B.A., N.W.C.S.
lit: Desmond, Waters

STONES, Margaret, M.B.E. 1920 -
Born Australia, studied at Swinburne and National Gallery Schools, Melbourne. Came to England in 1951.

In England she worked first at the R.B.G. Kew and the British Museum (Natural History). In 1958 she became principal contributing artist to *Curtis's Botanical Magazine* producing over 400 colour and 400 black and white text drawings over the next twenty-five years. Made most of the plates for supplements VIII and IX of Elwes' *Monograph of the Genus Lilium,* 1960 and '62. Illustrated Lord Talbot de Malahide's *The Endemic Flora of Tasmania* (published in six parts between 1967 and '78), 270 coloured drawings and many working drawings. She was commissioned by Louisiana State University to make 200 drawings of flora of the State and she illustrated many books and other publications.

Margaret Stones' important solo exhibitions include Colnaghi and Co., London, 1952, 1967, 1972 and 1975, Melbourne, Joshua McClelland Print Room 1965, 1970, 1975, 1981 and 1989, U.S. travelling exhibition Endemic Flora of Tasmania 1969 and 1976 in Tasmania, Washington D.C. Smithsonian Institution, Native Flora of Louisiana Natural History and National Museum of Man 1980, New Orleans 1985, Louisiana State University 1986 and 1992, Edinburgh R.B.G. 1991 Cambridge Fitzwilliam Museum 1991 and Ashmolean, Oxford, 1991. Other solo venues include Baskett and Day, London, 1984 and 1989, Melbourne University Retrospective 1975, R.B.G. Edinburgh Ascreavie Watercolours 1986, Cornell University 1990, Charlottesville, University of Virginia 1993 and Boston Athenaeum 1993. Group shows in which she participated include British Museum Flowers in Art from East to West 1979, National Gallery of Victoria 1993, also National Gallery of Victoria Retrospective 1946-86 for which illustrations were included in the catalogue *Beauty in Truth* (see page 66). In 1998 she was awarded the prestigious R.H.S. Victoria Medal of Honour.

STORER, Louisa fl.1816 - 1843
London artist who exhibited a number of flower paintings R.A.
lit: Brinsley Burbidge

STORY, Mary L.S. fl.1880s
Nottingham artist who exhibited flower paintings R.A., G.G.
lit: Brinsley Burbidge, Desmond

STOTHARD, Thomas, R.A. 1775 - 1824
Made many watercolour studies of flowers now in the Kew collection.
lit: Blunt and Stearn

STREET, Georgina fl.1858 - 1861
London artist who exhibited paintings of flowers and fruit S.B.A.
lit: Brinsley Burbidge, Desmond

STREVENS, John 1902 - 1989
John Strevens studied at Regent Street Polytechnic and attended Heatherley's (he walked out) although his individualistic approach suggests that he was always his own man rather than following anyone else's teaching or example. As a child his delicate constitution made his parents decide to send him away from London to live with an aunt in Dorset. Strevens clearly looked back on this time as his early inspiration — to a London child the sunshine, the flowers and the colours of the countryside created an almost fantasy world which, in retrospect, became more and more idyllic.

John Strevens is best known for his vital portraits and his flower paintings, always striking for their exciting colour and sheer exuberance. His portraits and compositions of figures were truly alive but no more so than the flowers — glorious, riotous displays of colour, perfect flowers but never studiously arranged or scientifically rendered, just flowers loved for their own sake. The influence of the French Impressionists shows in his clever use of light; also, in the joyful colour combinations, is the influence of Spain where he spent some happy times. He was an expert on the Spanish guitar and his contented strumming is almost audible through his paintings. Strevens knew how to appeal to the senses; the fragrance of the massed roses, lilies and other flowers adds to the visual enjoyment. Somehow it seems that the *joie de vivre* and simple Christian faith of the man himself shines through his paintings — especially the flowers.

John Strevens exhibited regularly at the R.A. and R.P.S. as well as other venues in this country and abroad and his work is in collections worldwide, especially the U.S.A. It has been reproduced as greetings cards, fine art prints and calendars and, like all portrait painters, he worked to commission. In the floral field his most spectacular commission was 'The Four Seasons', flowers of the seasons painted in oils on four 7ft. x 7ft. panels plus a central 17ft. panel (1947) for a public hall in Kingston-on-Thames.
lit: Zamparelli

STUART, W.E.D. fl.1846 - 1858 (d.1858)
London artist who exhibited flower and fruit paintings R.A., S.B.A., B.I. Work in a permanent collection in Maidstone.
lit: Brinsley Burbidge, Desmond, Wood

STURROCK, May Newberry 1892 - 1985
Studied at Glasgow School of Art ceramics, embroidery and flower painting. Painted flowers at Walberswick, Suffolk, with her friend Charles Rennie Mackintosh who inspired much of her early work.
lit: Harris and Halsby

SUTHERS, W. fl.1878 - 1887
London artist who exhibited flower paintings R.A., S.S., N.W.C.S.
lit: Brinsley Burbidge

SWALLOW, Jane fl.1860s

London artist who exhibited flower paintings R.A., S.B.A.

lit: Brinsley Burbidge, Desmond

SWAN, Alice, R.W.S. 1864 – 1939

Born Worcester but lived mainly in London. Painted most subjects but some flowers, mainly in watercolour, which were exhibited R.A. and other venues.

lit: Brinsley Burbidge, Desmond, Waters

SWAN, Ann, S.B.A., S.G.F.A. 1949 –

Ann Swan trained in the 1960s at Manchester College of Art and Design. She paints and exhibits flowers in watercolour but her favourite medium has always been pencil with which she is highly skilled. Sometimes her pencil drawings are enhanced with colour using a technique of applying conté pastel or coloured pencils with solvent.

She has exhibited her work worldwide including Kew Gardens in the U.K. and the Hunt Institute. She has received three Gold Medals from the R.H.S. and was awarded a Silver at the 14th World Orchid Conference. She holds many workshops and holidays where she demonstrates her technique including at Chelsea and other R.H.S. shows.

Many of her meticulous plant portraits have been reproduced as limited editions by a specialist fine art printer and Member of the Fine Art Trade Guild.

lit: Sherwood

SWINGER, John Frank
 fl.1880s and 1890s

London painter of flowers and still life. Exhibited R.A., S.B.A. and other venues.

lit: Brinsley Burbidge, Desmond, Wood

SWINTON, Gabrielle Joan 1921 –

Gabrielle Swinton obtained a Teacher Training Certificate from Leicester College in 1952 and taught Arts and Crafts in a Leicester school for five years. She had previously trained and worked as a textile designer and then as a draughtswoman at Standard Telephone and Cables. Always interested in flower painting, she decided in 1988 to take a two year course at Southfields College under Anne-Marie Evans. Since 1992 she has been teaching botanical painting in Leicester as well as pursuing her own flower painting career. Working mainly in watercolour and pencil she has had solo exhibitions in Northampton, Leicester and Vaughan College and in an R.H.S. Exhibition was awarded three Silver Gilt Grenfell Medals. She also holds a Silver Gilt Lindley Medal. She exhibits regularly with the Leicester Society of Artists, the Leicester Society of Botanical Illustrators and has shown at the Schuster Gallery, London, the Old Manor House, Market Overton, and at the Hunt Institute's 7th International Exhibition in 1992. She works to private commission and also provided illustrations for a travelling exhibition entitled *Favoured Sources of Nectar and Pollen for Bees.*

SYKES, Dorcie 1908 –

Born Sheffield but studied art in Cornwall and settled in Newlyn. Painted flowers and figures in watercolour and exhibited R.W.A. and Newlyn Society of Artists.

lit: Waters

SYME, Patrick 1714 – 1845

Painted almost all flowers but some portraits. For some time was drawing master at the Dollar Academy and also taught at Edinburgh School of Art. In 1810 published *Practical Directions for Learning Flower Drawing.* Founder Member of the Royal Scottish Academy, 1826. Contributed some delicate hand-coloured plates to *Curtis's Botanical Magazine* 1821-23. Sixty-seven of his watercolours of flowers, birds and insects are in the National Gallery of Scotland. Exhibited R.A., R.S.A. and the Society of Artists from 1808.

lit: Blunt and Stearn, Brinsley Burbidge, Desmond

SYMONDS, Mrs John Addington
 early 19th century

Sister of Marianne North who made many studies of alpine plants. Work reproduced in Farrer's *Among the Hills,* 1911. Blunt, with characteristic candour, states that, though amateur, her work is more sensitive than that of her sister.

lit: Blunt and Stearn, Brinsley Burbidge

★TAIT, Wendy, S.F.P. 1939 –

Wendy Tait, who was born in Derby, has an almost lifelong interest in drawing and painting flowers, although her early training consisted only of two teenage years at the Joseph Wright School of Art and evening classes. Later, when her children were old enough, she started tuition under Ray Berry and has never looked back. She now demonstrates and teaches for art societies and also takes residential courses for flower painters as well as her own work. She exhibits with the S.F.P. and S.W.A. and widely in Yorkshire and the Midlands. She has also written a book on *Watercolour Flower Painting* for Search Press.

The card company, Robertson Collection, have published about eighty of her designs and she was commissioned by the Government of Jersey to make a series of stamp designs called *Autumn Flowers.*

TALLER, Kate fl.1872 – 1893

London artist who exhibited flower paintings R.A. and N.W.C.S.

lit: Brinsley Burbidge

TANNER, Robin 1904 – 1988

Studied at Goldsmiths' College as etcher, printmaker and educationalist and spent much of his life teaching young children and later became a school inspector. At the same time he produced some excellent etchings and prints and illustration work, much of which centred on floral and woodland subjects. He illustrated *Hedge Flowers,* 1986, and *Woodland Plants,* 1981, the text being by his wife.

TARRANT, Margaret (Lady Mears)
 1888 – 1959

Born Ipswich, daughter of Percy Tarrant, an artist himself who encouraged his daughter at a very early age. Her training continued at Ipswich Art School and Heatherley's after which she became a professional artist and illustrator. Most of her illustrations were for children's books; she is perhaps not strictly a flower painter although flowers appear so frequently in her work that she merits inclusion. The *Flower Fairy* series of books and prints in particular show her talent in this field, even if the flowers appear in slightly romanticised settings, and she also produced a wild flower series of cards and prints for the Medici Society which are quite delightful.

lit: Ipswich Art Society, Medici Society

TAIT, Wendy. *Digitalis.*

TARRAWAY, Mary. Summer time.

TAYLER, Jane. *Pernettya macromata*.

★**TARRAWAY, Mary, BSc., S.B.A., S.F.P.**
1929 -
Mary Tarraway was born and still lives in Dorset. After graduating in Special Botany she was teaching for many years in a number of schools, usually at sixth form level but, on retirement, returned to illustration which she had loved from her schooldays and which combined well with her botanical knowledge and training.

Mary Tarraway has had four very successful solo exhibitions of over sixty paintings at the Dorchester County Museum and has also exhibited at Hillier's Gardens, Romsey, and Highcliffe Castle, Christchurch. She participates regularly in the S.B.A., S.F.P. and R.H.S. exhibitions and in 1991 she won the Osborne and Butler Award at Britain's Painters Exhibition at Westminster Central Hall for the best Flower Painting. She has more recently been learning etching and in 1997 was awarded an R.H.S. Silver Gilt Medal for a collection of eight etchings of flowering plants. She has work in the permanent collection of the Hunt Institute, the Shirley Sherwood Collection and in private collections all over the world.

She produces and distributes herself her own collection of floral greetings cards; I have seen many greetings card designs in my research for this book but hers have almost no equals.
lit: Sherwood

TATE, Barbara, P.S.W.A., R.M.S., F.S.B.A.,
A.S.A.F., F.R.S.A. **20th century**
A London artist, Barbara Tate paints many subjects as well as flowers, most notably portraits, but flowers play a very important part. She is a Founder Member of the S.B.A. She trained at Ealing Art School and studied under several important artists; she was also married to an artist, the late James Tate, A.R.M.S., F.R.S.A.

She has exhibited with the R.A., R.P., R.O.I.,
N.E.A.C., R.B.A., R.M.S., U.A., S.W.A., H.H., R.I., F.P.S., the Paris Salon, Salon Terres Satines, Salon du Comparaisons, Ville Eternal Rome, Nice and Monte Carlo. She has been President of the S.W.A. since 1985.

Awards include 1968 Silver Medal, Paris Salon, 1969 Gold Medal (Hors Concours) Paris Salon, 1971 Prix Marie Pinsoye, Paris Salon, 1972 Special Mention Palme d'Or de Beaux-Arts, Monte Carlo, 1972 Lauréat-Grand Prix de la Côte d'Azur and 1993 Hon. Professorship of the Thames Valley University. Many of her works have been reproduced as fine art prints and greetings cards.

★**TAYLER, Jane** **fl. Colchester 1795-1812**
Largely a botanical artist who contributed to Maund's *Botanist*. She also illustrated children's books together with her sister Anne.
lit: Maund
Colour Plate 27

TAYLER, Norman E., A.R.W.S.
fl.1863 - 1915
Studied at the R.A. Schools and in Rome. Painted flowers, genre and landscape and exhibited R.A., R.B.A., B.I., O.W.C.S. and other venues.
lit: Brinsley Burbidge, Desmond, Wood

TAYLOR, Jane **fl.1870s**
Little known botanical illustrator who specialised in orchids and other exotics. Exhibited S.B.A. and contributed to Maund's *Botanist*.
lit: Kramer

★**TAYLOR, Pamela, S.F.P.** **1944 -**
After many years spent abroad in Europe, the Caribbean and the Far East, on her return to England Pamela Taylor started to paint flowers seriously. Working from the studio at the bottom of her Somerset garden, she is particularly
interested in detailed flower portraits and groups of mixed flowers painted in watercolour on paper or vellum. She exhibits regularly with the S.B.A. and S.F.P. and in local exhibitions in Somerset. She also paints miniatures for the Hilliard Society of Miniaturists of which she is Honorary Secretary. She received a Bronze Medal at the R.H.S. exhibition in 1997 and a Silver in 1996. In 1995 she was awarded a Certificate of Botanical Merit from the S.B.A. chosen that year by Professor Stearn. Her work has been reproduced as greetings cards and she illustrated a chapter on flower shapes in *The Encyclopaedia of Flower Painting Techniques* (Headline/Quarto) as well as contributing pictures to the gallery section.

TAYLOR, Peter Geoffrey **1926 -**
Made 214 illustrations for *The Genus Utricularia*, 1989, in elaborate and meticulous detail noting every minute character of the species. 'The greatest single iconographic achievement by a modern Kew botanist' (Stearn).
lit: Stearn

TAYLOR, Simon **1742 - 1798**
Botanical artist who trained at William Shipley's School, London. He did some of the first paintings that were exclusively for Kew Gardens, also made drawings of plants for Lord Bute and the botanist John Fothergill which were subsequently sold to the Empress of Russia. His work, which was patently influenced by Ehret, is represented in the Kew collection and the British Museum.
lit: Blunt and Stearn, Brinsley Burbidge, Desmond, Mabey

TAYLOR, Walter **1875 -**
London flower painter. Studied under Walter Crane and at the R.C.A. under Sparkes 1898-9 where he was awarded Silver and Bronze Medals

TAYLOR, Pamela. June Roses.

for Flower Painting. He became art master at Beaufoy Technical Institute in 1910 and at the Central School of Arts and Crafts 1919-20. He designed four tapestries for William Morris, painted flowers in oil and watercolour and exhibited R.A., R.B.A. and other venues.
lit: Brinsley Burbidge, Desmond, Waters

TCHEREPNINE, Jessica, S.B.A. 1938 -
Born in Sussex, Jessica Tcherepnine trained in Florence under Signora Simi and now divides her time between the U.K. and North America. She has painted flowers since childhood and had an impressive career in botanical painting. She is Member of the S.B.A., the Horticultural Society of New York and is a Director of the American Society of Botanical Artists.

She has had solo exhibitions in London at Clarges Gallery, Hobhouse Gallery and Christopher Wood Contemporary Art, in New York at Shepherd Gallery (three times) and the New York Horticultural Society, in Palm Beach at Anne Norton Sculpture Gardens and in Paris at Galerie Jean-François et Philippe Heim. She has participated in mixed exhibitions at the S.B.A., R.H.S.,the Hunt Institute, Kew Gardens Gallery, the Smithsonian Institution and the Fort Lauderdale Museum. She has been awarded two R.H.S. Gold Medals and won first place at the Greater New York Orchid Show in 1988. Her work is in the R.H.S. collection, the British Museum, the Hunt Institute, the Shirley Sherwood Collection and other private collections in the U.K., U.S.A., Europe and the Middle East.
lit:Sherwood

TERRELL, Georgina fl.1876 - 1903
London painter mainly of flowers but also still life, genre and some portraits Exhibited R.A., N.W.C.S., S.B.A. and other venues.
lit: Desmond, Waters

**THEWSEY, Joan, D.F.A.(Lond.), S.B.A.
1931 -**
Joan Thewsey was born in Yorkshire and trained for two years at Barnsley College of Art followed by three years at the Slade where she received a Summer Exhibition Prize, a Goldsmiths' Company Travel Award to study in Florence and a degree in Fine Art.

She specialises in larger than average watercolours, many of which have been published. She exhibits with the major National Exhibitions, with the S.B.A., the Heifer Gallery, Highbury, where she has had several one-man shows, and other galleries in London, Essex and Suffolk. Reviewing one of her Suffolk exhibitions, Colin Moss wrote 'Joan Thewsey is a watercolourist of great manual skill, although this talent does not overshadow the freshness of her vision, as is shown in Blackberry and Apple, which is primarily a brilliant direct flower painting. Another, less complex flower study, Irises, has soft yet strong colour, and vigorously captures the thrusting growth of the plant'.

Joan Thewsey paints from live flowers and sometimes has to wait for a particular type of flower to come round again another year before she can complete a painting. She employs a most unusual technique best described by herself – 'I use a vast array of shades of paint all laid out in a sequence, a tray of some twelve different pinks, a tray of twelve different yellows and so on, some light, some deep and intense, some cold and some warm and vibrant, all accompanied by painted charts depicting their capabilities of tint, tone and depth. I use layer upon layer of pure unmixed colour wherever I possibly can to try to build up a dazzle of colour befitting those of the flower'. In some cases it takes her weeks and months to build up the layers of intensity to anything like completion – hence the year round wait.

Joan Thewsey is on the commissions register of the Federation of British Artists and, as a Member of the S.B.A., has twice been elected to the governing Council. For many years she was a visiting tutor at the V. and A. and the Sir John Cass School of Art. The Womens' Art Library, Fulham Palace, and the Bridgeman Art Library hold slides and transparencies of her work. Some 300 of her paintings of gardens, flowers in landscape and flowers with decorative china and fabrics are in public and private collections.

**THISELTON-DYER, Lady Harriet Anne
1854 - 1945**
Lady Thiselton-Dyer, who married Sir William Thiselton-Dyer, Professor of Natural History Royal Agricultural Society and Professor of Botany at the Royal College of Science, later Director of Kew 1895-1905, was the daughter of Sir Joseph Hooker. She was taught botanical drawing by W.H. Fitch, contributed eighty-four plates to *Curtis's Botanical Magazine* and others to Balfour's *Botany of Socotra,* 1888. Some of her drawings are in the Kew collection.
lit: Blunt and Stearn, de Bray Brinsley Burbidge, Desmond, Kramer

THOMAS, Graham Stuart, O.B.E., F.R.H.S. 1909 - 2003
The name of Graham Stuart Thomas is synonymous with anything to do with gardens and flowers — garden design, gardening, plant breeding, garden writing and lecturing and flower painting. For thirty years he was Gardens Adviser to the National Trust during which time he supervised the restoration and reconstruction of many beautiful but neglected gardens. He was a Fellow of the R.H.S., Vice-President of the Garden History Society and a respected Member of most other Societies with a garden connection.

He wrote about twenty books, the best known being those on old shrub roses and *The Complete Flower Paintings and Drawings of Graham Stuart Thomas,* contributed to many others and illustrated several for other garden writers. All these, too many to enumerate here, are listed in the appendix to *The Complete Flower Paintings.*

Both his parents were artists and nature lovers so he received every encouragement in his work from an early age. In his watercolour flower paintings he achieved an interesting and quite individual balance between the botanical and decorative. They could be nothing but botanically accurate and well observed but he refrained from excessive detail, giving them a more spontaneous appeal and a natural freedom. Although excellent, it would be wrong to say they are matchless in quality; I can, however, use the term to describe his pencil drawings which are superb. Although the medium itself is necessarily limited and there is no colour to help with tonal values, these are truly three-dimensional and absolutely alive. I can think of no other flower artist with comparable skill with the pencil.

Graham Stuart Thomas held the Victoria Medal of Honour and the Veitch Memorial Medal (R.H.S.) and the Dean Hole Medal of the Royal National Rose Society.

THOMPSON, Hilli, S.B.A. 20th century
Hilli Thompson, now living in Ipswich, comes from a long line of market gardeners and plant people and a flower painting father. She trained as an anthropologist at the University of Newcastle, 1964-67, and the New University of Ulster, 1968-71, then as a teacher of children and adults with learning difficulties at Leeds University 1976-77. Always interested in plants and flowers, she began seriously to take up botanical illustration and from 1985-96 worked as a botanical illustrator on *The New Flora of the British Isles.* In 1990-91 her drawings were shown at the Linnean Society.

Hilli Thompson works in watercolour and pastel and as a printmaker and etcher. She was elected a Member of the S.B.A. in 1987 and awarded their Certificate of Merit.

She has exhibited with the S.B.A., the Linnean Society, Gainsborough's House, Sudbury, John Russell Gallery, Ipswich, Monet's Gallery, Westleton, Yoxford Gallery, Suffolk Wildlife Trust, Aldeburgh Festival Gallery and Tudor House, Snape Maltings, Taplin Galley, Woodbridge and Angel Gallery Lavenham. She has had solo exhibitions at Belstead House, M.F. Frames and Ancient House, Ipswich, Lowestoft Art Centre and Westcliff Theatre, Clacton-on-Sea.

Her reproduced work includes, as well as *The New Flora* and its later extended edition, illustrations for the *B.S.B.I. Handbook of Crucifors.* She is also a creative embroideress.

THORBURN, Archibald 1860 - 1935
Although best known for his magnificent bird paintings, he illustrated many natural history books which included flowers. Exhibited R.A. and S.S. and is represented in the Harris Art Gallery, Preston.
lit: Brinsley Burbidge, Waters, Wood

**THORNEYCROFT, Helen, S.L.A.
1844 - 1912**
London artist who painted flowers and scriptural subjects. Exhibited R.A., N.G., S.B .A., N.W.C.S. and other venues.
lit: Brinsley Burbidge, Desmond, Wood

THORNTON, Robert J. 1768 - 1837
Best known for his flamboyant production, *The Temple of Flora,* although only only one plate is his own work. The flowery prose suggests that painting with words was, for him, more successful. (See page 28.)
lit: Blunt and Stearn, Brinsley Burbidge, de Bray, Coats, Fulton and Smith, Mabey, Rix, Sitwell

TRUELOVE, Jacky. Cyclamen.

THORPE, John Hall, R.B.A. **1874 -**
London artist who studied at Heatherley's and St Martin's. Painted flowers and provided illustrations for many magazines and periodicals, often using a black background. Exhibited R.A., R.B.A. and overseas.
lit: Brinsley Burbidge, Hardie, Waters

THURNALL, Harry J. **fl.1875 - 1893**
Artist of Royston, Herts, who painted flowers and game and exhibited R.A., S.B.A., N.W.C.S.
lit: Brinsley Burbidge, Desmond

THURSTAN, Meriel, S.F.P. **1940 -**
Meriel Thurstan was educated at Sherborne School for Girls, Dorset, then spent twenty years raising a family, farming and working as secretary and P.A., drawing and painting being a spare time pleasure only. After a move to Cornwall she started work at the Lost Gardens of Heligan which led to her interest in botanical painting which she went on to study at Kew under Ann Farrer. In 1999 she was accepted as a full Member of the S.F.P. with whom she exhibits as well as at other venues. She also carries out commissions for flower paintings.

TITCOMB, William Holt Yates, R.W.A.
 1858 - 1930
Cambridge artist who studied at South Kensington School of Art, R.C.A., in Antwerp and Paris. Painted flowers, genre and some domestic subjects and exhibited R.A., S.B.A. and in Paris, Chicago and other venues. He lived latterly in St Ives and the South of France. His work is in several public collections.
lit: Brinsley Burbidge, Desmond, Wood

TODD, Edith Jane **1884 - 1973**
Lived in Bury St Edmunds, Suffolk, and painted mainly flowers, some landscapes in oils. Exhibited R.W.S., Paris Salon, in the provinces especially East Anglia, and the U.S.A. Many of her flower paintings were reproduced as fine art prints.
lit: Waters

TODD, John George **fl.1861 - 1892**
Exhibited ten flower paintings R.A. but nothing else seems to be known of him.
lit: Brinsley Burbidge

TOMSON, Arthur **1858 - 1905**
Sussex artist who studied art in Düsseldorf and painted flowers, animals and landscape. Exhibited R.A., N.E.A.C., S.S., G.G., N.G. In 1903 wrote a book on Millet and the Barbizon School. Work is represented in the V. and A.
lit: Brinsley Burbidge, Desmond, Waters, Wood

TOULMIN-SMITH, Miss E. fl.1868 - 1872
Teacher of design and painter of flowers which she exhibited S.S. and other venues.
lit: Brinsley Burbidge

TRIER, Adeline **fl.1879 - 1883**
Camberwell artist who exhibited flower paintings R.A., S.B.A.
lit: Brinsley Burbidge, Desmond

TRINDER, Wendy, BSc., F.S.B.A., S.W.A.
 20th century
Wendy Trinder graduated from Hull University with an honours degree in botany and a post-graduate certificate in education. She taught sciences up to A level 1965-78 and art at Scaitcliffe preparatory school, Surrey, until 1984. Always keen on painting and botanical illustration she then started to take it completely seriously and has since exhibited R.W.S., R.I., N.E.A.C., Pastel Society, S.B.A. (elected Founder Member 1985), S.W.A. (elected Member 1988), R.E. (she started relief and intaglio printing in 1985), Adam Gallery, Coggeshall, Essex, Llewellyn Alexander, London, Wykeham Gallery, Stockbridge, Lannards Gallery, Billingshurst, Old Town Hall Arts Centre, Staines, Studio Gallery, Elton, Peterborough. She has illustrated several books, designs for cards, notelets and gift wrap for Harrods and Lings Cards and has published several limited edition prints.

★TRUELOVE, Jacky, F.S.B.A.
 20th century
Jacky Truelove is a self-taught artist who has been painting flowers in watercolour for many years. She was 'discovered' by a local gallery in 1976 who took her work and sold it so readily that she gave up her job to concentrate on her flower painting. She works in watercolour on various papers, vellum and ivorine.
 She has had seven one-man shows in the past but, in view of the amount of work involved, she has

participated in mixed and society exhibitions since 1988. As an invited Founder Member she exhibits regularly with the S.B.A. in London and with the Society of Limners (miniature painters) all over the country. She paints specifically for the Francis Iles Gallery, Rochester, Wolf House Gallery, Silverdale, Lancashire, and Greystoke Ghyll, Penrith. She has also exhibited with the North Wales Society of Botanical and Fine Art Watercolourists, the Medici Gallery (miniatures), the Lake Artists Society, Grasmere, the Sevenoaks Wildfowl Trust Flora Exhibition and Ambleside and District Art Society.
 Her work has been reproduced as greetings cards and calendars for the Medici Society, Royles, Collisons, Lings and Camden Graphics. She has had work in the Medici Flower Calendar every year for twelve years.

TWAMLEY, Louisa Anne Meredith
 1818 - 1895
Born in Birmingham but emigrated to Australia in 1838. Wrote about and illustrated plants simply under Louisa Anne Meredith; also wrote poetry with etchings of flowers to illustrate. Books included *Poems* 1835, *Romance of Nature or The Flower Seasons Illustrated, Flora's Gems, Our Wild Flowers* and later, in Australia, *An Australian Ramble in the Rye*.
lit: Kramer

TWEEDIE, Mrs E.M. **1900 - 1982**
Amateur botanist who became a competent botanical artist. Lived in Kenya for many years and presented her collection of the local plants to Kew in 1982. Published *Paintings of Wild Flowers of East Africa* in five volumes in the 1930s.
lit: Mabey, Waters

TWINING, Elizabeth **1805 - 1889**
One of the famous tea family but was always keen on drawing as a child and copying pictures. She later discovered *Curtis's Botanical Magazine* and from copying the illustrations started her own drawings of flowers and plants, becoming a very competent botanical painter. She produced *Illustrations of the Natural Order of Plants* (subjects from Kew and Lexden) in two volumes 1849-55. Some drawings are now in the British Museum. (See page 52.)
lit: Blunt and Stearn, Kramer
Colour Plate 15

TYLER, C.L. **fl.1827 - 1832**
Born Stratford and exhibited flower paintings R.A. and S.B.A.
lit: Brinsley Burbidge, Desmond

TYRWHITT, Ursula, N.E.A.C. 1878 - 1966
Born Essex, studied at the Slade and the Atelier Colarossi in France, also the British Academy in Rome. Lived and worked mainly in Oxford. Apart from the N.E.A.C. she did not exhibit a great deal but her work is in the Tate and other public collections.
lit: Brinsley Burbidge, Waters

UNITE, Daphne (née Munro) 1907 –
Painted flowers and landscape in oil and watercolour, Born and lived in London and studied at St John's Wood Art School. Exhibited R.B.A., N.E.A.C., S.W.A., W.I.A.C. and Paris Salon.
lit: Waters

UVEDALE, S. fl.1840s
London artist who exhibited flower paintings and still life S.B.A. and B.I.
lit: Brinsley Burbidge, Desmond

VARLEY, Lucy fl.1870s
Exhibited flower paintings R.A., S.B.A.
lit: Brinsley Burbidge, Desmond

*VODDEN, Celia, S.F.P. 1943 –
Celia Vodden trained at Swansea College of Art specialising in the design and making of stained glass. She then went to Bournemouth College of Art to study for a teaching Diploma. Always a lover of flowers and plants, Celia Vodden, who works in watercolour and pastel, never travels without pad and paints to record the local flora. Her main artistic activity is painting flowers on pongé silk using special dyes and the appropriate, quite complicated, procedure to produce some stunning results. She exhibits regularly with the S.F.P. and galleries in Swansea and Norfolk and 1999 saw her tenth solo exhibition.

She has relocated her studio/gallery to Wales to show her work and run courses in silk painting.

*WAIN, Rosaleen, N.D.D., A.T.D., S.B.A., G.M. 20th century
Rosaleen Wain, like so many of the very best artists, is unduly modest about her beautiful work which represents a perfect blend of the botanical and decorative. She studied at Liverpool College of Art, is a Member of the S.B.A. and an R.H.S. Gold Medallist. She is also a member of the Dartington Print Workshop.

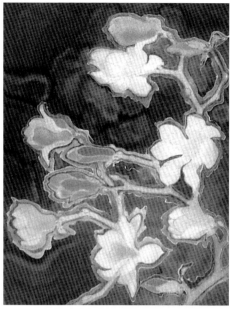

VODDEN, Celia. Springtime.

VODDEN, Celia. Tropical white waterlily.

She exhibits regularly with the S.B.A. and R.H.S., also at the National Trust Exhibitions, the Devon Guild of Craftsmen's Printmakers' Flora, Ship Aground Gallery, Exeter, East Street Gallery, Ashburton, Stephanie Hoppen, London, Thackeray Gallery, London, and the V. and A. Museum's Artists' Book Collection. She had a one-man exhibition to commemorate the Quarter-Centenary of poet Robert Herrick, Devon. Her work is in private collections in the British Isles, Canada, Australia, Belgium and Germany and has been reproduced as greetings cards and prints.
Colour Plate 98

WAINWRIGHT, John fl.1859 – 1869
Painted flowers in the style of the Dutch masters and exhibited R.A., B.I., and S.S..
lit: Brinsley Burbidge, Mitchell

WALES, Patricia, S.W.A., S.F.P. 20th century
Patricia Wales was born in Canada of British parents, came to England at the age of two and now lives in the New Forest where, as a flower painter, she finds plenty of subject matter. She works in watercolour in a rather romantic style, although her flowers are real and accurate – the backgrounds and settings give them their attractive, rather fairy-tale, quality. For many years she was retained as a colourist by a well-known antiquarian bookseller but she now works full time on her flower painting at home. She exhibits regularly with the S.W.A. and S.F.P., of which societies she is a Member. She exhibits also in many London and local galleries and in

France and Sweden and her work is in many collections. It has also been reproduced as greetings cards.

WALFORD, James F. 20th century
Illustrated a book of orchard paintings which was published by the Medici Society in 1972.
lit: Brinsley Burbidge

WAIN, Rosaleen. Marigolds.

WARD, Vernon. Summer rhapsody.

WARD, Vernon. Symphony in blue and white.

WALKER, Edmund **fl.1836 - 1849**
Known to have exhibited nine flower paintings
R.A.
lit: Brinsley Burbidge, Desmond

WALKER, Elizabeth **fl.1877 - 1882**
Exhibited a few flower paintings R.A.
lit: Brinsley Burbidge

**WALKER, Dame Ethel, D.B.E., A.R.A.,
R.B.A., R.P., N.E.A.C., S.M.P. 1861 - 1951**
Born Edinburgh but later lived and worked in
Yorkshire. Studied at Ridley School of Art, Putney
School of Art, Westminster School of Art and the
Slade. Among a variety of subjects she painted
some significant flower studies and exhibited
R.A., N.E.A.C., R.B.A., R.P. and other venues,
often in Edinburgh. She has also had a one-man
show at the Redfern Gallery in London.

WALKER, William **fl.1860s - 1850s**
London artist who painted flowers and portraits;
exhibited R.A., S.B.A.
lit: Brinsley Burbidge, Desmond

WALKER, Winifred **fl.1920 - 1960**
Well-known botanical artist who was an official
R.H.S. artist from 1929-1939 drawing plants for
records. In 1943 she became artist in residence
at the University of California. She is perhaps
best known generally for her superbly illustrated
book *All the Plants of the Bible* published in
1957. She is a Fellow of the Linnean Society.
(See pages 13-14.)
lit: Blunt and Stearn, Walker, Waters

WALL, Cynthia, R.S.W. **1927 -**
Glasgow artist who painted flowers and
landscape, worked in France a great deal.
lit: Harris and Halsby

WALLER, Richard **c.1650 - 1715**
Started life as a City merchant but was a keen
student of botany, natural history and zoology. He
was an extremely talented though amateur flower
painter concentrating on wild flowers, often
those classified as weeds, delicately executed in
watercolour. It is thought that he may have
intended producing a book on the subject. A
folio of about forty of these little studies is in the
library of the Royal Society of which he became
Secretary in 1687. (See page 22.)
lit: Blunt and Stearn, Brinsley Burbidge

WALLIS, Rosa **1857 - 1931**
Born Stretton, studied at the Royal Cambrian
Academy, Manchester, and in Berlin. Painted
flowers and some landscape and exhibited R.A.,
N.W.C.S., R.I., S.S., Rembrandt Galleries and
Walker Art Gallery, Liverpool. Work is
represented in the V. and A.
lit: Brinsley Burbidge, Desmond, Waters

WALTER, Emma **fl.1885 - 1891**
London painter of flowers and fruit and Member
of the Society of Female Artists. Exhibited R.A.,
S.S., N.W.C.S. and other venues.
lit: Brinsley Burbidge

WARD, Amy Margaret **1863 -**
Studied at Lincoln School of Art and under
Frank Calderon, painted flowers and animals in
oils and exhibited R.I., R.O.I., S.W.A.
lit: Waters

**WARD, John Stanton, R.W.S., R.P.,
N.E.A.C., A.R.C.A.** **1917 -**
Eminent London artist who includes flowers in a
very large repertoire as well as some very well-
known portraits. Studied in Hereford and at the
R.C.A. where he was awarded a travelling

scholarship in 1947. Cousin of the late Vernon
Ward and wrote the foreword to my biography of
V.W. Exhibited R.A., N.E.A.C., R.W.S., R.P.,
Trafford Gallery, Richard Jefferies Gallery and
other venues. Well into his eighties he was still
carrying out some important commissions.
lit: Brinsley Burbidge, Walpole, Waters

***WARD, Vernon Beauvoir** **1905 - 1985**
Vernon Ward, the son of an antique dealer,
restorer and picture framer, was encouraged in his
artistic aspirations and accepted for the Slade at
age fourteen under Tonks, Russell and Wilson
Steer. The early death of his father meant that he
had to support himself and his mother and take
on the sort of commercial 'popular' work that
was hardly his choice — advertising, book
jackets, brochures, chocolate boxes and the like.
Sadly his reputation suffered from the inferior
reproduction of the time and many galleries were
not interested in showing his work. However, his
commercial connections gave him an
introduction to publishers of fine art prints and
greetings cards and the high quality colour
printing which was being introduced did much
to enhance his reputation and gain him good
commissions and the chance to exhibit more
widely. Although of necessity he painted many
subjects, flowers constituted the cream of his
work, many excellent examples only coming to
light after his death. (See page 87.)
lit: Brinsley Burbidge, Walpole, Waters
Colour Plate 49

WARING, John Burley **1823 - 1875**
Studied R.A. Schools and in Italy and became
apprenticed to an architect in 1840. He wrote a
number of books on art and architecture, also
painted flowers and landscape. Exhibited R.A.
and work is represented in the V. and A.
lit: Brinsley Burbidge, Desmond, Graves

WARNER, Sybil, S.F.P. **1943 -**
Sybil Warner is a retired head teacher with a
long-term interest in botany, plants and gardens
and an enjoyment of painting flowers in
watercolour. Since retirement she has given
much of her time to flower painting and
exhibiting including with the S.F.P. of which she
is now a full Member.

WASSE, Arthur **fl.1879 - 1895**
Manchester artist who exhibited flower paintings
R.A. and S.B.A.
lit: Brinsley Burbidge, Desmond

WATERHOUSE, J. Esther
 fl.1880s and 1890s
Wife of John William Waterhouse, R.A. Painted
flowers and exhibited R.A., N.W.C.S., S.S. and
other venues.
lit: Brinsley Burbidge, Desmond

**WATERLOW, Sir Ernest Albert, R.A.,
P.R.W.S.** **1850 - 1919**
London artist who, although mainly a landscape
painter, painted some significant flower studies.
Studied R.A. Schools and in Lausanne and
Heidelberg and was awarded the Turner Gold

WATERMAN, Catherine. Anemones.

WATTS, Brenda. Geranium.

WEBB, Kenneth. Summer haze.

Medal in 1873. Exhibited R.A., G.G., O.W.C.S., S.B.A., N.G. and other venues and his work is in several public collections.
lit: Brinsley Burbidge, Waters, Wood

★WATERMAN, Catherine, M.A., V.P.S.B.A.
1939 -
Catherine Waterman was born in Scotland and educated at Lanark Grammar School and Glasgow University. She had always painted as a hobby while following a career (in London) in banking and investment, finding subjects in her own garden – another hobby. She now exhibits regularly with the S.B.A. of which she has been a Member since 1988, has had two solo exhibitions in Leatherhead and participated in others. Although she does paint landscapes, flowers are her main interest and her watercolours are in collections in the U.K., Auckland, Melbourne, California and New York. Her work has been reproduced as prints and greetings cards.

WATSON, Lesley　　　　　**1952 -**
Lesley Watson has always enjoyed painting for pleasure and in 1997 decided to give up a business career in order to paint full time. In January 2000 she graduated with a Diploma in Botanic Art after a course at the Chelsea Physic Garden led by Anne-Marie Evans. She has exhibited with the Society of Botanic Artists and the Society of Women Artists. In addition to her botanic work, she particularly enjoys life painting in oils.

WATSON, Patricia (Mrs James Rennie)
1931 -
London artist, also independent botanist at Kew from 1956-81. Botanical work is illustrated in Wood's *Pipterocarpus Bor-surat Grasses*. Exhibited flower paintings R.A. and R.W.S. and her work is represented in the Hunt Institute.
lit: Brinsley Burbidge

★WATTS, Brenda, S.B.A.　　**20th century**
Brenda Watts started her artistic career as a lettering artist/designer then lived in Africa for ten years where she married and had two children. On her return to England she took a teacher training course and taught for the next twenty years, then returned to her real love – painting flowers. She now exhibits with the S.B.A. and has been made a Member; also works to private commissions.

★WEBB, Kenneth, F.R.S.A., R.W.A., A.R.U.A.　　**1927 -**
Kenneth Webb was born in London, educated at Bristol and Lydney Grammar Schools, attended Lydney College of Art and was awarded a Slade Scholarship. After service in the Fleet Air Arm from 1945-48 he started exhibiting seriously and his work was accepted by the R.A., R.I., R.O.I., R.B.A. and other important bodies. He graduated from the University of Wales with distinction in 1953 and was appointed Head of the Painting School at Ulster College of Art where he stayed until he had founded his own Irish School of Landscape Painting which continues to grow and flourish. In 1963 he opened a Studio and Gallery in Ballywalter, all the time exhibiting his own work and executing important commissions not only in the U.K. but in Spain, Gibraltar, North and East Africa, Tanzania, Kenya, the Canary Islands and the U.S.A. He paints all subjects with comparable skill but flowers play a very prominent part and he is particularly known for his vibrant paintings of poppies and the gentler renderings of flowers of the Irish bog and meadow. He has contributed to numerous exhibitions in Ireland, the U.K. and U.S.A. and had over fifty solo exhibitions mainly in Belfast, Dublin, Galway and the U.S.A., also occasionally in London and Woodbridge. (See pages 87-93.)
lit: Kenny, Walpole, Wykes-Joyce
Colour Plate 50

WEBBER, John　　　　**1752 - 1798**
Another artist cum botanist who joined Cook's third voyage. In his illustrative work he had a keen eye for detail and every botanical nuance was closely observed and faithfully recorded. He also did some much freer work but even in a broad brush style he managed to feature the structure of his plants and his understanding of their make-up gave them their individual character. The voyage in *Resolution* was meticulously documented through his illustrations of plants and appeared in the official account of the voyage which was published in 1784.
lit: Fulton and Smith

WEBSTER, Ann　　　　　**1930 -**
Studied at Guildford School of Art 1948-9 and became a freelance botanical artist. She has contributed to Curtis' *Icones Plantarum* and the *Botanical Magazine* (103 plates), *Flora of East Africa* and the Kew Handbooks – *British Trees and Shrubs*, 1958, *British Wild Flowers*, 1958, *British Ferns and Mosses*, 1960, and *Garden Shrubs and Trees*, 1960
lit: Brinsley Burbidge, Lewis, Mabey, Stearn

WEBSTER, Moses　　　**1792 - 1870**
Born Derby and painted flowers on porcelain for the Derby factory, also Worcester and Robins of London. He gave up porcelain painting to teach flower painting. He exhibited O.W.C.S. and was a Member of the Spring Gardens Association of Watercolour Painters. Work is represented in the V. and A.
lit: Brinsley Burbidge, Desmond

WELBY, Rose Ellen　　　**fl.1879 - 1897**
London painter of flowers and genre who exhibited R.A., S.B.A., N.W.C.S., G.G., N.G. and other venues.
lit: Brinsley Burbidge, Desmond, Waters, Wood

WELCH, Alice. Silken flowers.

WHITAKER, Gillean. Rhododendron.

WHITAKER, Gillean. Yellow roses.

★WELCH, Alice M., S.F.P. 1919 –
Alice Welch always wanted to go to art school but, on leaving school in 1934, had to take care of her invalid stepmother. At the same time she went to evening classes in art, hoping to make constructive use of her talents. She took up a career in nursing following general nursing during the Battle of Britain in the 1940s and forty years later retired as a Queen's Nursing Sister. Her interest in painting, notably flower painting, was still alive and for three years she attended day courses at Wensum Lodge, Norwich, and three years at Beccles under Frank Forward. She paints in oil and watercolour but her most striking work is her painting on silk in which she has found her real métier. Her main interest is in the more showy, exotic, blooms, the Chinese tree Paeonies, hibiscus and lovely full blown roses. Whatever the medium, all her paintings glow.

She participates in a number of exhibitions including the S.F.P. and Snape Maltings and has had one-man shows in Norwich, Lowestoft (her home town), Southwold and Walberswick. She also gives demonstrations for charity and has conducted classes for the disabled.

WEST, Keith. Lily (New Zealand).

★WEST, Keith 1933 –
Keith West, who was born in Buckinghamshire, emigrated to New Zealand in 1950, married in 1956, and became Botanical Artist for Botany Division, NZ Department of Scientific and Industrial Research from 1959-1979. During this time he illustrated numerous scientific papers and monographs and lectured on art for the Department of Extension Studies, University of Canterbury, Christchurch, N.Z. In 1980 he returned to Britain to work freelance, also making several visits to the U.S.A. to work on paintings commissioned by the Missouri Botanic Garden, St Louis, and the British Natural History Museum. He continues to illustrate countless books and periodicals on botanic, scientific and natural history subjects and has written a number of books himself including *How to Draw Plants, Painting Plant Portraits* and *How to Draw and Paint Wild Flowers*. His botanical paintings are in collections around the world.

WEST, Maud Astley fl.1880s and 1890s
Studied at Bloomsbury College of Art, painted flowers and exhibited N.W.C.S. and other venues.
lit: Brinsley Burbidge, Desmond

WESTCOTT, Jane, S.F.P., S.B.A. 1950 –
Jane Westcott took a Foundation Course at the West of England College of Art 1968-69 and graduated from Leeds College of Art in 1972. She worked as a freelance illustrator for an advertising agency, then spent four years employed as a graphic designer by Leeds City Council and West Yorkshire Metropolitan County Council before returning to freelance work with a special interest in botanical illustration and flower painting. She has since been made a Member of both the S.B.A. and S.F.P. and exhibits with them regularly as well as other venues and working to private commissions.

WHICKER, Gwendoline (née Cross) fl.1940 – 1965
Bristol flower painter in oil and watercolour, also etcher and illustrator. Studied at Bristol College of Art and exhibited R.A., R.O.I., R.B.A., R.W.A., S.W.A. and abroad. Later lived in Cornwall.
lit: Waters

WHIPPLE, Agnes fl.1881 – 1888
London artist who exhibited flower paintings R.A., S.B.A.
lit: Brinsley Burbidge, Desmond

★WHITAKER, Gillean, S.W.A., S.F.P. 1932 –
Gillean Whitaker attended Cheltenham College of Art 1949-1953; still living there, she is a Member of the Cheltenham Group of Artists (secretary since 1991) and a Member of the Fosseway Group of Artists. She is also a Member of the S.W.A. and S.F.P. with whom she regularly exhibits her flower paintings. She has also exhibited at the R.A., R.W.S., R.W.A., S.B.A., the Royal Birmingham Society of Artists, the R.H.S. (Gold Medal 1983, Silver Gilt 1984), the Tryon Gallery, Mall Galleries, Windsor Fine Art and many provincial galleries. She has had several one-man shows in Falmouth and the Cotswolds and one at the Sladmore Gallery, Berkeley Square, London. Her work is in collections throughout the world including Australia, Canada, the U.S.A., Switzerland, the Netherlands, France, Denmark and Sweden. Her work has been reproduced as greetings cards and calendars by Royles, Paper House and other major card companies.

Although for many years her work was confined to flora and fauna she has more recently added still life, portraiture and other subjects to her repertoire. She works in watercolour and acrylic.
Colour Plate 99

WHITE, Florence fl.1881 – 1917
Member of the S.L.A. who painted flowers, portraits and domestic subjects. Exhibited R.A., S.B.A., G.G. and other venues.
lit: Brinsley Burbidge

WHITE, John fl.1540 – 1594
Early botanical painter who went on Raleigh's expedition to colonise Virginia to make drawings of the indigenous plants. Drawings are now in the British Museum. (See page 22.)
lit: Blunt and Stearn, Brinsley Burbidge, Fulton and Smith, Rix

WILCOCK, Doreen. Oriental poppies.

WHITEHEAD, Elizabeth fl.1870s - 1930s
Artist from Leamington Spa who painted flowers and landscape and exhibited R.A., S.B.A. and other venues.
lit: Brinsley Burbidge, Waters

WHITLEY, Gladys Ethel, R.M.S.
 fl.1884 - 1892 (d.1920)
Lived in London, then Cornwall. Studied at Heatherley's and Cope's School and painted flowers and miniatures, some portrait miniatures. Exhibited R.A., R.I., S.W.A., R.M.S. and Paris Salon.
lit: Brinsley Burbidge, Waters

WHITLEY, Kate Mary, R.I
 fl.1884 - 1893 (d.1935)
London artist educated in Manchester, painted flowers and still life. Exhibited R.A., R.I., N.W.C.S. and in Dresden, Chicago and Brussels.
lit: Wood

WHITTLE, Janet, S.W.A., S.B.A, S.F.P.
 20th century
Janet Whittle is a professional artist specialising in flowers and some landscape. She is also a qualified and experienced teacher of watercolour painting and drawing and runs classes in her home town of Grantham.
 She exhibits regularly with the S.W.A., S.B.A. and the S.F.P. and at many galleries in London and the provinces. Many of her paintings are reproduced as greetings cards throughout the British Isles, U.S.A. and Europe; de Montfort Fine Art have published four floral limited editions and Solomon and Whitehead have published two fine art prints.

★WILCOCK, Doreen, S.B.A., S.F.P. 1922 -
Born in Walthamstow, Doreen Wilcock has lived in Teddington and Hampton for the past fifty years. Initially she worked as a clerical civil servant then, during the war, in laboratories attached to the Royal Ordnance factories and Woolwich Arsenal.
 In her forties she joined an evening class in painting and soon became completely hooked. She went on to take the equivalent of A level Art at New Maldon Education Centre and was awarded a Diploma. Since then she has gone from strength to strength, working in oils, acrylics and pastels. Her favourite subjects are flowers and gardens and many of these have been

reproduced by the Medici Society.
 She has been made a Member of the S.B.A. and S.F.P. and exhibits regularly with both societies including with the S.F.P. in Sofiero Castle, Sweden, in 1998. She holds occasional teaching workshops and demonstrates to local art groups.

WILD, Rosina Beatrice 1898 -
Studied at Gateshead School of Art and painted flowers and portraits. Exhibited at many venues in N.E. England.
lit: Waters

WILKINSON, Lady Caroline Catherine (née Lucas) 1822 - 1881
Wife of a distinguished Egyptologist who helped him with editing and illustrating his books. Best known for her paintings of fungi; in 1889 her own *Weeds and Wild Flowers* was published.
lit: Kramer

WILKINSON, Ellen fl.1853 - 1878
Lived in London, later Chelmsford. Painted flowers and genre and exhibited R.A., S.B.A. and other venues.
lit: Brinsley Burbidge, Desmond, Wood

WILKINSON, Evelyn Harriet (née Mackenzie) 1893 - 1965
Flower painter who was born in China but studied at Edinburgh School of Art and married the artist Norman Wilkinson. Later lived in London and exhibited R.A., R.I., R.O.I. and other venues.
lit: Waters

★WILKINSON, John, F.S.B.A. 1934 -
John Wilkinson trained initially as a printer working on colour analysis and worked in printing for over twenty years, all the time painting in his spare time until, eventually, he gave up printing to become a full-time freelance botanical artist. Although flowers remain his first love (he holds two R.H.S. Gold Medals and was invited to become Founder Vice-President of the S.B.A. in 1986), he has introduced other subjects and works in watercolour, oil, acrylic, egg tempera and pastel.
 He exhibits with the R.H.S. and S.B.A. as well as other galleries in London, the U.S.A. and locally. He has illustrated a number of books, including those by Stefan Buczacki; as well as books on the countryside including flowers butterflies and moths; trees and mushrooms are regular subjects. Many of his paintings have been

WILKINSON, John.
Strelitzia nicolae.

227

WILLIAMS, Albert.
Bouquet of spring
flowers.

reproduced as greetings cards, calendars, postcards and sets of prints on water creatures, animals, flowers and still life, and flowers and roses as well as twelve limited edition prints. In 1987 he designed the Chelsea Flower Show Plate and he has designed twelve plates and four vases for Franklin Mint. For fifteen years he has taught flower painting on occasional residential courses and takes a weekly class at Leighton Buzzard.
Colour Plate 101

★WILLIAMS, Albert 1913 - c.1990
Born Hove, Sussex; one of the best known 20th century flower painters whose father and grandfather were both professional painters from whom he received his initial training. Later he went to Brighton School of Art and to London and Paris before taking up portraiture and the flower painting for which he is best known, working in a very traditional and perfectionist style.
Albert Williams exhibited at all the main London venues, R.A., R.O.I., R.W.S., R.B.A., the better known provincial galleries and the Paris Salon. His work was on permanent display in Harrods Art Gallery for many years. Commissions were always plentiful and his paintings are in many collections in this country, U.S.A., South Africa and Italy. His work has been widely reproduced as greetings cards, calendars and fine art prints including limited editions. (See page 110.)
Colour Plate 62

WILLIAMS, Emily fl.1869 - 1889
Exhibited flower paintings R.A., S.S. and other venues.
lit: Brinsley Burbidge

WILLIAMS, Juliet Nora fl.1920s
Studied Herkomer School of Art and in Paris and painted flowers and gardens. Exhibited R.A., R.O.I. and in the provinces.
lit: Waters

WILSON, David, R.I., R.B.A. d.1935
Painted flowers and landscape in watercolour and also drew cartoons and caricatures. Contributed to many magazines and periodicals and taught at St John's Wood School of Art. Exhibited R.A., R.B.A. and R.I.
lit: Waters

WILSON, Florence fl.1882 - 1890
Exhibited flower paintings R.A., S.S., N.W.C.S.
lit: Brinsley Burbidge

WISE, Alfred John 1908 -
Artist employed by the R.H.S. drawing plants for records.
lit: Blunt and Stearn

WITHERBY, Henry Forbes, R.B.A.
** fl.1854 - 1907**
Lived at various addresses in London and later in the New Forest. Painted flowers and landscape and exhibited R.A., B.I., S.S. and in Dudley.
lit: Brinsley Burbidge, Waters, Wood

★WITHERS, Augusta Innes (née Baker)
** 1792 - 1877**
Along with Miss S.A. Drake, one of the most talented botanical artists of her time. As well as teaching botanical drawing she and Miss Drake illustrated Bateman's *Orchidaceae of Mexico and Guatemala*, 1837-41, published in a limited edition of 125 copies. She also contributed 100 plates to Maund's *Botanist* 1836-41, contributed to *Curtis's Botanical Magazine*, the *Floral Cabinet*, Thompson's *Garden Assistant*, the *Transactions of the Horticultural Society*, the *Illustrated Bouquet* and illustrated the entire *Pomological Magazine* 1828-30. She was Flower and Fruit Painter in Ordinary to Queen Adelaide. Exhibited R.A., N.W.C.S. and other venues until 1865. Work is in the Lindley Library and the Kew Collection. (See pages 48-50.)
lit: Blunt and Stearn, de Bray, Brinsley Burbidge, Desmond, Kramer, Mabey, Rix, Scott-James, Wood
Colour Plates 20 and 21

WOOD, Catherine M. (Mrs R.H. Wright)
** fl.1880 - 1992**
London artist who painted flowers and still life and exhibited R.A., S.S., N.G., and other venues.
lit: Brinsley Burbidge, Waters, Wood

WOOD, Thomas William, R.W.S., R.O.I.
** 1877 - 1958**
Painted flowers in rather 'tight' arrangements and some landscapes. in oil and watercolour. Born in Ipswich but later lived in London where he studied at the Regent Street Polytechnic, then in Italy. Exhibited R.A., R.I., R.W.S. and other venues and had several one-man shows at the Leicester Galleries in London. Work is in public collections in Leeds, Hull, Manchester and Perth.
lit: Blunt and Stearn, Brinsley Burbidge, Hardie, Waters

WOOLEY, Alice Mary fl.1883 - 1892
Sheffield artist who exhibited flower paintings R.A., S.B.A.
lit: Brinsley Burbidge, Desmond

WORBY, Carolyn, S.B.A. 20th century
Although Carolyn Worby received no formal art training she has always drawn and painted and, as a child, was always encouraged by an artistic family. Since her own family have grown up she has concentrated seriously on her flower painting with a special interest in the portrayal of texture. She exhibits regularly with the S.B.A. and R.H.S. and was awarded a Silver Grenfell Medal in 1989 and a Silver Gilt in 1990. She has also exhibited with the Royal Show at Stoneleigh, the Hampton Court Flower Show and the Linnean Society. She is a member of the Chelsea Physic Garden Florilegium Society.

WORSEY, Thomas, R.B.S.A. 1829 - 1875
Birmingham artist who trained in japanning but later turned to flower painting with great success c.1850. He exhibited R.A, B.I., S.S., the Portland Gallery and in all the main provincial towns and cities (see page 47.).
lit: Brinsley Burbidge, Desmond, Wood

WITHERS, Augusta Innes. *Stylidium drummondii.*

WRIGHT, Ethel (Mrs Barclay) fl.1887 – 1915
Painted flowers and domestic subjects. Exhibited R.A., S.S., Paris Salon and other venues. Her work was reproduced in many magazines.
lit: Brinsley Burbidge

WRIGHT, Valerie, S.W.A., S.B.A.
 20th century
Although Valerie Wright followed several careers – fashion, librarianship, civil service – studying art as part of her honours degree in education some years ago rekindled an early interest in painting. Since 1984 she has worked full time teaching and painting, particularly botanical subjects, flowers and gardens. She exhibits with the S.W.A. and S.B.A., of which societies she is a full Member, and with the R.I., R.W.S. and many well-known galleries, as well as having several solo exhibitions in the North-west.

Many of her paintings have been reproduced as greetings cards and much of her work is commissioned and her paintings are in many private and corporate collections. Her paintings of peoples' houses and their gardens are much in demand.
Colour Plate 100

WYKES, Nigel **1906 –**
Educated in Cambridge and painted flowers. Work has been reproduced by the R.H.S., otherwise little is known.
lit: Brinsley Burbidge

WYLIE, Kate **1877 – 1941**
Painted flowers and portraits in oil and landscapes in watercolour. Born Scotland and studied at Glasgow School of Art. Exhibited R.A., R.S.A., G.I. and work is represented in the Glasgow Art Gallery collection.
lit: Waters

YATES, Ann **1897 –**
Lived Walmsbury and Dorking. Painted flowers and landscape in oil and watercolour. Exhibited flower paintings R.A., R.I., R.B.A., R.Cam.A. and other venues.
lit: Brinsley Burbidge, Waters

YOUNG, Jessie, R.W.S. **1879 –**
Studied Beckenham School of Art, painted flowers in oil and watercolour. Exhibited R.Cam.A., R.W.S. and other galleries in London and the provinces.
lit: Waters

YOUNG, M. **fl.1830s**
Mabey illustrates one drawing for *Curtis's Botanical Magazine,* but little else seems to be known.
lit: Mabey

★ZINKEISEN, Anna Katrina, R.I., R.O.I., R.P., F.R.S.A., R.D.I. **1900 – 1973**
The famous sisters, Doris and Anna Zinkeisen, were born in Kilgreggan, Dumbartonshire,

Scotland, but came south to London as young children. They were educated under a succession of governesses who left one after the other because their charges had no inclination to do anything but draw.

From a small neighbourhood art school both won scholarships to the R.A. Schools, Anna at fifteen, and from there on her career was devoted exclusively to the various facets of her art. Nothing defeated her — murals, designs for Wedgwood china, cards, posters and prints, commissions for animal charities, wartime paintings of wounds and injuries for the Royal College of Surgeons as well as such hospital paintings as operations by candlelight, air raid victims, etc. — all these things interspersed with the society portraits for which she is so famous, not least because of the eminence of many of her sitters.

Anna's flower paintings, whether of bouquets (the best known being H.M. the Queen's Coronation bouquet), random wild flowers or single subjects were an extension of her portraits. Each bloom is a miniature portrait, painted with the same care and attention to detail as a human personal likeness. Anna Zinkeisen always painted for the joy of it — the extra bonus attached to most of her flower paintings was that she could paint to her own choice. (See pages 84–87.)
lit: Brinsley Burbidge, Walpole, Waters, Willcox
Colour Plates 2, 47, 48, 101 and 102

ZINKEISEN, Anna. Flowers in a glass vase.

Abbreviations

A.D.A.E.	Advanced Diploma in Art Education		N.W.C.S.	New Watercolour Society
A.E.C.	Adult Education Centre		N.Y.B.G.	New York Botanic Gardens
A.I.A.	Academy of Irish Art		O.B.E.	Officer of the Order of the British Empire
A.R.A.	Associate of the Royal Academy		O.W.C.S.	Old Watercolour Society
A.R.C.A.	Associate of the Royal College of Art		P.S.	Pastel Society/Paris Salon
A.R.W.S.	Associate of the Royal West of England Academy		R.A.	Royal Academy/Royal Academician
A.R.U.A.	Associate of the Royal Ulster Academy		R.B.A.	Royal Society of British Artists
A.T.D.	Art Teachers' Diploma		R.B.G.	Royal Botanic Gardens, Kew
B.A.	Bachelor of Arts		R.B.G.Edin.	Royal Botanic Gardens, Edinburgh
B.I.	British Institute		R.C.A.	Royal College of Art
B.M.	British Museum		R.Cam.A.	Royal Cambrian Academy
B.S. (B.I.)	Botanical Society (of the British Isles)		R.D.I.	Royal Designer for Industry
B.Sc.	Bachelor of Science		R.E.	Royal Society of Painter-Etchers and Engravers
B.W.S.	British Watercolour Society		R.F.S.	Royal Female School of Art
C. and G.	City and Guilds		R.G.I.	Royal Glasgow Institute
C.B.M.	Certificate of Botanical Merit		R.H.A.	Royal Hibernian Academy
C.V.O.	Commander of the (Royal) Victorian Order		R.H.S.	Royal Horticultural Society
D.B.E.	Dame Commander of the Order of the British Empire		R.H.S. G.M.	Royal Horticultural Society Gold Medal
			R.I.	Royal Institute
Des.R.C.A.	Designer of the Royal College of Arts		R.I.A.	Royal Irish Academy
D.F.A.	Diploma in Fine Art		R.I.B.A.	Royal Institute of British Architects
F.B.A.	Fellow of the British Academy		R.M.S.	Royal Society of Miniature Painters
F.I.G.A.	Fellow of the Institute of Graphic Artists		R.N.R.S.	Royal National Rose Society
F.L.S.	Fellow of the Linnean Society of London		R.O.I.	Royal Institute of Oil Painters
F.P.H.	Founder President's Honour of the Society of Botanical Artists		R.P.G.	Royal Portrait Gallery
			R.P.	Member of the Royal Portrait Society
F.P.S.	Free Painters and Sculptors		R.P.S.	Royal Portrait Society
F.R.C.A.	Fellow of the Royal College of Art		R.S.A.	Royal Society of Arts
F.R.C.P.	Fellow of the Royal College of Physicians		R.S.M.	Royal Society of Miniaturists
F.R.S.A.	Fellow of the Royal Society of Arts		R.S.M.A.	Royal Society of Marine Artists
F.S.A.	Free Society of Artists		R.S.W.	Royal Scottish Society of Painters in Watercolour
F.S.B.A.	Founder Member of the Society of Botanic Artists		R.U.A.	Royal Ulster Academy
F.S.I.A.	Fellow of the Society of Industrial Artists		R.W.S.	Royal Watercolour Society
G.G.	Grosvenor Galleries – 1878-1890		R.W.A.	Royal West of England Academy
G.I.	Royal Glasgow Institute of Fine Arts		S.A.	Society of Artists (1760-1791)
G.S. of A.	Glasgow School of Art/Glasgow Society of Arts		S.B.A.	Society of British Artists/Society of Botanic Artists
H.N.D.	Higher National Diploma		S.F.P.	Society of Flower Painters
H.S.	Hilliard Society of Miniaturists		S.G.A.	Society of Graphic Artists
I.C.A.	Institute of Contemporary Arts		S.G.F.A.	Society of Graphic and Fine Arts
L.G.	London Group		S.L.A.	Society of Lady Artists
L.M.	Linnean Medal		S.M.A.	Society of Miniaturists
L.S.	Linnean Society of London		S.M.P.	Society of Mural Artists
M.A.	Master of Arts		S.S.	Suffolk Street
M.B.E.	Member of the Order of the British Empire		S.S.A.	Society of Scottish Artists
M.D.	Doctor of Medicine		S.W.A.	Society of Women Artists
M.G.M.A.	Member of the Guild of Memorial Artists		S.W.E.	Society of Wood Engravers
M.I. Hort.	Member of the Institute of Horticulture		S.W.L.A.	Society of Wildlife Artists
M.S.	Society of Miniaturists		U.A.	United Artists
M.S I.A.	Member of the Society of Industrial Artists		U.K.	United Kingdom
M.S.T.D.	Member of the Society of Typographical Artists and Designers		U.S.A.	United States of America
			U.S.W.A.	Ulster Society of Women Artists
N.D.D.	National Diploma of Design		U.W.S.	Ulster Watercolour Society
N.E.A.C.	New English Art Club		V. and A.	Victoria and Albert Museum
N.E.C.	National Exhibition Centre, Birmingham		V.H.M.	Victorian Medal of Honour
N.G.	New Gallery 1888-		V.M.M.	Veitch Memorial Medal
N.P.S.	National Portrait Society		W.A.A.F.	Women's Auxiliary Air Force
N.S.	National Society		W.I.A.C.	Women's International Art Club
N.S.A.	New Society of Artists		W.R.N.S.	Women's Royal Naval Service

Bibliography

BAZIN, Germain, *A Gallery of Flowers*, Thames & Hudson, 1960
BÉNÉZIT, *Dictionnaire des Peintres, Sculpteurs, etc.*, 8 vols.,1976
BILLCLIFFE, Roger, *The Glasgow Boys*, John Murray Ltd., 1985
BLAMEY, Marjorie, *Learn to Paint Flowers in Watercolour*, Harper Collins, c.1950
BLATCHLEY, John and EDEN, Peter, *Isaac Johnson of Woodbridge*, Suffolk Record Office, 1979
BLUNT, Wilfrid, *The Art of Botanical Illustration*, Collins, 1950
BLUNT, Wilfrid and STEARN, William T., *The Art of Botanical Illustration*, Antique Collectors' Club, 1994
BOL, L.J., *The Bosschaert Dynasty*, F. Lewis, 1960
BRAY, Lys de, *The Art of Botanical Illustration*, Christopher Helm Ltd., 1989
BROOKSHAW, G. *A New Treatise on Flower Painting or Every Lady her own Drawing Master*, Hurst, Rees, Orme and Brown, 1816
BRINSLEY BURBIDGE, Richard, *Dictionary of British Fruit and Flower Painters* Vols.1 and 11, F. Lewis, 1974
BRYAN's *Dictionary of Painters and Engravers*, 1930

CHADWICK, Lee, *In Search of Heathland*, Dobson, 1982
CHAFFERS' *Marks and Monograms*, 15th edition, 1965
CLAYTON, E.C., *English Female Artists*, 1876
CLIFFORD, D., *Watercolours of the Norwich School*, 1965
COATS, Alice M., *The Book of Flowers*, Phaidon Press, 1973
CONSTABLE, Freda, *John Constable*, Dalton 1975

DAY, Harold, *The Norwich School of Painters*, Eastbourne Fine Art, 1979
DESMOND, Ray, *A Celebration of Flowers – 200 years of Curtis's Botanical Magazine*, R.B.G., Kew, 1987
DESMOND, Ray, *Dictionary of British and Irish Botanists and Horti-culturists*, Taylor & Francis, 1994
DESMOND, Ray, *Sir Joseph Dalton Hooker*, Antique Collectors' Club, 1999

EVANS and EVANS, *An Approach to Botanical Painting*, Hannaford & Evans, 1993

FISHER, John, *Mr Marshal's Flower Album from the Royal Library at Windsor Castle*, Gollancz Ltd., 1985
FLEMING-WILLIAMS, Ian and Parris, Leslie, *The Discovery of Constable*, Hamish Hamilton, 1984
FOSHAY, Ella M., *Art in Bloom*, Phaidon Universe, 1990
FULTON, Paul and SMITH, Lawrence, *Flowers in Art from East and West*, British Museum Publications, 1979

GOODMAN, Jean, *With Love from Bunty*, Parke, Sutton, Ltd., 1992
GOODY, Jack, *The Culture of Flowers*, C.U.P., 1983
GRANT, Col. Maurice H., *Flowers through Four Centuries – the Broughton Collection*, F. Lewis, 1952

HADFIELD, John, *Reflections of Country Life*, Tate Gallery Publications, 1986

HAIRS, Marie Louise, *The Flemish Flower Painters in the XVIIth Century*, Université de Liège, 1979
HARDIE, Martin, R.E., Hon. R.W.S., *Flower Paintings*, F. Lewis, 1947
HARDOUIN-FUGIER, Elizabeth and GRAFE, Etienne, *The Lyon School of Flower Painters*, F. Lewis, 1978
HARDOUIN-FUGIER, Elizabeth, *The Pupils of Redouté*, F. Lewis, 1981
HARDOUIN-FUGIER, Elizabeth and GRAFE, Etienne, *French Flower Painters of the 19th Century*, Philip Wilson, 1989
HARRIS, Paul and HALSBY, Julian, *The Dictionary of Scottish Painters 1600 to the Present*, Canongate Books, Edinburgh, 1998
HEMINGWAY, Andrew, *The Norwich School of Painters*, Phaidon, 1979

*IPSWICH MUSEUMS SERVICE

JEKYLL, Gertrude, *A Gardener's Testament*, Antique Collectors' Club, 1982

KEBLE-MARTIN, Rev. William, *A Concise British Flora in Colour*, 1965
KELLAWAY, Deborah, *Favourite Flowers – watercolours by Elizabeth Blackadder*, Pilgrim Books
KENNY, Thomas, *Webb – A Profile*, Kenny's, Galway, 1990
KRAMER, Jack, *Women of Flowers*, Stewart, Tabor & Chang, 1996

LESLIE, C.R., *Memoirs of the Life of John Constable*, Phaidon, 1951
LESTER, Anthony J., 'Anatomy of Contemporary British Artists' Antique Collecting, April 1999
LEWIS, Cherry, *The Making of a Garden – Gertrude Jekyll*, Antique Collectors' Club, 1984
LEWIS, Frank, *Edward Ladell 1821-1886*, F. Lewis, 1976
LEWIS, John, *Rowland Hilder – Painter and Illustrator*, Barrie & Jenkins, 1978

MABEY, Richard, *The Flowering of Kew*, Century, 1998
MABEY, Richard, *The Frampton Flora*, Century, 1985
MACMILLAN – *The Macmillan Dictionary of Art*, 34 vols., 1996
McMURTRIE, Mary, *Scots Roses of Hedgerows and and Wild Gardens*, Garden Art Press, 1998
McMURTRIE, Mary, *Scottish Wild Flowers*, Garden Art Press, 2001
McMURTRIE, Mary, *Old Cottage Pinks*, Garden Art Press, 2004
MALLALIEU, Huon, *The Dictionary of British Watercolour Artists up to 1920*, Vols. I and II, Antique Collectors' Club, 2002
MASSINGHAM, Betty, *Miss Jekyll* (Saturday Book 16, John Hadfield), Hutchinson, 1956
*MEDICI SOCIETY
MEE, Margaret, *In Search of the Flowers of the Amazon Forests*, Lefèbvre & Gillet, 1988
MEE, Margaret, *Margaret Mee's Amazon – Diaries of an Artist Explorer*, Antique Collectors' Club, 2004
MITCHELL, Peter, *European Flower Painters*, A. & C. Black, 1973

MITCHELL, Peter, *Great Flower Painters – Four Centuries of Floral Art,* Overlord Press, New York, 1973

MOORE, Andrew, *The Norwich School of Artists,* Norfolk Museums Service, 1985

MORRISON, Tony, Ed., *Margaret Mee – In Search of the Flowers of the Amazon Forest,* Antique Collectors' Club, 1988

MOYNE de MORGUES, Jacques le, *Portraits of Plants,* V. and A., n.d.

MURDOCH, John, 'Which Constable', *Burlington Magazine,* 1980

PAVIÈRE, S.H., *A Dictionary of Victorian Landscape Painters,* 1968

PEACOCK, Carlos, *John Constable – The Man and his Work,* John Baker, 1965

PONSONBY, Laura, *Marianne North at Kew ,* Webb & Brown (with Kew)

REISS, Stephen, *Peggy Somerville – An English Impressionist,* Antique Collectors' Club, 1996

REYNOLDS, Graham, *English Watercolours,* Herbert, 1950

REYNOLDS, G., *Victorian Painting,* 1966

★R.H.S.

RIX, Martin, *The Art of Botanical Illustration,* Cameron Books, 1981

ROBERTSON, Pamela, *Charles Rennie Mackintosh – Art is the Flower,* Pavilion Books, 1995

ROGET, J.L., *History of the Old Watercolour Society,* 1891

ROTHENSTEIN, John, *An Introduction to English Painting,* Cornell, 1965

SANDERS, R., *The English Apple,* Phaidon, 1988

SAVILLE, John, *Paxton Chadwick,* Leiston Leader, 1993

SCOTT-JAMES, Anne, DESMOND, Ray and WOOD, Francis, *The British Museum Book of Flowers,* British Museum, 1989

SCRACE, David, *Flowers of Three Centuries,* International Exhibitions Foundation, Washington, 1983

SHERWOOD, Shirley, *Contemporary Botanical Artists, the Shirley Sherwood Collection,* Weidenfield & Nicholson, 1996

SITWELL, *Great Flower Books,* 1952

★SKIPWITH

SPALDING, Frances, *20th Century Painters and Sculptors,* Antique Collectors' Cub, 1990

STEARN, William T., *Flower Artists of Kew,* Herbert Press (with Kew, 1990)

SYNGE, Patrick, *In Search of Flowers,* Michael Joseph, 1973

★TATE GALLERY

THOMAS, Graham Stuart, *The Complete Flower Paintings and Drawings of Graham Stuart Thomas,* Thames & Hudson, 1987

THOMAS, Graham Stuart, *A Garden of Roses – watercolours by Alfred Parsons, R.A.,* Pavilion Books, 1987

VERRIER, Michelle, *Fantin-Latour,* Academy Editions, 1977

WALKER, Winifred, *All the Plants of the Bible,* Lutterworth Press, 1957

★WALLACE

WALPOLE, Josephine, *Kenneth Webb – A Life in Colour,* Antique Collectors' Club 2003

WALPOLE, Josephine, *Art and Artists of the Norwich School,* Antique Collectors' Club, 1998

WALPOLE, Josephine, *Vernon Ward – Child of the Edwardian Era,* Antique Collectors' Club, 1988

WALPOLE, Josephine, *Anna – A Memorial Biography,* Royle Publications, 1978

WALPOLE AND WILLIAMS, *Woodbridge Then and Now,* Hamlyn Publishing, 1993

WATERS, Grant, *Dictionary of British Artists, 1900-1950,* Vols. I and II, Eastbourne Fine Art, 1974

WHYBROW, Marion, *St. Ives 1883-1993,* Antique Collectors' Club, 1994

WILLIAMS, I.O., *Early English Watercolours,* 1952, repr. 1971

WOOD, Christopher, *Dictionary of Victorian Painters,* Antique Collectors' Club, 1971

WOOD, Jeremy, *Hidden Talents – A Dictionary of Neglected Artists Working 1880-1950,* 1994

WYKES-JOYCE, Max, *Kenneth Webb,* New York Herald Tribune, 1973

ZAMPARELLI, Dr., *John Strevens – the Man and his Art,* Kurt Schon Ltd., 1982

★ This includes numerous catalogues of exhibitions and collections in Great Britain

Index of Artists

(Chapters I to V)
Page numbers in bold type refer to illustrations

Adrien, Caroline, 19
Aelst, Pauwels Coecke van, 15
Aelst, Evert van, 15
Aelst, Willem van, 15-16, 17
Andrews, Jennifer, **78-79,** 84
Arellano, Juan de, 18
Arson, Olympe-Marie, 19
Assteyn, Bartholomeus, 17
Ast, Balthasar van der, 16, 17
Aubriet, Claude, 15, 19

Bailly, Jacques, 18
Baker, John, 27
Baudesson, Nicolas, 18
Bauer, Francis, 15, 37
Bauer, Frederick, 15
Beaurepaire, Lucy de, 19
Beert, Osias the Elder, 17
Bellenge, Michel-Bruno, 19
Benner, Jean, 18
Benner-Fries, Jean, 18
Ber, Jacob, 18
Berjon, Antoine, 19
Bessa, Pancrace, 15
Bideau, Eugène, 19
Blackadder, Elizabeth, 93-96
Blackwell, Elizabeth, 37-40, **38-39**
Blamey, Marjorie, 74-78, **74-75**
Bollongier, Hans, 17
Booth, Raymond, **84-87,** 96-99
Bosch, Lodewyck Jansz van der, 15
Bosschaert, Abraham, 17
Bosschaert, Ambrosius the Elder, 15, 16-17
Bosschaert, Ambrosius the Younger, 16, 17
Bosschaert, Johannes, 17
Bourdichon, Jean, 14
Brueghel, Abraham, 16
Brueghel, Ambrosius, 16
Brueghel, Jan the Elder, 15-16
Brueghel, Jan the Younger, 15
Bruyère, Elise, 18
Bury, Priscilla Susan, 51-52, **51**

Camprobin, Pedro de, 18
Castex-Degrange, Adolphe Louis, 19
Catesby, Mark, **22-23,** 28
Cauchois, Eugène-Henri, 19
Cézanne, Paul, 20
Chabal-Dussurgey, Pierre-Adrien, 19
Champin, Elisa Honorine, 19

Charlotte, Queen, 37
Chase, Marion, 47
Chazal, Antoine, 19
Churchyard, Ellen, **56-57**
Clare, George, 44, **49**
Clare, Oliver and Vincent, 44
Claude, Eugène, 19
Clayton, Harold, **88-89,** 101-102, 107
Clifford sisters, 59-61
Clifford, Charlotte Ann – *see* Purnell,
 Charlotte Anne
Comolera, Melanie de, 19
Cooper, Gerald, **90,** 101-102, 107
Cotterill, Anne, **98-99,** 112-115
Couder, Jean Alexandre, 19
Courbet, Gustave, 20

Dael, Jan Franz van, 17
Daffinger, Moritz Michael, 15
Delacroix, Ferdinand-Victor-Eugène, 20
Delany, Mary, 40
Desportes, Alexandre-François, 18
Drake, S.A., 48-50
Dumillier, Dominique, 19
Dürer, Albrecht, 14-15, 22

Edwards, Sydenham Teast, 30, 34
Ehret, Georg Dionysius, 15
Eliaerts, Jean-François, 17, 19
Ensor, Mary, 47

Fantin-Latour, Henri, 19
Farrer, Ann, 72
Faux-Froidure, Eugénie-Juliette, 19
Ferguson, William Gowe, 22, 25 (n.)
Fitch, John Nugent, 48
Fitch, Walter Hood, 48
Flegel, Georg, 15
Fontenay, Jean Baptiste Belin de, 18
Fontenay, Jean Baptiste Belin de, the
 Younger, 18

Gerard, 14
Géradin, Pauline, 19
Gheyn, Jacob de, 15
Greche, Domenico dalle, 15
Grierson, Mary, **67-69,** 68
Grivolas, Antoine, 20
Guardi, Francesco, 18

Haverman, Margareta, 18
Hecke, Jan van der, 17
Heem, Cornelis de, 17
Heem, Jan Davidsz de, 18
Henderson, Peter, **25,** 28
Hewlett, James, 27
Hill, 'Sir' John, 34-37
Hoefnagel, Georg, 14
Hooker, Sir Joseph Dalton, 47-48
Hooker, Sir William Jackson, 47
Hughes, Trajan, 28
Hunt, William, 44
Huysum, Jacobus van, 17
Huysum, Jan, Justus and Michiel van, 17

Jeannin, Georges, 19
Jekyll, Gertrude, 62-63
Johnson, Isaac, 28, **30-31**

Kease, Mary – *see* Lawrance, Mary
Kennedy, Cecil, **91-93,** 101-107
Kessel, Jan van, 16
Keyse, Thomas, 27
Kilburn, William, 32, **35**
King, Christabel, 72

Ladell, Edward, 44, **46-47**
Ladell, Ellen, 44
Ladey, Jean Marc, 18
Lancaster, John Henry, **93-95,** 107-110
Langhorne, Joanna, 68-72, **70**
Largillière, Nicolas de, 18
Laurent, François Nicolas, 18
Lawrance, Mary, **39,** 40
Lays, Jean-Pierre, 19
Le Moyne de Morgues, Jacques, 15
Lee, Ann, 37
Leeuween, Gerrit Jan van, 17
Ligozzi, Giacomo, 15
Linthorst, Jacobus, 17
Linard, Jacques and Jacobus, 18
Lloyd, Mary – *see* Moser, Mary
Longpré, Paul-Henri and Raoul-Henri
 Maucherat de, 19
Lucas, Albert Dürer and Edward George
 Handel, 44-47
Luyckx, Christiaan, 87

Mackintosh, Charles Rennie, **58-61,** 62
Manet, Edouard, 19

Margitson, Maria, 44
Marlier, Philip de, 17
Marrel, Jacob, 18
Marshal, Alexander, **12,** 15, 22-25
Mary of Burgundy, Master, 14
Masson, Francis, 34
Matisse, Henri, 20
Maund, Miss and Miss S., 52, **52-53**
Maw, George, 50-51
Mee, Margaret Ursula, **76-77,** 80-84
Meen, Margaret, 37
Merian, Maria Sybilla, 15
Micheux, Michel Nicholas, 18
Michiel, Pietro, 15
Mignon, Abraham, 18
Miller, John Frederick, 30-32
Miller, John Sebastian, 30, *32-33*
Mills, R., 52, **55**
Moggridge, John Traherne, 51
Monet, Oscar-Claude, 19
Monnoyer, Antoine and, Jean-Baptiste, 18
Monticelli, Adolphe, 20
Morel, Jan Baptiste, 17
Morgan, Robert, 48
Morison, Robert, 22
Morisot, Berthe, 19
Moser, Mary, **26-27,** 27
Müller, Johan Sebastian – *see* Miller, John
Mutrie, Annie Feray and Martha Darley, 47

Nash, John Northcote, 68, 84
Nodder, Frederick Polydore, 30
North, Marianne, 52-57
Nuzzi, Mario, 18

Oates, Bennett, **100-101,** 115-123
Oosterwyck, Maria van, 18
d'Orléans, Louise, 19
Os, Georgius Jacobus Johannes van, 17
Os, Jan van, 17

Panckoucke, Anne-Ernestine, 19
Papera, Paolo, 18
Parkinson, John, 22
Parkinson, Sydney, 30
Parsons, Alfred, 57-59
Parsons, Beatrice, 57-59
Pascal, Antoine, 19
Paterson, James, 19
Peeters, Clara, 18
Perez, Bartolomo, 18
Perrachon, André-Benoit, 19
Pether, Abraham, 28
Pissarro, Camille, 19
Pol, Christien van, 17
Pope, Clara Maria, 37
Prévosts, the, 19
Purnell, Charlotte Anne, 59-61
Purves, Rodella, **70-71,** 72-74

Raffaëlli, Jean-François, 20
Ray, John, 22
Recco, Giuseppi, 18
Redon, Odilon, 20
Redouté, Pierre-Joseph, 15, 19
Reignier, Jean-Marie, 20
Reinagle, Philip, 15, **24,** 28
Renoir, Pierre-Auguste, 19
Robert, Nicolas, 15, 19, 24
Robins, Thomas the Elder, 34, **36-37**
Robins, Thomas the Younger, 34
Ross-Craig, Stella, 65-66
Rousseau, Henri-Julien, 20
Ruskin, John, 47, 51, 61-62
Rust, Graham, 65
Ruysch, Rachel, 18

Saint-Jean, Simon, 19
Scacciati, Andrea, 18
Schilt, Louis-Pierre, 19
Seghers, Daniel, 16, 17, 18, **20,** 87

Sellars, Pandora, 78-80
Sillett, James, 27-28, **28-29, 61**
Snelling, Lilian, **64-65,** 66
Somerville, Stuart, **frontispiece, 103,** 123-124
Sowerby, James, 32
Sowerby, James de Carle, 32, 34
Spaendonck, Cornelis van, 17
Spaendonck, Gérard van, 17, 19
Stanier, Henry, 47
Stannard, Eloise Harriet, 18, 43-44, **44-45, 63**
Stannard, Emily, **42-43,** 43
Stannard, Emily the Younger, 43
Stones, Margaret, 66
Sweerts. Jeronimus, 16

Tayler, Jane, 52, **54-55**
Thielen, Jan Philips van, 17
Thierriat, Augustin, 19
Thornton, Robert J., **24, 25,** 28
Twining, Elizabeth, **41,** 52

Vallayer-Coster, Anne, 18
Venne, Pieter van der, 17
Verendael, Nicholas van, 17
Vuillard, Edouard, 20

Walker, Winifred, 13-14
Waller, Richard, 22
Walscapelle, Jacob, 17
Ward, Vernon, **82,** 87
Webb, Kenneth, **82-83,** 87-93
White, John, 22
Williams, Albert, **97,** 110
Withers, Augusta Innes, 48-50, **50**
Worsey, Thomas, 47
Wouterez, Jacob, 17

Zinkeisen, Anna, **20-21, 80-81,** 84-87